The Italian Painters
of the Renaissance

The Italian Painters of the Renaissance

Bernard Berenson

A Phaidon Book

Cornell University Press

ITHACA, NEW YORK

First published by Phaidon Press Ltd. 1952
First published, Cornell Paperbacks, 1980

International Standard Book Number 0–8014–9195–9
Library of Congress Catalog Card Number 80–66412

Printed in Great Britain by The Pitman Press, Bath

THIS VOLUME

HAS BEEN PRODUCED

IN COLLABORATION WITH

THE SAMUEL H·KRESS FOUNDATION

AS A TRIBUTE TO

BERNARD BERENSON

AND IN APPRECIATION OF

MORE THAN A QUARTER CENTURY

OF FRIENDSHIP AND COOPERATION

IN THE FIELD OF RENAISSANCE PAINTING

BETWEEN BERNARD BERENSON AND

SAMUEL H·KRESS

CONTENTS

PUBLISHER'S NOTE

This volume has been photographically reprinted from the first edition, published in 1952, and incorporates several minor corrections from subsequent reprints. The colour plates from the earlier editions have been removed. The locations of some of the works reproduced have changed. Plates 155, 274, 296, 299, 343 and 361 are now in the Harvard Center, Villa I Tatti, Florence; Plate 53 is in a private collection; and Plate 174 is now in the National Gallery of Scotland, Edinburgh.

PREFACE

MANY see pictures without knowing what to look at. They are asked to admire works of pretended art and they do not know enough to say, like the child in Andersen's tale, 'Look, the Emperor has nothing on'.

Vaguely the public feels that it is not being fed, perhaps taken in, possibly made fun of.

It is as if suddenly they were cut off from familiar food and told to eat dishes utterly unknown, with queer tastes, foreboding perhaps that they were poisonous.

In a long experience humanity has learnt what beasts of the field, what fowl of the air, what creeping things, what fishes, what vegetables and fruits it can feed on. In the course of thousands of years it has learnt how to cook them so as to appeal to smell, palate and teeth, to be toothsome.

In the same way some few of us have learnt in the course of ages what works of art, what paintings, what sculpture, what architecture feed the spirit.

Not many feel as convinced of what they are seeing as of what they are eating.

Just as all of us have learnt what is best as food, some of us think we have learnt what is best as art.

A person with convictions about his normal workaday food may enjoy highly savoured cookery for a change, or out of curiosity, but he will always return to the dishes he grew up on—as we Americans say, to 'mother's cooking'.

Art lacks the urgency of food, and little children are not taught what to look at as they are taught what to eat. And unless they are brought up in families of taste as well as of means, they are not likely to develop unconsciously a feeling for visual art, as they do, let us say, for language. Words and speech they pick up before they know what instruments they are learning to use. Later at school they are taught to practise and enjoy language as an art, as communicative speech and writing, chiefly through the reading of graduated passages from the best authors and through being taught how to understand and appreciate and enjoy them. In that way habits of liking and disliking are lodged in the mind. They guide us through life in encountering the not yet classified, the not yet consecrated, and in recognizing what is and what is not valuable and enjoyable or worth making the effort to

understand and enjoy. They end by giving us a sense of antecedent
probability towards literature.

Why should we not try to implant such habits in a child's mind also
for the visual arts?

Unhappily pictures cannot as yet be printed (so to speak) exactly as
they are painted, in the way a writer's manuscript can be, without
losing the quality of the original. The reproduction of a picture is still
a makeshift, and may remain so for a long time, even if accurate and
satisfactory colour reproductions should become available. The size
of a composition has a certain effect on its quality, and colour clings to
what is behind it. Thus a colour will, of course, not be the same on
wood as on slate or marble or copper, and will vary from textile to
textile on which it is applied, as for instance rough or ordinary canvas
or fine linen.

On the whole therefore (despite the childish hanker today for colour
reproductions, no matter how crude) the black and white, made from
a photo that preserves tones and values, give the most satisfactory
image of the original.

With that conviction in mind and with the idea of furnishing
examples on which to educate the eye and the faculties that use the
eye as an instrument, the present edition of *Italian Painters of the
Renaissance* offers 400 illustrations representing all phases of Italian
pictorial art during the three hundred years that begin a little before
1300 and end short of 1600.

For example: the Byzantine phase is represented by the greatest and
completest master of that style anywhere in the world, namely, Duccio.
The sturdy, severely tactile Romanesque mode by Giotto, its most
creative and most accomplished master, and by his best followers,
Andrea Orcagna and Nardo di Cione.

Then comes the fifteenth century and the struggle started by
Masolino and Masaccio to emancipate painting from degenerate
calligraphic Gothic affectation. Masaccio was a resurrected Giotto,
with even increased power of communicating dignity, responsibility,
spirituality by means of appropriate shapes, attitudes and grouping of
figures. After his early death, Florentine painting, profiting by the
great sculptors Donatello and Ghiberti and developed by artists like
Fra Angelico, Fra Filippo Lippi, Pollaiuolo, Botticelli and Leonardo,
culminated in Michelangelo, Andrea del Sarto and their immediate
followers Pontormo and Bronzino. By that time the Florentines not
only had recovered the indispensable mastery of the nude that the

Greeks cherished, but in the painting of landscape went beyond them, thanks to their better understanding of light and shade and perspective.

They handed on these achievements to Venice and to the rest of Italy, but to Venice particularly and later to France and Spain.

Venice and Umbria were sufficiently gifted to take advantage of what Florence could give them. They could throw away the scaffolding that the Florentines were too pious or too proud to cast off and produce painters like Perugino and Raphael at their most radiant best, and Giorgione, Titian and Tintoretto, with all their magic and colour, splendour of form and delight in placing the human figure in lordly surroundings and romantic scenery.

Excepting Paolo Veronese (who came, it is true, from Verona, but ended in Venice and was as Venetian as his only equals, namely, Titian and Tintoretto), the north of Italy produced only one artist of the highest mark, Andrea Mantegna of Padua. Milan to be sure had Foppa, Borgognone and Luini, the last valued by Ruskin as Italy's most communicative and convincing religious painter. Nowadays we care more for the energy and vehemence and fancy of the Ferrarese, Tura, Cossa and Ercole Roberti. They put to good use what they took from Donatello, Fra Filippo, Andrea Mantegna, as well as from Piero della Francesca.

Southern Italy during the centuries we are dealing with had no painter worth considering. Sicily had but one, Antonello da Messina, who never would have been the artist we admire without coming in touch first with Petrus Christus and then with Giovanni Bellini, the most creative, the most fascinating of fifteenth-century Venetians.

Visual language changes as much as spoken language. It takes deliberate training to understand the Saxon spoken by our ancestors till toward 1300. In painting that phase corresponds in Italy to Cimabue and Duccio and their close followers.

It takes a serious effort to learn to understand them. By the end of the fourteenth century there was Chaucer, and we can follow him with less difficulty as we can Giotto and Simone Martini and their successors well into the fifteenth century. In that, and in the next century, our ancestors, under various Latin impulsions, were struggling towards a speech which approaches our own, and in the course of the struggle produced Marlowe, Shakespeare and Sidney, Milton, Donne, Herbert and Herrick, and a galaxy of minor poets, just as Italy in the same phase had Fra Angelico, Domenico Veneziano, Masaccio, Fra Filippo, Pollaiuolo, Mantegna and the Bellinis, Botticelli,

Leonardo and Michelangelo. With Dryden and Addison and Pope we come to current English and to their visual equivalents Titian and Veronese, Lotto and Tintoretto.

Happily visual language is easier to acquire than spoken language. One can learn to understand Giotto and Cimabue with less effort and in shorter time than Anglo-Saxon or even Middle English writers.

We therefore do not ask too much of the reader if we expect him to begin with looking at what is remotest from him instead of what is nearest, as would be the case with literature.

I am not an assiduous reader of my own writings. Decades have passed without my perusing the text of the *Italian Painters of the Renaissance* from cover to cover. In glancing through its pages now, I have tried to approach it as I would any other book that treated the same subject.

On the whole, it still seems to fulfil its purpose. It does not attempt to give an account of the painters' domestic lives or even of their specific techniques, but of what their pictures mean to us today as works of art, of what they can do for us as ever contemporary life-enhancing actualities. The text may help the reader to understand what the reproductions tell him, and may make him ask what he feels when he looks at them and try to account for his reactions while enjoying a work of visual art—in this instance, the paintings of the Italian Renaissance.

The quality of art remains the same, regardless of time and place and artist. Nevertheless, our feeling for it is conditioned by time and place and the personality of the artist. Acquaintance with these limitations is necessary for the enjoyment and understanding of the work of art. We are so made that we cannot help asking whence and whither, and we appreciate an object more when we know not only what it is intrinsically on its own merits, but also where it came from and what it led to.

Yet too much time should not be wasted in reading about pictures instead of looking at them. Reading will help little towards the enjoyment and appreciation and understanding of the work of art. It is enough to know when and where an artist was born and what older artist shaped and inspired him, rarely, as it happens, the master or teacher who first put pen, pencil and brush into his hands. Least profit is to be got from the writings of the metaphysical and psycho-analytical kind. If read one must, let it be the literature and history of the time and place to which the paintings belong.

We must look and look and look till we live the painting and for a fleeting moment become identified with it. If we do not succeed in loving what through the ages has been loved, it is useless to lie ourselves into believing that we do. A good rough test is whether we feel that it is reconciling us with life.

No artifact is a work of art if it does not help to humanize us. Without art, visual, verbal and musical, our world would have remained a jungle.

BERNARD BERENSON

I Tatti, Settignano, Florence

January, 1952

BOOK I
THE VENETIAN PAINTERS

BOOK I

I

AMONG the Italian schools of painting the Venetian has, for the majority of art-loving people, the strongest and most enduring attraction. In the course of the present brief account of the life of that school we shall perhaps discover some of the causes of our peculiar delight and interest in the Venetian painters, as we come to realize what tendencies of the human spirit their art embodied, and of what great consequence their example has been to the whole of European painting for the last three centuries.

The Venetians as a school were from the first endowed with exquisite tact in their use of colour. Seldom cold and rarely too warm, their colouring never seems an afterthought, as in many of the Florentine painters, nor is it always suggesting paint, as in some of the Veronese masters. When the eye has grown accustomed to make allowance for the darkening caused by time, for the dirt that lies in layers on so many pictures, and for unsuccessful attempts at restoration, the better Venetian paintings present such harmony of intention and execution as distinguishes the highest achievements of genuine poets. Their mastery over colour is the first thing that attracts most people to the painters of Venice. Their colouring not only gives direct pleasure to the eye, but acts like music upon the moods, stimulating thought and memory in much the same way as a work by a great composer.

The Venetians' use of colour

II

The Church from the first took account of the influence of colour as well as of music upon the emotions. From the earliest times it employed mosaic and painting to enforce its dogmas and relate its legends, not merely because this was the only means of reaching people who could neither read nor write, but also because it instructed them in a way which, far from leading to critical inquiry, was peculiarly capable of being used as an indirect stimulus to moods of devotion and contrition. Next to the finest mosaics of the first centuries, the early works of Giovanni Bellini, the greatest Venetian master of the fifteenth century, best fulfil this religious intention. Painting had in his lifetime reached a point where the difficulties of technique no longer stood in the way of the expression of profound emotion. No one can look at

The Church and painting

Pls. 18, 20 Bellini's pictures of the Dead Christ upheld by the Virgin or angels without being put into a mood of deep contrition, nor at his earlier Pl. 19 Madonnas without a thrill of awe and reverence. And Giovanni Bellini does not stand alone. His contemporaries, Gentile Bellini, the Vivarini, Crivelli, and Cima da Conegliano all began by painting in the same spirit, and produced almost the same effect.

The Church, however, thus having educated people to understand painting as a language and to look to it for the expression of their sincerest feelings, could not hope to keep it always confined to the channel of religious emotion. People began to feel the need of painting as something that entered into their everyday lives almost as much as we nowadays feel the need of the newspaper; nor was this unnatural, considering that, until the invention of printing, painting was the only way, apart from direct speech, of conveying ideas to the masses. At about the time when Bellini and his contemporaries were attaining maturity, the Renaissance had ceased to be a movement carried on by scholars and poets alone. It had become sufficiently widespread to seek popular as well as literary utterance, and thus, towards the end of the fifteenth century, it naturally turned to painting, a vehicle of expression which the Church, after a thousand years of use, had made familiar and beloved.

To understand the Renaissance at the time when its spirit began to find complete embodiment in painting, a brief survey of the movement of thought in Italy during its earlier period is necessary, because only when that movement had reached a certain point did painting come to be its most natural medium of expression.

III

The spirit
of the
Renaissance The thousand years that elapsed between the triumph of Christianity and the middle of the fourteenth century have been not inaptly compared to the first fifteen or sixteen years in the life of the individual. Whether full of sorrows or joys, of storms or peace, these early years are chiefly characterized by tutelage and unconsciousness of personality. But towards the end of the fourteenth century something happened in Europe that happens in the lives of all gifted individuals. There was an awakening to the sense of personality. Although it was felt to a greater or less degree everywhere, Italy felt the awakening earlier than the rest of Europe, and felt it far more strongly. Its first manifestation was a boundless and insatiable curiosity, urging people to find out all they could about the world and about man. They turned

eagerly to the study of classic literature and ancient monuments, because these gave the key to what seemed an immense storehouse of forgotten knowledge; they were in fact led to antiquity by the same impulse which, a little later, brought about the invention of the printing-press and the discovery of America.

The first consequence of a return to classical literature was the worship of human greatness. Roman literature, which the Italians naturally mastered much earlier than Greek, dealt chiefly with politics and war, seeming to give an altogether disproportionate place to the individual, because it treated only of such individuals as were concerned in great events. It is but a step from realizing the greatness of an event to believing that the persons concerned in it were equally great, and this belief, fostered by the somewhat rhetorical literature of Rome, met the new consciousness of personality more than half-way, and led to that unlimited admiration for human genius and achievement which was so prominent a feature of the early Renaissance. The two tendencies reacted upon each other. Roman literature stimulated the admiration for genius, and this admiration in turn reinforced the interest in that period of the world's history when genius was supposed to be the rule rather than the exception; that is to say, it reinforced the interest in antiquity. *Worship of greatness*

The spirit of discovery, the never satisfied curiosity of this time, led to the study of ancient art as well as of ancient literature, and the love of antiquity led to the imitation of its buildings and statues as well as of its books and poems. Until comparatively recent times scarcely any ancient paintings were found, although buildings and statues were everywhere to be seen, the moment anyone seriously thought of looking at them. The result was that, while the architecture and sculpture of the Renaissance were directly and strongly influenced by antiquity, painting felt its influence only in so far as the study of antiquity in the other arts had conduced to better draughtsmanship and purer taste. The spirit of discovery could thus show itself only indirectly in painting—only in so far as it led painters to the gradual perfection of the technical means of their craft. *Study of ancient art*

Unlimited admiration for genius and wonder that the personalities of antiquity should have survived with their great names in no way diminished, soon had two consequences. One was love of glory, and the other the patronage of those arts which were supposed to hand down a glorious name undiminished to posterity. The glory of old Rome had come down through poets and historians, architects and sculptors, and the Italians, feeling that the same means might be used

Passion for
glory
to hand down the achievements of their own time to as distant a posterity, made a new religion of glory, with poets and artists for the priests. At first the new priesthood was confined almost entirely to writers, but in little more than a generation architects and sculptors began to have their part. The passion for building is in itself one of the most instinctive, and a man's name and armorial bearings, tastefully but prominently displayed upon a church or palace, were as likely, it was felt, to hand him down to posterity as the praise of poets or historians. It was the passion for glory, in reality, rather than any love of beauty, that gave the first impulse to the patronage of the arts in the Renaissance. Beauty was the concern of the artists, although no doubt their patrons were well aware that the more impressive a building was, the more beautiful a monument, the more likely was it to be admired, and the more likely were their names to reach posterity. Their instincts did not mislead them, for where their real achievements would have tempted only the specialist or antiquarian into a study of their career, the buildings and monuments put up by them—by such princes as Sigismondo Malatesta, Federico of Urbino, or Alfonso of Naples— have made the whole intelligent public believe that they were really as great as they wished posterity to believe them.

Attitude to
painting
As painting had done nothing whatever to transmit the glory of the great Romans, the earlier generations of the Renaissance expected nothing from it, and did not give it that patronage which the Church, for its own purposes, continued to hold out to it. The Renaissance began to make especial use of painting only when its own spirit had spread very widely, and when the love of knowledge, of power, and of glory had ceased to be the only recognized passions, and when, following the lead of the Church, people began to turn to painting for the expression of deep emotion. The new religion, as I have called the love of glory, is in its very essence a thing of this world, founded as it is on human esteem. The boundless curiosity of the Renaissance led back inevitably to an interest in life and to an acceptance of things for what they were—for their intrinsic quality. The moment people stopped looking fixedly towards heaven, their eyes fell upon the earth, and they began to see much on its surface that was pleasant. Their own faces and figures must have struck them as surprisingly interesting, and, considering how little St. Bernard and other medieval saints and doctors had led them to expect, singularly beautiful. A new feeling arose that mere living was a big part of life, and with it came a new passion, the passion for beauty, for grace, and for comeliness.

It has already been suggested that the Renaissance was a period in

the history of modern Europe comparable to youth in the life of the individual. It had all youth's love of finery and of play. The more people were imbued with the new spirit, the more they loved pageants. The pageant was an outlet for many of the dominant passions of the time, for there a man could display all the finery he pleased, satisfy his love of antiquity by masquerading as Caesar or Hannibal, his love of knowledge by finding out how the Romans dressed and rode in triumph, his love of glory by the display of wealth and skill in the management of the ceremony, and, above all, his love of feeling himself alive. Solemn writers have not disdained to describe to the minutest details many of the pageants which they witnessed.

Love of pageantry

We have seen that the earlier elements of the Renaissance, the passion for knowledge and glory, were not of the kind to give a new impulse to painting. Nor was the passion for antiquity at all so direct an inspiration to that art as it was to architecture and sculpture. The love of glory had, it is true, led such as could not afford to put up monumental buildings, to decorate chapels with frescoes in which their portraits were timidly introduced. But it was only when the Renaissance had attained to a full consciousness of its interest in life and enjoyment of the world that it naturally turned, and indeed was forced to turn, to painting; for it is obvious that painting is peculiarly fitted for rendering the appearances of things with a glow of light and richness of colour that correspond to warm human emotions.

IV

When it once more reached the point where its view of the world naturally sought expression in painting, as religious ideas had done before, the Renaissance found in Venice clearer utterance than elsewhere, and it is perhaps this fact which makes the most abiding interest of Venetian painting. It is at this point that we shall take it up.

The Renaissance in Venice

The growing delight in life with the consequent love of health, beauty, and joy were felt more powerfully in Venice than anywhere else in Italy. The explanation of this may be found in the character of the Venetian government which was such that it gave little room for the satisfaction of the passion for personal glory, and kept its citizens so busy in duties of state that they had small leisure for learning. Some of the chief passions of the Renaissance thus finding no outlet in Venice, the other passions insisted all the more on being satisfied. Venice, moreover, was the only state in Italy which was enjoying, and for many generations had been enjoying, internal peace. This gave the

Venetians a love of comfort, of ease, and of splendour, a refinement of manner, and humaneness of feeling, which made them the first modern people in Europe. Since there was little room for personal glory in Venice, the perpetuators of glory, the Humanists, found at first scant encouragement there, and the Venetians were saved from that absorption in archaeology and pure science which overwhelmed Florence at an early date. This was not necessarily an advantage in itself, but it happened to suit Venice, where the conditions of life had for some time been such as to build up a love of beautiful things. As it was, the feeling for beauty was not hindered in its natural development. Archaeology would have tried to submit it to the good taste of the past, a proceeding which rarely promotes good taste in the present. Too much archaeology and too much science might have ended in making Venetian art academic, instead of letting it become what it did, the product of a natural ripening of interest in life and love of pleasure. In Florence, it is true, painting had developed almost simultaneously with the other arts, and it may be due to this cause that the Florentine painters never quite realized what a different task from the architect's and sculptor's was theirs. At the time, therefore, when the Renaissance was beginning to find its best expression in painting, the Florentines were already too much attached to classical ideals of form and composition, in other words, too academic, to give embodiment to the throbbing feeling for life and pleasure.

Thus it came to pass that in the Venetian pictures of the end of the fifteenth century we find neither the contrition nor the devotion of those earlier years when the Church alone employed painting as the interpreter of emotion, nor the learning which characterized the Florentines. The Venetian masters of this time, although nominally continuing to paint the Madonna and saints, were in reality painting handsome, healthy, sane people like themselves, people who wore their splendid robes with dignity, who found life worth the mere living and sought no metaphysical basis for it. In short, the Venetian pictures of the last decade of the century seemed intended not for devotion, as they had been, nor for admiration, as they then were in Florence, but for enjoyment.

The Church itself, as has been said, had educated its children to understand painting as a language. Now that the passions men dared to avow were no longer connected with happiness in some future state only, but mainly with life in the present, painting was expected to give voice to these more human aspirations and to desert the outgrown ideals of the Church. In Florence, the painters seemed unable or

unwilling to make their art really popular. Nor was it so necessary there, for Poliziano, Pulci, and Lorenzo dei Medici supplied the need of self-expression by addressing the Florentines in the language which their early enthusiasm for antiquity and their natural gifts had made them understand better than any other—the language of poetry. In Venice alone painting remained what it had been all over Italy in earlier times, the common tongue of the whole mass of the people. Venetian artists thus had the strongest inducements to perfect the processes which painters must employ to make pictures look real to their own generation; and their generation had an altogether firmer hold on reality than any that had been known since the triumph of Christianity. Here again the comparison of the Renaissance to youth must be borne in mind. The grasp that youth has on reality is not to be compared to that brought by age, and we must not expect to find in the Renaissance a passion for an acquaintance with things as they are such as we ourselves have; but still its grasp of facts was far firmer than that of the Middle Ages.

Painting as common tongue

Painting, in accommodating itself to the new ideas, found that it could not attain to satisfactory representation merely by form and colour, but that it required light and shadow and effects of space. Indeed, venial faults of drawing are perhaps the least disturbing, while faults of perspective, of spacing, and of colour completely spoil a picture for people who have an everyday acquaintance with painting such as the Venetians had. We find the Venetian painters, therefore, more and more intent upon giving the space they paint its real depth, upon giving solid objects the full effect of the round, upon keeping the different parts of a figure within the same plane, and upon compelling things to hold their proper places one behind the other. As early as the beginning of the sixteenth century a few of the greater Venetian painters had succeeded in making distant objects less and less distinct, as well as smaller and smaller, and had succeeded also in giving some appearance of reality to the atmosphere. These are a few of the special problems of painting, as distinct from sculpture for instance, and they are problems which, among the Italians, only the Venetians and the painters closely connected with them solved with any success.

V

The painters of the end of the fifteenth century who met with the greatest success in solving these problems were Giovanni and Gentile Bellini, Cima da Conegliano, and Carpaccio, and we find each of them

enjoyable to the degree that he was in touch with the life of his day. I have already spoken of pageants and of how characteristic they were of the Renaissance, forming as they did a sort of safety-valve for its chief passions. Venice, too, knew the love of glory, and the passion was perhaps only the more intense because it was all dedicated to the State. There was nothing the Venetians would not do to add to its greatness, glory, and splendour. It was this which led them to make of the city itself that wondrous monument to the love and awe they felt for their Republic, which still rouses more admiration and gives more pleasure than any other one achievement of the art-impulse in man. They were not content to make their city the most beautiful in the world; they performed ceremonies in its honour partaking of all the solemnity of religious rites. Processions and pageants by land and by sea, free from that gross element of improvisation which characterized them elsewhere in Italy, formed no less a part of the functions of the Venetian State than the High Mass in the Catholic Church. Such a function, with Doge and Senators arrayed in gorgeous costumes no less prescribed than the raiments of ecclesiastics, in the midst of the fairy-like architecture of the Piazza or canals, was the event most eagerly looked forward to, and the one that gave most satisfaction to the Venetian's love of his State, and to his love of splendour, beauty, and gaiety. He would have had them every day if it were possible, and, to make up for their rarity, he loved to have representations of them. So most Venetian pictures of the beginning of the sixteenth century tended to take the form of magnificent processions, if they did not actually represent them. They are processions in the Piazza, as in Gentile Bellini's 'Corpus Christi' picture, or on the water, as in Carpaccio's picture where St. Ursula leaves her home; or they represent what was a gorgeous but common sight in Venice, the reception or dismissal of ambassadors, as in several pictures of Carpaccio's St. Ursula series; or they show simply a collection of splendidly costumed people in the Piazza, as in Gentile's 'Preaching of St. Mark'. Not only the pleasure-loving Carpaccio, but the austere Cima, as he grew older, turned every biblical and saintly legend into an occasion for the picture of a pageant.

But there was a further reason for the popularity of such pictures. The decorations which were then being executed by the most reputed masters in the Hall of Great Council in the Doge's Palace, were, by the nature of the subject, required to represent pageants. The Venetian State encouraged painting as did the Church, in order to teach its subjects its own glory in a way that they could understand without

Marginal notes (left column):
Venetians' passion for glory

Gorgeous functions

Pageant pictures

Pl. 3

Pl. 7

Pls. 4, 5

Pl. 29

State patronage in Venice

being led on to critical inquiry. Venice was not the only city, it is true, that used painting for political purposes; but the frescoes of Lorenzetti at Siena were admonitions to govern in accordance with the Catechism, while the pictures in the Great Hall of the Doge's Palace were of a nature to remind the Venetians of their glory and also of their state policy. These mural paintings represented such subjects as the Doge bringing about a reconciliation between the Pope and the Emperor Barbarossa, an event which marked the first entry of Venice into the field of Continental politics, and typified as well its unchanging policy, which was to gain its own ends by keeping a balance of power between the allies of the Pope and the allies of his opponents. The first edition, so to speak, of these works had been executed at the end of the fourteenth century and in the beginning of the fifteenth. Towards the end of that century it no longer satisfied the new feeling for reality and beauty, and thus had ceased to serve its purpose, which was to glorify the State. The Bellini, Alvise Vivarini, and Carpaccio were employed to make a second rendering of the very same subjects, and this gave the Venetians ample opportunity for finding out how much they liked pageant pictures.

It is curous to note here that at the same time Florence also commissioned its greatest painters to execute works for its Council Hall, but left them practically free to choose their own subjects. Michelangelo chose for his theme 'The Florentines while Bathing Surprised by the Pisans', and Leonardo 'The Battle of the Standard'. Neither of these was intended in the first place to glorify the Florentine Republic, but rather to give scope to the painter's genius, Michelangelo's for the treatment of the nude, Leonardo's for movement and animation. Each, having given scope to his peculiar talents in his cartoon, had no further interest, and neither of the undertakings was ever completed. Nor do we hear that the Florentine councillors enjoyed the cartoons, which were instantly snatched up by students who turned the hall containing them into an academy.

State patronage in Florence

VI

It does not appear that the Hall of Great Council in Venice was turned into a students' academy, and, although the paintings there doubtless gave a decided incentive to artists, their effect upon the public, for whom they were designed, was even greater. The councillors were not allowed to be the only people to enjoy fascinating pictures of gorgeous pageants and ceremonials. The Mutual Aid Societies—the Schools, as

they were called—were not long in getting the masters who were employed in the Doge's Palace to execute for their own meeting-places pictures equally splendid. The Schools of San Giorgio, Sant' Ursula, and Santo Stefano, employed Carpaccio, the Schools of San Giovanni and San Marco, Gentile Bellini, and other Schools employed minor painters. The works carried out for these Schools are of peculiar importance, both because they are all that remain to throw light upon the pictures in the Doge's Palace destroyed in the fire of 1576, and because they form a transition to the art of a later day. Just as the State chose subjects that glorified itself and taught its own history and policy, so the Schools had pictures painted to glorify their patron saints, and to keep their deeds and example fresh. Many of these pictures—most in fact—took the form of pageants; but even in such, intended as they were for almost domestic purposes, the style of high ceremonial was relaxed, and elements taken directly from life were

Pl. 3 introduced. In his 'Corpus Christi', Gentile Bellini paints not only the solemn and dazzling procession in the Piazza, but the elegant young men who strut about in all their finery, the foreign loungers, and even the unfailing beggar by the portal of St. Mark's. In his 'Miracle of the

Pl. 6 True Cross', he introduces gondoliers, taking care to bring out all the beauty of their lithe, comely figures as they stand to ply the oar, and does not reject even such an episode as a serving-maid standing in a doorway watching a negro who is about to plunge into the canal. He treats this bit of the picture with all the charm and much of that delicate feeling for simple effects of light and colour that we find in such Dutch painters as Vermeer van Delft and Peter de Hoogh.

Episodes such as this in the works of the earliest great Venetian master must have acted on the public like a spark on tinder. They certainly found a sudden and assured popularity, for they play a more and more important part in the pictures executed for the Schools, many of the subjects of which were readily turned into studies of ordinary Venetian life. This was particularly true of the works of

Carpaccio Carpaccio. Much as he loved pageants, he loved homelier scenes as

Pl. 9 well. His 'Dream of St. Ursula' shows us a young girl asleep in a room filled with the quiet morning light. Indeed, it may be better described as the picture of a room with the light playing softly upon its walls, upon the flower-pots in the window, and upon the writing-table and the cupboards. A young girl happens to be asleep in the bed, but the picture is far from being a merely economic illustration to this episode in the life of the saint. Again, let us take the work in the same series

Pl. 8 where King Maure dismisses the ambassadors. Carpaccio has made

this a scene of a chancellery in which the most striking features are neither the king nor the ambassadors, but the effect of the light that streams through a side door on the left and a poor clerk labouring at his task. Or, again, take St. Jerome in his study, in the Scuola di San Giorgio. He is nothing but a Venetian scholar seated in his comfortable, bright library, in the midst of his books, with his little shelf of bric-à-brac running along the wall. There is nothing in his look or surroundings to speak of a life of self-denial or of arduous devotion to the problems of sin and redemption. Even the 'Presentation of the Virgin', which offered such a splendid chance for a pageant, Carpaccio, in one instance, turned into the picture of a simple girl going to her first communion. In other words, Carpaccio's quality is the quality of a painter of genre, of which he was the earliest Italian master. His genre differs from Dutch or French not in kind but in degree. Dutch genre is much more democratic, and, as painting, it is of a far finer quality, but it deals with its subject, as Carpaccio does, for the sake of its own pictorial capacities and for the sake of the effects of colour and of light and shade.

Pl. 10

But happily art is too great and too vital a subject to be crowded into any single formula; and a formula that would, without distorting our entire view of Italian art in the fifteenth century, do full justice to such a painter as Carlo Crivelli, does not exist. He takes rank with the most genuine artists of all times and countries, and does not weary even when 'great masters' grow tedious. He expresses with the freedom and spirit of Japanese design a piety as wild and tender as Jacopo da Todi's, a sweetness of emotion as sincere and dainty as of a Virgin and Child carved in ivory by a French craftsman of the fourteenth century. The mystic beauty of Simone Martini, the agonized compassion of the young Bellini, are embodied by Crivelli in forms which have the strength of line and the metallic lustre of old Satsuma or lacquer, and which are no less tempting to the touch. Crivelli must be treated by himself and as the product of stationary, if not reactionary, conditions. Having lived most of his life away from the main currents of culture, in a province where St. Bernardino had been spending his last energies in the endeavour to call the world back to the ideals of an infantile civilization, Crivelli does not belong to a movement of constant progress, and therefore is not within the scope of this work.

Crivelli

Pls. 12–15

VII

At the beginning of the Renaissance, painting was almost wholly confined to the Church. From the Church it extended to the Council

Hall, and thence to the Schools. There it rapidly developed into an art which had no higher aim than painting the sumptuous life of the aristocracy. When it had reached this point, there was no reason whatever why it should not begin to grace the dwellings of all well-to-do people.

In the sixteenth century painting was not looked upon with the estranging reverence paid to it now. It was almost as cheap as printing has become since, and almost as much employed. When the Venetians had attained the point of culture where they were able to differentiate their sensations and distinguish pleasure from edification, they found that painting gave them decided pleasure. Why should they always have to go to the Doge's Palace or to some School to enjoy this pleasure? That would have been no less a hardship than for us never to hear music outside of a concert-room. There is no merely rhetorical comparison, for in the life of the Venetian of the sixteenth century painting took much the same place that music takes in ours. He no longer expected it to tell him stories or to teach him the Catechism. Printed books, which were beginning to grow common, amply satisfied both these needs. He had as a rule very little personal religion, and consequently did not care for pictures that moved him to contrition or devotion. He preferred to have some pleasantly coloured thing that would put him into a mood connected with the side of life he most enjoyed—with refined merrymaking, with country parties, or with the sweet dreams of youth. Venetian painting alone among Italian schools was ready to satisfy such a demand, and it thus became the first genuinely modern art: for the most vital difference that can be indicated between the arts in antiquity and modern times is this—that now the arts tend to address themselves more and more to the actual needs of men, while in olden times they were supposed to serve some more than human purpose.

The pictures required for a house were naturally of a different kind from those suited to the Council Hall or the School, where large paintings, which could be filled with many figures, were in place. For the house smaller pictures were necessary, such as could easily be carried about. The mere dimensions, therefore, excluded pageants, but, in any case, the pageant was too formal a subject to suit all moods —too much like a brass band always playing in the room. The easel picture had to be without too definite a subject, and could no more permit being translated into words than a sonata. Some of Giovanni Bellini's late works are already of this kind. They are full of that subtle, refined poetry which can be expressed in form and colour alone. But

Venetian
culture

Easel pictures

they were a little too austere in form, a little too sober in colour, for the gay, care-free youth of the time. Carpaccio does not seem to have painted many easel pictures, although his brilliancy, his delightful fancy, his love of colour, and his gaiety of humour would have fitted him admirably for this kind of painting. But Giorgione, the follower of both these masters, starting with the qualities of both as his inheritance, combined the refined feeling and poetry of Bellini with Carpaccio's gaiety and love of beauty and colour. Stirred with the enthusiasms of his own generation as people who had lived through other phases of feeling could not be, Giorgione painted pictures so perfectly in touch with the ripened spirit of the Renaissance that they met with the success which those things only find that at the same moment wake us to the full sense of a need and satisfy it.

Giorgione

Giorgione's life was short, and very few of his works—not a score in all—have escaped destruction. But these suffice to give us a glimpse into that brief moment when the Renaissance found its most genuine expression in painting. Its over-boisterous passions had quieted down into a sincere appreciation of beauty and of human relations. It would be really hard to say more about Giorgione than this, that his pictures are the perfect reflex of the Renaissance at its height. His works, as well as those of his contemporaries and followers, still continue to be appreciated most by people whose attitude of mind and spirit has most in common with the Renaissance, or by those who look upon Italian art not merely as art, but as the product of this period. For that is its greatest interest. Other schools have accomplished much more in mere painting than the Italian. A serious student of art will scarcely think of putting many of even the highest achievements of the Italians, considered purely as technique, beside the works of the great Dutchmen, the great Spaniard, or even the masters of today. Our real interest in Italian painting is at bottom an interest in that art which we almost instinctively feel to have been the fittest expression found by a period in the history of modern Europe which has much in common with youth. The Renaissance has the fascination of those years when we seemed so full of promise both to ourselves and to everybody else.

Pls. 32–8

VIII

Giorgione created a demand which other painters were forced to supply at the risk of finding no favour. The older painters accommodated themselves as best they could. One of them indeed, turning towards the new in a way that is full of singular charm, gave his later

Catena

works all the beauty and softness of the first spring days in Italy. Upon
hearing the title of one of Catena's works in the National Gallery, 'A
Pl. 30 Warrior Adoring the Infant Christ', who could imagine what a treat
the picture itself had in store for him? It is a fragrant summer land-
scape enjoyed by a few quiet people, one of whom, in armour, with
the glamour of the Orient about him, kneels at the Virgin's feet, while
a romantic young page holds his horse's bridle. I mention this picture
in particular because it is so accessible, and so good an instance of the
Giorgionesque way of treating a subject; not for the story, nor for the
display of skill, nor for the obvious feeling, but for the lovely land-
scape, for the effects of light and colour, and for the sweetness of
Pls. 32–5 human relations. Giorgione's altar-piece at Castelfranco is treated in
precisely the same spirit, but with far more genius.

The young painters had no chance at all unless they undertook at
once to furnish pictures in Giorgione's style. But before we can appre-
ciate all that the younger men were called upon to do, we must turn
to the consideration of that most wonderful product of the Renaissance
and of the painter's craft—the Portrait.

IX

The portrait The longing for the perpetuation of one's fame, which has already
been mentioned several times as one of the chief passions of the
Renaissance, brought with it the more universal desire to hand down
the memory of one's face and figure. The surest way to accomplish this
end seemed to be the one which had proved successful in the case
of the great Romans, whose effigies were growing more and more
familiar as new busts and medals were dug up. The earlier generations
of the Renaissance relied therefore on the sculptor and the medallist to
Sculpture
and medals hand down their features to an interested posterity. These artists were
ready for their task. The mere materials gave them solidity, an effect
so hard to get in painting. At the same time, nothing was expected
from them except that they should mould the material into the desired
shape. No setting was required and no colour. Their art on this account
alone would naturally have been the earliest to reach fruition. But over
and above this, sculptors and medallists had the direct inspiration of
antique models, and through the study of these they were at an early
date brought in contact with the tendencies of the Renaissance. The
passion then prevailing for pronounced types, and the spirit of analysis
this produced, forced them to such patient study of the face as would
enable them to give the features that look of belonging to one con-

sistent whole which we call character. Thus, at a time when painters had not yet learned to distinguish between one face and another, Donatello was carving busts which remain unrivalled as studies of character, and Pisanello was casting bronze and silver medals which are among the greatest claims to renown of those whose effigies they bear.

Donatello's bust of Niccolo d'Uzzano shows clearly, nevertheless, that the Renaissance could not long remain satisfied with the sculptured portrait. It is coloured like nature, and succeeds so well in producing for an instant the effect of actual life as to seem uncanny the next moment. Donatello's contemporaries must have had the same impression, for busts of this kind are but few. Yet these few prove that the element of colour had to be included before the satisfactory portrait was found: in other words, that painting and not sculpture was to be the portrait-art of the Renaissance. *Donatello*

The most creative sculptor of the earlier Renaissance was not the only artist who felt the need of colour in portraiture. Vittore Pisano, the greatest medallist of this or any age, felt it quite as keenly, and being a painter as well, he was among the first to turn this art to portraiture. In his day, however, painting was still too undeveloped an art for the portrait not to lose in character what it gained in a more life-like colouring, and the two of Pisanello's portraits which still exist are profiles much inferior to his best medals, seeming indeed to be enlargements of them rather than original studies from life. *Pisanello*

It was only in the next generation, when the attention of painters themselves was powerfully concentrated upon the reproduction of strongly pronounced types of humanity, that they began to make portraits as full of life and energy as Donatello's busts of the previous period. Even then, however, the full face was rarely attempted, and it was only in the beginning of the sixteenth century that full-face portraits began to be common. The earliest striking achievement of this sort, Mantegna's head of Cardinal Scarampo (now in Berlin), was not the kind to find favour in Venice. The full-face likeness of this wolf in sheep's clothing brought out the workings of the self-seeking, cynical spirit within too clearly not to have revolted the Venetians, who looked upon all such qualities as impious in the individual because they were the strict monopoly of the State. In the portraits of Doges which decorated the frieze of its great Council Hall, Venice wanted the effigies of functionaries entirely devoted to the State, and not of great personalities, and the profile lent itself more readily to the omission of purely individual traits. *The new portraiture*

It is significant that Venice was the first state which made a business

Pls. 23, 24

of preserving the portraits of its chief rulers. Those which Gentile and Giovanni Bellini executed for this end must have had no less influence on portraiture than their mural paintings in the same Hall had on other branches of the art. But the State was not satisfied with leaving records of its glory in the Ducal Palace alone. The Church and the saints were impressed for the same purpose—happily for us, for while the portraits in the Great Hall have perished, several altar-pieces still preserve to us the likenesses of some of the Doges.

Choice of subjects

Early in the sixteenth century, when people began to want pictures in their own homes as well as in their public halls, personal and religious motives combined to dictate the choice of subjects. In the minds of many, painting, although a very familiar art, was too much connected with solemn religious rites and with state ceremonies to be used at once for ends of personal pleasure. So landscape had to slide

Pl. 28
Pl. 36

in under the patronage of St. Jerome; while romantic biblical episodes, like the 'Finding of Moses', or the 'Judgement of Solomon', gave an excuse for genre, and the portrait crept in half hidden under the mantle of a patron saint. Its position once secure, however, the portrait took no time to cast off all tutelage, and to declare itself one of the most attractive subjects possible. Over and above the obvious satisfaction afforded by a likeness, the portrait had to give pleasure to the eye, and to produce those agreeable moods which were expected from all other paintings in Giorgione's time. Portraits like that of Scarampo are scarcely less hard to live with than such a person himself must have been. They tyrannize rather than soothe and please. But Giorgione and his immediate followers painted men and women whose very look leads one to think of sympathetic friends, people whose features are pleasantly rounded, whose raiment seems soft to touch, whose surroundings call up the memory of sweet landscapes and refreshing breezes. In fact, in these portraits the least apparent object was the likeness, the real purpose being to please the eye and to turn the mind toward pleasant themes. This no doubt helps to account for the great popularity of portraits in Venice during the sixteenth century. Their number, as we shall see, only grows larger as the century advances.

<div style="text-align:center">X</div>

Giorgione's followers

Giorgione's followers had only to exploit the vein their master hit upon to find ample remuneration. Each, to be sure, brought a distinct personality into play, but the demand for the Giorgionesque article, if one may be allowed the phrase, was too strong to permit of much

deviation. It no longer mattered what the picture was to represent or where it was going to be placed; the treatment had to be always bright, romantic, and joyous. Many artists still confined themselves to painting ecclesiastical subjects chiefly, but even among these, such painters as Lotto and Palma, for example, are fully as Giorgionesque as Titian, Bonifazio, or Paris Bordone.

Titian, in spite of a sturdier, less refined nature, did nothing for a generation after Giorgione's death but work on his lines. A difference in quality between the two masters shows itself from the first, but the spirit that animated each is identical. The pictures Titian was painting ten years after his companion's death have not only many of the qualities of Giorgione's, but something more, as if done by an older Giorgione, with better possession of himself, and with a larger and firmer hold on the world. At the same time, they show no diminution of spontaneous joy of life, and even an increased sense of its value and dignity. What an array of masterpieces might be brought to witness! In the 'Assumption', for example, the Virgin soars heavenward, not helpless in the arms of angels, but borne up by the fullness of life within her, and by the feeling that the universe is naturally her own, and that nothing can check her course. The angels seem to be there only to sing the victory of a human being over his environment. They are embodied joys, acting on our nerves like the rapturous outburst of the orchestra at the end of 'Parsifal'. Or look at the 'Bacchanals' in Madrid, or at the 'Bacchus and Ariadne' in the National Gallery. How brim-full they are of exuberant joy! you see no sign of a struggle of inner and outer conditions, but life so free, so strong, so glowing, that it almost intoxicates. They are truly Dionysiac, Bacchanalian triumphs —the triumph of life over the ghosts that love the gloom and chill and hate the sun.

The portraits Titian painted in these years show no less feeling of freedom from sordid cares, and no less mastery over life. Think of 'The Man with the Glove' in the Louvre, of the 'Concert' and 'Young Englishman' in Florence, and of the Pesaro family in their altarpiece in the Frari at Venice—call up these portraits, and you will see that they are true children of the Renaissance whom life has taught no meannesses and no fears.

Titian

The Assunta
Pls. 40–2

Pls. 43–5

Pls. 47, 48, 50, 51

XI

But even while such pictures were being painted, the spirit of the Italian Renaissance was proving inadequate to life. This was not the

fault of the spirit, which was the spirit of youth. But youth cannot last more than a certain length of time. No matter how it is spent, manhood and middle age will come. Life began to show a sterner and more sober face than for a brief moment it had seemed to wear. Men became conscious that the passions for knowledge, for glory, and for personal advancement were not at the bottom of all the problems that life presented. Florence and Rome discovered this suddenly, and with a shock. In the presence of Michelangelo's sculptures in San Lorenzo, or of his 'Last Judgement', we still hear the cry of anguish that went up as the inexorable truth dawned upon them. But Venice, although humiliated by the League of Cambrai, impoverished by the Turk, and by the change in the routes of commerce, was not crushed, as was the rest of Italy, under the heels of Spanish infantry, nor so drained of resource as not to have some wealth still flowing into her coffers. Life grew soberer and sterner, but it was still amply worth the living, although the relish of a little stoicism and of earnest thought no longer seemed out of place. The spirit of the Renaissance had found its way to Venice slowly; it was even more slow to depart.

We therefore find that towards the middle of the sixteenth century, when elsewhere in Italy painting was trying to adapt itself to the hypocrisy of a Church whose chief reason for surviving as an institution was that it helped Spain to subject the world to tyranny, and when portraits were already exhibiting the fascinating youths of an earlier generation turned into obsequious and elegant courtiers—in Venice painting kept true to the ripened and more reflective spirit which succeeded to the most glowing decades of the Renaissance. This led men to take themselves more seriously, to act with more consideration of consequences, and to think of life with less hope and exultation. Quieter joys were sought, the pleasures of friendship and of the affections. Life not having proved the endless holiday it had promised to be, earnest people began to question whether under the gross mask of the official religion there was not something to console them for departed youth and for the failure of hopes. Thus religion began to revive in Italy, this time not ethnic nor political, but personal—an answer to the real needs of the human soul.

XII

It is scarcely to be wondered at that the Venetian artist, in whom we first find the expression of the new feelings, should have been one who by wide travel had been brought in contact with the miseries of Italy

in a way not possible for those who remained sheltered in Venice. Lorenzo Lotto, when he is most himself, does not paint the triumph of man over his environment, but in his altar-pieces, and even more in his portraits, he shows us people in want of the consolations of religion, of sober thought, of friendship and affection. They look out from his canvases as if begging for sympathy.

Pls. 54-7

But real expression for the new order of things was not to be found by one like Lotto, sensitive of feeling and born in the heyday of the Renaissance, to whom the new must have come as a disappointment. It had to come from one who had not been brought in personal contact with the woes of the rest of Italy, from one less conscious of his environment, one like Titian who was readier to receive the patronage of the new master than to feel an oppression which did not touch him personally; or it had to come from one like Tintoretto, born to the new order of things and not having to outlive a disappointment before adapting himself to it.

XIII

It is as impossible to keep untouched by what happens to your neighbours as to have a bright sky over your own house when it is stormy everywhere else. Spain did not directly dominate Venice, but the new fashions of life and thought inaugurated by her nearly universal triumph could not be kept out. Her victims, among whom the Italian scholars must be reckoned, flocked to Venice for shelter, persecuted by a rule that cherished the Inquisition. Now for the first time Venetian painters were brought in contact with men of letters. As they were already, fortunately for themselves, too well acquainted with the business of their own art to be taken in tow by learning or even by poetry, the relation of the man of letters to the painter became on the whole a stimulating and at any rate a profitable one, as in the instance of two of the greatest, where it took the form of a partnership for mutual advantage. It is not to our purpose to speak of Aretino's gain, but Titian would scarcely have acquired such fame in his lifetime if that founder of modern journalism, Pietro Aretino, had not been at his side, eager to trumpet his praises and to advise him whom to court.

Spread of Spanish influence

The overwhelming triumph of Spain entailed still another consequence. It brought home to all Italians, even to the Venetians, the sense of the individual's helplessness before organized power—a sense which, as we have seen, the early Renaissance, with its belief in the

The Triumph of Spain

omnipotence of the individual, totally lacked. This was not without a decided influence on art. In the last three decades of his long career,

Titian Titian did not paint man as if he were as free from care and as fitted to his environment as a lark on an April morning. Rather did he represent man as acting on his environment and suffering from his reactions. He made the faces and figures show clearly what life had done to them.

Pl. 61
Pl. 58 The great 'Ecce Homo' and the 'Crowning with Thorns' are imbued with this feeling no less than the equestrian portrait of Charles the Fifth. In the 'Ecce Homo' we see a man with a godlike personality, humbled by the imperial majesty, broken by the imperial power, and utterly unable to hold out against them. In the 'Crowning with Thorns' we have the same godlike being almost brutalized by pain and suffering. In the portrait of the Emperor we behold a man whom life has enfeebled, one who has to meet a foe who may crush him.

Yet Titian became neither soured nor a pessimist. Many of his late portraits are even more energetic than those of his early maturity. He shows himself a wise man of the world. 'Do not be a grovelling sycophant,' some of them seem to say, 'but remember that courtly manners and tempered elegance can do you no harm.' Titian, then, was ever ready to change with the times, and on the whole the change was

Titian's greatness towards a firmer grasp of reality, necessitating yet another advance in the painter's mastery of his craft. Titian's real greatness consists in the fact that he was as able to produce an impression of greater reality as he was ready to appreciate the need of a firmer hold on life. In painting, as has been said, a greater effect of reality is chiefly a matter of light and shadow, to be obtained only by considering the canvas as an enclosed space, filled with light and air, through which the objects are seen. There is more than one way of getting this effect, but Titian attains it by the almost total suppression of outlines, by the harmonizing of his colours, and by the largeness and vigour of his

The old Titian brushwork. In fact, the old Titian was, in his way of painting, remarkably like some of the best French masters at the end of the nineteenth century. This makes him only the more attractive, particularly when with handling of this kind he combined the power of creating forms of beauty such as he has given us in the 'Wisdom' of the Venetian

Pls. 59, 63 Library of San Marco, or in the 'Shepherd and Nymph' of Vienna. The difference between the old Titian, author of these works, and the young Titian, painter of the 'Assumption', and of the 'Bacchus and Ariadne', is the difference between the Shakespeare of the *Midsummer-Night's Dream* and the Shakespeare of the *Tempest*. Titian and Shakespeare begin and end so much in the same way by no mere

accident. They were both products of the Renaissance, they underwent similar changes, and each was the highest and completest expression of his own age. This is not the place to elaborate the comparison, but I have dwelt so long on Titian, because, historically considered, he is the only painter who expressed nearly all of the Renaissance that could find expression in painting. It is this which makes him even more interesting than Tintoretto, an artist who in many ways was deeper, finer, and even more brilliant.

XIV

Tintoretto grew to manhood when the fruit of the Renaissance was ripe on every bough. The Renaissance had resulted in the emancipation of the individual, in making him feel that the universe had no other purpose than his happiness. This brought an entirely new answer to the question, 'Why should I do this or that?' It used to be, 'Because self-instituted authority commands you.' The answer now was, 'Because it is good for men.' In this lies our greatest debt to the Renaissance, that it instituted the welfare of man as the end of all action. The Renaissance did not bring this idea to practical issue, but our debt to it is endless on account of the results the idea has produced in our own days. This alone would have made the Renaissance a period of peculiar interest, even if it had had no art whatever. But when ideas are fresh and strong, they are almost sure to find artistic embodiment, as indeed this whole epoch found in painting, and this particular period in the works of Tintoretto.

Tintoretto

XV

The emancipation of the individual had a direct effect on the painter in freeing him from his guild. It now occurred to him that possibly he might become more proficient and have greater success if he deserted the influences he was under by the accident of birth and residence, and placed himself in the school that seemed best adapted to foster his talents. This led to the unfortunate experiment of Eclecticism which checked the purely organic development of the separate schools. It brought about their fusion into an art which no longer appealed to the Italian people, as did the art which sprang naturally from the soil, but to the small class of dilettanti who considered a knowledge of art as one of the birthrights of their social position. Venice, however, suffered little from Eclecticism, perhaps because a strong sense of

The experiment of Eclecticism

individuality was late in getting there, and by that time the painters were already well enough educated in their craft to know that they had little to learn elsewhere. The one Venetian who became an Eclectic *Pls. 64-7* remained in spite of it a great painter. Sebastiano del Piombo fell under the influence of Michelangelo, but while this influence was pernicious in most cases, the hand that had learned to paint under Bellini, Cima, and Giorgione never wholly lost its command of colour and tone.

XVI

Tintoretto Tintoretto stayed at home, but he felt in his own person a craving for something that Titian could not teach him. The Venice he was born in was not the Venice of Titian's early youth, and his own adolescence fell in the period when Spain was rapidly making herself mistress of Italy. The haunting sense of powers almost irresistible gave a terrible fascination to Michelangelo's works, which are swayed by that sense as by a demonic presence. Tintoretto felt this fascination because he was in sympathy with the spirit which took form in colossal torsos and limbs. To him these were not, as they were to Michelangelo's enrolled followers, merely new patterns after which to model the nude.

But beside this sense of overwhelming power and gigantic force, Tintoretto had to an even greater degree the feeling that whatever existed was for mankind and with reference to man. In his youth people were once more turning to religion, and in Venice poetry was making its way more than it had previously done, not only because Venice had become the refuge of men of letters, but also because of the diffusion of printed books. Tintoretto took to the new feeling for religion and poetry as to his birthright. Yet whether classic fable or Biblical episode were the subject of his art, Tintoretto coloured it with his feeling for the human life at the heart of the story. His sense of power did not express itself in colossal nudes so much as in the immense energy, in the glowing health of the figures he painted, and more still in his effects of light, which he rendered as if he had it in his hands to brighten or darken the heavens at will and subdue them to his own moods.

Light and shadow He could not have accomplished this, we may be sure, if he had not had even greater skill than Titian in the treatment of light and shadow and of atmosphere. It was this which enabled him to give such living versions of Biblical stories and saintly legends. For, granting that an effect of reality were attainable in painting without an adequate treatment of light and atmosphere, even then the reality would look

hideous, as it does in many modern painters who attempt to paint people of today in their everyday dress and among their usual surroundings. It is not 'Realism' which makes such pictures hideous, but the want of that toning down which the atmosphere gives to things in life, and of that harmonizing to which the light subjects all colours.

It was a great mastery of light and shadow which enabled Tintoretto to put into his pictures all the poetry there was in his soul without once tempting us to think that he might have found better expression in words. The poetry which quickens most of his works in the Scuola di San Rocco is almost entirely a matter of light and colour. What is it but the light that changes the solitudes in which the Magdalen and St. Pl. 68 Mary of Egypt are sitting, into dreamlands seen by poets in their moments of happiest inspiration? What but light and colour, the gloom and chill of evening, with the white-stoled figure standing resignedly before the judge, that give the 'Christ before Pilate' its sublime magic? Pl. 69 What, again, but light, colour, and the star-procession of cherubs that imbue the realism of the 'Annunciation' with music which thrills us Pl. 70 through and through?

Religion and poetry did not exist for Tintoretto because the love Tintoretto's religious sense and cultivation of the Muses was a duty prescribed by the Greeks and Romans, and because the love of God and the saints was prescribed by the Church; but rather, as was the case with the best people of his time, because both poetry and religion were useful to man. They helped him to forget what was mean and sordid in life, they braced him to his task, and consoled him for his disappointments. Religion answered to an ever-living need of the human heart. The Bible was no longer a mere document wherewith to justify Christian dogma. It was rather a series of parables and symbols pointing at all times to the path that led to a finer and nobler life. Why then continue to picture Christ and the Apostles, the Patriarchs and Prophets, as persons living under Roman rule, wearing the Roman toga, and walking about in the landscape of a Roman bas-relief? Christ and the Apostles, the Patriarchs and Prophets, were the embodiment of living principles and of living ideals. Tintoretto felt this so vividly that he could not think of them otherwise than as people of his own kind, living under conditions easily intelligible to himself and to his fellow men. Indeed, the more intelligible and the more familiar the look and garb and surroundings of Biblical and saintly personages, the more would they drive home the principles and ideas they incarnated. So Tintoretto did not hesitate to turn every Biblical episode into a picture of what the scene would Pls.70-1, 73-4

look like had it taken place under his own eyes, nor to tinge it with his own mood.

Conception of the human form

His conception of the human form was, it is true, colossal, although the slender elegance that was then coming into fashion, as if in protest against physical force and organization, influenced him considerably in his construction of the female figure; but the effect which he must always have produced upon his contemporaries, which most of his works still produce, is one of astounding reality as well as of wide

Pl. 78

sweep and power. Thus, in the 'Discovery of the Body of St. Mark', in the Brera, and in the 'Storm Rising while the Corpse is being Carried through the Streets of Alexandria', in the Academy at Venice,

Pl. 79

the figures, although colossal, are so energetic and so easy in movement, and the effects of perspective and of light and atmosphere are so on a level with the gigantic figures, that the eye at once adapts itself to the scale, and you feel as if you too partook of the strength and health of heroes.

XVII

Value of minor episodes

That feeling for reality which made the great painters look upon a picture as the representation of a cubic content of atmosphere enveloping all the objects depicted, made them also consider the fact that the given quantity of atmosphere is sure to contain other objects than those the artist wants for his purpose. He is free to leave them out, of course, but in so far as he does, so far is he from producing an effect of reality. The eye does not see everything, but all the eye would naturally see along with the principal objects must be painted, or the picture will not look true to life. This incorporation of small episodes running parallel with the subject rather than forming part of it, is one of the chief characteristics of modern as distinguished from ancient art. It is this which makes the Elizabethan drama so different from the Greek. It is this again which already separates the works of Duccio and Giotto from the plastic arts of Antiquity. Painting lends itself willingly to the consideration of minor episodes, and for that reason is almost as well fitted to be in touch with modern life as the novel itself. Such a treatment saves a picture from looking prepared and cold, just as light and atmosphere save it from rigidity and crudeness.

Tintoretto's 'Crucifixion'

No better illustration of this can be found among Italian masters than Tintoretto's 'Crucifixion' in the Scuola di San Rocco. The scene is a vast one, and although Christ is on the Cross, life does not stop. To most of the people gathered there, what takes place is no more than

a common execution. Many of them are attending to it as to a tedious duty. Others work away at some menial task more or less connected with the Crucifixion, as unconcerned as cobblers humming over their last. Most of the people in the huge canvas are represented, as no doubt they were in life, without much personal feeling about Christ. His own friends are painted with all their grief and despair, but the others are allowed to feel as they please. The painter does not try to give them the proper emotions. If one of the great modern novelists, if Tolstoy, for instance, were describing the Crucifixion, his account would read as if it were a description of Tintoretto's picture. But Tintoretto's fairness went even farther than letting all the spectators feel as they pleased about what he himself believed to be the greatest event that ever took place. Among this multitude he allowed the light of heaven to shine upon the wicked as well as upon the good, and the air to refresh them all equally. In other words, this enormous canvas is a great sea of air and light at the bottom of which the scene takes place. Without the atmosphere and the just distribution of light, it would look as lifeless and desolate, in spite of the crowd and animation, as if it were the bottom of a dried-up sea.

XVIII

While all these advances were being made, the art of portraiture had not stood still. Its popularity had only increased as the years went on. Titian was too busy with commissions for foreign princes to supply the great demand there was in Venice alone. Tintoretto painted portraits not only with much of the air of good breeding of Titian's likenesses, but with even greater splendour, and with an astonishing rapidity of execution. The Venetian portrait, it will be remembered, was expected to be more than a likeness. It was expected to give pleasure to the eye, and to stimulate the emotions. Tintoretto was ready to give ample satisfaction to all such expectations. His portraits, although they are not so individualized as Lotto's, nor such close studies of character as Titian's, always render the man at his best, in glowing health, full of life and determination. They give us the sensuous pleasure we get from jewels, and at the same time they make us look back with amazement to a State where the human plant was in such vigour as to produce old men of the kind represented in most of Tintoretto's portraits.

Tintoretto's portraits

Pls. 75-7

With Tintoretto ends the universal interest the Venetian school arouses; for although painting does not deteriorate in a day any more

than it grows to maturity in the same brief moment, the story of the decay has none of the fascination of the growth. But several artists remain to be considered who were not of the Venetian school in the strict sense of the term, yet have always been included within it.

<div style="text-align:center">XIX</div>

The Venetian provinces were held together not merely by force of rule. In language and feeling no less than in government, they formed a distinct unit within the Italian peninsula. Painting being so truly a product of the soil as it was in Italy during the Renaissance, the art of the provinces could not help holding the same close relation to the art of Venice that their language and modes of feeling held. But a difference must be made at once between towns like Verona, with a school of at least as long a growth and with as independent an evolution as the school of Venice itself, and towns like Vicenza and Brescia whose chief painters never developed quite independently of Venice or Verona. What makes Romanino and Moretto of Brescia, or even the powerful Montagna of Vicenza, except when they are at their very best, so much less enjoyable as a rule than the Venetians—that is to say, the painters wholly educated in Venice—is something they have in common with the Eclectics of a later day. They are ill at ease about their art, which is no longer the utterly unpremeditated outcome of a natural impulse. They saw greater painting than their own in Venice and Verona, and not unfrequently their own works show an uncouth attempt to adopt that greatness, which comes out in exaggeration of colour even more than of form, and speaks for that want of taste which is the indelible stamp of provincialism. But there were Venetian towns without the traditions even of the schools of Vicenza and Brescia, where, if you wanted to learn painting, you had to apprentice yourself to somebody who had been taught by somebody who had been a pupil of one of Giovanni Bellini's pupils. This was particularly true of the towns in that long stretch of plain between the Julian Alps and the sea, known as Friuli. Friuli produced one painter of remarkable Pl. 80 talents and great force, Giovanni Antonio Pordenone, but neither his talents nor his force, nor even later study in Venice, could erase from his works that stamp of provincialism which he inherited from his first provincial master.

Such artists as these, however, never gained great favour in the capital. Those whom Venice drew to herself when her own strength was waning and when, like Rome in her decline, she began to absorb

into herself the talent of the provinces, were rather painters such as Paolo Veronese whose art, although of independent growth, was sufficiently like her own to be readily understood, or painters with an entirely new vein, such as the Bassani.

XX

Paolo was the product of four or five generations of Veronese painters, the first two or three of which had spoken the language of the whole mass of the people in a way that few other artists had ever done. Consequently, in the early Renaissance, there were no painters in the North of Italy, and few even in Florence, who were not touched by the influence of the Veronese. But Paolo's own immediate predecessors were no longer able to speak the language of the whole mass of the people. There was one class they left out entirely, the class to whom Titian and Tintoretto appealed so strongly, the class that ruled, and that thought in the new way. Verona, being a dependency of Venice, did no ruling, and certainly not at all so much thinking as Venice, and life there continued healthful, simple, unconscious, untroubled by the approaching storm in the world's feelings. But although thought and feeling may be slow in invading a town, fashion comes there quickly. Spanish fashions in dress, and Spanish ceremonial in manners, reached Verona soon enough, and in Paolo Caliari we find all these fashions reflected, but health, simplicity, and unconsciousness as well. This combination of seemingly opposite qualities forms his great charm for us today, and it must have proved as great an attraction to many of the Venetians of his own time, for they were already far enough removed from simplicity to appreciate to the full his singularly happy combination of ceremony and splendour with an almost childlike naturalness of feeling. Perhaps among his strongest admirers were the very men who most appreciated Titian's distinction and Tintoretto's poetry. But it is curious to note that Paolo's chief employers were the monasteries. His cheerfulness, and his frank and joyous worldliness, the qualities, in short, which we find in his huge pictures of feasts, seem to have been particularly welcome to those who were expected to make their meat and drink of the very opposite qualities. This is no small comment on the times, and shows how thorough had been the permeation of the spirit of the Renaissance when even the religious orders gave up their pretence to asceticism and piety.

Paolo Veronese

Life in Verona

Pls. 81–6

Pls. 83–4

XXI

Love of the
countryside

Venetian painting would not have been the complete expression of the riper Renaissance if it had entirely neglected the country. City people have a natural love of the country, but when it was a matter of doubt whether a man would return if he ventured out of the town gates, as was the case in the Middle Ages, this love had no chance of showing itself. It had to wait until the country itself was safe for way-farers, a state of things which came about in Italy with the gradual submission of the country to the rule of the neighbouring cities and with the general advance of civilization. During the Renaissance the love of the country and its pleasures received an immense impulse from Latin authors. What the great Romans without exception recom-mended, an Italian was not slow to adopt, particularly when, as in this case, it harmonized with natural inclination and with an already common practice. It was the usual thing with those who could afford to do so to retire to the villa for a part of the year. Classic poets helped such Italians to appreciate the simplicity of the country and to feel a little of its beauty. Many took so much delight in country life that they wished to have reminders of it in town. It may have been in response

Palma
Vecchio
Pl. 88
Bonifazio
Veronese

Pl. 90

to some such half-formulated wish that Palma began to paint his 'Sante Conversazioni'—groups of saintly personages gathered under pleasant trees in pretty landscapes. His pupil, Bonifazio, continued the same line, gradually, however, discarding the traditional group of Madonna and saints, and, under such titles as 'The Rich Man's Feast' or 'The Finding of Moses', painting all the scenes of fashionable country life, music on the terrace of a villa, hunting parties, and picnics in the forest.

Jacopo
Bassano

Bonifazio's pupil, Jacopo Bassano, no less fond of painting country scenes, did not, however, confine himself to representing city people in their parks. His pictures were for the inhabitants of the small market-town from which he takes his name, where inside the gates you still see men and women in rustic garb crouching over their many-coloured wares; and where, just outside the walls, you may see all the ordinary occupations connected with farming and grazing. Inspired, although unawares, by the new idea of giving perfectly modern versions of

Pls. 92–5

Biblical stories, Bassano introduced into nearly every picture he painted episodes from the life in the streets of Bassano, and in the country just outside the gates. Even Orpheus in his hands becomes a farmer's lad fiddling to the barn-yard fowls.

Pls. 96–7

Bassano's pictures and those of his two sons, who followed him

very closely, found great favour in Venice and elsewhere, because they were such unconscious renderings of simple country life, a kind of life whose charm seemed greater and greater the more fashionable and ceremonious private life in the city became. But this was far from being their only charm. Just as the Church had educated people to understand painting as a language, so the love of all the pleasant things that painting suggested led in time to the love of this art for its own sake, serving no obvious purpose either of decoration or suggestion, but giving pleasure by the skilful management of light and shadow, and by the intrinsic beauty of the colours. The third quarter of the sixteenth century thus saw the rise of the picture-fancier, and the success of the Bassani was so great because they appealed to this class in a special way. In Venice there had long been a love of objects for their sensuous beauty. At an early date the Venetians had perfected an art in which there is scarcely any intellectual content whatever, and in which colour, jewel-like or opaline, is almost everything. Venetian glass was at the same time an outcome of the Venetians' love of sensuous beauty and a continual stimulant to it. Pope Paul II, for example, who was a Venetian, took such a delight in the colour and glow of jewels, that he was always looking at them and always handling them. When painting, accordingly, had reached the point where it was no longer dependent upon the Church, nor even expected to be decorative, but when it was used purely for pleasure, the day could not be far distant when people would expect painting to give them the same enjoyment they received from jewels and glass. In Bassano's works this taste found full satisfaction. Most of his pictures seem at first as dazzling, then as cooling and soothing, as the best kind of stained glass; while the colouring of details, particularly of those under high lights, is jewel-like, as clear and deep and satisfying as rubies and emeralds.

It need scarcely be added after all that has been said about light and atmosphere in connexion with Titian and Tintoretto, and their handling of real life, that Bassano's treatment of both was even more masterly. If this were not so, neither picture-fanciers of his own time, nor we nowadays, should care for his works as we do. They represent life in far more humble phases than even the pictures of Tintoretto, and, without recompensing effects of light and atmosphere, they would not be more enjoyable than the cheap work of the smaller Dutch masters. It must be added, too, that without his jewel-like colouring Bassano would often be no more delightful than Teniers.

Success of the Bassani

Pl. 92 Bassano's treatment of light

Pls. 92–4
The first
modern
landscapes

Another thing Bassano could not fail to do, working as he did in the country, and for country people, was to paint landscape. He had to paint the real country, and his skill in the treatment of light and atmosphere was great enough to enable him to do it well. Bassano was in fact the first modern landscape painter. Titian and Tintoretto and Giorgione, and even Bellini and Cima before them, had painted beautiful landscapes, but they were seldom direct studies from nature. They were decorative backgrounds, or fine harmonizing accompaniments to the religious or human elements of the picture. They never failed to get grand and effective lines—a setting worthy of the subject. Bassano did not need such setting for his country versions of Bible stories, and he needed them even less in his studies of rural life. For pictures of this kind the country itself naturally seemed the best background and the best accompaniment possible—indeed, the only kind desirable. Without knowing it, therefore, and without intending it, Bassano was the first Italian who tried to paint the country as it is, and not arranged to look like scenery.

XXII

The
Venetians and
Velasquez

Had Bassano's qualities, however, been of the kind that appealed only to the collectors of his time, he would scarcely rouse the strong interest we take in him. We care for him chiefly because he has so many of the more essential qualities of great art—truth to life, and spontaneity. He has another interest still, in that he began to beat out the path which ended at last in Velazquez. Indeed, one of the attractions of the Venetian school of painting is that, more than all others, it went to form that great Spanish master. He began as a sort of follower of Bassano, but his style was not fixed before he had given years of study to Veronese, to Tintoretto, and to Titian.

XXIII

Bassano appealed to collectors by mere accident. He certainly did not work for them. The painters who came after him and after Tintoretto no longer worked unconsciously, as Veronese did, nor for the whole intelligent class, as Titian and Tintoretto had done, but for people who prided themselves on their connoisseurship.

Pl. 98
The Epigoni

Palma the Younger and Domenico Tintoretto began well enough as natural followers of Tintoretto, but before long they became aware

of their inferiority to the masters who had preceded them, and, feeling no longer the strength to go beyond them, fell back upon painting variations of those pictures of Tintoretto and Titian which had proved most popular. So their works recall the great masters, but only to bring out their own weakness. Padovanino, Liberi, and Pietro della Vecchia went even lower down and shamelessly manufactured pictures which, in the distant markets for which they were intended, passed for works of Titian, Veronese, and Giorgione. Nor are these pictures altogether unenjoyable. There are airs by the great composers we so love that we enjoy them even when woven into the compositions of some third-rate master.

XXIV

But Venetian painting was not destined to die unnoticed. In the eighteenth century, before the Republic entirely disappeared, Venice produced three or four painters who deserve at the least a place with the best painters of that century. The constitution of the Venetian State had remained unchanged. Magnificent ceremonies still took place, Venice was still the most splendid and the most luxurious city in the world. If the splendour and luxury were hollow, they were not more so than elsewhere in Europe. The eighteenth century had the strength which comes from great self-confidence and profound satisfaction with one's surroundings. It was so self-satisfied that it could not dream of striving to be much better than it was. Everything was just right; there seemed to be no great issues, no problems arising that human intelligence untrammelled by superstition could not instantly solve. Everybody was therefore in holiday mood, and the gaiety and frivolity of the century were of almost as much account as its politics and culture. There was no room for great distinctions. Hairdressers and tailors found as much consideration as philosophers and statesmen at a lady's levee. People were delighted with their own occupations, their whole lives; and whatever people delight in, that they will have represented in art. The love for pictures was by no means dead in Venice, and Longhi painted for the picture-loving Venetians their own lives in all their ordinary domestic and fashionable phases. In the hairdressing scenes we hear the gossip of the periwigged barber; in the dressmaking scenes, the chatter of the maid; in the dancing-school, the pleasant music of the violin. There is no tragic note anywhere. Everybody dresses, dances, makes bows, takes coffee, as if there were nothing else in the world that wanted doing. A tone of high courtesy,

The later
Venice

Longhi

Pl. 99

of great refinement, coupled with an all-pervading cheerfulness, distinguishes Longhi's pictures from the works of Hogarth, at once so brutal and so full of presage of change.

XXV

Venice herself had not grown less beautiful in her decline. Indeed, the building which occupies the centre of the picture Venice leaves in the mind, the Salute, was not built until the seventeenth century. This was the picture that the Venetian himself loved to have painted for him, and that the stranger wanted to carry away. Canale painted Venice with a feeling for space and atmosphere, with a mastery over the delicate effects of mist peculiar to the city, that make his views of the Salute, the Grand Canal, and the Piazzetta still seem more like Venice than all the pictures of them that have been painted since. Later in the century Canale was followed by Guardi, who executed smaller views with more of an eye for the picturesque, and for what may be called instantaneous effects, thus anticipating both the Romantic and the Impressionist painters of the nineteenth century.

Canaletto

Pl. 100

Guardi
Pl. 102

XXVI

Yet delightful as Longhi, Canale, and Guardi are, and imbued with the spirit of their own century, they lack the quality of force, without which there can be no impressive style. This quality their contemporary Tiepolo possessed to the utmost. His energy, his feeling for splendour, his mastery over his craft, place him almost on a level with the great Venetians of the sixteenth century, although he never allows one to forget what he owes to them, particularly to Veronese. The grand scenes he paints differ from those of his predecessor not so much in inferiority of workmanship, as in a lack of that simplicity and candour which never failed Paolo, no matter how proud the event he might be portraying. Tiepolo's people are haughty, as if they felt that to keep a firm hold on their dignity they could not for a moment relax their faces and figures from a monumental look and bearing. They evidently feel themselves so superior that they are not pleasant to live with, although they carry themselves so well, and are dressed with such splendour, that once in a while it is a great pleasure to look at them. It was Tiepolo's vision of the world that was at fault, and his vision of the world was at fault only because the world itself was at fault. Paolo saw a world barely touched by the fashions of the Spanish

Tiepolo

Pls. 103-4

Court, while Tiepolo lived among people whose very hearts had been vitiated by its measureless haughtiness.

But Tiepolo's feeling for strength, for movement, and for colour was great enough to give a new impulse to art. At times he seems not so much the last of the old masters as the first of the new. The works he left in Spain do more than a little to explain the revival of painting in that country under Goya; and Goya, in his turn, had a great influence upon many of the best French artists of recent times.

XXVII

Thus, Venetian painting before it wholly died, flickered up again strong enough to light the torch that is burning so steadily now. Indeed, not the least attraction of the Venetian masters is their note of modernity, by which I mean the feeling they give us that they were on the high road to the art of today. We have seen how on two separate occasions Venetian painters gave an impulse to Spaniards, who in turn have had an extraordinary influence on modern painting. It would be easy, too, although it is not my purpose, to show how much other schools of the seventeenth and eighteenth centuries, such as the Flemish, led by Rubens, and the English, led by Reynolds, owed to the Venetians. My endeavour has been to explain some of the attractions of the school, and particularly to show its close dependence upon the thought and feeling of the Renaissance. This is perhaps its greatest interest, for being such a complete expression of the riper spirit of the Renaissance, it helps us to a larger understanding of a period which has in itself the fascination of youth, and remains particularly attractive to us, because the spirit that animates us is singularly like the better spirit of that epoch. We, too, are possessed of boundless curiosity. We, too, have an almost intoxicating sense of human capacity. We, too, believe in a great future for humanity, and nothing has yet happened to check our delight in discovery or our faith in life.

The death of Venetian painting

(N.B.—Written in 1894!)

BOOK II
THE FLORENTINE PAINTERS

BOOK II

I

FLORENTINE painting between Giotto and Michelangelo contains the names of such artists as Orcagna, Masaccio, Fra Filippo, Pollaiuolo, Verrocchio, Leonardo, and Botticelli. Put beside these the greatest names in Venetian art, the Vivarini, the Bellini, Giorgione, Titian, and Tintoretto. The difference is striking. The significance of the Venetian names is exhausted with their significance as painters. Not so with the Florentines. Forget that they were painters, they remain great sculptors; forget that they were sculptors, and still they remain architects, poets, and even men of science. They left no form of expression untried, and to none could they say, 'This will perfectly convey my meaning.' Painting, therefore, offers but a partial and not always the most adequate manifestation of their personality, and we feel the artist as greater than his work, and the man as soaring above the artist.

The Florentines many-sided-ness

The immense superiority of the artist even to his greatest achievement in any one art form means that his personality was but slightly determined by the particular art in question, that he tended to mould it rather than let it shape him. It would be absurd, therefore, to treat the Florentine painter as a mere link between two points in a necessary evolution. The history of the art of Florence can never be, as that of Venice, the study of a placid development. Each man of genius brought to bear upon his art a great intellect, which, never condescending merely to please, was tirelessly striving to reincarnate what it comprehended of life in forms that would fitly convey it to others; and in this endeavour each man of genius was necessarily compelled to create forms essentially his own. But because Florentine painting was pre-eminently an art formed by great personalities, it grappled with problems of the highest interest, and offered solutions that can never lose their value. What they aimed at, and what they attained, is the subject of the following essay.

II

The first of the great personalities in Florentine painting was Giotto. Although he offers no exception to the rule that the great Florentines exploited all the arts in the endeavour to express themselves, he, Giotto, renowned as architect and sculptor, reputed as wit and

Giotto

versifier, differed from most of his Tuscan successors in having peculiar aptitude for the essential in painting *as an art*.

Before we can appreciate his real value, we must come to an agreement as to what in the art of figure-painting—the craft has its own altogether diverse laws—*is* the essential; for figure-painting, we may say at once, was not only the one pre-occupation of Giotto, but the dominant interest of the entire Florentine school.

Psychology has ascertained that sight alone gives us no accurate sense of the third dimension. In our infancy long before we are conscious of the process, the sense of touch, helped on by muscular sensations of movement, teaches us to appreciate depth, the third dimension, both in objects and in space.

Tactile
values
In the same unconscious years we learn to make of touch, of the third dimension, the test of reality. The child is still dimly aware of the intimate connexion between touch and the third dimension. He cannot persuade himself of the unreality of Looking-Glass Land until he has touched the back of the mirror. Later, we entirely forget the connexion, although it remains true that every time our eyes recognize reality, we are, as a matter of fact, giving tactile values to retinal impressions.

Now, painting is an art which aims at giving an abiding impression of artistic reality with only two dimensions. The painter must, therefore, do consciously what we all do unconsciously—construct his third dimension. And he can accomplish his task only as we accomplish ours, by giving tactile values to retinal impressions. His first business, therefore, is to rouse the tactile sense, for I must have the illusion of being able to touch a figure, I must have the illusion of varying muscular sensations inside my palm and fingers corresponding to the various projections of this figure, before I shall take it for granted as real, and let it affect me lastingly.

The essential
in painting
It follows that the essential in the art of painting—as distinguished from the art of colouring, I beg the reader to observe—is somehow to stimulate our consciousness of tactile values, so that the picture shall have at least as much power as the object represented, to appeal to our tactile imagination.

Well, it was of the power to stimulate the tactile consciousness—of the essential, as I have ventured to call it, in the art of painting—that
Giotto's
greatness
Giotto was supreme master. This is his everlasting claim to greatness, and it is this which will make him a source of highest aesthetic delight for a period at least as long as decipherable traces of his handiwork remain on mouldering panel or crumbling wall. For great though he was as a poet, enthralling as a story-teller, splendid and majestic as a

composer, he was in these qualities superior in degree only, to many of the masters who painted in various parts of Europe during the thousand years that intervened between the decline of antique, and the birth, in his own person, of modern painting. But none of these masters had the power to stimulate the tactile imagination, and, consequently, they never painted a figure which has artistic existence. Their works have value, if at all, as highly elaborate, very intelligible symbols, capable, indeed, of communicating something, but losing all higher value the moment the message is delivered.

Giotto's paintings, on the contrary, have not only as much power of appealing to the tactile imagination as is possessed by the objects represented—human figures in particular—but actually more; with the necessary result that to his contemporaries they conveyed a *keener* sense of reality, of life-likeness than the objects themselves! We whose current knowledge of anatomy is greater, who expect more articulation and suppleness in the human figure, who, in short, see much less naïvely now than Giotto's contemporaries, no longer find his paintings more than life-like; but we still feel them to be intensely real in the sense that they powerfully appeal to our tactile imagination, thereby compelling us, as do all things that stimulate our sense of touch while they present themselves to our eyes, to take their existence for granted. And it is only when we can take for granted the existence of the object painted that it can begin to give us pleasure that is genuinely artistic, as separated from the interest we feel in symbols.

His appeal to tactile imagination

At the risk of seeming to wander off into the boundless domain of aesthetics, we must stop at this point for a moment to make sure that we are of one mind regarding the meaning of the phrase 'artistic pleasure', in so far at least as it is used in connexion with painting.

What is the point at which ordinary pleasures pass over into the specific pleasures derived from each one of the arts? Our judgement about the merits of any given work of art depends to a large extent upon our answer to this question. Those who have not yet differentiated the specific pleasures of the art of painting from the pleasures they derive from the art of literature, will be likely to fall into the error of judging a picture by its dramatic presentation of a situation or its rendering of character; will, in short, demand of a painting that it shall be in the first place a good *illustration*. Others who seek in painting what is usually sought in music, the communication of a pleasurable state of emotion, will prefer pictures which suggest pleasant associations, nice people, refined amusements, agreeable landscapes. In many cases this lack of clearness is of comparatively slight importance, the

Artistic pleasure

given picture containing all these pleasure-giving elements in addition to the qualities peculiar to the art of painting. But in the case of the Florentines, the distinction is of vital consequence, for they have been the artists in Europe who have most resolutely set themselves to work upon the specific problems of the art of figure-painting, and have neglected, more than any other school, to call to their aid the secondary pleasures of association. With them the issue is clear. If we wish to appreciate their merit, we are forced to disregard the desire for pretty or agreeable types, dramatically interpreted situations, and, in fact, 'suggestiveness' of any kind. Worse still, we must even forgo our pleasure in colour, often a genuinely artistic pleasure, for they never systematically exploited this element, and in some of their best works the colour is actually harsh and unpleasant. It was in fact upon form, and form alone, that the great Florentine masters concentrated their efforts, and we are consequently forced to the belief that, in their pictures at least, form is the principal source of our aesthetic enjoyment.

Form as source of aesthetic enjoyment

Now in what way, we ask, can form in painting give me a sensation of pleasure which differs from the ordinary sensations I receive from form? How is it that an object whose recognition in nature may have given me no pleasure, becomes, when recognized in a picture, a source of aesthetic enjoyment, or that recognition pleasurable in nature becomes an enhanced pleasure the moment it is transferred to art? The answer, I believe, depends upon the fact that art stimulates to an unwonted activity psychical processes which are in themselves the source of most (if not all) of our pleasures, and which here, free from disturbing physical sensations, never tend to pass over into pain. For instance: I am in the habit of realizing a given object with an intensity that we shall value as 2. If I suddenly realize this familiar object with an intensity of 4, I receive the immediate pleasure which accompanies a doubling of my mental activity. But the pleasure rarely stops here. Those who are capable of receiving direct pleasure from a work of art, are generally led on to the further pleasures of self-consciousness. The fact that the psychical process of recognition goes forward with the unusual intensity of 4 to 2 overwhelms them with the sense of having twice the capacity they had credited themselves with: their whole personality is enhanced, and, being aware that this enhancement is connected with the object in question, they for some time after take not only an increased interest in it, but continue to realize it with the new intensity. Precisely this is what form does in painting: it lends a higher coefficient of reality to the object represented, with the consequent enjoyment of accelerated psychical processes, and the

exhilarating sense of increased capacity in the observer. (Hence, by the way, the greater pleasure we take in the object painted than in itself.)

And it happens thus. We remember that to realize form we must give tactile values to retinal sensations. Ordinarily we have considerable difficulty in skimming off these tactile values, and by the time they have reached our consciousness, they have lost much of their strength. Obviously, the artist who gives us these values more rapidly than the object itself gives them, gives us the pleasures consequent upon a more vivid realization of the object, and the further pleasures that come from the sense of greater psychical capacity. *Importance of tactile values*

Furthermore, the stimulation of our tactile imagination awakens our consciousness of the importance of the tactile sense in our physical and mental functioning, and thus, again, by making us feel better provided for life than we were aware of being, gives us a heightened sense of capacity. And this brings us back once more to the statement that the chief business of the figure painter, as an artist, is to stimulate the tactile imagination.

The proportions of this book forbid me to develop further a theme, the adequate treatment of which would require more than the entire space at my command. I must be satisfied with the crude and un-illumined exposition given already, allowing myself this further word only, that I do not mean to imply that we get no pleasure from a picture except the tactile satisfaction. On the contrary, we get much pleasure from composition, more from colour, and perhaps more still from movement, to say nothing of all the possible associative pleasures for which every work of art is the occasion. What I do wish to say is that *unless* it satisfies our tactile imagination, a picture will not exert the fascination of an ever-heightened reality; first we shall exhaust its ideas, and then its power of appealing to our emotions, and its 'beauty' will not seem more significant at the thousandth look than at the first.

My need of dwelling upon this subject at all, I must repeat, arises from the fact that although this principle is important indeed in other schools, it is all-important in the Florentine school. Without its due appreciation it would be impossible to do justice to Florentine painting. We should lose ourselves in admiration of its 'teaching', or perchance of its historical importance—as if historical importance were synonymous with artistic significance!—but we should never realize what artistic idea haunted the minds of its great men, and never understand why at a date so early it became academic.

Let us now turn back to Giotto and see in what way he fulfils the *Giotto and tactile values*

first condition of painting as an art, which condition, as we agreed, is somehow to stimulate our tactile imagination. We shall understand this without difficulty if we cover with the same glance two pictures of nearly the same subject that hang side by side in the Uffizi at Florence, one by 'Cimabue', and the other by Giotto. The difference is striking, but it does not consist so much in a difference of pattern and types, as of realization. In the 'Cimabue' we patiently decipher the lines and colours, and we conclude at last that they were intended to represent a woman seated, men and angels standing by or kneeling. To recognize these representations we have had to make many times the effort that the actual objects would have required, and in consequence our feeling of capacity has not only not been confirmed, but actually put in question. With what sense of relief, of rapidly rising vitality, we turn to the Giotto! Our eyes have scarcely had time to light on it before we realize it completely—the throne occupying a real space, the Virgin satisfactorily seated upon it, the angels grouped in rows about it. Our tactile imagination is put to play immediately. Our palms and fingers accompany our eyes much more quickly than in presence of real objects, the sensations varying constantly with the various projections represented, as of face, torso, knees; confirming in every way our feeling of capacity for coping with things—for life, in short. I care little that the picture endowed with the gift of evoking such feelings has faults, that the types represented do not correspond to my ideal of beauty, that the figures are too massive, and almost unarticulated; I forgive them all, because I have much better to do than to dwell upon faults.

But how does Giotto accomplish this miracle? With the simplest means, with almost rudimentary light and shade, and functional line, he contrives to render, out of all the possible outlines, out of all the possible variations of light and shade that a given figure may have, only those that we must isolate for special attention when we are actually realizing it. This determines his types, his schemes of colour, even his compositions. He aims at types which both in face and figure are simple, large-boned, and massive—types, that is to say, which in actual life would furnish the most powerful stimulus to the tactile imagination. Obliged to get the utmost out of his rudimentary light and shade, he makes his scheme of colour of the lightest that his contrasts may be of the strongest. In his compositions he aims at clearness of grouping, so that each important figure may have its desired tactile value. Note in the 'Madonna' we have been looking at, how the shadows compel us to realize every concavity, and the lights

Pls. 105-8

'Cimabue'

*Giotto's
Enthroned
Madonna*

Pls. 107-8

every convexity, and how, with the play of the two, under the guidance of line, we realize the significant parts of each figure, whether draped or undraped. Nothing here but has its architectonic reason. Above all, every line is functional; that is to say, charged with purpose. Its existence, its direction, is absolutely determined by the need of rendering the tactile values. Follow any line here, say in the figure of the angel kneeling to the left, and see how it outlines and models, how it enables you to realize the head, the torso, the hips, the legs, the feet, and how its direction, its tension, is always determined by the action. There is not a genuine fragment of Giotto in existence but has these qualities, and to such a degree that the worst treatment has not been able to spoil them. Witness the resurrected frescoes in Santa Croce at Florence!

The rendering of tactile values once recognized as the most Giotto's
other merits important specifically artistic quality of Giotto's work, and as his personal contribution to the art of painting, we are all the better fitted to appreciate his more obvious though less peculiar merits—merits, I must add, which would seem far less extraordinary if it were not for the high plane of reality on which Giotto keeps us. Now what is behind this power of raising us to a higher plane of reality but a genius for grasping and communicating real significance? What is it to render the tactile values of an object but to communicate its material significance? A painter who, after generations of mere manufacturers of symbols, illustrations, and allegories, had the power to render the material significance of the objects he painted, must, as a man, have had a profound sense of the significant. No matter, then, what his theme, Giotto feels its real significance and communicates as much of it as the general limitations of his art and of his own skill permit. When the theme is sacred story, it is scarcely necessary to point out with what processional gravity, with what hieratic dignity, with what sacramental intentness he endows it; the eloquence of the greatest critics has here found a darling subject. But let us look a moment at certain of his symbols in the Arena at Padua, at the 'Inconstancy', the 'Injustice', the Pls. 110-2 'Avarice', for instance. 'What are the significant traits', he seems to have asked himself, 'in the appearance and action of a person under the exclusive domination of one of these vices? Let me paint the person with these traits, and I shall have a figure that perforce must call up the vice in question.' So he paints 'Inconstancy' as a woman with a blank face, her arms held out aimlessly, her torso falling backwards, her feet on the side of a wheel. It makes one giddy to look at her. 'Injustice' is a powerfully-built man in the vigour of his years, dressed

in the costume of a judge, with his left hand clenching the hilt of his sword, and his clawed right hand grasping a double-hooked lance. His cruel eye is sternly on the watch, and his attitude is one of alert readiness to spring in all his giant force upon his prey. He sits enthroned on a rock, overtowering the tall waving trees, and below him his underlings are stripping and murdering a wayfarer. 'Avarice' is a horned hag with ears like trumpets. A snake issuing from her mouth curls back and bites her forehead. Her left hand clutches her moneybag, as she moves forward stealthily, her right hand ready to shut down on whatever it can grasp. No need to label them: as long as these vices exist, for so long has Giotto extracted and presented their visible significance.

Action and
movement Still another exemplification of his sense for the significant is furnished by his treatment of action and movement. The grouping, the gestures never fail to be just such as will most rapidly convey the meaning. So with the significant line, the significant light and shade, the significant look up or down, and the significant gesture, with means technically of the simplest, and, be it remembered, with no knowledge of anatomy, Giotto conveys a complete sense of motion such as we get in his Paduan frescoes of the 'Resurrection of the Blessed', of the 'Ascension of our Lord', of the God the Father in the 'Baptism', or the angel in 'St. Joachim's Dream'.

Pl. 113

Pls. 116–7

This, then, is Giotto's claim to everlasting appreciation as an artist: that his thorough-going sense for the significant in the visible world enabled him so to represent things that we realize his representations more quickly and more completely than we should realize the things themselves, thus giving us that confirmation of our sense of capacity which is so great a source of pleasure.

III

Giotto's
followers For a hundred years after Giotto there appeared in Florence no painter equally endowed with dominion over the significant. His immediate followers so little understood the essence of his power that some thought it resided in his massive types, others in the swiftness of his line, and still others in his light colour, and it never occurred to any of them that the massive form without its material significance, its tactile values, is a shapeless sack, that the line which is not functional is mere calligraphy, and that light colour by itself can at the best spot a surface prettily. The better of them felt their inferiority, but knew no remedy, and all worked busily, copying and distorting Giotto, until they and

the public were heartily tired. A change at all costs became necessary, and it was very simple when it came. 'Why grope about for the significant, when the obvious is at hand? Let me paint the obvious; the obvious always pleases', said some clever innovator. So he painted the obvious—pretty clothes, pretty faces, and trivial action, with the results foreseen: he pleased then, and he pleases still. Crowds still flock to the Spanish chapel in S. Maria Novella to celebrate the triumph of the obvious and non-significant. Pretty faces, pretty colour, pretty clothes, and trivial action! Is there a single figure in the fresco representing the 'Triumph of St. Thomas' which incarnates the idea it symbolizes, which, without its labelling instrument, would convey any meaning whatever? One pretty woman holds a globe and sword, and I am required to feel the majesty of empire; another has painted over her pretty clothes a bow and arrow, which are supposed to rouse me to a sense of the terrors of war; a third has an organ on what was intended to be her knee, and the sight of this instrument must suffice to put me into the ecstasies of heavenly music; still another pretty lady has her arm akimbo, and if you want to know what edification she can bring, you must read her scroll. Below these pretty women sit a number of men looking as worthy as clothes and beards can make them; one highly dignified old gentleman gazes with all his heart and all his soul at—the point of his quill. The same lack of significance, the same obviousness characterize the fresco representing the 'Church Militant and Triumphant'. What more obvious symbol for *the* Church than *a* church? what more significant of St. Dominic than the refuted Paynim philosopher who (with a movement, by the way, as obvious as it is clever) tears out a leaf from his own book? And I have touched only on the value of these frescoes as allegories. Not to speak of the emptiness of the one and the confusion of the other, as compositions, there is not a figure in either which has tactile values—that is to say, artistic existence.

Pls. 127-8

While I do not mean to imply that painting between Giotto and Masaccio existed in vain—on the contrary, considerable progress was made in the direction of landscape, perspective, and facial expression—it is true that, excepting the works of two men, no masterpieces of art were produced. These two, one coming in the middle of the period we have been dwelling upon, and the other just at its close, were Andrea Orcagna and Fra Angelico.

Of the Orcagnas it is difficult to speak, as only a single fairly intact painting of Andrea's remains, the altar-piece in S. Maria Novella. Here he reveals himself as a man of considerable endowment: as in Giotto,

Andrea
Orcagna
Pls. 118-20

we have tactile values, material significance; the figures artistically exist. But while this painting betrays no peculiar feeling for beauty of face and expression, the frescoes by Nardo in the same chapel, the one in particular representing Paradise, have faces full of charm and grace. Although badly damaged, these mural paintings must always have had real artistic existence, great dignity of slow but rhythmic movement, and splendid grouping. They still convince us of their high purpose. On the other hand, we are disappointed in Andrea's sculptured tabernacle at Or Sammichele, where the feeling for both material and spiritual significance is much lower.

We are happily far better situated toward Fra Angelico, enough of whose works have come down to us to reveal not only his quality as an artist, but his character as a man. Perfect certainty of purpose, utter devotion to his task, a sacramental earnestness in performing it, are what the quantity and quality of his work together proclaim. It is true that Giotto's profound feeling for either the materially or the spiritually significant was denied him—and there is no possible compensation for the difference; but although his sense for the real was weaker, it yet extended to fields which Giotto had not touched. Like all the supreme artists, Giotto had no inclination to concern himself with his attitude towards the significant, with his feelings about it; the grasping and presentation of it sufficed him. In the weaker personality, the significant, vaguely perceived, is converted into emotion, is merely felt, and not realized. Over this realm of feeling Fra Angelico was the first great master. 'God's in his heaven—all's right with the world' he felt with an intensity which prevented him from perceiving evil anywhere. When he was obliged to portray it, his imagination failed him and he became a mere child; his hells are bogy-land; his martyrdoms are enacted by children solemnly playing at martyr and executioner; and he nearly spoils one of the most impressive scenes ever painted—the great 'Crucifixion' at San Marco—with the childish violence of St. Jerome's tears. But upon the picturing of blitheness, of ecstatic confidence in God's loving care, he lavished all the resources of his art. Nor were they small. To a power of rendering tactile values, to a sense for the significant in composition, inferior, it is true, to Giotto's, but superior to the qualifiations off any intervening painter, Fra Angelico added the charm of great facial beauty, the interest of vivid expression, the attraction of delicate colour. What in the whole world of art more rejuvenating than Angelico's 'Coronation' —the happiness on all the faces, the flower-like grace of line and colour, the childlike

Nardo
Orcagna
Pls. 122–3

Fra Angelico

Pl. 133

Pl. 132

simplicity yet unqualifiable beauty of the composition? And all this in tactile values which compel us to grant the reality of the scene, although in a world where real people are standing, sitting, and kneeling we know not, and care not, on what. It is true, the significance of the event represented is scarcely touched upon, but then how well Angelico communicates the feeling with which it inspired him! Yet simple though he was as a person, simple and onesided as was his message, as a product he was singularly complex. He was the typical painter of the transition from Medieval to Renaissance. The sources of his feeling are in the Middle Ages, but he *enjoys* his feelings in a way which is almost modern; and almost modern also are his means of expression. We are too apt to forget this transitional character of his, and, ranking him with the moderns, we count against him every awkwardness of action, and every lack of articulation in his figures. Yet both in action and in articulation he made great progress upon his precursors—so great that, but for Masaccio, who completely surpassed him, we should value him as an innovator. Moreover, he was not only the first Italian to paint a landscape that can be identified (a view of Lake Trasimene from Cortona), but the first to communicate a sense of the pleasantness of nature. How readily we feel the freshness and spring-time gaiety of his gardens in the frescoes of the 'Annunciation' and the 'Noli me tangere' at San Marco!

Pls. 134-5

IV

Giotto born again, starting where death had cut short his advance, instantly making his own all that had been gained during his absence, and profiting by the new conditions, the new demands—imagine such an avatar, and you will understand Masaccio.

Masaccio

Giotto we know already, but what were the new conditions, the new demands? The medieval skies had been torn asunder and a new heaven and a new earth had appeared, which the abler spirits were already inhabiting and enjoying. Here new interests and new values prevailed. The thing of sovereign price was the power to subdue and to create; of sovereign interest all that helped man to know the world he was living in and his power over it. To the artist the change offered a field of the freest activity. It is always his business to reveal to an age its ideals. But what room was there for sculpture and painting—arts whose first purpose it is to make us realize the material significance of things—in a period like the Middle Ages, when the human body was denied all intrinsic significance? In such an age the figure artist can

thrive, as Giotto did, only in spite of it, and as an isolated phenomenon. In the Renaissance, on the contrary, the figure artist had a demand made on him such as had not been made since the great Greek days, to reveal to a generation believing in man's power to subdue and to possess the world, the physical types best fitted for the task. And as this demand was imperative and constant, not one, but a hundred Italian artists arose, able each in his own way to meet it—in their combined achievement, rivalling the art of the Greeks.

The Example
of Donatello In sculpture Donatello had already given body to the new ideals when Masaccio began his brief career, and in the education, the awakening, of the younger artist the example of the elder must have been of incalculable force. But a type gains vastly in significance by being presented in some action along with other individuals of the same type; and here Donatello was apt, rather than to draw his meed of profit, to incur loss by descending to the obvious—witness his bas-reliefs at Siena, Florence, and Padua. Masaccio was untouched by this taint. Types, in themselves of the manliest, he presents with a sense of the materially significant which makes us realize to the utmost their power and dignity; and the spiritual significance thus gained he uses to give the highest import to the event he is portraying; this import, in turn, gives a higher value to the types, and thus, whether we devote our attention to his types or to his action, Masaccio keeps us on a high plane of reality and significance. In later painting we shall easily find greater science, greater craft, and greater perfection of detail, but greater reality, greater significance, I venture to say, never. Dust-bitten and ruined though his Brancacci Chapel frescoes now are, I never see them without the strongest stimulation

Pls. 139–41 of my tactile consciousness. I feel that I could touch every figure, that it would yield a definite resistance to my touch, that I should have to expend thus much effort to displace it, that I could walk around it. In short, I scarcely could realize it more, and in real life I should scarcely realize it so well, the attention of each of us being too apt to concentrate itself upon some dynamic quality, before we have at all begun to realize the full material significance of the person before us. Then what strength to his young men, and what gravity and power to his old! How quickly a race like this would possess itself of the earth, and brook no rivals but the forces of nature! Whatever they do—simply because it is they—is impressive and important, and every movement, every gesture, is world-changing. Compared with his figures, those in

Pl. 138 the same chapel by his precursor, Masolino, are childish, and those by his follower, Filippino, unconvincing and without significance,

because without tactile values. Even Michelangelo, where he comes in rivalry, has, for both reality and significance, to take a second place. Compare his 'Expulsion from Paradise' (in the Sistine Chapel) with the one here by Masaccio. Michelangelo's figures are more correct, but far less tangible and less powerful; and while he represents nothing but a man warding off a blow dealt by a sword, and a woman cringing with ignoble fear, Masaccio's Adam and Eve stride away from Eden heartbroken with shame and grief, hearing, perhaps, but not seeing, the angel hovering high overhead who directs their exiled footsteps.

Pls. 140, 142
The 'Expulsion from Paradise'

Masaccio, then, like Giotto a century earlier—himself the Giotto of an artistically more propitious world—was, as an artist, a great master of the significant, and, as a painter, endowed to the highest degree with a sense of tactile values, and with a skill in rendering them. In a career of but few years he gave to Florentine painting the direction it pursued to the end. In many ways he reminds us of the young Bellini. Who knows? Had he but lived as long, he might have laid the foundation for a painting not less delightful and far more profound than that of Venice. As it was, his frescoes at once became, and for as long as there were real artists among them remained, the training school of Florentine painters.

V

Masaccio's death left Florentine painting in the hands of two men older, and three somewhat younger than himself, all men of great talent, if not of genius, each of whom—the former to the extent habits already formed would permit, the latter overwhelmingly—felt his influence. The older, who, but for Masaccio, would themselves have been the sole determining personalities in their art, were Fra Angelico and Paolo Uccello; the younger, Fra Filippo, Domenico Veneziano, and Andrea del Castagno. As these were the men who for a whole generation after Masaccio's death remained at the head of their craft, forming the taste of the public, and communicating their habits and aspirations to their pupils, we at this point can scarcely do better than try to get some notion of each of them and of the general art tendencies they represented.

Masaccio's successors

Fra Angelico we know already as the painter who devoted his life to picturing the departing medieval vision of a heaven upon earth. Nothing could have been farther from the purpose of Uccello and Castagno. Different as these two were from each other, they have this much in common, that in their works which remain to us, dating, it is

true, from their years of maturity, there is no touch of medieval sentiment, no note of transition. As artists they belonged entirely to the new era, and they stand at the beginning of the Renaissance as types of two tendencies which were to prevail in Florence throughout the whole of the fifteenth century, partly supplementing and partly undoing the teaching of Masaccio.

Uccello

Uccello had a sense of tactile values and a feeling for colour, but in so far as he used these gifts at all, it was to illustrate scientific problems. His real passion was perspective, and painting was to him a mere occasion for solving some problem in this science, and displaying his mastery over its difficulties. Accordingly he composed pictures in which he contrived to get as many lines as possible leading the eye

Pl. 143

inward. Prostrate horses, dead or dying cavaliers, broken lances, ploughed fields, Noah's arks, are used by him, with scarcely an attempt at disguise, to serve his scheme of mathematically converging lines. In his zeal he forgot local colour—he loved to paint his horses green or pink—forgot action, forgot composition, and, it need scarcely be added, significance. Thus in his battle-pieces, instead of adequate action of any sort, we get the feeling of witnessing a show of stuffed figures whose mechanical movements have been suddenly arrested by some clog in their wires; in his fresco of the 'Deluge', he has so covered his space with demonstrations of his cleverness in perspective and foreshortening that, far from bringing home to us the terrors of a cataclysm, he at the utmost suggests the bursting of a mill-dam; and in the neighbouring fresco of the 'Sacrifice of Noah', just as some capitally constructed figures are about to enable us to realize the scene, all possibility of artistic pleasure is destroyed by our seeing an object in the air which, after some difficulty, we decipher as a human being plunging downward from the clouds. Instead of making this figure, which, by the way, is meant to represent God the Father, plunge toward us, Uccello deliberately preferred to make it dash inward, away from us, thereby displaying his great skill in both perspective and fore-shortening, but at the same time writing himself down as the founder of two families of painters which have flourished ever since, the artists

Art for dexterity's sake

for dexterity's sake—mental or manual, it scarcely matters—and the naturalists. As these two clans increased rapidly in Florence, and, for both good and evil, greatly affected the whole subsequent course of Florentine painting, we must, before going farther, briefly define to ourselves dexterity and naturalism, and their relation to art.

The essential in painting, especially in figure-painting, is, we agreed, the rendering of the tactile values of the forms represented, because

by this means, and this alone, can the art make us realize forms better than we do in life. The great painter, then, is, above all, an artist with a great sense of tactile values and great skill in rendering them. Now this sense, though it will increase as the man is revealed to himself, is something which the great painter possesses at the start, so that he is scarcely, if at all, aware of possessing it. His conscious effort is given to the means of rendering. It is of means of rendering, therefore, that he talks to others; and, because his triumphs here are hard-earned and conscious, it is on his skill in rendering that he prides himself. The greater the painter, the less likely he is to be aware of aught else in his art than problems of rendering—but all the while he is communicating what the force of his genius makes him feel without his striving for it, almost without his being aware of it, the material and spiritual significance of forms. However—his intimates hear him talk of nothing but skill; he seems to think of nothing but skill; and naturally they, and the entire public, conclude that his skill is his genius, and that skill *is* art. This, alas, has at all times been the too prevalent notion of what art is, divergence of opinion existing not on the principle, but on the kind of dexterity to be prized, each generation, each critic, having an individual standard, based always on the several peculiar problems and difficulties that interest them. At Florence these inverted notions about art were especially prevalent because it was a school of art with a score of men of genius and a thousand mediocrities all egging each other on to exhibitions of dexterity, and in their hot rivalry it was all the great geniuses could do to be faithful to their sense of significance. Even Masaccio was driven to exhibit his mere skill, the much admired and by itself wonderfully realized figure of a naked man trembling with cold being not only without real significance, but positively distracting, in the representation of a baptism. A weaker man like Paolo Uccello almost entirely sacrificed what sense of artistic significance he may have started with, in his eagerness to display his skill and knowledge. As for the rabble, their work has now the interest of prize exhibitions at local art schools, and their number merely helped to accelerate the momentum with which Florentine art rushed to its end. But out of even mere dexterity a certain benefit to art may come. Men without feeling for the significant may yet perfect a thousand matters which make rendering easier and quicker for the man who comes with something to render, and when Botticelli and Leonardo and Michelangelo appeared, they found their artistic patrimony increased in spite of the fact that since Masaccio there had been no man at all approaching their genius. This increase, however, was due not at all

Masaccio's skill
Pl. 141

so much to the sons of dexterity, as to the intellectually much nobler, but artistically even inferior race of whom also Uccello was the ancestor—the Naturalists.

Naturalism
in art

What is a Naturalist? I venture upon the following definition: A man with a native gift for science who has taken to art. His purpose is not to extract the material and spiritual significance of objects, thus communicating them to us more rapidly and intensely than we should perceive them ourselves, and thereby giving us a sense of heightened vitality; his purpose is research, and his communication consists of nothing but facts. From this perhaps too abstract statement let us take refuge in an example already touched upon—the figure of the Almighty in Uccello's 'Sacrifice of Noah'. Instead of presenting this figure as coming towards us in an attitude and with an expression that will appeal to our sense of solemnity, as a man whose chief interest was

Pl. 116

artistic would have done—as Giotto, in fact, did in his 'Baptism'— Uccello seems to have been possessed with nothing but the scientific intention to find out how a man swooping down head-foremost would have looked if at a given instant of his fall he had been suddenly congealed and suspended in space. A figure like this may have a mathematical but certainly has no psychological significance. Uccello, it is true, has studied every detail of this phenomenon and noted down his observations, but because his notes happen to be in form and colour, they do not therefore constitute a work of art. Wherein does his achievement differ in quality from a coloured map of a country? We can easily conceive of a relief map of Cadore or Giverny on so large a scale, and so elaborately coloured, that it will be an exact reproduction of the physical aspects of those regions, but never for a moment should we place it beside a landscape by Titian or Monet, and think of it as a work of art. Yet its relation to the Titian or Monet painting is exactly that of Uccello's achievement to Giotto's. What the scientist who paints—the naturalist, that is to say—attempts to do is not to give us what art alone can give us, the life-enhancing qualities of objects, but a reproduction of them as they are. If he succeeded, he would give us the exact visual impression of the objects themselves; but art, as we have already agreed, must give us not the mere reproductions of things but a quickened sense of capacity for realizing them. Artistically, then, the naturalists, Uccello and his numerous successors, accomplished nothing. Yet their efforts to reproduce objects as they are, their studies in anatomy and perspective, made it inevitable that when another great genius did arise, he should be a Leonardo or a Michelangelo, and not a Giotto.

Uccello, as I have said, was the first representative of two strong tendencies in Florentine painting—of art for dexterity's sake, and art for scientific purposes. Andrea del Castagno, while also unable to resist the fascination of mere science and dexterity, had too much artistic genius to succumb to either. He was endowed with great sense for the significant, although, it is true, not enough to save him completely from the pitfalls which beset all Florentines, and even less from one more peculiar to himself—the tendency to communicate at any cost a feeling of power. To make us feel power as Masaccio and Michelangelo do at their best is indeed an achievement, but it requires the highest genius and the profoundest sense for the significant. The moment this sense is at all lacking, the artist will not succeed in conveying power, but such obvious manifestations of it as mere strength, or, worse still, the insolence not infrequently accompanying high spirits. Now Castagno, who succeeds well enough in one or two such single figures as his Cumaean Sibyl or his Farinata degli Uberti, which have great, if not the greatest, power, dignity, and even beauty, elsewhere condescends to mere swagger—as in his Pipo Spano or Niccolò di Tolentino—or to mere strength, as in his 'Last Supper', or, worse still, to actual brutality, as in his Santa Maria Nuova 'Crucifixion'. Nevertheless, his few remaining works lead us to suspect in him the greatest artist, and the most influential personality among the painters of the first generation after Masaccio.

Castagno

Pls. 146-9
169

Pl. 146

VI

To distinguish clearly, after the lapse of nearly five centuries, between Uccello and Castagno, and to determine the precise share each had in the formation of the Florentine school, is already a task fraught with difficulties. The scantiness of his remaining works makes it more than difficult, makes it almost impossible, to come to accurate conclusions regarding the character and influence of their contemporary, Domenico Veneziano. That he was an innovator in technique, in affairs of vehicle and medium, we know from Vasari; but as such innovations, indispensable though they may become to painting as a craft, are in themselves questions of theoretic and applied chemistry, and not of art, they do not here concern us. His artistic achievements seem to have consisted in giving to the figure movement and expression, and to the face individuality. In his existing works we find no trace of sacrifice made to dexterity and naturalism, although it is clear that he must have been master of whatever science and whatever craft were

Domenico
Veneziano

prevalent in his day. Otherwise he would not have been able to render
Pls. 153-4 a figure like the St. Francis in his Uffizi altar-piece, where tactile values
and movement expressive of character—what we usually call indi-
vidual *gait*—were perhaps for the first time combined; or to attain to
such triumphs as his St. John and St. Francis, at Santa Croce, whose
entire figures express as much fervour as their eloquent faces. As to his
sense for the significant in the individual, in other words, his power
as a portrait-painter, we have several heads to witness, ranking among
the first great achievements in this kind of the Renaissance.

No such difficulties as we have encountered in the study of Uccello,
Castagno, and Veneziano meet us as we turn to Fra Filippo. His works
Fra Filippo
Lippi are still copious, and many of them are admirably preserved; we
therefore have every facility for judging him as an artist, yet nothing
is harder than to appreciate him at his due. If attractiveness, and
attractiveness of the best kind, sufficed to make a great artist, then
Filippo would be one of the greatest, greater perhaps than any other
Florentine before Leonardo. Where shall we find faces more winsome,
more appealing, than in certain of his Madonnas—the one in the
Pl. 159 Uffizi, for instance—more momentarily evocative of noble feeling
Pls. 157-8 than in his Louvre altar-piece? Where in Florentine painting is there
anything more fascinating than the playfulness of his children, more
poetic than one or two of his landscapes, more charming than is at
times his colour? And with all this, health, even robustness, and almost
unfailing good-humour! Yet by themselves all these qualities con-
stitute only a high-class illustrator, and such by native endowment I
believe Fra Filippo to have been. That he became more—very much
more—is due rather to Masaccio's potent influence than to his own
genius; for he had no profound sense of either material or spiritual
significance—the essential qualifications of the real artist. Working
under the inspiration of Masaccio, he at times renders tactile values
admirably, as in the Uffizi Madonna—but most frequently he betrays
no genuine feeling for them, failing in his attempt to render them by
the introduction of bunchy, billowy, calligraphic draperies. These,
acquired from the late Giottesque painter (probably Lorenzo Monaco)
who had been his first master, he seems to have prized as artistic
elements no less than the tactile values which he attempted to adopt
later, serenely unconscious, apparently, of their incompatibility. Fra
Filippo's strongest impulse was not toward the pre-eminently artistic
one of re-creation, but rather toward expression, and within that field,
toward the expression of the pleasant, genial, spiritually comfortable
feelings of ordinary life. His real place is with the genre painters; only

his genre was of the soul, as that of others—of Benozzo Gozzoli, for example—was of the body. Hence a sin of his own, scarcely less pernicious than that of the naturalists, and cloying to boot—expression at any cost.

VII

From the brief account just given of the four dominant personalities in Florentine painting from about 1430 to about 1460, it results that the leanings of the school during this interval were not artistic and artistic alone, but that there were other tendencies as well, tendencies, on the one side, toward the expression of emotion (scarcely less literary because in form and colour than if in words), and, on the other, toward the naturalistic reproduction of objects. We have also noted that while the former tendency was represented by Filippo alone, the latter had Paolo Uccello, and all of Castagno and Veneziano that the genius of these two men would permit them to sacrifice to naturalism and science. To the extent, however, that they took sides and were conscious of a distinct purpose, these also sided with Uccello and not with Filippo. It may be agreed, therefore, that the main current of Florentine painting for a generation after Masaccio was naturalistic, and that consequently the impact given to the younger painters who during this period were starting in life, was mainly towards naturalism. Later, in studying Botticelli, we shall see how difficult it was for any one young at the time to escape this tide, even if by temperament farthest removed from scientific interests.

[Naturalism in Florentine art]

Meanwhile we must continue our study of the naturalists, but now of the second generation. Their number and importance from 1460 to 1490 is not alone due to the fact that art education toward the beginning of this epoch was mainly naturalistic, but also to the real needs of a rapidly advancing craft, and even more to the character of the Florentine mind, the dominant turn of which was to science and not to art. But as there were then no professions scientific in the stricter sense of the word, and as art of some form was the pursuit of a considerable proportion of the male inhabitants of Florence, it happened inevitably that many a lad with the natural capacities of a Galileo was in early boyhood apprenticed as an artist. And as he never acquired ordinary methods of scientific expression, and never had time for occupations not breadwinning, he was obliged his life long to make of his art both the subject of his strong instinctive interest in science, and the vehicle of conveying his knowledge to others.

[The second generation]

Baldovinetti
Pl. 170

Pollaiuolo
and
Verrocchio

Pl. 175

Advances in
landscape,
movement
and the nude

This was literally the case with the oldest among the leaders of the new generation, Alesso Baldovinetti, in whose scanty remaining works no trace of purely artistic feeling or interest can be discerned; and it is only less true of Alesso's somewhat younger, but far more gifted contemporaries, Antonio Pollaiuolo and Andrea Verrocchio. These also we should scarcely suspect of being more than men of science, if Pollaiuolo once or twice, and Verrocchio more frequently, did not dazzle us with works of almost supreme art, which, but for our readiness to believe in the manifold possibilities of Florentine genius, we should with exceeding difficulty accept as their creation— so little do they seem to result from their conscious striving. Alesso's attention being largely devoted to problems of vehicle—to the side of painting which is scarcely superior to cookery—he had time for little else, although that spare time he gave to the study of landscape, in the rendering of which he was among the innovators. Andrea and Antonio set themselves the much worthier task of increasing on every side the effectiveness of the figure arts, of which, sculpture no less than painting, they aimed to be masters.

To confine ourselves, however, as closely as we may to painting, and leaving aside for the present the question of colour, which, as I have already said, is, in Florentine art, of entirely subordinate importance, there were three directions in which painting as Pollaiuolo and Verrocchio found it had greatly to advance before it could attain its maximum of effectiveness: landscape, movement, and the nude. Giotto had attempted none of these. The nude, of course, he scarcely touched; movement he suggested admirably, but never rendered; and in landscape he was satisfied with indications hardly more than symbolical, although quite adequate to his purpose, which was to confine himself to the human figure. In all directions Masaccio made immense progress, guided by his never-failing sense for material significance, which, as it led him to render the tactile values of each figure separately, compelled him also to render the tactile values of groups as wholes, and of their landscape surroundings—by preference, hills so shaped as readily to stimulate the tactile imagination. For what he accomplished in the nude and in movement, we have his 'Expulsion' and his 'Man Trembling with Cold' to witness. But in his works neither landscape nor movement nor the nude are as yet distinct sources of artistic pleasure—that is to say, in themselves life-enhancing. Although we can well leave the nude until we come to Michelangelo, who was the first to completely realize its distinctly artistic possibilities, we cannot so well dispense with an inquiry into the sources of our aesthetic

pleasure in the representation of movement and of landscape, as it was in these two directions—in movement by Pollaiuolo especially, and in landscape by Baldovinetti, Pollaiuolo, and Verrocchio—that the great advances of this generation of Florentine painters were made.

VIII

Turning our attention first to movement—which, by the way, is not the same as motion, mere change of place—we find that we realize it just as we realize objects, by the stimulation of our tactile imagination, only that here touch retires to a second place before the muscular feelings of varying pressure and strain. I see (to take an example) two men wrestling, but unless my retinal impressions are immediately translated into images of strain and pressure in my muscles, of resistance to my weight, of touch all over my body, it means nothing to me in terms of vivid experience—not more, perhaps, than if I heard someone say 'Two men are wrestling'. Although a wrestling match may, in fact, contain many genuinely artistic elements, our enjoyment of it can never be quite artistic; we are prevented from completely realizing it not only by our dramatic interest in the game, but also, granting the possibility of being devoid of dramatic interest, by the succession of movements being too rapid for us to realize each completely, and too fatiguing, even if realizable. Now if a way could be found of conveying to us the realization of movement without the confusion and the fatigue of the actuality, we should be getting out of the wrestlers more than they themselves can give us—the heightening of vitality which comes to us whenever we keenly realize life, such as the actuality itself would give us, *plus* the greater effectiveness of the heightening brought about by the clearer, intenser, and less fatiguing realization. This is precisely what the artist who succeeds in representing movement achieves: making us realize it as we never can actually, he gives us a heightened sense of capacity, and whatever is in the actuality enjoyable, he allows us to enjoy at our leisure. In words already familiar to us, he *extracts the significance of movements*, just as, in rendering tactile values, the artist extracts the corporeal significance of objects. His task is, however, far more difficult, although less indispensable: it is not enough that he should extract the values of what at any given moment is an actuality, as is an object, but what at no moment really is—namely, movement. He can accomplish his task in only one way, and that is by so rendering the one particular movement that we shall be able to realize all other movements that the same

Perception of
movement

Representa-
tion of
movement

figure may make. 'He is grappling with his enemy now,' I say of my wrestler. 'What a pleasure to be able to realize in my own muscles, on my own chest, with my own arms and legs, the life that is in him as he is making his supreme effort! What a pleasure, as I look away from the representation, to realize in the same manner, how after the contest his muscles will relax, and rest trickle like a refreshing stream through his nerves!' All this I shall be made to enjoy by the artist who, in representing any one movement, can give me the logical sequence of visible strain and pressure in the parts and muscles.

The scientific spirit of the Florentines

It is just here that the scientific spirit of the Florentine naturalists was of immense service to art. This logic of sequence is to be attained only by great, although not necessarily more than empiric, knowledge of anatomy, such perhaps as the artist pure would never be inclined to work out for himself, but just such as would be of absorbing interest to those scientists by temperament and artists by profession whom we have in Pollaiuolo and, to a less extent, in Verrocchio. We remember how Giotto contrived to render tactile values. Of all the possible outlines, of all the possible variations of light and shade that a figure may have, he selected those that we must isolate for special attention when we are actually realizing it. If, instead of figure, we say figure in movement, the same statement applies to the way Pollaiuolo rendered movement—with this difference, however, that he had to render what in actuality we never can perfectly isolate, the line and light and shade most significant of any given action. This the artist must construct himself out of his dramatic feeling for pressure and strain and his ability to articulate the figure in all its logical sequences, for, if he would convey a sense of movement, he must give the line and the light and shade which will best render not tactile values alone, but the sequences of articulations.

Pollaiuolo

It would be difficult to find more effective illustrations of what has just been said about movement than one or two of Pollaiuolo's own works, which, in contrast to most of his achievements, where little more than effort and research are visible, are really masterpieces of life-communicating art. Let us look first at his engraving known as the

Pl. 168

'Battle of the Nudes'. What is it that makes us return to this sheet with ever-renewed, ever-increased pleasure? Surely it is not the hideous faces of most of the figures and their scarcely less hideous bodies. Nor is it the pattern as decorative design, which is of great beauty indeed, but not at all in proportion to the spell exerted upon us. Least of all is it—for most of us—an interest in the technique or history of engraving. No, the pleasure we take in these savagely battling forms arises

from their power to directly communicate life, to immensely heighten our sense of vitality. Look at the combatant prostrate on the ground and his assailant bending over, each intent on stabbing the other. See how the prostrate man plants his foot on the thigh of his enemy, and note the tremendous energy he exerts to keep off the foe, who, turning as upon a pivot, with his grip on the other's head, exerts no less force to keep the advantage gained. The significance of all these muscular strains and pressures is so rendered that we cannot help realizing them; we imagine ourselves imitating all the movements, and exerting the force required for them—and all without the least effort on our side. If all this without moving a muscle, what should we feel if we too had exerted ourselves! And thus while under the spell of this illusion—this hyperaesthesia not bought with drugs, and not paid for with cheques drawn on our vitality—we feel as if the elixir of life, not our own sluggish blood, were coursing through our veins.

Let us look now at an even greater triumph of movement than the Nudes, Pollaiuolo's 'Hercules Strangling Antaeus'. As you realize the Pl. 166 suction of Hercules' grip on the earth, the swelling of his calves with the pressure that falls on them, the violent throwing back of his chest, the stifling force of his embrace; as you realize the supreme effort of Antaeus, with one hand crushing down upon the head and the other tearing at the arm of Hercules, you feel as if a fountain of energy had sprung up under your feet and were playing through your veins. I cannot refrain from mentioning still another masterpiece, this time not only of movement, but of tactile values and personal beauty as well—Pollaiuolo's 'David' at Berlin. The young warrior has sped his Pl. 165 stone, cut off the giant's head, and now he strides over it, his graceful, slender figure still vibrating with the rapidity of his triumph, expectant, as if fearing the ease of it. What lightness, what buoyancy we feel as we realize the movement of this wonderful youth!

IX

In all that concerns movement, Verrocchio was a learner from Verrocchio Pollaiuolo rather than an initiator, and he probably never attained his master's proficiency. We have unfortunately but few terms for comparison, as the only paintings which can be with certainty ascribed to Verrocchio are not pictures of action. A drawing, however, like that of his angel, in the British Museum, which attempts as much movement as the Hercules by Pollaiuolo, in the same collection, is of obviously inferior quality. Yet in sculpture, along with works which

are valuable as harbingers of Leonardo rather than for any intrinsic perfection, he created two such masterpieces of movement as the Pls. 171–2 'Child with the Dolphin' in the courtyard of the Palazzo Vecchio, and the Colleoni monument at Venice—the latter sinning, if at all, by an over-exuberance of movement, by a step and swing too suggestive of drums and trumpets. But in landscape Verrocchio was a decided innovator. To understand what new elements he introduced, we must at this point carry out our determination to inquire into the source of our pleasure in landscape painting; or rather—to avoid a subject of vast extent for which this is not the place—of landscape painting as practised by the Florentines.

Florentine Landscape painting Pl. 175 Before Verrocchio, his precursors, first Alesso Baldovinetti and then Pollaiuolo, had attempted to treat landscape as naturalistically as painting would permit. Their ideal was to note it down with absolute correctness from a given point of view; their subject almost invariably the Valdarno; their achievement, a bird's-eye view of this Tuscan paradise. Nor can it be denied that this gives pleasure, but the pleasure is only such as is conveyed by tactile values. Instead of having the difficulty we should have in nature to distinguish clearly points near the horizon's edge, we here see them perfectly and without an effort, and in consequence feel great confirmation of capacity for life. Now if landscape were, as most people vaguely believe, a pleasure coming through the eyes alone, then the Pollaiuolesque treatment could be equalled by none that has followed, and surpassed only by Rogier van der Weyden, or by the quaint German 'Master of the Lyversberg Passion', who makes us see objects miles away with as great a precision and with as much intensity of local colour as if we were standing off from them a few feet. Were landscape really this, then nothing more inartistic than gradation of tint, atmosphere, and *plein air*, all of which help to make distant objects less clear, and therefore tend in no way to heighten our sense of capacity. But as a matter of fact the pleasure we take in actual landscape is only to a limited extent an affair of the eye, and to a great extent one of unusually intense well-being. The painter's problem, therefore, is not merely to render the tactile values of the visible objects, but to convey, more rapidly and unfailingly than nature would do, the *consciousness* of an unusually intense degree of well-being. This task—the communication by means purely visual of feelings occasioned chiefly by sensations non-visual—is of such difficulty that, until recently, successes in the rendering of what is peculiar to landscape as an art, and to landscape alone, were accidental and sporadic. Only now, in our own days, may painting be said to be

grappling with this problem seriously; and perhaps we are already at the dawn of an art which will have, to what has hitherto been called landscape, the relation of our music to the music of the Greeks or of the Middle Ages.

Verrocchio was, among Florentines at least, the first to feel that a faithful reproduction of the contours is not landscape, that the painting of nature is an art distinct from the painting of the figure. He scarcely knew where the difference lay, but felt that light and atmosphere play an entirely different part in each, and that in landscape these have at least as much importance as tactile values. A vision of *plein air*, vague I must grant, seems to have hovered before him, and, feeling his powerlessness to cope with it in full effects of light such as he attempted in his earlier pictures, he deliberately chose the twilight hour, when, in Tuscany, on fine days, the trees stand out almost black against a sky of light opalescent grey. To render this subduing, soothing effect of the coolness and the dew after the glare and dust of the day—the effect so matchlessly given in Gray's 'Elegy'—seemed to be his first desire as a painter, and in presence of his 'Annunciation' (in Pl. 191 the Uffizi), we feel that he succeeded as only one other Tuscan succeeded after him, that other being his own pupil Leonardo.[1]

X

It is a temptation to hasten on from Pollaiuolo and Verrocchio to Botticelli and Leonardo, to men of genius as artists reappearing again after two generations, men who accomplished with scarcely an effort what their precursors had been toiling after. But from these it would be even more difficult than at present to turn back to painters of scarcely any rank among the world's great artists, and of scarcely any importance as links in a chain of evolution, but not to be passed by, partly because of certain qualities they possess, and partly because their names would be missed in an account, even so brief as this, of Florentine painting. The men I chiefly refer to, one most active toward the middle and the other toward the end of the fifteenth century, are Benozzo Gozzoli and Domenico Ghirlandaio. Although they have been rarely coupled together, they have much in common. Both were, as artists, little more than mediocrities with almost no genuine feeling for what makes painting a great art. The real attractiveness of both lies entirely outside the sphere of pure art, in the realms of genre

[1] The author still believes that this picture was painted in Verrocchio's shop. Not by himself, however, but by Leonardo with the assistance of Credi.

illustration. And here the likeness between them ends; within their common ground they differed widely.

Gozzoli Benozzo was gifted with a rare facility not only of execution but of invention, with a spontaneity, a freshness, a liveliness in telling a story that wake the child in us, and the lover of the fairy tale. Later in life his more precious gifts deserted him, but who wants to resist the fascination of his early works, painted, as they seem, by a Fra Angelico who had forgotten heaven and become enamoured of the earth and the spring-time? In his Riccardi Palace frescoes he has sunk already to

Pl. 177 portraying the Florentine apprentice's dream of a holiday in the country on St. John's Day; but what a naïve ideal of luxury and splendour it is! With these, the glamour in which he saw the world began to fade away from him, and in his Pisan works we have, it is true, many a quaint bit of genre (superior to Teniers only because of

Pl. 178 superior associations), but never again the fairy tale. And as the better recedes, it is replaced by the worse, by the bane of all genre painting, non-significant detail, and positive bad taste. Have London or New York or Berlin worse to show us than the jumble of buildings in his

Pl. 176 ideal of a great city, his picture of Babylon? It may be said he here continues medieval tradition, which is quite true; but this fact indicates his place, which, in spite of his adopting so many of the fifteenth-century improvements, is not with the artists of the Renaissance, but with the story-tellers and costumed fairy-tale painters of the transition, with Spinello Aretino and Gentile da Fabriano, for instance. And yet, once in a while, he renders a head with such character or a movement with such ease that we wonder whether he had not in him, after all, the making of a real artist.

Ghirlandaio Ghirlandaio was born to far more science and cunning in painting than was current in Benozzo's early years, and all that industry, all that love of his occupation, all that talent even, can do for a man, they did for him; but unfortunately he had not a spark of genius. He appreciated Masaccio's tactile values, Pollaiuolo's movement, Verrocchio's effects of light, and succeeded in so sugaring down what he adopted from these great masters that the superior philistine of Florence could say: 'There now is a man who knows as much as any of the great men, but can give me something that I can really enjoy!' Bright colour, pretty faces, good likenesses, and the obvious everywhere—attractive and delightful, it must be granted, but, except in certain single figures, never significant. Let us glance a moment at his famous frescoes in Santa Maria Novella. To begin with, they are so undecorative that, in spite of the tone and surface imparted to them by four centuries, they

still suggest so many *tableaux vivants* pushed into the wall side by side, and in tiers. Then the compositions are as overfilled as the sheets of an illustrated newspaper—witness the 'Massacre of the Innocents', a Pl. 181 scene of such magnificent artistic possibilities. Finally, irrelevant episodes and irrelevant groups of portraits do what they can to distract our attention from all higher significance. Look at the 'Birth of John'; Ginevra dei Benci stands there, in the very foreground, staring out at you as stiff as if she had a photographer's iron behind her head. An even larger group of Florentine housewives in all their finery disfigures the 'Birth of the Virgin', which is further spoiled by a bas-relief to show off the painter's acquaintance with the antique, and by the figure of the serving maid who pours out water, with the rush of a whirlwind in her skirts—this to show off skill in the rendering of movement. Yet elsewhere, as in his 'Epiphany' in the Uffizi, Pl. 180 Ghirlandaio has undeniable charm, and occasionally in portraits his talent, here at its highest, rises above mediocrity, in one instance, the fresco of Sassetti in Santa Trinità, becoming almost genius. Pl. 182

XI

All that Giotto and Masaccio had attained in the rendering of tactile Leonardo da Vinci values, all that Fra Angelico or Filippo had achieved in expression, all that Pollaiuolo had accomplished in movement, or Verrocchio in light and shade, Leonardo, without the faintest trace of that tentativeness, that painfulness of effort which characterized his immediate precursors, equalled or surpassed. Outside Velazquez, and perhaps, when at their best, Rembrandt and Degas, we shall seek in vain for tactile values so stimulating and so convincing as those of his 'Monna Lisa'; outside Degas, we shall not find such supreme mastery over the art of movement as in the unfinished 'Epiphany' in the Uffizi; and if Pls. 192-3 Leonardo has been left far behind as a painter of light, no one has succeeded in conveying by means of light and shade a more penetrating feeling of mystery and awe than he in his 'Virgin of the Rocks'. Add to all this a feeling for beauty and significance that have scarcely ever been approached. Where again youth so poignantly attractive, manhood so potently virile, old age so dignified and possessed of the world's secrets? Who like Leonardo has depicted the mother's happi- Pl. 194 ness in her child and the child's joy in being alive; who like Leonardo has portrayed the timidity, the newness to experience, the delicacy and refinement of maidenhood; or the enchantress intuitions, the inexhaustible fascination of the woman in her years of mastery? Look at

his many sketches for Madonnas, look at his profile drawing of Isabella d'Este, or at the *Belle Joconde,* and see whether elsewhere you find their equals. Leonardo is the one artist of whom it may be said with perfect literalness: Nothing that he touched but turned into a thing of eternal beauty. Whether it be the cross-section of a skull, the structure of a weed, or a study of muscles, he, with his feeling for line and for light and shade, for ever transmuted it into life-communicating values; and all without intention, for most of these magical sketches were dashed off to illustrate purely scientific matter, which alone absorbed his mind at the moment.

Leonardo's personality And just as his art is life-communicating as is that of scarcely another, so the contemplation of his personality is life-enhancing as that of scarcely any other man. Think that great though he was as a painter, he was no less renowned as a sculptor and architect, musician and improviser, and that all artistic occupations whatsoever were in his career but moments snatched from the pursuit of theoretical and practical knowledge. It would seem as if there were scarcely a field of modern science but he either foresaw it in vision or clearly anticipated it, scarcely a realm of fruitful speculation of which he was not a free-man; and as if there were hardly a form of human energy which he did not manifest. And all that he demanded of life was the chance to be useful! Surely, such a man brings us the gladdest of all tidings—the wonderful possibilities of the human family, of whose chances we all partake.

Painting, then, was to Leonardo so little of a pre-occupation that we must regard it as merely a mode of expression used at moments by a man of universal genius, who recurred to it only when he had no more absorbing occupation, and only when it could express what nothing else could, the highest spiritual through the highest material significance. And great though his mastery over his craft, his feeling for significance was so much greater that it caused him to linger long over his pictures, labouring to render the significance he felt but which his hand could not reproduce, so that he rarely finished them. We thus have lost in quantity, but have we lost in quality? Could a mere painter, or even a mere artist, have seen and felt as Leonardo? We may well doubt. We are too apt to regard a universal genius as a number of ordinary brains somehow conjoined in one skull, and not always on the most neighbourly terms. We forget that genius means mental energy, and that a Leonardo, for the self-same reason that prevents his being merely a painter—the fact that it does not exhaust a hundredth part of his energy—will, when he does turn to painting, bring to bear

a power of seeing, feeling, and rendering, as utterly above that of the ordinary painter as the 'Monna Lisa' is above, let us say, Andrea del Sarto's 'Portrait of his Wife'. No, let us not join in the reproaches made to Leonardo for having painted so little; because he had much more to do than to paint, he has left all of us heirs to one or two of the supremest works of art ever created.

XII

Never pretty, scarcely ever charming or even attractive; rarely correct in drawing, and seldom satisfactory in colour; in types ill favoured; in feeling acutely intense and even dolorous—what is it then that makes Sandro Botticelli so irresistible that nowadays we may have no alternative but to worship or abhor him? The secret is this, that in European painting there has never again been an artist so indifferent to representation and so intent upon presentation. Educated in a period of triumphant naturalism, he plunged at first into mere representation with almost self-obliterating earnestness; the pupil of Fra Filippo, he was trained to a love of spiritual genre; himself gifted with strong instincts for the significant, he was able to create such a type of the thinker as in his fresco of St. Augustine; yet in his best years he left everything, even spiritual significance, behind him, and abandoned himself to the presentation of those qualities alone which in a picture are *directly* life-communicating, and life-enhancing. Those of us who care for nothing in the work of art but what it represents are either powerfully attracted or repelled by his unhackneyed types and quivering feeling; but if we are such as have an imagination of touch and of movement that it is easy to stimulate, we feel a pleasure in Botticelli that few, if any, other artists can give us. Long after we have exhausted both the intensest sympathies and the most violent antipathies with which the representative elements in his pictures may have inspired us, we are only on the verge of fully appreciating his real genius. This in its happiest moments is an unparalleled power of perfectly combining values of touch with values of movement.

Look, for instance, at Botticelli's 'Venus Rising from the Sea'. Throughout, the tactile imagination is roused to a keen activity, by itself almost as life-heightening as music. But the power of music is even surpassed where, as in the goddess's mane-like tresses of hair fluttering to the wind, not in disorderly rout but in masses yielding only after resistance, the movement is directly life-communicating. The entire picture presents us with the quintessence of all that is

Botticelli

Pl. 201

Pl. 204

pleasurable to our imagination of touch and of movement. How we revel in the force and freshness of the wind, in the life of the waves! And such an appeal he always makes. His subject may be fanciful, as in the 'Realms of Venus' (the 'Spring'); religious, as in the Sistine Chapel frescoes or in the 'Coronation of the Virgin'; political, as in the recently discovered 'Pallas Taming a Centaur'; or even crudely allegorical: as in the Louvre frescoes—no matter how unpropitious, how abstract the idea, the vivid appeal to our tactile sense, the life-communicating movement is always there. Indeed, at times it seems that the less artistic the theme, the more artistic the fulfilment, the painter being impelled to give the utmost values of touch and movement to just those figures which are liable to be read off as mere empty symbols. Thus, on the figure representing political disorder—the Centaur—in the 'Pallas', Botticelli has lavished his most intimate gifts. He constructs the torso and flanks in such a way that every line, every indentation, every boss appeals so vividly to the sense of touch that our fingers feel as if they had everywhere been in contact with his body, while his face gives to a still heightened degree this convincing sense of reality, every line functioning perfectly for the osseous structure of brow, nose, and cheeks. As to the hair—imagine shapes having the supreme life of line you may see in the contours of licking flames, and yet possessed of all the plasticity of something which caresses the hand that models it to its own desire!

In fact, the mere subject, and even representation in general, was so indifferent to Botticelli, that he appears almost as if haunted by the idea of communicating the *unembodied* values of touch and movement. Now there is a way of rendering even tactile values with almost no body, and that is by translating them as faithfully as may be into values of movement. For instance—we want to render the roundness of a wrist without the slightest touch of either light or shade; we simply give the movement of the wrist's outline and the movement of the drapery as it falls over it, and the roundness is communicated to us almost entirely in terms of movement. But let us go one step farther. Take this line that renders the roundness of the wrist, or a more obvious example, the lines that render the movements of the tossing hair, the fluttering draperies, and the dancing waves in the 'Birth of Venus'—take these lines alone with all their power of stimulating our imagination of movement, and what do we have? Pure values of movement abstracted, unconnected with any representation whatever. This kind of line, then, being the quintessence of movement, has, like the essential elements in all the arts, a power of stimulating our

Pls. 203, 206 208-9

Pls. 199-200

Pl. 200

Pl. 205

imagination and of directly communicating life. Well! imagine an art made up entirely of these quintessences of movement-values, and you will have something that holds the same relation to representation that music holds to speech—and this art exists, and is called linear decoration. In this art of arts Sandro Botticelli may have had rivals in Japan and elsewhere in the East, but in Europe never. To its demands he was ready to sacrifice everything that habits acquired under Filippo and Pollaiuolo—and his employers!—would permit. The representative element was for him a mere libretto: he was happiest when his subject lent itself to translation into what may be called a linear symphony. And to this symphony everything was made to yield; tactile values were translated into values of movement, and, for the same reason—to prevent the drawing of the eye inward, to permit it to devote itself to the rhythm of the line—the backgrounds were either entirely suppressed or kept as simple as possible. Colour also, with almost a contempt for its representative function, Botticelli entirely subordinated to his linear scheme, compelling it to draw attention to the line, rather than, as is usual, away from it.

This is the explanation of the value put upon Botticelli's masterpieces. In some of his later works, such as the Dresden *predelle*, we Pl. 214 have, it is true, bacchanals rather than symphonies of line, and in many of his earlier paintings, in the 'Fortezza', for instance, the harness and Pl. 213 trappings have so disguised Pegasus that we scarcely know him from a cart-horse. But the painter of the 'Venus Rising from the Sea', of Pls. 203-6 the 'Spring', or of the Villa Lemmi frescoes is the greatest artist of Pl. 207 linear design that Europe has ever had.

XIII

Leonardo and Botticelli, like Michelangelo after them, found imitators but not successors. To communicate more material and spiritual significance than Leonardo would have taken an artist with deeper feeling for significance; to get more music out of design than Botticelli would have required a painter with even greater passion for the re-embodiment of the pure essences of touch and movement. There were none such in Florence, and the followers of Botticelli—Leonardo's were all Milanese, and do not here concern us—could but imitate the patterns of their master: the patterns of the face, the Popularizers patterns of the composition, and the patterns of the line; dragging of art them down to their own level, sugaring them down to their own palate, slowing them down to their own insensitiveness for what is

life-communicating. And although their productions, which were nothing but translations of great man's art into average man's art, became popular, as was inevitable, with the average man of their time (who comprehended them better and felt more comfortable in their presence than in that of the originals which he respectfully admired but did not so thoroughly enjoy), nevertheless we need not dwell on these popularizers nor on their popularizations—not even on Filippino, with his touch of consumptive delicacy, nor Raffaelino del Garbo, with his glints of never-to-be-fulfilled promise.

Before approaching the one man of genius left in Florence after Botticelli and Leonardo, before speaking of Michelangelo, the man in whom all that was most peculiar and much that was greatest in the striving of Florentine art found its fulfilment, let us turn for a moment to a few painters who, just because they were men of manifold talent, might elsewhere almost have become masters. Fra Bartolommeo, Andrea del Sarto, Pontormo, and Bronzino were perhaps no less gifted as artists than Palma, Bonifazio Veronese, Lotto, and Tintoretto; but their talents, instead of being permitted to flower naturally, were scorched by the passion for showing off dexterity, blighted by academic ideals, and uprooted by the whirlwind force of Michelangelo.

Fra
Bartolommeo Fra Bartolommeo, who in temperament was delicate, refined, graceful, and as a painter had a miniaturist's feeling for the dainty, Pls. 219–21 was induced to desert his lovely women, his exquisite landscape, and his gentleness of expression for figures constructed mechanically on a colossal scale, or for effects of the round at any cost. And as evil is more obvious than good, Bartolommeo, the painter of that masterpiece of colour and light and shade, of graceful movement and charming feeling, the 'Madonna with the Baptist and St. Stephen' in the Cathedral at Lucca, Bartolommeo, the dainty deviser of the tiny Melchett 'Nativity', Bartolommeo, the artificer of a hundred masterpieces of pen drawing, is almost unknown; and to most people Fra Bartolommeo is a sort of synonym for pomposity. He is known only as the author of physically colossal, spiritually insignificant prophets and apostles, or, perchance, as the painter of pitch-dark altar-pieces: this being the reward of devices to obtain mere relief.

Andrea del
Sarto Andrea del Sarto approached perhaps as closely to a Giorgione or a Titian as could a Florentine, ill at ease in the neighbourhood of Leonardo and Michelangelo. As an artist he was, it is true, not endowed with the profoundest sense for the significant, yet within the sphere of common humanity who has produced anything more genial Pl. 224 than his 'Portrait of a Lady' with a Petrarch in her hands? Where out

of Venetia can we find portraits so simple, so frank, and yet so inter-
pretive as his 'Architect', or as his various portraits of himself—these, Pl. 225
by the way, an autobiography as complete as any in existence, and
tragic as few? Almost Venetian again is his 'St. James' caressing
children, a work of the sweetest feeling. Even in colour effect, and
technique, how singularly close to the best Venetian painting is his
'Dispute about the Trinity'—what blacks and whites, what greys and
purplish browns! And in addition, tactile values peculiar to Florence—
what a back St. Sebastian's! But in a work of scarcely less technical
merit, the 'Madonna of the Harpies', we already feel the man not Pl. 222
striving to get the utmost out of himself, but panting for the grand
and magnificent. Even here he remains almost a great artist, because
his natural robustness comes to his rescue; but the 'Madonna' is too
obviously statuesque, and, good saints, pray why all these draperies?

The obviously statuesque and draperies were Andrea's devices for
keeping his head above water in the rising tide of the Michel-
angelesque. As you glance in sequence at the Annunziata frescoes, on
the whole so full of vivacity, gaiety, and genuine delight in life, you see
from one fresco to another the increased attention given to draperies. In
the Scalzo series, otherwise masterpieces of tactile values, the draperies
do their utmost to smother the figures. Most of these paintings are
closed in with ponderous forms which have no other purpose than
to serve as a frame, and as clothes-horses for draperies: witness the
scene of Zacharias in the temple, wherein none of the bystanders Pl. 227
dare move for fear of disturbing their too obviously arranged folds.

Thus by constantly sacrificing first spiritual, and then material
significance to pose and draperies, Andrea loses all feeling for the
essential in art. What a sad spectacle is his 'Assumption', wherein the
Apostles, the Virgin herself, have nothing better to do than to show
off draperies! Instead of feeling, as in the presence of Titian's 'Assunta',
wrapt to heaven, you gaze at a number of tailor's men, each showing
how a stuff you are thinking of trying looks on the back, or in a certain
effect of light. But let us not end on this note; let us bear in mind that,
despite all his faults, Andrea painted the one 'Last Supper' which can Pl. 226
be looked at with pleasure after Leonardo's.

Pontormo, who had it in him to be a decorator and portrait-painter Pontormo
of the highest rank, was led astray by his awe-struck admiration for
Michelangelo, and ended as an academic constructor of monstrous
nudes. What he could do when expressing *himself*, we see in the lunette
at Poggio a Caiano, as design, as colour, as fancy, the freshest, gayest, Pl. 229
most appropriate mural decoration now remaining in Italy; what he

could do as a portrait-painter, we see in his wonderfully decorative panel of Cosimo dei Medici at San Marco, or in his portrait of a 'Lady with a Dog' (at Frankfort), perhaps the first portrait ever painted in which the sitter's social position was insisted upon as much as the personal character. What Pontormo sank to, we see in such a riot of meaningless nudes, all caricatures of Michelangelo, as his 'Martyrdom of Forty Saints'.

Bronzino, Pontormo's close follower, had none of his master's talent as a decorator, but happily much of his power as a portrait-painter. Would he had never attempted anything else! The nude without material or spiritual significance, with no beauty of design or colour, the nude simply because it was the nude, was Bronzino's ideal in composition, and the result is his 'Christ in Limbo'. But as a portrait-painter he took up the note struck by his master and continued it, leaving behind him a series of portraits which not only had their effect in determining the character of Court painting all over Europe, but, what is more to the point, a series of portraits most of which are works of art. As painting, it is true, they are hard, and often timid; but their air of distinction, their interpretive qualities, have not often been surpassed. In his Uffizi portraits of Eleonora da Toledo, of Prince Ferdinand, of the Princess Maria, we seem to see the prototypes of Velazquez's queens, princes, and princesses: and for a fine example of dignified rendering of character, look in the Sala Baroccio of the Uffizi at a bust of a young woman with a missal in her hand.

<div style="margin-left: -15%; float: left;">Pl. 230</div>
<div style="margin-left: -15%; float: left;">Bronzino</div>
<div style="margin-left: -15%; float: left;">Pls. 231-4</div>

XIV

The great Florentine artists, as we have seen, were, with scarcely an exception, bent upon rendering the material significance of visible things. This, little though they may have formulated it, was the conscious aim of most of them; and in proportion as they emancipated themselves from ecclesiastical dominion, and found among their employers men capable of understanding them, their aim became more and more conscious and their striving more energetic. At last appeared the man who was the pupil of nobody, the heir of everybody, who felt profoundly and powerfully what to his precursors had been vague instinct, who saw and expressed the meaning of it all. The seed that produced him had already flowered into a Giotto, and once again into a Masaccio; in him, the last of his race, born in conditions artistically most propitious, all the energies remaining in his stock were concentrated, and in him Florentine art had its logical culmination.

<div style="margin-left: -15%; float: left;">Michelangelo</div>

Michelangelo had a sense for the materially significant as great as Giotto's or Masaccio's, but he possessed means of rendering, inherited from Donatello, Pollaiuolo, Verrocchio, and Leonardo—means that had been undreamt of by Giotto or even by Masaccio. Add to this that he saw clearly what before him had been felt only dimly: that there was no other such instrument for conveying material significance as the human nude. This fact is as closely dependent on the general conditions of realizing objects as tactile values are on the psychology of sight. We realize objects when we perfectly translate them into terms of our own states, our own feelings. So obviously true is this, that even the least poetically inclined among us, because we keenly realize the movement of a railway train, to take one example out of millions, speaks of it as *going* or *running*, instead of *rolling on its wheels*, thus being no less guilty of anthropomorphizing than the most unregenerate savages. Of this same fallacy we are guilty every time we think of anything whatsoever with the least warmth—we are lending this thing some human attributes. The more we endow it with human attributes, the less we merely know it, the more we realize it, the more does it approach the work of art. Now there is one and only one object in the visible universe which we need not anthropomorphize to realize—and that is man himself. His movements, his actions, are the only things we realize without any myth-making effort—directly. Hence, there is no visible object of such artistic possibilities as the human body; nothing with which we are so familiar; nothing, therefore, in which we so rapidly perceive changes; nothing, then, which if represented so as to be realized more quickly and vividly than in life, will produce its effect with such velocity and power, and so strongly confirm our sense of capacity for living.

Values of touch and movement, we remember, are the specifically artistic qualities in figure painting (at least, as practised by the Florentines), for it is through them chiefly that painting directly heightens life. Now while it remains true that tactile values can, as Giotto and Masaccio have for ever established, be admirably rendered on the draped figure, yet drapery is a hindrance, and, at the best, only a way out of a difficulty, for we *feel* it masking the really significant, which is *the form underneath*. A mere painter, one who is satisfied to reproduce what everybody sees, and to paint for the fun of painting, will scarcely comprehend this feeling. His only significant is the obvious—in a figure, the face and the clothing, as in most of the portraits manufactured nowadays. The artist, even when compelled to paint draped figures, will force the drapery to render the nude, in

The human nude

Value of the nude

other words the material significance of the human body. But how much more clearly will this significance shine out, how much more convincingly will the character manifest itself, when between its perfect rendering and the artist nothing intervenes! And this perfect rendering is to be accomplished with the nude only.

Rendering of
movement

If draperies are a hindrance to the conveyance of tactile values, they make the perfect rendering of movement next to impossible. To realize the play of muscle everywhere, to get the full sense of the various pressures and resistances, to receive the direct inspiration of the energy expended, we must have the nude; for here alone can we watch those tautnesses of muscle and those stretchings and relaxings and ripplings of skin which, translated into similar strains on our own persons, make us fully realize movement. Here alone the translation, owing to the multitude and the clearness of the appeals made, is instantaneous, and the consequent sense of increased capacity almost as great as can be attained; while in the draped figure we miss all the appeal of visible muscle and skin, and realize movement only after a slow translation of certain functional outlines, so that the sense of capacity which we receive from the perception of movement is increased but slightly.

We are now able to understand why every art whose chief pre-occupation is the human figure must have the nude for its chief interest; why, also, the nude is the most absorbing problem of classic art at all times. Not only is it the best vehicle for all that in art which is directly life-confirming and life-enhancing, but it is itself the most significant object in the human world. The first person since the great days of Greek sculpture to comprehend fully the identity of the nude with great figure art was Michelangelo. Before him it had been studied for scientific purposes—as an aid in rendering the draped figure. He saw that it was an end in itself, and the final purpose of his art. For him the nude and art were synonymous. Here lies the secret of his successes and his failures.

Michel-
angelo's
nudes

First, his successes. Nowhere outside of the best Greek art shall we find, as in Michelangelo's works, forms whose tactile values so increase our sense of capacity, whose movements are so directly communicated and inspiring. Other artists have had quite as much feeling for tactile values alone—Masaccio, for instance; others still have had at least as much sense of movement and power of rendering it—Leonardo, for example; but no other artist of modern times, having at all his control over the materially significant, has employed it as Michelangelo did, on the one subject where its full value can be manifested—the nude.

Hence of all the achievements of modern art, his are the most invigorating. Surely not often is our imagination of touch roused as by his Adam in the 'Creation', by his Eve in the 'Temptation', or by his many nudes in the same ceiling of the Sistine Chapel—there for no other purpose, be it noted, than their direct tonic effect! Nor is it less rare to quaff such draughts of unadulterated energy as we receive from the 'God Creating Adam', the 'Boy Angel' standing by Isaiah, or—to choose one or two instances from his drawings (in their own kind the greatest in existence)—the 'Gods Shooting at a Mark' or the 'Hercules and the Lion'.

Pl. 238

Pls. 237, 236, 240–1

And to this feeling for the materially significant and all this power of conveying it, to all this more narrowly artistic capacity, Michelangelo joined an ideal of beauty and force, a vision of a glorious but possible humanity, which, again, has never had its like in modern times. Manliness, robustness, effectiveness, the fulfilment of our dream of a great soul inhabiting a beautiful body, we shall encounter nowhere else so frequently as among the figures in the Sistine Chapel. Michelangelo completed what Masaccio had begun, the creation of the type of man best fitted to subdue and control the earth, and, who knows! perhaps more than the earth.

The Ideal of beauty and force

But unfortunately, though born and nurtured in a world where his feeling for the nude and his ideal of humanity could be appreciated, he passed most of his life in the midst of tragic disasters, and while yet in the fullness of his vigour, in the midst of his most creative years, he found himself alone, perhaps the greatest, but alas! also the last of the giants born so plentifully during the fifteenth century. He lived on in a world he could not but despise, in a world which really could no more employ him than it could understand him. He was not allowed, therefore, to busy himself where he felt most drawn by his genius, and, much against his own strongest impulses, he was obliged to expend his energy upon such subjects as the 'Last Judgement'. His later works all show signs of the altered conditions, first in an overflow into the figures he was creating of the scorn and bitterness he was feeling, then in the lack of harmony between his genius and what he was compelled to execute. His passion was the nude, his ideal power. But what outlet for such a passion, what expression for such an ideal could there be in subjects like the 'Last Judgement', or the 'Crucifixion of Peter'—subjects which the Christian world imperatively demanded should incarnate the fear of the humble and the self-sacrifice of the patient? Now humility and patience were feelings as unknown to Michelangelo as to Dante before him, or, for that matter, to any other

of the world's creative geniuses at any time. Even had he felt them, he had no means of expressing them, for his nudes could convey a sense of power, not of weakness; of terror, not of dread; of despair, but not

The 'Last
Judgement'

of submission. And terror the giant nudes of the 'Last Judgement' do feel, but it is not terror of the Judge, who, being in no wise different from the others, in spite of his omnipotent gesture, seems to be

Pl. 239

announcing rather than *willing* what the bystanders, his fellows, could not *unwill*. As the representation of the moment before the universe disappears in chaos—Gods huddling together for the *Götter-dämmerung*—the 'Last Judgement' is as grandly conceived as possible: but when the crash comes, none will survive it, not even God. Michelangelo therefore failed in his conception of the subject, and could not but fail. But where else in the whole world of art shall we receive such blasts of energy as from this giant's dream, or, if you will,

The
'Crucifixion
of St. Peter'

nightmare? For kindred reasons the 'Crucifixion of Peter' is a failure. Art can be only life-communicating and life-enhancing. If it treats of pain and death, these must always appear as manifestations and as results only of living resolutely and energetically. What chance is there, I ask, for this, artistically the only possible treatment, in the representation of a man crucified with his head downwards? Michelangelo could do nothing but make the bystanders, the executioners, all the more life-communicating, and therefore inevitably more sympathetic! No wonder he failed here! What a tragedy, by the way, that the one subject perfectly cut out for his genius, the one subject which required none but genuinely artistic treatment, his 'Bathers', executed forty years before these last works, has disappeared, leaving but scant traces! Yet even these suffice to enable the competent student to recognize that this composition must have been the greatest masterpiece in figure art of modern times.

Michel-
angelo's
faults

That Michelangelo had faults of his own is undeniable. As he got older, and his genius, lacking its proper outlets, tended to stagnate and thicken, he fell into exaggerations—exaggerations of power into brutality, of tactile values into feats of modelling. No doubt he was also at times as indifferent to representation as Botticelli! But while there is such a thing as movement, there is no such thing as tactile values without representation. Yet he seems to have dreamt of presenting nothing but tactile values: hence his many drawings with only the torso adequately treated, the rest unheeded. Still another result from his passion for tactile values. I have already suggested that Giotto's types were so massive because such figures most easily convey values of touch. Michelangelo tended to similar exaggerations, to

making shoulders, for instance, too broad and too bossy, simply because they make thus a more powerful appeal to the tactile imagination. Indeed, I venture to go even farther, and suggest that his faults in all the arts, sculpture no less than painting, and architecture no less than sculpture, are due to this self-same predilection for salient projections. But the lover of the figure arts for what in them is genuinely artistic and not merely ethical, will in Michelangelo, even at his worst, get such pleasures as, excepting a few, others, even at their best, rarely give him.

In closing, let us note what results clearly even from this brief account of the Florentine school, namely that, although no Florentine merely took up and continued a predecessor's work, nevertheless all, from first to last, fought for the same cause. There is no opposition between Giotto and Michelangelo. The best energies of the first, of the last, and of all the intervening great Florentine artists were persistently devoted to the rendering of tactile values, or of movement, or of both. Now successful grappling with problems of form and of movement is at the bottom of all the higher arts; and because of this fact, Florentine painting, despite its many faults, is, after Greek sculpture, the most serious figure art in existence.

Constant aims of Florentine art

Pls. 114, 115

BOOK III
THE CENTRAL ITALIAN PAINTERS

BOOK III

THE consistent pursuit of the Florentine painters was form and movement; of the Venetians, splendour and harmony of colour: what did the Central Italians contribute to the magic of Renaissance art? Rarely does colour penetrate the senses and warm the heart more quickly than in certain frescoes or panels of Simone Martini or Gentile da Fabriano, of Perugino or Raphael. Yet even these great masters could be at times indifferent, or, indeed, harsh, while their inferiors have slight merit as colourists. Seldom have problems of form and movement been better solved than by Signorelli; but he had few, if any, followers. It is not with the magicians in colour and the creators in form that the Central Italian Painters, as a school, hold high rank. What is it, then, that gives them their place not only with the greatest, but with the most popular names in art? Our present quest, if successful, will yield an answer.

I

Every time we see an object we carry away in our memory some shadow of its shape and colour. This ghost of animate or inanimate things, passing under the name of 'visual image', haunts different minds in different degrees. Some people scarcely recognize its presence, although they know it exists; others can at will conjure up shadows so defined that they, in their turn, evoke emotions after their kind, and tinged with the poignancy of the feelings aroused by the objects themselves; still others need only shut their eyes to see absent shapes with the vividness and warmth of direct retinal impressions. Strictly speaking, each person varies from every other in the richness of his visual images, but for our purpose it suffices to distribute all people into the three classes we have just defined. Of the first, we say that they visualize badly, or not at all; of the second, that they visualize fairly; of the third, that they visualize perfectly.

The visual image

The course of art would probably have been a very different one if people had never visualized at all, or had always visualized perfectly. Had we no faculty whatever for calling up the shapes of things, it might never have given us pleasure to see mere reproductions of them. Why should it? Nor should we be any more likely to care for mere reproductions if we had within ourselves the faculty of calling up at will perfect visual images. But most of us belong to the second

class—those who have a moderate power of visualizing. When objects are named, some image of them looms up in our minds. It is, however, apt to be so vague, so elusive, that it tantalizes rather than satisfies. After a vain effort to fix the image of an absent friend, the crudest manual reproduction may be pounced upon with pleasure, and a photograph seem the friend himself; for almost anything may be more complete and more vivid than our indwelling picture of him.

All this would be different if we visualized perfectly. At the mention of a friend's name we should see him almost as if he were present— nay, more—as we have seen him at a hundred significant moments. Not one, but a thousand sweet shades of himself hover past, each greeting us as our friend; and at will, as mood inspires, we fix upon this or that as his best and faithfullest lieutenant in our affection. Should we still care for the mere reproduction of his likeness? Granting that the reproduction, as such, were perfect, it would be one, and only one, moment in the flux of his life. Any other instant would represent him perhaps equally well. But does the single moment represent him at all? Even the single images we have of him each take colour and warmth from the others. The mere reproduction of our friend would hardly please us, because it could convey one only of his manifold aspects, an aspect which, even then, would be inferior to any one single image of him in our own minds. The pleasure in mere likeness is, in fact, the outcome of a feeble power of visualizing, and but for this might never have been known.

Now conceive of an art that could have had no purpose in helping out our actual visualizing, each one of our images being perfect. What could such an art have done to please us through the channel of our eyes? It still would have had two broad domains, one of which we shall call Illustration, and the other Decoration. Both terms need explanation, if not apology. By Decoration I mean all those elements in a work of art which appeal directly to the senses, such as Colour and Tone; or directly stimulate ideated sensations, such as, for instance, Form and Movement. The word has never deliberately been used in quite so wide a sense; indeed, it is one of the vaguest and least hedged-in terms of our language; but as the tendency for some time past has been to make it designate all in a work of art that is not merely expressive, or academic, or dexterous, we shall not be imposing upon it too hard a burden if we make it convey the full meaning I have given it.

Decoration

Illustration

A definition of Illustration now follows as a matter of course: it is all that which, in a work of art, is not Decorative. But this definition

is too negative, too verbal, to satisfy. We must make it more concrete. The current use of the word is at once too comprehensive, and, as I shall try to show, too narrow. Raphael's illustrations to the Bible in the *loggia* of the Vatican cannot be illustrations in the same sense as are the photographic views which commonly embellish magazine articles on travel. We all feel the difference; but in what does it really consist? The answer will appear if we stop to consider what each does for us. The view being a mere reproduction, we regard it as a fact, and not as art at all. It may give pleasure, but only to such as crave either for knowledge, or for greater precision of visual imagery. Raphael's frescoes reproduce nothing which was ever seen in that precise form in the world about us, either by himself or by anyone else. They convey no information. But do they also do nothing for our visualizing? On the contrary, they stock our minds with images. Images of what— of scenes that never took place? Just so. But surely these are not the visual images we spoke of a little while ago, which we agreed were but shadows in the mind of things actually seen? What, then, are they?

Ultimately they also are shadows of things actually seen, but combined, blended, and composed in the artist's mind under the spell of the Bible narrative. The process which went on in Raphael's brain takes place in all of us who visualize with any ease. Every word tends to evoke an image, and as we read we are accompanied by an ever unfolding scroll of vague and evanescent shapes—blendings and fusings of the shadows dwelling within—which correspond to the sense of the phrases. Even if this panorama in our own minds lacked nothing in distinctness, we still should get a certain pleasure from the images conjured up by the same words in another mind; not, as in the case of very poor visualizers, because we longed for greater precision of imagery, but simply for the reason that the imaginary picture can never be quite the same in any two minds. And what if another mind is stocked with shadows of shapes in themselves superior to those of our individual world; what if that mind also possesses a more effective power of fusing and blending these images, already more attractive than ours? Let that person read the Old Testament, or contemplate anything that can possibly have its graphic counterpart, and pictures will troop past his mental vision which, could we but see them, would reveal higher conceptions and deeper meanings than we ourselves had found, would thrill us with the contagious presence of an imagination —here and at the moment, at least—richer, warmer, and completer than our own.

But how does a mental picture like this become a work of art? The

Evocation of images

answer would seem simple enough: before the mental image becomes a work of art it must be copied exactly in marble or on canvas. But *is* that really all? Most people would unhesitatingly say yes. They would define art as the faithful reproduction of things in themselves beautiful, or of the fused and blended images of such things. The old talk of the ideal, the new talk of the temperament, Aristotle and Zola, nestle comfortably in this basket. And the common difficulty, the difference between a photograph and such a work of art as, for example, a portrait by Watts, most people would explain by saying that the one reproduces a single image of a person, the other reproduces a composite formed by a mind of exceptional power. And thus great art would be defined not as the blind imitation of nature, but as the reproduction of the visual images haunting great minds.

There are some people, however, who would not rest happy in this definition. Mere reproduction, they would say, is not art, no matter how beautiful and exalted the object reproduced. The pleasure this gives, they would add, is not artistic, but aesthetic in a more general sense, or perhaps only intellectual; and they would insist on making a difference between a thing in itself beautiful (or a beautiful mental picture) on the one hand, and a work of art on the other. They would insist also on distinguishing between the terms 'aesthetic' and 'artistic', allowing the meaning of the first to include the second, but confining 'artistic' to designate that pleasure only which is derived from a conscious appreciation of the quality that makes the difference between objects, or mental images—in themselves beautiful—and works of art having the qualities which I have called Decorative. They would not deny that a work of art might gain from the character of the object, or of the mental image reproduced, but they would uphold that its specific value as Art was perfectly distinct from, and but slightly dependent upon, the value of the original. They would go even farther and say that the work of art, as such, had comparatively little to gain from the attractiveness of the object represented, but that the artist could enhance and glorify almost any object that lent itself to his treatment. Mere reproductions of things, no matter how exalted in themselves, no matter whether of objects in actual existence, or of the sublimest visions of the sublimest imaginations, they would speak of as 'Literature'—and I, disagreeing with them only in phrase, as Illustration.

At last we have seen the definition we have been seeking. Illustration is everything which in a work of art appeals to us, not for any intrinsic quality, as of colour or form or composition, contained in

Art as reproduction *(margin note)*

Distinction between 'aesthetic' and 'artistic' *(margin note)*

Definition of Art *(margin note)*

the work of art itself, but for the value the thing represented has elsewhere, whether in the world outside, or in the mind within. If a work of art has no intrinsic value whatever, or if we fail to perceive it, for us it is nothing but an Illustration, and it does not matter whether it be drawn, engraved, or coloured on sheets of paper, or painted on a panel or wall. Raphael and Michelangelo, Leonardo and Giorgione, if we perceive in them no qualities except such as, in the realms of actual or ideal things, belong to the images set down in their paintings, are as much mere Illustrators as the hacks who furnish designs for the popular press. In the domain of Illustration, there are, it is true, whole universes of difference between the illustrations of the great men just named and the illustrations of the nameless folk of today, but from this point of view they are all mere Illustrators.

'Illustration', as I shall employ the word, is, then, somewhat narrower, and, at the same time, considerably wider a term than the current use, which confines it to art as subordinated to letterpress. It will exclude mere reproduction of single perceptions of objects, too formless to give pleasure to any but the quite uncultivated, for whom simple recognition is already a delight. It will comprise, on the other hand, the mere reproduction of all those visual images, no matter how elaborate and significant, and no matter in what shapes they are cast, of which the form has no intrinsic merit of its own that we more or less consciously perceive.

Illustration

II

Now it is no academic reason which has led me, at the opening of a small book on the Central Italian Painters, to speak of visual images, and to distinguish clearly in the work of art between Decoration and Illustration. It is a steep short-cut—would we had had the leisure to build a broad, gently climbing highway!—which, once bravely over, places us where we shall understand a great deal that otherwise would have for ever puzzled and perplexed us.

What more perplexing, for example, than the veerings of fashion, or even of taste? It makes scornful sceptics of most, and forces upon the few who still believe, the alternative of silence or paradox. *De gustibus non est disputandum* is a maxim no less maintained now than in more barbarous ages. It is true, politeness forbids pushing too far a discussion on matters of taste; but if such questions were of enough consequence to compel attention, and if we could communicate our views without fear of offending, is it so certain that we should arrive

Changes of taste

at no conclusions? I think not. Fortunately it is not our business here and now to make the perilous attempt. But one thing, at least, must be made clear at once. It is this. The question of preference in art is not at all the same that it is in life. Life makes different demands from generation to generation, from decade to decade, from year to year, nay, from day to day, and hour to hour. Our attention is stretched with the utmost interest toward those things that will help us to satisfy these demands, and with admiration toward those of our fellows who, without crowding or hindering us, have perfectly satisfied them. As the demands, so the objects of our desire and our admiration vary. And as the objects of desire and admiration are altered, so will the subject-matter of the arts change. It cannot be otherwise. But depth of conception and attractiveness of ideal are, as we have seen, all that the greater number of even cultivated people care for in the arts; and, this being so, art must either present the current conceptions and ideals, or fail of a result in which even a restricted public will take an interest. Now the fluctuation of the ideal can affect those elements only in the work of art in which the ideal can be obviously manifest—in the Illustrative part. But this, as we have agreed, is far from being the whole, or even the more essential factor in art. There remain all the Decorative elements which mere change in the ideal cannot touch, for the good reason that the ideal can be adequately presented without them. All, therefore, in the work of art which distinguishes it from the mere mental image, all the Decorative elements, the more essential elements, as I believe, are above the revolutions of fashion and taste. Ages may arise which lack even the few who in better periods have a feeling for Art as distinct from Illustration or dexterity, and they are ages of bad taste—not of different taste. Some may prefer Guido Reni to Botticelli, the Carracci to Giorgione, and Bouguereau to Puvis de Chavannes, but let them not fancy that their preference rests on artistic grounds. The truth is that the elements essential to a painting as a work of art are beyond their perception, and that they look in a picture for nothing but a representation of something that would please them in actual life, or perhaps for the exhibition of a kind of skill that they happen to appreciate. (There are a thousand standards whereby one's tastes in matters of actual life may be judged, but as none of them are purely artistic, they are not my concern just here.)

Thus our rough division of the elements that constitute the work of art and divide it into two classes, the one Illustrative and the other Decorative, has already been of service. It has enabled us to distinguish what is subject to change and fashion from what is permanent in the

work of art. The Decorative elements, the intrinsic values, are as perdurable as the psychic processes themselves, which, as we have reason to believe, vary only in degree from age to age, but in kind remain the same through all time. But Illustration changes from epoch to epoch with the contents of the mind, the visual part of which it reproduces, and it is as varied as are races and individuals.

It follows, then, as a clear conclusion that a phase of art which contains few if any except Illustrative elements will tend to pass away with the ideals it reproduces; also, that if we do not perceive the Decorative factors in the work of art (which yet may exist there in spite of our incapacity) we shall cease caring for it the moment we are tired of the phase of life or feeling or thought which it embodies.

III

And now, for the present at all events, we can cease from abstractions and definitions, and turn in earnest to the Central Italian Painters. They were, as we agreed at the outset, not always enchanting in colour, and seldom great in form, yet one or another branch of their school has ever retained the attention, I will not say of the most artistic, but certainly of the most cultivated public. We shall now understand the reason. The Central Italian Painters were not only among the profoundest and grandest, but among the most pleasing and winning Illustrators that we Europeans ever have had. They saw and reproduced visions which have embodied the aspirations, the ideals, of two distinct epochs. Of these epochs, the first, the Middle Age, is so far behind us that to most of us its desires and ideals are no longer comprehensible, and the art which embodies them, losing for all but a few whatever glamour and spell it once had as Illustration, has faded into the dullness of documents recording dead things. But in the other epoch we are living still, and the forms which first expressed its cravings and aspirations answer as well today as when they were conceived in the mind of Raphael, four hundred years ago.

We shall begin with that school of Central Italian painting which illustrates the Middle Ages. The practice in Italy of the graphic arts had probably never been interrupted since the early days of their origin, and it would be a tedious task to pursue their course throughout its whole length, now stagnating, then dwindling, and finally almost disappearing, until they gushed forth again, fed by vigorous unsearched springs. Was it Etrurian genius reviving? Was it wafted overseas from Byzantium, or did it come from over the mountains,

The Central Italian painters

from the smiling fields of France? Let historians find answers to these fascinating questions. For our interest lies not in the origin, but in the enjoyment, of the work of art, and for enjoyment it is enough to know that painting as an art was flowering toward the end of the thirteenth century within the walls of 'soft Siena', then, as always, sorceress and queen among Italian cities.

<div style="text-align: right; font-style: italic;">The School
of Siena</div>

The first flower of this new growth, the flower from whose seed all Sienese art sprang, was Duccio di Buoninsegna. For this reason, and because he was so typical of his time and school, and anticipated so much that was characteristic of all Central Italian Painters—for all these considerations, we must dwell on him at some length.

<div style="text-align: right; font-style: italic;">Duccio</div>

All that the medieval mind demanded of a painter, Duccio perfectly fulfilled. It was the chief business of the medieval artist to re-write the stories of the Saviour, and of His immaculate Mother, in pictographs so elaborate that even the most unlettered could read them. At the same time these pictographs were intended to be offered up as a sacrifice, along with all the rest of the furnishing and actual decoration of God's holy house, and for this they were to be as resplendent as gold and skill could make them. In the hands of a man of genius the pictograph could transform itself into great Illustration, and the sacrifice into great Decoration. Did they suffer this change at the hands of Duccio?

Let us look for answer at the paintings on the reredos that once enclosed with splendour the altar of as proud a temple as Christendom could show. Now it moulders away in the museum outside the Cathedral of Siena, without interest for men, and consequently no longer a fit sacrifice to God. Their metallic lustre, the green and gold, give to these panels such an aspect of subdued sumptuousness as we expect not from paintings, but from bronze reliefs—from Ghiberti's 'Gates of Paradise'. For the person who approaches them with all his theories safely put to sleep, and his mind on the alert for the distinguishing notes in what he is about to perceive, there is a glamour compounded of sensuous appeal and spiritual association in the first flash of this mysterious work. It is like the binding of some priceless illuminated manuscript, inlaid with ivory, adorned with gold, and set with precious stones. As you look closer, it is as if you had turned the covers of a book wherein you behold a series of splendid Illustrations. The long-familiar stories are here retold with a simplicity, a clearness, and a completeness that, alongside of the blurred images these tales usually evoked, must have seemed to most of Duccio's contemporaries like the buoyant sparkle of the morning after groping dark. And not

<div style="text-align: right; font-style: italic;">Pls. 244–9</div>

this alone: Duccio did not merely furnish the best attainable picto-graphs. He gave the stories he told all the value that he, as a man of genius, felt in them; he lifted his spectators to his own level of perception.

Let us glance at a few of these scenes. In a palace, at the end of two rows of pondering thought-vexed greybeards, sits a majestic boy. On Pl. 244 the left a woman and an old man entering lift up their hands in amaze-ment and reproach. Never has the story of 'Christ among the Doctors' found a fitter illustration. Not a figure too much; nothing trivial, yet not a touch to lift it beyond human sympathy. Attitude, gesture, and expression can do no more for the theme.

Another scene: Christ addresses His disciples before He bends to wash their feet. He sits facing them, hieratic, majestic, and they look as if, though they have known Him long, for the first time He is now revealed to them. Fervour of ecstatic credence, the pathetic yearning to lift one's self up, to comprehend, to make one's own the good manifested for too brief a moment, have perhaps never again been so convincingly rendered. Expression—and, be it noted, individual expression, for here are different ages and different temperaments—has never been a more obedient handmaid of the gift for sublime interpretation.

In the next panel we see the disciples looking on while Christ washes Peter's feet. Consternation, almost horror, is on their faces, Pl. 246 and incredulity withal, as if they cannot believe the evidence of their eyes. Christ is all pity and humility. Peter holds his hand to his head as if to make sure of his own identity.

It would be easy to fill the rest of this little book with descriptions of the scarcely surpassable triumphs of interpretation and expression to be met with in this one reredos of Duccio's. But one or two instances more must suffice. We see Christ, resplendent now in robes all gold, leaping through the gates of hell to deliver from limbo the patriarchs and prophets. They troop up to the mouth of the black cavern, majestic greybeards, with the yearning expectancy of thousands of years lingering on their faces. Then, on earth, it is Easter Day, and as the light is breaking over the jagged rocks, the three Marys approach the tomb, and start back as they behold its lid swung open and upon Pl. 245 it a white-stoled angel, radiant and glorious. I know no more impres-sive rendering of this most marvellous of all subjects. To the drama of expression and gesture, Duccio adds the drama of light, with all its transfiguring magic. A bronzed purple glow flashes through the thin air, and we feel the vivifying cool of the dayspring.

Expression, then, and interpretation, grandeur of conception, and depth of feeling—the qualities most essential to great Illustration— Duccio possessed to the utmost, and this implies that he had sufficient control also of form and movement to render his effects. There remain two other requisites without which the art of Illustration limps rather than leaps. These are Grouping and Arrangement. That Duccio possessed both these in addition to his other gifts we shall be persuaded if we look at several more panels of the Sienese reredos.

Let us turn first to a subject which demands dramatic action and Pl. 247 many actors—the 'Betrayal of Judas'. Motionless, in the middle of the foreground, we see the figure of Christ. The slim and supple Judas entwines Him in an embrace, while the lightly-clad soldiers lay hands on Him, the guards crowd round Him, and the Pharisee elders, at the sight of His face, which betrays no feeling but pity, start back in horrified consternation. Meanwhile, on the left, hot-tempered Peter rushes at a soldier with his knife, and, on the right, the disciples in a crowded flock scurry away, only the most courageous venturing to look back. We have here two masses of men, and in each the action and expression are kept so clear that to mistake them would imply sheer want of wits. In another panel, representing the 'Incredulity of Pl. 249 Thomas', Christ, with right arm uplifted, appears baring the wound in His side to the impudent touch of His doubting disciple. These two figures stand out by themselves, and to right and left, more crowded on one side, more scattered on the other, stand the remaining disciples, so arranged that we get the expression on each face.

That Duccio could make us realize space, depth, and distance we must have noticed already while looking at such scenes as the 'Marys at the Tomb' or the 'Betrayal', but it will not be out of place to add to these a couple of signal instances. First we turn to a bit of *genre* which Duccio has introduced into the midst of all this hieratic solemnity. Pl. 248 We see a group of men in the open air huddling about a fire, and bending over with hands outstretched to catch its glow. Peter in the midst is denying Christ, as the serving-maid passes by. While the perspective is far from perfect, we cannot ask for clearer localization than is here given; the inner court and chambers, the staircase running up the side of the house, the space where the men are sitting—all are perfectly detached from one another, and each has ample depth.

Yet another panel, in some ways Duccio's masterpiece—the 'Entry into Jerusalem'. We are in a garden, and as we look over the low wall to the high road, we behold Christ followed by His disciples mounting the paved way. Little boys bearing palm branches and sprigs of olive

march ahead, roguishly looking back, and meet the crowd streaming through the grand city gate. On the other side of the high road we see an orchard with people clambering up its high walls and climbing its trees. Beyond are the Temple and the towers of Jerusalem. Not only are we made to realize the space in which all this takes place, but—and this is extraordinary—we are compelled to take a fixed position as spectators of the scene, and thus are not only brought in intimate relation to it, but are obliged to become aware of, to attend to, the space as space.

It is clear, then, that Duccio could turn the pictographs, which for centuries pious souls had gone on deciphering, into Illustrations that extracted and presented all the significance that the sacred story owned, at least in the medieval mind. But was he equally successful in giving his visual conceptions an intrinsic value beyond their merit as Illustrations? Are, in Duccio's work, the Decorative elements, all that they must be in order that the skilfully transcribed visual image may be lifted into the realm of real art? This is the inquiry we must now pursue.

On first looking at his reredos, we were struck by the glamour of its subdued refulgence. Touching us as the gold of old mosaics touches us, to which time has added a tinge of bronze, Duccio's panels attune our mood for the enjoyment of whatsoever they may present. This is doubtless direct and intrinsic, and yet it has small value from an artistic standpoint; for the pleasure thus derived rises but little above that which the mere material itself would give. You would get as much and more from old goldsmith's work, from old stuffs, or from old embroideries. The sensation is still too undifferentiated to be of moment in those arts which, like painting, depend but slightly upon materials in themselves pleasurable. But, as we looked closer at Duccio's pictures, we noticed certain qualities essential to good Illustration, which, as we shall now see, have great Decorative value also. How admirably Duccio makes us realize space we have observed but now, and we can here forgo returning to the subject. That it is a quality, however, too specifically artistic to be required by mere Illustration, the work of most illustrators of our century, whether popular or profound, could prove.

In yet another respect we have already found Duccio eminent—in his grouping. We have dealt with it hitherto only in so far as it concerned clearness of rendering; but Duccio went farther, and so grouped as to produce effects of mass and line, pleasant to the eye in and by themselves, and pleasantly distributed within the space at his

Duccio's composition

command. In other words, he composed well. A few examples will make my meaning clear. In one or two panels, we have already noted the arrangement for its value as Illustration, we now shall see that it Pl. 249 has still greater merit. The 'Incredulity of Thomas' would be brought home to us as a mere historical episode nearly as well if the masses made by the figures were not so rhythmically divided, if a façade of just the right size and shape did not give the entire group the exact background it needed. The expression of Christ and His attitude would have been no different if He did not stand directly under the peak of a pediment, whose height magnifies His own stature, or were not seen against an arched door, which frames Him in, and separates Him from the bystanders, thus making Him more strikingly the centre of attention. Nor, as the mere telling of a tale, would much have been lost if the composition were comprised in a square, instead of being on a panel, that begins, half-way up its height, to slope inwards, thus emphasizing those lines of the sloping roof, which have, in their turn, given distinction to the figure of Christ. Even with all this, the sloping lines of the panel might have been continued until they met high above in a peak. But this would have had many unhappy results, among them one most unhappy. The centre of attention, the point at which all the lines tend to converge, would no longer have been the head of Christ, but a spot high above Him in the pediment. There would have been a conflict between the inclination of our eyes to rest on the spot marked out for them by the tendency of the dominant lines, and the desire of our hearts to dwell in rapt contemplation upon the point of highest spiritual interest, the face of Christ. This picture, then, does much besides telling its story: it is a Composition so subtle in its effects of mass and line that we shall scarcely find its like—at least outside the works of one other artist, that artist also a Central Italian, and holding the place among the Renaissance masters of that region which Duccio held among those of the Middle Ages—I refer of course to Raphael.

Let it not be believed that I have chosen the one and only instance in which Duccio is a great composer. There is scarcely a painting of his which does not betray a sense little less delicate, if at all, for mass and line and enclosure. Want of space, and the fear of vexing the reader with descriptions which, to be exact, should be couched in the jangling vocabulary of geometry, restrain me from giving many further examples. But let me refer to one with which we already are Pl. 247 familiar, the 'Betrayal of Judas'. What compactness and dignity are given to the mass in which we find Christ, by the two tufted trees that

surmount it! Without them, the group would look dwarfed and heavy. Note that the most important figure here, that of Christ, stands directly under one of these trees, which occupies the middle of the whole composition. See how this tree serves, not only to converge all the lines upon His head, but helps, by being in continuous upward movement with Him, to heighten His figure. And what a glamour of beauty is lent to the scene by the lances and torches of the soldiers—lines that are and are not parallel—an effect so easily attained, yet counting for so much, not only here, but in numerous compositions ranging through art, from the Pompeian 'Battle of Alexander' to the 'Lancers' of Velazquez!

If Duccio was so sublime in his conceptions, so deep in feeling, so skilful in transcribing them in adequate forms; if, in addition to all these merits as an Illustrator, he can win us with the material splendour of his surfaces; if he composes as few but Raphael, and can even make us realize space, why have we heard of him so seldom? Why is he not as renowned as Giotto? Why is he not ranked with the greatest painters? Giotto was but little younger, and there could have been a scarcely perceptible difference between the public of the one and the public of the other. Most of Giotto's paintings now existing were, in fact, executed rather earlier than Duccio's reredos. Is the illustrative part of Giotto's work greater? On the whole, it certainly is not; at times it is decidedly inferior, seldom having Duccio's manifold expressiveness and delicately shaded feeling. If Giotto, then, was no greater an Illustrator than Duccio, and if his illustrations, as illustrations, correspond no more than Duccio's to topics we crave nowadays to see interpreted in visual form, and if, as interpretation, they are equally remote from our own conception and feeling; if, in short, one is no more than the other a writer of pictorial leaders on the entrancing interests of the hour, why is the one still a living force, while the other has faded to the shadow of a name? There must exist surely a *viaticum* which bears its possessor to our own hearts, across the wastes of time—some secret that Giotto possessed and Duccio had never learned.

What is this mysterious life-conserving virtue—in what does it consist? The answer is brief—*in life itself*. If the artist can cunningly seize upon the spirit of life and imprison it in his paintings, his works, barring material accidents, will live for ever. If he contrives to give range to this spirit, to make it leap out, to mingle with and increase the life in our veins, then, for as long as we remain humanized beings, he will hold us in his thrall.

The essential
in painting
I have attempted elsewhere in this volume to explain what is this *viaticum*, this quality so essential to the figure arts that, for want of it, when scarcely born, they dwindle away; and to Book II, *Florentine Painters* (pp. 40–43), wherein the question is discussed, I must refer the reader. Here I shall limit myself to saying that, by means of their more subtle Decorative elements, the arts must be life-enhancing—not by their material charm alone, still less by their attractiveness as Illustrations. This particular life-communicating quality is in the figure arts to be attained by the rendering of form and movement. I prefer to the word 'form' to use the expression 'tactile values', for form in the figure arts gives us pleasure because it has extracted and presented to us the corporeal and structural significance of objects more quickly and more completely than we—unless, indeed, we also be great artists, or see as they see—could have grasped them by ourselves. This intimate realization of an object comes to us only when we unconsciously translate our retinal impressions of it into ideated sensations of touch, pressure, and grasp—hence the phrase 'tactile values'. Correct drawing, fine modelling, subtle light and shade, are not final goods. In themselves they have no value whatever, and it does not in the least explain the excellence of a picture to say it is well modelled, well lighted, and well drawn. We esteem these qualities because with them the artist succeeds in conveying tactile values and movement; but to suppose that we love pictures merely because they are well painted, is as if we said that we like a dinner because it is well cooked, whereas, in fact, we like it only because it *tastes* good. To speak of the drawing, the modelling, the chiaroscuro, as to speak of cookery in the instance of a dinner, is the business of the persons who paint and cook; but we whose privilege it is to enjoy what has been cooked or painted for us—we, I say, must either talk of it in terms of enjoyment and the psychology thereof, or—talk nonsense!

Tactile values
and move-
ment
Tactile values and movement, then, are the essential qualities in the figure arts, and no figure-painting is real—has a value of its own apart from the story it has to tell, the ideal it has to present—unless it conveys ideated sensations of touch and movement. If I may be pardoned a very childish parable, it is like someone who comes to us with a message. He tells us something we are very eager to know. No matter how we have been rejoiced by his news, no matter how attractive he seems, if he is merely a messenger, it is only of his message that we think. But let him be a man of character and a gentleman, let him be sympathetic, and his message will have been but the happy accident that has initiated a lifelong friendship. And so with a picture;

long after, years after we have exhausted its message, if it have tactile values and movement, we are more in love with it than ever, because these qualities, like the attractions in a friend, have the power of directly enhancing life.

And now to return to Duccio. His paintings do not possess these virtues, and therefore have been nearly forgotten, while Giotto's works contain them to a degree so remarkable that even today the real lover of art prefers them to all but a very few masterpieces. For Duccio, the human figure was in the first place important as a person in a drama, then as a member in a composition, and only at the last, if at all, as an object whereby to stimulate our ideated feelings of touch and movement. The result is that we admire him profoundly as a pictorial dramatist, as a Christian Sophocles, somewhat astray in the realm of painting; we enjoy his material splendour and his exquisite composition, but rarely if ever do we find him directly life-communicating.

A few instances will prove my point, and I choose them among subjects which not only lend themselves to specifically pictorial treatment, but even seem to suggest such treatment on Duccio's part. Let us turn again to the now familiar 'Incredulity of Thomas'. That it Pl. 249 appeals to our hearts and minds we were more than convinced when we studied it as Illustration; that it causes the optic muscles and the mental activities directly dependent on them to function delightfully, we found while admiring it as Composition; but there we stop. The figures have not even the effectiveness for evoking sensations of touch and movement that things bodily present possess, and yet art should be *more* evocative than actuality. Look at Thomas. As long as you regard him as a mere shape in a given attitude and with a given action, he probably corresponds to reality more than do your visual images, and you find him pleasant. But once look for something within this shape, and you will be surprised, for you will find, not, it is true, a complete lack of tactile values, but only just enough to make the figure pass as a familiar shape and no more. Thomas is draped in the very best way for enabling one to realize his corporeal and functional significance, but unfortunately—although he is perhaps the best modelled figure in Duccio's entire works—there is not enough under his robe even to persuade one of reality, not to speak of stimulating one's own internal activities; and as for the action, it is scarcely indicated at all. He certainly seems to move, yet the legs have not the slightest existence under the drapery, admirably arranged as it is to indicate the action of the limbs it ought to cover; and the feet, while sufficiently

resembling feet, have almost no weight and certainly do not press down on the ground. As a consequence we get none of those ideated sensations of movement and pressure in our own legs and feet—sensations which, when we feel them, not only convince us of the reality of the object that has stimulated them, but give us much of the pleasure of activity with none of its drawbacks and fatigues. If we look at the Christ in this same composition, we find that He does not stand at all; and it is almost as bad with another figure which, for mere shape and attitude, has all the qualities of the 'Sophocles' of the Lateran. In the panel which represents the 'Denial of Peter', we found the story told with the familiarity of *genre*, and even with a touch of humour; yet here again, except for their heads and hands, the figures seem manufactured of tissue-paper. None of the bodies suggests resistance to push, they have no weight, they do not settle or press down as they sit, although the artist reproduces well the mere shapes of people in the attitude of sitting and stretching to warm themselves. In the 'Washing of the Feet' we see one of the younger disciples half kneeling, half sitting, with his arms stretched down to take off his sandals. Here, again, the shape and attitude are well reproduced, and they happen to be such as a great artist would have chosen for the splendid opportunity they afford to render tactile values and movement. But alas! tissue-paper clothes are all we get. Look at the 'Miraculous Draught'. Three of the disciples have to perfection the facial expression and the attitudes and gestures of people pulling up a heavy weight, but nothing could be flatter and emptier than the figure of just that disciple who is making the greatest effort. Even the net is scarcely given any weight, and the fish inside neither struggle nor sprawl—are not yet aware that they are in its meshes.

It is a thankless task demonstrating the failings of a great man, and one instance more shall suffice. Again it is a subject which affords unsurpassable opportunities for rendering tactile values and movement—the 'Deposition from the Cross'. A more pathetic, a more felt, a more dignified version of this theme does not exist, and Duccio has arranged it as if to go even farther. An elderly disciple, with his foot firmly planted on the ladder, and one arm hooked over the beam of the cross, supports with the other arm the body of Jesus as it falls forward lifeless into His Mother's embrace. Meanwhile, another disciple, kneeling, draws out the nails from Christ's feet while still they are fixed to the cross, and yet another disciple clasps the body about the waist to prevent its falling forward too far. As mere shape, Christ's body is a much finer nude than any Giotto ever painted;

Pl. 248

Pl. 246

The 'Deposition'

nor could the attitudes and gestures of limp helplessness be better expressed: yet nothing really happens. There are no tactile values; nothing has the weight wherewith to fall; the arms and hands do not really support—and all for a very good reason. The reason is that, even if Duccio felt tactile values and movement, here, at least, he was so preoccupied with the facial expression that he could not attend to them.

A question suggests itself at this point, which requires at least a brief answer. If, as results from all that we have just now been observing, Duccio either had no feeling for tactile values and movement, or was too busy elsewhere to attend to them, why has he chosen attitudes and actions which seem to suggest an absorbing interest in them? Surely, for mere Illustration, for mere Composition, for mere material charm—the qualities in which we have found him great— other arrangements of the figures would have done as well; and how does it happen that he has preferred precisely the arrangements which an artist would have chosen whose dominant interest lay in the presentation of directly life-communicating elements?

The answer is, I think, simple. Duccio did not choose them, but found them ready-made, probably the entire compositions, certainly the single figures; for it is, to me at least, inconceivable that a painter who had perhaps no feeling for tactile values and movement, and certainly no interest in rendering them, should have invented motives valuable chiefly as opportunities for modelling and action. Duccio, I repeat, must have found these motives ready and used them, not for what their inventors had valued in them, but for the mere shapes and attitudes as dramatic factors in Illustration.[1] To him, then, form and movement—the two most essential elements in the figure arts—had no real meaning of their own. He exploited them as a dilettante, but did not understand their real purpose; and herein again Duccio, the first of the great Central Italian Painters, was

[1] I am not writing a history of art, and I need not here enter into the question of Duccio's origin and education as an artist; but I owe a word to the curious reader. Duccio must have got his training from some Byzantine master, perhaps at Constantinople itself. Whoever and wherever this master was, he must have been imbued with the feelings of that extraordinary revival of antique art which began at Byzantium in the ninth and lasted on into the thirteenth century. Duccio, properly regarded, is the last of the great artists of antiquity, in contrast to Giotto, who was the first of the moderns. Duccio's motives, types, and attitudes are still the old art-alphabet of Hellas, made cursive and somewhat debased. His old men are the last descendants, in unbroken line, of the Alexandrian philosophers; his angels, of Victories and Genii; his devils, of Silenus. As Giotto compares with Giovanni Pisano, so does Duccio with Giovanni's father, Niccolo, only that Duccio was far more subtly antique.

singularly like the last of them; for Raphael also saw in tactile values and movement not the principal pursuit of the artist, but a mere aid to Illustration.

IV

Such, then, was Duccio. Had he been less, it might have been better for the art of Central Italy; for then either a painter of perchance more talent would have had room to expand freely, or else the example of Giotto would have been more attractive. Duccio, however, not only trained his followers to conceptions and methods necessarily his own, but by furnishing to an emotional people like the Sienese an art that appealed to the feelings, he compelled the painters who came after him to deal in that perniciously popular article, expressive Illustration.

Simone Martini

It is quite conceivable that if Simone Martini had had for master a painter less powerful than Duccio, the example of Giovanni Pisano—excepting perhaps Donatello, the most determining influence in all Italian art—and the example of Giotto as well, with both whose works he certainly was acquainted, would have roused him to a sense of the real issues in the creation of a work of art. In him we might have had another painter with Giotto's feeling for both tactile values and for the materially significant, but with different ideals to reveal and a different message to convey.

But Simone had behind him an art, as Illustration so perfectly satisfying both to himself and to his townsmen, as Decoration so adequate, far though it was from perfect, that it would have taken overwhelming genius—if, even then, the conditions of a medieval town had permitted it—to transcend them and start afresh. There was no departing from Duccio's moulds, in so far as they existed, and individual temperament could manifest itself only by chiselling on the casts that had come out of them.

That Simone felt hampered by Duccio's precedent we see clearly in works which show him in close rivalry with his master, and it is therefore not in the more dramatic and passionate Gospel themes—themes in which Duccio excelled—that we shall discover Simone's peculiar greatness. In this field Duccio had carried expression to its utmost limits. To retrench on this domain would have been most unacceptable, and the only alternative, for one who would not copy, was to leap over the widest limits of artistic expression into the outer waste of mere Illustration. In his scenes from the Passion, Simone, so much above Duccio even there in tactile values, in movement, in

charm, falls far below him in dramatic rendering, sacrificing the restraint and severity needed for conveying the real significance of the world-tragedy to the obvious portrayal of facile emotion.

Even when he is freed from Duccio's example, it is not as an artist with a feeling for the solemnity of actions which have almost a sacramental import that Simone reveals himself. The charm, the beauty, even the pride of life attracted him more. For him also painting was not in the first place an occasion for presenting tactile values and movement, but equally little was it an opportunity for communicating his sense of moral and spiritual significance. Simone subordinates everything—and he was great enough to have much to subordinate—to his feeling for magnificence, beauty, and grace.

In the Council Hall of Siena we see him in all his splendour. On one side, radiant in beauty, the Queen of Heaven sits in the midst of the noblest of the Saints, the loveliest of the Virgins, and the sweetest of the Angels. They hold a more than regal canopy over her head, they kneel in worship at her feet, they offer flowers. It is a vision as gorgeous and as elaborate as the façade of Orvieto Cathedral, but here all is melted into a glow of feeling for beauty of feature, charm of pose, and loveliness of colour. On the opposite wall you see medieval pride of life incarnate. It is Guidoriccio da Fogliano riding through the land. Horse and rider are emblazoned with the proud heraldry of a long lineage. How completely Guidoriccio possesses his steed, how firmly he holds his commander's staff, with what a level look he fronts the world!

Then what extraordinary grace of motion and beauty of line in Simone's miracles of the Blessed Agostino Novello! What charm of feeling in that exquisite fresco at Assisi wherein we behold the young St. Martin receiving his knighthood! The Emperor girds his sword about the fair youth, a knight fastens his spurs, while many gay squires look on and listen to the twanging and piping of the minstrels. One of the squires has a profile of the subtlest beauty, and profiles like it—nay, more subtle and mysterious still—are far from rare in Simone's paintings. In this small chapel at Assisi you see types of beauty so strange, so penetrating, that, far from suggesting our favourite classic or modern ideals, they waft our thoughts away to Japanese Geishas and Egyptian Queens.

To convey his feeling for beauty and grace and splendour, Simone possessed means more than sufficient. He was master of colour as few have been before him or after him. He had a feeling for line always remarkable, and once, at least, attaining to a degree of perfection not to be surpassed. He understood decorative effects as a great musician

Pl. 253

Pl. 254

Pls. 251-2

Pl. 255

understands his instruments. Where shall we see colour more symphonic than in the single figures among his Assisi frescoes? What has line accomplished that can outvie the miraculous contours of his 'Coronation of King Robert'? How subtle the beauty, how dainty the movements, how sweet the olive in the Uffizi 'Annunciation'! As you look at the angel's mantle it is as if you were seeing the young sunlight on driven snow. Simone is the most lovable of all the Italian artists before the Renaissance.

Pl. 256

Pl. 257

V

The native tendency of Sienese art toward mere Illustration, in Duccio was held in bond by a sense for the significant, and by a feeling for all the subtleties of composition. Simone was held back by his love of beauty and his delight in splendour of colour and flow of line. No such check was operative upon the brothers Lorenzetti. Singularly gifted, they display their gifts but listlessly. Beauty, which they felt with passion; form, which Giovanni Pisano and Giotto had so amply revealed to them, even the sense of human significance with which they were aglow, they sooner or later sacrificed, either to the mere representation of things, or to the vain endeavour to body forth dim, infinite meanings.

Ambrogio and Pietro Lorenzetti

What fascination they can give to figures possessed of the highest dignity and solemnity we see in Ambrogio's portable altar-piece at Siena, wherein the Madonna, hieratic, Egyptian, sits enthroned in the midst of virgins, glowing like flames, and ancient saints yearning towards her. Also in the Siena collection you shall see Ambrogio's 'Annunciation', where the Blessed Virgin is warm with welcome and gladness as she leans forward to receive the palm of martyrdom which Gabriel brings her with his message. At Assisi, in a fresco by Pietro, of such relief and such enamel as to seem contrived of ivory and gold rather than painted, the Madonna holds back heartbroken tears as she looks fixedly at her Child, who, Babe though He is, addresses her earnestly; but she remains unconsoled. Nowhere is beauty more penetrating than in Ambrogio's St. Catherine, or earnestness and intellect more convincing than in his Francis or Bernard. And where is there more magic than in that most precious panel of the Uffizi, in which Nicholas of Myra, standing by the rock-bound sea, fronts the setting sun?

Pl. 258

Pl. 259

Pl. 260

Pl. 262

Such artists Ambrogio and Pietro Lorenzetti could have been always had they not made the great refusal. But Pietro sank to the rubbish

of his Passion scenes at Assisi, where he carries Duccio's themes to the utmost pitch of frantic feeling. Form, movement, composition— even depth and significance—all have been sacrificed to the expression of the most obvious and easy emotion. A like anarchy has seldom again overtaken an Italian master, even of the Bolognese School. To find its parallel you must go to Spain and to certain Germans. As for Ambrogio, the more gifted of the brothers, his fall was scarcely less. At his worst he hardly surpasses the elder Breughel. He seems to have itched to reproduce whatsoever he saw. Having to paint frescoes symbolizing Good and Bad Government, he makes no attempt to Pl. 261 extract the essence of these conceptions and to clothe them in forms which must needs convey them to us. Giotto, in two or three figures, could make us not only grasp with our minds what good and bad government are, but realize them with our bodies. Ambrogio Lorenzetti could think of nothing but vast panoramas overshadowed by figures powerless to speak for themselves, and obliged to ply us with signs and scrolls. Scores and scores of episodes—some of them charming when taken alone—depict with remorseless detail what happens in town and country when they are well or ill governed. You look at one after another of these episodes, and you get much informa- tion about the way of living at Siena in the fourteenth century, and a certain sum of pleasure from the quaintness, and even the skill, with which it has all been done; but none of that life-enhancement which comes with the vivid apprehension of thoughts and feelings vaster and deeper than our own. And matters are not mended when even vaguer allegory is attempted. If the frescoes just described are little more than a painted charade, certain compositions of the Lorenzetti are no better than a rebus. And with this departure from artistic intention there went, as a matter of course, a decline in artistic value. First to disappear utterly was composition; then the never too strong feeling for tactile values and movement; finally, even the sense of beauty left them in disdain.

But in an age wherein Italy was almost as troubled and as wistful as Germany two centuries later, the works of the Lorenzetti, with their turbid outpourings of uncouth yearnings, had the kindling effect of those fly-leaf engravings that so powerfully stirred the later age—with which indeed their art had much in common. Finding fit substance, they once or twice fanned into flame talents actually surpassing their own.

A talent of this kind was that of the painter in the Campo Santo at Pisa, who has left, as the great trace of his activity, the famous Traini 'Triumph of Death', as mere Illustration by far the greatest Italian

Pl. 266 achievement of the Middle Ages. Endowed with more feeling for the essential problems in painting than the Lorenzetti, he yet follows them closely in moral and philosophical purpose. He has a sense of form, a command of movement, not common at any time; he has a plastic fancy, and a power of giving real feature and life to his dream, rarer still. His devils and goblins—herein so different from the rabble of such representations—are not feebly and ludicrously quaint, but alive and endowed with the hard-won beauty of the true grotesque. His Death would be terrifyingly recognizable even without the bat's wings and the scythe.

All these talents the unknown painter[1] of these frescoes sacrificed, as in our day Maupassant, Ibsen, and Tolstoi have done, to the presentation of glaring contrasts for the pure joy thereof, or to the teaching of maxims absorbingly new yesterday, tediously trite tomorrow. Apart from its artistic qualities, the 'Triumph of Death' is made up of two contrasts. Under shady trees, in a bower, a gay company of knights and ladies solace their hours with music and love. It would not be difficult to describe this scene in language most modern, but the reader who wishes to preserve its glamour, and who yet must have a text, should read the opening pages of Boccaccio's *Decameron*. Outside, the pest is raging and the crumbling lepers stretch their vain hands towards Death, who, heedless of their lamentation, swoops down upon the merry bower. Here is contrast enough. Surely there is no more in '*La Maison Tellier*'. But it did not seem sufficient to the artist, and he repeats the tale in even clearer language. The pride and joy of life, cavaliers and ladies, a cheerful hunting party, are breathing the morning air. Suddenly their horses start back, their dogs snarl, their own hands go to their noses. They have come upon rotting carcasses of kings and prelates. This time surely the contrast must be enough. But no! Our painter did not credit us with sufficient intelligence, and an officious hermit presents a text on a scroll. And then we become aware that the fresco is full of texts on scrolls. What an artist, and what must he have thought of his public!

VI

The later Sienese With the death of the Lorenzetti, the Sienese school of painting fell into a decline from which it never seriously rallied. It had moments of hopefulness and hours of hectic beauty, but never again did it receive that replenishment of force without which art is doomed to dwindle

[1] It now seems likely that he was Francesco Traini.

away. Barna, Bartolo di Fredi, and Taddeo di Bartolo at times catch a Pls. 265, 269
glow from the splendour of Simone Martini and the Lorenzetti; and
Domenico di Bartolo made an uncouth attempt to breathe new life Domenico
di Bartolo
into the school, to replenish it by introducing the shapes and attitudes Pl. 270
which the great Florentines had just saved out of chaos and for ever
fixed. But as he felt not at all the real significance of these new forms and
new gestures (as serving to render either tactile values or movement),
his fellows in craft and town had the taste to prefer, to the mock-
heroics of a misunderstood naturalism, the unsubstantial but lovely
shapes of their long-hallowed tradition. The ever winsome Sassetta Sassetta
lived and painted as if Florence were not forty but forty millions of
miles away, as if Masaccio and Donatello, Uccello and Castagno had
not yet deserted the limbo of unborn babes. And he has made us the
richer by many works of rich, decorative beauty, and by that scene of
visionary splendour, the Chantilly 'Marriage of the Seraphic St. Francis'. Pl. 271
But stealthily and mysteriously the new visual imagery, the new
feeling for beauty, found its way into Siena, though it had to filter
through those frowning walls. And the old feeling for line, for
splendid surface, for effects rudimentarily decorative, mingled with
the new ideals. Painters of this newness were Vecchietta, Francesco di Pls. 272-6
Giorgio and Benvenuto di Giovanni, and, finer than these, Matteo di
Giovanni and Neroccio de' Landi, the two greatest masters of Renais-
sance Siena. Matteo had a feeling for movement which would have Matteo di
Giovanni
led to real art if he had had the necessary knowledge of form; lacking
this, he became an inferior Crivelli, giving us effects of firm line cut
in gilt cordovan or in old brass. As for Neroccio—why, he was Neroccio
Simone come to life again. Simone's singing line, Simone's endlessly
refined feeling for beauty, Simone's charm and grace—you lose but
little of them in Neroccio's panels, and you get what to most of us Pls. 277-8
counts more, ideals and emotions more akin to our own, with quicker
suggestions of freshness and joy.

Then it was already the end of the fifteenth and the beginning of the
sixteenth century, and even the Sienese could no longer be satisfied
with the few painters who remained in their midst. Masters were
summoned from without, Signorelli, Pintoricchio, and Perugino from
Umbria, Fra Paolino from Florence, Sodoma from Lombardy; and as
there were no forces at home to offer sufficient resistance, there
resulted from all these mingled influences a most singular and charm-
ing eclecticism—saved from the pretentiousness and folly usually
controlling such movements by the sense for grace and beauty even
to the last seldom absent from the Sienese.

VII

The school of Siena fails to rank among the great schools of art
because its painters never devoted themselves with the needed zeal to
form and movement. They preferred to give body to their dream, to
record the visual images teeming in their minds. But little as the
specifically artistic elements, those which are neither Illustrative nor
rudimentarily Decorative, are prized at any time, the visual images
evoked by the faded ideals and vanished longings of a past epoch are
wanted still less. The very way of visualizing has so changed since the
full flood of the Renaissance set in, that to most of us the forms of the
fourteenth-century painters are little more than grotesque. We hail in
them no goal for our own groping efforts to body forth familiar
shapes. They remain, as far as we are concerned, in the realm of
curiosity, and never, by such stimulating of more rapid processes of
consciousness as Illustration of a nearer epoch gives, do they enhance
life. For so deeply inrooted is the gross fallacy that art is the mere
reproduction of an actual or ideal reality, that, unless we recognize
such a reality in a picture, most of us will look no farther.

This is not the place to discuss in detail the relation of visual images
to the objects they reflect—a question, however, which I trust may
some day be carefully studied by psychologists. Whatever be their
relation in a world where art does not exist, in civilized men this
relation is certainly much determined by the works of art surrounding
them. For nature is a chaos, indiscriminately clamouring for attention.
Even in its least chaotic state it has much more resemblance to a
freakish and whirlingly fantastical 'Temptation of St. Antony' by
Bosch, than to compositions by Duccio that I have already described,
or to others by Raphael that we shall look at later. To save us
from the contagious madness of this cosmic tarantella, instinct and
intelligence have provided us with stout insensibility and inexor-
able habits of inattention, thanks to which we stalk through the
universe tunnelled in and protected on every hand, bigger than the
ants and wiser than the bees. And such superior brute beasts we
should be, no more, no less, but for that Garden of Eden which is
Art, and Science, its serpent-haunted Tree. For art is a garden cut off
from chaos wherein there is provided, not only an accord like that of
the beasts between our physical needs and our environment, but a
perfect attuning of the universe to our entire state of consciousness.
In one point alone is the unknown author of the Book of Genesis in
the wrong. Too narrow in his devotion to art, as is the wont of critics,

*Character-
istics of the
Sienese*

*Change in
visual
imagery*

he regarded the Tree of Knowledge as an afterthought, whereas surely knowledge must have existed before there was a Garden; for the accumulating of facts and the reasoning about them (in no matter how unconscious a form) must precede every endeavour to harmonize them with the needs of the human spirit. Eden is really begotten of the Tree of Knowledge, whereof Art is but the flower. It is the Serpent, misunderstood and maligned by the narrow aestheticism of the writer of Genesis, who nurses the fruit which will, in its turn, produce other trees blossoming into other Edens; for the Serpent is the symbol of mental energy for ever at work.

But to speak plainly—the most difficult thing in the world is to see clearly and with one's own eyes, naïvely. What with the almost numberless shapes assumed by an object, which shapes only we see, but never a form perfectly expressing the object itself; what with our insensitiveness and inattention, things scarcely would have for us features and outlines so determined and clear that we could recall them at will, but for the stereotyped shapes art has lent them. So invincible a task is the business of learning to see for one's self, that all except the few men of genius—with a gift for seeing—have to be taught how to see. Only when a person is to become an artist is a systematic effort made to teach him. But note how it is done—or at least how, until the other day, it used to be done. He was set to copy simple drawings of his own master, or of other artists. Then the antique was put before him, and he had to copy that. By this time his habits of vision were well on the way to becoming fixed, and, unless he were endowed with unusual powers of reacting against teaching, he passed the rest of his life seeing in objects only those shapes and forms that the drawings and antiques put before him had pointed out to him. How difficult, in the result, it still is to see, may be gathered from the extensive use of the photographic camera among painters, even when copying the works of others!

As for the rest of us, who are not artists by profession, we get no systematic training at all in seeing forms, though we may be well able, owing to natural talent or education in science, to observe detail. The little we learn we pick up from illustrated periodicals and books, from statues, from pictures. And unless years devoted to the study of all schools of art have taught us also to see with our own eyes, we soon fall into the habit of moulding whatever we look at into the forms borrowed from the one art with which we are acquainted. There is our standard of artistic reality. Let anyone give us shapes and colours which we cannot instantly match in our paltry stock of hackneyed

forms and tints, and we shake our heads at his failure to reproduce things as we know they certainly are, or we accuse him of insincerity. When, some years ago, the impressionist *plein-air* painting arose, how still and small were the voices asking whether it was beautiful, how loud and indignant those which denied its truth!

This brings me back to my theme. If we are sufficiently displeased when the painter of today does not visualize objects exactly as we do, how remote must we find the art of people who visualized in a way perfectly distinct from our own! To how many of us, for this very reason, are Chinese and Japanese art not art at all! But no less remote to those who have not been trained to appreciate it is the art, or, to be more exact, that part of art which is all most people care for, the Illustration, of the Middle Ages. For, since then, our manner of visualizing forms has changed in a thousand ways.

What brought about this change? In the first place, the Serpent, that restless energy which never allows man to abide long in any Eden, the awakening of the scientific spirit. Then the fact that, by a blessed accident, much, if not most, of this awakened energy was at first turned not to science but to art. The result was Naturalism, which I have defined elsewhere as science using art as the object of its studies and as its vehicle of expression. Now science, devoting itself, as it earnestly did at the beginning of the fifteenth century, to the study of the shapes of things, did not take long to discover that objective reality was not on the side of the art then practised. And, thanks to the existence at that moment of a man not less endowed with force to react against tradition, than with power to see—a power, I believe, unparalleled before or since—thanks to this one man, Donatello, art in an instant wrenched itself free from its immediate past, threw to the winds its whole medieval stock of images, and turned with ardour and zeal to the reproduction of things as research was discovering them to be. There was scarcely a trace of an ideal remaining. Every man had a shape of his own; any man therefore was as good for reproducing as another. Why not? This chaos, or at best the Walt-Whitmanism, to which in the plastic arts mere Naturalism would have led, was prevented, and its force conducted into nourishing channels, by certain other tendencies and impulses then happily prevalent.

Donatello himself was much more than a Naturalist; he was eager with a desire to communicate movement, to express action. He tended, therefore, out of the countless shapes which presented themselves, to choose those that would best manifest the play of alert and agile forces. Carried to an extreme, this tendency would have ended

Donatello and
his influence

in an art more like that of Japan than of modern Europe. That we were not brought to this point is due chiefly to Masaccio, whose controlling instinct was for tactile values. His choice among shapes was of such only as could most readily be made to stimulate ideated sensations of touch—of figures, therefore, tall, broad-shouldered, reservoirs of force and resistance. Whatever danger there was in this of an art too monumental, was, in its turn, counteracted by Donatello's feeling for movement. The resulting canon of the human figure would have been no nearer to the Medieval, not much farther away from our own, than it now is, if it had remained the mere composite of Donatello and Masaccio. But at the last moment two other influences entered in to fix the canon and make it permanent even to our own day. Antiquity, the dream, the hope, the glamour of the cultivated classes in the fifteenth century, had left behind it a few scattered fragments of its own art. Crude copies though these were, many removes away from their originals, yet—being in the last resort creations of men with almost unrivalled feeling for tactile values, movement, and the relation of the two—they bore a conspicuous resemblance to the new art. And this likeness to antiquity, resulting, not from the imitation of the one by the other, but from kinship of purpose and similarity of material, won over the Humanists—the men of letters and all-powerful journalists of that time—to the art of their contemporaries. Not that they understood the real meaning of the new movement—how could people without a vast experience in the enjoyment of all schools of art do that? Imitation of antiquity was their only thought; they seemed to recognize such an imitation in the new art, and thereupon it received their full sanction. This, however, was not without evil consequences, for, later, as I hope to show elsewhere, the Humanists ended by forcing weaker spirits to some slight aping of Antiquity. Great has been their success in spreading the belief that Renaissance art throughout (not, as was the case, architecture alone, the other arts only here and there) was the product of Antiquity imitated.

Created by Donatello and Masaccio, and sanctioned by the Humanists, the new canon of the human figure, the new cast of features, expressing, because the figure arts, properly used, could not express anything else, power, manliness, and stateliness, presented to the ruling classes of that time the type of human being most likely to win the day in the combat of human forces. It needed no more than this to assure the triumph of the new over the old way of seeing and depicting. And as the ideals of effectiveness have not changed since the fifteenth century, the types presented by Renaissance art, despite the

The canon of the human figure

ephemeral veerings of mere fashion and sentiment, still embody our choice, and will continue to do so, at least as long as European civilization keeps the essentially Hellenic character it has had ever since the Renaissance.

The way of visualizing affected by the artists, the Humanists, and the ruling classes could not help becoming universal. Who had the power to break through this new standard of vision and, out of the chaos of things, to select shapes more definitely expressive of reality than those fixed by men of genius? No one had such power. People had perforce to see things in that way and in no other, to see only the shapes depicted, to love only the ideals presented. Nor was this all. Owing to those subtle and most irresistible of all forces, the unconscious habits of imitation, people soon ended either by actually resembling the new ideals, or at all events, earnestly endeavouring to be like them. The result has been that, after five centuries of constant imitation of a type first presented by Donatello and Masaccio, we have, as a race, come to be more like that type than we ever were before. For there is no more curious truth than the trite statement that nature imitates art. Art teaches us not only what to see but what to be.

VIII

The Tuscan
painters The art of Siena exhausted itself in presenting the ideals and feelings of the Middle Ages with an intensity and a beauty not surpassed even by their spiritual kindred, those sculptors of Northern France who, in our weaker moments, almost win us away from Greece. It remained for another school of Central Italy, the Umbrian, to carry on through the Renaissance purposes and aims nowise different in their essence from those of Siena, different as they may seem in actual result. For Umbrian art, as we shall see, is, as a whole, no more in earnest over tactile values and movement than Sienese art had been, and no less devoted to the task of illustrating the ideals and expressing the wistful desires of the time.

But before we turn to the Umbrians, our attention must first be given to a master and his two pupils, neither Sienese nor Umbrian, dwellers in Southern Tuscany and the Romagna, who as men of genius were greater than any of the Umbrians, as artists freer and more powerful, if not always so delightful—I mean Piero della Francesca, Luca Signorelli, and Melozzo da Forli.

Piero della
Francesca And first to Piero. The pupil of Domenico Veneziano in characterization, of Paolo Uccello in perspective, himself an eager student of

this science, as an artist he was more gifted than either of his teachers. He is hardly inferior to Giotto and Masaccio in feeling for tactile values; in communicating values of force, he is the rival of Donatello; he was perhaps the first to use effects of light for their direct tonic or subduing and soothing qualities; and, finally, judged as an Illustrator, it may be questioned whether another painter has ever presented a world more complete and convincing, has ever had an ideal more majestic, or ever endowed things with more heroic significance.

Pls. 279–82

Unfortunately he did not always avail himself of his highest gifts. At times you feel him to be clogged by his science, although never, like Uccello, does he suggest the surveyor and topographer rather than the painter. Now and again those who are on the outlook for their favourite type of beauty, will receive shocks from certain of Piero's men and women. Others still may find him too impersonal, too impassive.

Impersonality—that is the quality whereby he holds us spellbound, that is his most distinguishing virtue—one which he shares with only two other artists: the one nameless, who carved the pediments of the Parthenon, and the other Velazquez, who painted without ever betraying an emotion.

Impersonal art

'The impersonality of art'—a phrase not familiar enough to pass without comment. I mean two different things, one a method, the other a quality. As a method, impersonality has been understood by all the great artists and the few competent critics who have ever existed. They have appreciated the fact that in art, as in life, those few among us who have not reduced the whole of the phenomenal universe (or at least all of it that ever concerns us) to a series of mere symbols, those of us whom physical and mental habits have not so crushingly enslaved but that we retain some freedom of perception— they have understood that such people will react to every different object in a different way, no matter how slight the difference. If a given situation in life, a certain aspect of landscape, produces an impression upon the artist, what must he do to make us feel it as he felt it? There is one thing he must not do, and that is to reproduce his own feeling about it. That may or may not be interesting, may or may not be artistic: but one thing it certainly cannot do—it cannot produce upon us the effect of the original situation in life or the original aspect of the landscape; for the feeling is not the original phenomenon itself, but the phenomenon, to say the least, as refracted by the personality of the artist. And this personal feeling being another thing, must needs produce another effect. The artist will therefore carefully avoid

reproducing his own feeling. He will leave himself out of count, and, reducing the original phenomenon to its essential significant facts and forces, will reproduce these, and thus really make us, in our turn, react to them as he has reacted, and feel as he has felt.

That Piero della Francesca was impersonal in this sense will be readily granted; for was he not a great artist? He was, however, impersonal not in his method only, as all great artists have to be, but he was what would be commonly called impassive, that is to say, unemotional, in his conceptions as well. He loved impersonality, the absence of expressed emotion, as a quality in things. Having, for artistic reasons, chosen types the most manly, and, for perhaps similar reasons, a landscape which happens to be of the greatest severity and dignity, he combined and recombined them as each subject required, allowing the grand figures, the grand action, and the severe landscape, these, and these alone, to exercise upon us, as they must when all special emotion is disregarded, their utmost power. He never asks what his actors feel. Their emotions are no concern of his. Yet no
'Flagellation' is more impressive than one of his, although you will not find on the face of any of the dramatis personae an expression responsive to the situation; and, as if to make the scene all the more severely impersonal, Piero has introduced into this marvellous picture three majestic forms who stand in the foreground as unconcerned as the everlasting rocks. And so, in his fresco of the 'Resurrection', Piero has not even thought of asking himself what type of person Christ was. He chose one of the manliest and most robust, and in the grey watered light of the morning, by the spreading cypresses and plane trees, you see this figure rising out of the tomb. You feel the solemnity, the importance of the moment, as in perhaps no other version of this subject; and, if you are a person sensitive to art, you will have felt all this before you have thought of asking whether Christ looks appropriately Christ-like, or whether there is a fit expression on His face.

The spell of an art as impersonal, as unemotional as Piero's (or that of Velazquez) is undeniably great, but why is it—in what does its charm, its potent attractiveness consist? It is, I think, a compound of many things. In the first place, where there is no specialized expression of feeling—so attractive to our weak flesh—we are left the more open to receive the purely artistic impressions of tactile values, movement, and chiaroscuro. So unnecessary do I find facial expression, and indeed, at times so disturbing, that if a great statue happens to be without a head, I seldom miss it; for the forms and the action, if both be adequate, are expressive enough to enable me to complete the

Pl. 280

Pl. 282

figure in the sense that they indicate; while there is always a chance that the head, in works of even the best masters, will be over-expressive—in a direction either not necessitated by the forms and action, or in flat contradiction to them.

But there is another reason, less artistic and more general, to account for the effect of impassiveness in art. Ardently as we love those beings who react to things by the measure and in the quality that we ourselves react to them, so, in other moods, in moments of spent sensibility, we no less eagerly love those other beings or objects which, though we endow them with a splendid and kindred personality, yet do not react at all to things that almost overpower us. Taking it for granted that they are no less sensitive than we are, and seeing that they are not moved at all where perhaps we should be overwhelmed, we ascribe to them the calm and majesty of heroes; and as we more than half become the things we admire, we also, for a moment too brief, are heroes. This sentiment, when exaggeration does not make it Byronic, becomes an attitude toward landscape like Wordsworth's, an attitude toward man like Piero della Francesca's. The artist, depicting man disdainful of the storm and stress of life, is no less reconciling and healing than the poet who, while endowing Nature with Humanity, rejoices in its measureless superiority to human passions and human sorrows.

IX

Piero was followed by two pupils, Melozzo and Signorelli, each of whom, starting with the heritage Piero left them, and following the promptings of his own temperament, and the guidance of his own genius, touched excellence in his own splendid way. Melozzo was the grander temperament, Signorelli the subtler and deeper mind.

Melozzo took the heroic creations of his master—hearts which an emotion had never visited. He assimilated as much as he thought necessary of Piero's science, the science for which Piero had fought so hard that his paintings too often retain more trace of the battleground than are pleasant. These majestic types, and the wonderful knowledge of movement needed to articulate them, Melozzo expended upon a purpose at the farthest remove from Piero's. For Melozzo, the figure was never impassive, never an end in itself, but always a means for embodying emotion. And these emotions are so overpowering, his grandly robust forms are so possessed by them, that personality and even mere awareness are swept clean away, the figures becoming pure incarnations of the one great feeling by which they are animated. Of

Melozzo da Forlì

these feelings the figures would be the concrete symbols, could we ourselves but stand off and regard them at the distance of the intellect. But they carry us away and we also become possessed. You might as well remain indifferent to Calvé where in *Carmen* she is most the sorceress. As abandoned to the one feeling, as unconscious of others, or even of self, as impersonal, are the music-making angels in Melozzo's sacred fragments at St. Peter's. Nor is it Dionysiac rapture only that the master could portray. Nowhere perhaps as in his re-nowned 'Apothecary's Apprentice Pounding Herbs' does painting show such embodiment of the joy in mere living, the play of muscles, and the use of limbs: and his Prophets (in a sacristy of the Holy House at Loreto) have a solemnity and magical aloofness such as can be found only in Aeschylus and Keats when they speak of fallen dynasties of gods.

Pl. 284

Luca Signorelli does not glow with Melozzo's consuming fire; and yet he takes his rank beyond. His was the finer and deeper mind, his genius fetched the larger compass, his perception of value, both in life and in art, was subtler and more just. Even in feeling for the poetry in things, Luca was inferior to no man. Then—to be more specific—to a sense for tactile values scarcely less than Giotto's, Luca added Masaccio's or Piero della Francesca's command over action. In this, indeed, he almost rivalled his own teacher in that art and its un-paralleled master, Antonio Pollaiuolo. Great artist he would have been with these qualities alone, but for him they were means to an end, and that end, different from Melozzo's, was his joy in the Nude.

Signorelli

Pls. 285–9

What the Nude is and whence its super-eminence in the figure arts, I have discussed elsewhere.[1] I must limit myself here to the statement that the nude human figure is the only object which in perfection conveys to us values of touch and particularly of movement. Hence the painting of the Nude is the supreme endeavour of the very greatest artists; and, when successfully treated, the most life-communicating and life-enhancing theme in existence. The first modern master to appreciate this truth in its utmost range, and to act upon it, was Michelangelo, but in Signorelli he had not only a precursor but almost a rival. Luca, indeed, falls behind only in his dimmer perception of the import of the Nude and in his mastery over it. For his entire treat-ment is drier, his feeling for texture and tissue of surface much weaker, and the female form revealed itself to him but reluctantly. Signorelli's Nude, therefore, does not attain to the soaring beauty of Michelangelo's; but it has virtues of its own—a certain gigantic robustness and suggestions of primeval energy.

[1] Bk. II, The Florentine Painters.

The reason why, perhaps, he failed somewhat in his appreciation of the Nude may be, not that 'the time was not ripe for him', as is often said, but rather that he was a Central Italian—which is almost as much as to say an Illustrator. Preoccupied with the purpose of conveying ideas and feelings by means of his own visual images, he could not devote his complete genius to the more essential problems of art. Michelangelo also was an Illustrator—alas!—but he, at least, where he could not perfectly weld Art and Illustration, sacrificed Illustration to Art.

But a truce to his faults! What though his nudes are not perfect; what though—as in candour must be said—his colour is not always, as it should be, a glamour upon things, and his composition is at times crowded and confused? Luca Signorelli none the less remains one of the grandest—mark you, I do not say pleasantest—Illustrators of modern times. His vision of the world may seem austere, but it already is ours. His sense of form is our sense of form; his images are our images. Hence he was the first to illustrate our own house of life. Compare his designs for Dante (frescoed under his Heaven and Hell at Orvieto) with even Botticelli's, and you will see to what an extent the great Florentine artist still visualizes as an alien from out of the Middle Ages, while Signorelli estranges us, if indeed at all, not by his quaintness but by his grand austerity. Pl. 286

It is as a great Illustrator first, and then as a great artist that we must appreciate Signorelli. And now let us look at a few of his works— works which reveal his mastery over the nude and action, his depth and refinement of emotion, the splendour of his conceptions. How we are made to feel the murky bewilderment of the risen dead, the glad, sweet joy of the blessed, the forces overwhelming the damned! It would not have been possible to communicate such feelings but for the Nude, which possesses to the highest degree the power to make us feel, all over our own bodies, its own state. In these frescoes at Orvieto how complete a match for the 'Dies Irae' are the skies with their overshadowing trains of horror, and the trumpet blasts of the angels! What high solemnity in his Volterra 'Annunciation'—the flaming sunset sky, the sacred shyness of the Virgin, the awful look of Gabriel! At Cortona, in an 'Entombment', you see Christ upheld by a great angel who has just alighted from a blessed sphere, its majesty still on his face, its dew on his wings. Look at Signorelli's music-making angels in a cupola at Loreto. Almost they are French Gothic in their witchery, and they listen to their own playing as if to charm out the most secret spirit of their instruments. And you can see what a Signorelli as illustrator Pl. 285

sense Signorelli had for refined beauty, if, when sated with Guido's 'Aurora', you will rest your eyes on a Madonna by him in the same pavilion of the Rospigliosi Palace.

The Nude for its own sake, for its distinctly tonic value, was used by Signorelli in one of the few most fascinating works of art in our Pl. 288 heritage—I mean his 'Pan' at Berlin. The goat-footed Pan, with the majestic pathos of nature in his aspect, sits in the hushed solemnity of the sunset, the tender crescent moon crowning his locks. Primevally grand nude figures stand about him, while young Olympus is piping, and another youth lies at his feet playing on a reed. They are holding solemn discourse, and their theme is 'The Poetry of Earth is never Dead'. The sunset has begotten them upon the dew of the earth, and they are whispering the secrets of the Great Mother.

And now, just a glance at one or two of Luca's triumphs in movement. They are to be found chiefly in his *predelle*, executed in his hoary old age, where, with a freedom of touch at times suggesting Daumier, he gives masses in movement, conjoined, and rippling like chain mail. Perhaps the very best are certain bronzed *predelle* at Umbertide, a village situate upon the Tiber's bank; but more at hand is one in the Pl. 289 Uffizi, painted in earlier years, an 'Annunciation', wherein the Angel runs so swiftly that he drinks the air before him.

<div align="center">X</div>

Among the other Central Italians Piero della Francesca, Melozzo, and Signorelli stand out as conspicuous exceptions, being artists unusually endowed with a feeling for tactile values and movement, and all that by these means may accrue as advantage to art. We shall find no such men among the masters of the third school of Central Italian painting —the Umbrian.

The Umbrian School Umbrian painting, when first we meet it, is but a provincial offshoot of Sienese art, the strides of which it followed with timid short Pl. 290 steps. Left to itself, it produced such a marsh growth as Ottaviano Nelli's frescoes at Foligno, works of such senile imbecility that Siena, in her most palsied moments, cannot show their equal. Yet Umbria, although succeeding to the aspirations, ideals, and methods of Siena, was not, like that proud city, closed to foreign influences; and contact, direct or indirect, with Florence gave the Umbrian school not only the wherewithal to pursue its career to a glorious climax, but to do for the Renaissance and subsequent times what Siena had done for the Middle Ages to pick out from the chaos of things and to fix those images and

visions which in actual life would bring gladness and peace, to charge with fresh meanings great themes grown too familiar, to set fresh goals for tireless aspirations, to enshrine in new-made forms a new-felt loveliness.

And to this task, perhaps more priest-like than pictorial, the school of Umbria remained severely faithful. Never once was it won over to art for art's own sake. It remained *dilettante*, with no feeling for form, caring little for movement, using them ready-made, not for their own tonic virtues, but as means to the Illustrator's end.

Umbrian art reveals itself clearly, if not completely, in its first great master, Gentile da Fabriano. To a feeling for beauty, and a sense for colour nurtured on Sienese models, to a power of construction fostered by contact with Florentine art, Gentile added a glowing vivacity of fancy, and, thus prepared, he devoted his life to recording the Medieval ideal of terrestrial happiness, clear, complete at last (as is the wont of ideals) when the actuality, of which it was the enchanting refraction, was just about to fade into the past. Fair knights and lovely ladies, spurs of gold, jewelled brocade, crimson damasks, gorgeous trains on regal steeds ride under golden skies wherein bright suns flatter charmed mountain tops. All the faces are aglow with blitheness. Why are they so happy? Have they waked from nightmare hauntings of Purgatory and Hell? So it would seem, and they rejoice in the blood tickling their veins, in the cool breezes, in the smell of flowers. And what a love of flowers! Gentile fills with them even the nooks and crannies of the woodwork enframing his gorgeous 'Epiphany'.

But in Umbria such was the dearth of talent that among his country-men Gentile found no one to succeed him. (What rich fabrics could be constructed with his ore we may behold in the fascinating achieve-ments of his North Italian pupils, Vittore Pisano and Jacopo Bellini.) The child's prattle of Boccatis, winning at times, but ever crude, is all that languishing Umbrian art can show for a generation after Gentile's death. And it is quite conceivable that painting in Umbria would have dribbled on in a failing, sickly stream, but for the providential aid suddenly sent from Florence. Not her greatest son did she speed thither, nor even one among her greatest. Benozzo Gozzoli came—like many a Roman proconsul, second- or third-rate at home, yet a reful-gent source of light and life in the distant British or Dacian province. And Benozzo not only woke to activity whatever latent talent there was in Umbria, not only furnished this talent with models to form itself upon, but, best of all, taught the Umbrians to look to Florence for instruction and enlightenment.

Gentile da Fabriano

Pls. 291–2

Boccatis Pl. 296

Lorenzo da
Viterbo
By far the most gifted of these native talents stung to consciousness
by Benozzo was Lorenzo of Viterbo, who perished in his prime,
leaving great paintings to his little town. There you may see a chapel
frescoed by him—exuberant, full of splendid failure, more splendid
promise, and great achievement withal. Seldom shall you witness a
Pl. 297
more spacious ceremony than his 'Marriage of the Virgin', festive
yet stately, filled with majestic men, staid matrons, and proud, life-
enjoying youth—these, fitter suitors of Penelope than of the Galilean
maiden.

Niccolò da
Foligno
Very different indeed was Niccolò da Foligno, in some respects the
founder of the school in the narrower sense known as Umbrian—really
the school of Perugia and its vale—and certainly the first painter in
whom the emotional, now passionate and violent, now mystic and
ecstatic, temperament of St. Francis's countrymen was fully revealed.
Pl. 298
Regarded merely as an Illustrator, Niccolò ranks high. With a sincerity
convincing beyond question, he expresses the frantic grief of the
believer who has dwelt upon Christ's passion until he himself almost
feels the stigmata, brooded over Mary's sorrow until he also is pierced
with the seven wounds of her anguish. Niccolò feels penetratingly,
expresses his wailful yearnings unhushed, and makes no compromises.
The result is that, with the precisely identical purpose of the later
Bolognese, he holds our attention, even gives us a certain pungent
dolorous pleasure, while we turn away from Guido Reni with disgust
unspeakable. These later painters coquette in most unseemly fashion
with the flesh and the devil, even while they crucify Christ, or torture
a virgin martyr. Niccolò is single-minded. You may dislike him as you
dislike Calderon, but his power is undeniable, and he also was an
artist—for Niccolò was not devoid of feeling for line and colour, nor
unstudied in the art of rendering movement.

XI

And at last we are at Perugia, the Umbrian capital, the town destined
to shelter that school of painting which, of all, is at once the most
pleasing and the most famous, the school which culminated in
Raphael, the most beloved name in art.
The School
of Perugia
But despite its grand destiny, Perugia was not peculiarly gifted with
artistic genius, or it would not have called on Boccatis of Camerino,
on Fra Angelico, on Domenico Veneziano, on Benozzo Gozzoli, on
Piero della Francesca, and Luca Signorelli, to supply the pictures it
needed. Nor could much have been augured from Perugia's first

native painter of note. As an artist Bonfigli scarcely ranks as high as Bonfigli
Niccolò da Foligno, his fellow-pupil under Benozzo Gozzoli. He was
a much more dependent person, but being more imitative, with the
models of Fra Angelico or Benozzo before him, he at times painted
exquisite things, and by nature he was gifted with that sense of the
charming wherewith Perugia was later to take the world captive.
Some of the freshest and loveliest of all angel faces may be seen in
Bonfigli's altar-pieces and standards. His colour has almost always Pl. 299
that hint of gold which never fades from Umbrian art. But far was it
from him to harbour a feeling, no matter how faint, for what in
painting is more essential than charming faces and pretty colour; and
no degenerate Sienese ever was more garrulous and incompetent than
Bonfigli when he attempted historical composition. Such a task
was not to be performed by Perugians before further contact with
Florence had given them as much acquaintance at least with form and
movement as was just necessary.

Fiorenzo di Lorenzo was thrice dipped in the vivifying stream of Fiorenzo di Lorenzo
Florentine art. At the dawn of his career, Benozzo had been his
inspiration; while yet a youth, he put himself to school at Florence
under Antonio Pollaiuolo, the great artist in movement; and before
returning to his provincial home, he learned many a secret from Luca
Signorelli. Fresh from these stimulating influences Fiorenzo created
works not less naïve as illustration than those of his fellow artists who
had not moved from Perugia, yet greatly superior in drawing and
modelling, like the Nativity now in the gallery of that town. But Pl. 300
the inexorable dullness of provincialism soon began to settle down
on him, and before the end he sank to caricaturing his splendid
beginnings.

He naturally could not hold his own with Perugino and Pin-
toricchio, two other painters associated with his native town, painters
whose triumphs were so great that to this day their names are among
the most familiar in art. At first there scarcely could have existed
that disparity between their talents which became so manifest later.
Starting nearly on a level, Perugino for many years was ever to renew
his strength by Antaean contact with Florence; Pintoricchio never had Pintoricchio
such purification from provincial dry-rot, and the leaden cope of
humdrum custom once settled upon him, the invigorating air of the
outer world never touched him more.

But Pintoricchio's natural endowments were great, and his earliest
works are among the most faithful representations of refined splendour
and elegance of living which prevailed with the great gentlemen and

humanists of his time. Gentle feeling, lovely women and children, romantic landscape, clear arrangement, splendid portraiture, do their best to absorb and please us. As more serious tasks have been carefully avoided, there is nothing to suggest a higher plane of artistic activity. We lazily enjoy these frescoes as so much refined genre. And we shall find the same characteristics in most of his earlier works—all those in Rome which he executed with his own hand and without too much hurry. What lovely faces those of the angels in the Aracoeli! What pretty women in the Borgia Apartments, or in S. Maria del Popolo! What splendid portraits, what romantic landscape everywhere! And, in addition to all this, how much of that peculiarly Central Italian feeling for arrangement and space which already we found so noteworthy in the early Sienese—a feeling which we shall find more remarkable by far in the Perugians. We shall look in vain among earlier painters or other schools for a scene more spacious within its limits, where the figures are better placed, the architecture more nobly suggestive, where the landscape brings indoors more of its hypaethral fragrance, than in Pintoricchio's lunette at S. Maria del Popolo representing St. Jerome preaching. Vainer still would be a search for the setting of a ceremony more ample and gracious than the Aracoeli
Pl. 301 'Funeral of St. Bernardino'—a city square more noble, where one would breathe more freely.

But if mere prettiness pleased so well, why then, the more pretty faces, the more splendid costumes, and romantic surroundings per square foot, the better! And so Pintoricchio, never possessing much feeling for form or movement, now, under the pressure of favour and popularity, forgot their very existence, and tended to make of his work an *olla podrida* rich and savoury, but more welcome to provincial palates than to the few *gourmets*. And when such an opulent and luxurious half-barbarian as Pope Alexander VI was his employer, then no spice nor condiment nor seasoning was spared, and a more gorgeously barbaric blaze of embossed gold and priceless ultramarine than in the Borgia Apartments you shall not soon see again!

As a painter, we could now leave Pintoricchio to the contempt he deserves. His later work, seriously considered, is all tinsel and costume-painting, a reversion to the worst Umbrian art of the beginning of the century—and, writing this, I do not forget the famous frescoes in the Libreria del Duomo at Siena. These frescoes, recounting the life and adventures of the great journalist and diplomat, afterwards Pope
Pl. 302 Pius II, bring me to the one further point I wish to make. As figure-painting, they scarcely could be worse. Not a creature stands on his

feet, not a body exists; even the beauty of his women's faces has, through carelessness and thoughtless, constant repetition, become soured; as colour, these frescoes could hardly be gaudier or cheaper. And yet they have an undeniable charm. Bad as they are in every other way, they are almost perfect as architectonic decoration. Pintoricchio had been given an oblong room of no extraordinary dimensions; but what did he not make of it! Under a ceiling daintily enamelled with cunningly set-in panels of painting, grand arches open spaciously on romantic landscapes. You have a feeling of being under shelter, surrounded by all the splendour that wealth and art can contrive, yet in the open air—and that open air not boundless, raw, but measured off, its immensity made manifest by the arches which frame it, made commensurate with your own inborn feeling for roominess, but improved upon, extended, and harmonized, until you feel that there at last you can breathe so that mere breathing shall be music. Now it happens that certain processions, certain ceremonies, rather motley, not over-impressive, are going on in this enchanted out-of-doors. But you are so attuned that either you notice nothing unpleasant at all, or you take it as you would a passing band of music on a spring morning when your own pulses were dancing.

The last word, then, about Pintoricchio is that he was a great space-composer, even here not the equal of Perugino, and not to be admitted to the inner sanctuary where Raphael reigns supreme, yet great enough to retain in his worst daubs so much of this rare, tonic quality that, if you are not over-subtle in the analysis of your enjoyment, you will be ready to swear that these daubs are not daubs but most precious pictures.

XII

And if space-composition could do so much for Pintoricchio, how much more could it accomplish for Perugino or Raphael, who possessed far greater dominion over it! In them it was all clear gain, for, slight though their mastery over the most essential qualities in the figure arts, they took good care not to advertise their failings, and seldom do they offend by attempts too ambitious for their powers. Yet, apart from their greatness, particularly Raphael's, as Illustrators, their only conspicuous merit as artists was in space-composition, in which art Perugino surpassed all who ever came before him, and indeed all who came after him, excepting, however, his own pupil, Raphael, by whom even he was left far behind.

Space-composition

But what is this unheard-of art of space-composition? To begin with, it is not at all a synonym for 'composition' as ordinarily used, a word by which, I take it, we mean such an arrangement of objects within a given area as will satisfy our feelings for symmetry, harmony, compactness, and clearness. But all this arrangement is with reference to a flat surface, and extensions up and down, to right and left of an ideal centre—not inwards—and we already have met with a perfect example of this art in Duccio's 'Incredulity of Thomas'. Now space-composition differs from ordinary composition in the first place most obviously in that it is not an arrangement to be judged as extending only laterally, or up and down on a flat surface, but as extending inwards in depth as well. It is composition in three dimensions, and not in two, in the cube, not merely on the surface. And, though less obviously, space-composition differs even more widely from ordinary composition in its effect. The latter, reduced to its elements, plays only on our feeling for pattern—itself a compound of direct optical sensations and their mental consequences, of faint impressions of balance, and fainter ideated movements. Space-composition is much more potent. Producing as it does immediate effects—how and why cannot here be discussed—on the vaso-motor system, with every change of space we suffer on the instant a change in our circulation and our breathing—a change which we become aware of as a feeling of heightened or lowered vitality. The direct effect, then, of space-composition is not only almost as powerful as that of music, but is brought about in much the same way; for, although many other factors enter in to produce the impression made by music, the body of its force grows out of the revolutions it produces in the vaso-motor system. Hence the likeness so often felt, but, to my knowledge at least, never explained, between music and architecture,—the latter, in so far as it is not merely superior carpentry, being essentially a manifestation, the most specific and the most powerful, of the art of space-composition.

With this last statement many will agree who then will wonder how in painting space-composition can have a place, unless, indeed, it reproduces architecture. But a painting that represents architecture is intrinsically no more of a space-composition than any other picture. This art comes into existence only when we get a sense of space not as a void, as something merely negative, such as we customarily have, but, on the contrary, as something very positive and definite, able to confirm our consciousness of being, to heighten our feeling of vitality. Space-composition is the art which humanizes the void, making of it an enclosed Eden, a domed mansion wherein our higher

selves find at last an abode, not only as comforting, as measured to our everyday needs, as the homes of the happier among us, but as transporting, as exalting as are those things only which build up the ideal life. Near as it is to music in the form of great architecture, space-composition is even more musical in painting; for here there is less of the tyranny of mere masses of material, and their inexorable suggestions of weight and support; here there is more freedom, less is determined for one, though nothing is left to wayward fancy; and here, with this seeming greater freedom, many more instruments are playing to woo us away from our tight, painfully limited selves, and to dissolve us into the space presented, until at last we seem to become its indwelling, permeating spirit.

Space-composition in painting, then, is not the upstart rival of architecture, but its lovelier sister, an art capable of effects finer, more enchanting, more surely winning. And it produces its effects by totally different means. Architecture closes in and imprisons space, is largely an affair of interiors. Painted space-composition opens out the space it frames in, puts boundaries only ideal to the roof of heaven. All that it uses, whether the forms of the natural landscape, or of grand architecture, or even of the human figure, it reduces to be its ministrants in conveying a sense of untrammelled, but not chaotic spaciousness. In such pictures how freely one breathes—as if a load had just been lifted from one's breast; how refreshed, how noble, how potent one feels; again, how soothed; and still again, how wafted forth to abodes of far-away bliss!

The feeling just described is one that, at happy moments, many of us have had in the presence of nature, and it is one that we expect, but too seldom get, from landscape-painting. Yet space-composition is as distinct from the art of landscape as it is from architecture. It can produce its effects with a grand city square (as indeed we have it in paintings by Piero della Francesca) no less, if not better, than with the lines of the hills; its triumphs do not depend on subtle modelling of the atmosphere, nor on elaborate study of light and shade. Nay, so little mere dexterity, skill, and science are required to succeed in this art, that, provided the artists have the feeling for it, and be brought up in a good tradition, even the poorest can attain to some success; and there scarcely can be found an Umbrian picture, wretched though it may be in all other respects, which does not win us by its pleasant sweep of space. And if our interest be really in the work of art—not in the artist, and his madness, triumph, or despair—we shall not despise space-composition because it requires less dexterity and skill than

landscape-painting as now practised. Believe me, if you have no native feeling for space, not all the science, not all the labour in the world will give it you. And yet without this feeling there can be no perfect landscape. In spite of the exquisite modelling of Cézanne, who gives the sky its tactile values as perfectly as Michelangelo has given them to the human figure, in spite of all Monet's communication of the very pulse-beat of the sun's warmth over fields and trees, we are still waiting for a real art of landscape. And this will come only when some artist, modelling skies like Cézanne's, able to communicate light and heat as Monet does, will have a feeling for space rivalling Perugino's or even Raphael's. And because Poussin, Claude, and Turner have had much of this feeling, despite their inferiority in other respects to some of the artists of our own generation, they remain the greatest European landscape painters—for space-composition is the bone and marrow of the art of landscape.

XIII

Space-
composition

Now that we have some inkling of the resemblances and differences between space-composition on one side, and architecture and land-scape-painting on the other; now that we understand why it has a distinct place among the arts, we shall be able to appreciate the real qualities of Perugino and Raphael, as otherwise we could not possibly have done. One point, however, still remains to be noted. It is this. Space-composition, as we agreed, woos us away from our tight, painfully limited selves, dissolves us into the space presented, until at last we seem to become its permeating, indwelling spirit. In other words, this wonderful art can take us away from ourselves and give us, while we are under its spell, the feeling of being identified with the universe, perhaps even of being the soul of the universe. The feeling may be so conscious that it remains an artistic sensation—the most artistic of all; or it may transport one into the raptures of mysticism; but for those of us who are neither idolaters nor suppliants, this sense of identification with the universe is of the very essence of the reli-gious emotion—an emotion, by the way, as independent of belief and conduct as love itself. And now behold whither we have come. The religious emotion—for some of us entirely, for others at least in part—is produced by a feeling of identification with the universe; this feeling, in its turn, can be created by space-composition; it follows then that this art can directly communicate religious emotion—or at least all the religious emotion that many of us really have, good church-members

though we may be. And indeed I scarcely see by what other means the religious emotion can be directly communicated by painting—mark you, I do not say represented.

If, then, space-composition is the only art intrinsically religious, since the Perugian school is the great mistress of this art, we see why the paintings of Perugino and Raphael produce, as no others, the religious emotion. And so strong is it when produced, that the haunting quandary of commonplace minds is how Perugino could have painted pictures so profoundly religious and yet have been an atheist and a villain.

If here it were our business to discuss the relation of the work of art to the artist, it could be pointed out that a villain and an atheist might paint sweet, holy people because he preferred them in life, finding them easier victims, lovely, tender, pure women, because they were a rarer or more fragile prey. Finding these people more convenient, he might even be crafty enough to do what he could to add to their number by painting pictures that would wake those who looked on them to a consciousness of preference for a life holy and refined. All this is a quite conceivable, but here at least an unnecessary, hypothesis. Perugino, as I have but now said, produces his religious effect by means of his space-composition. Of his figures we require no more than that they shall not disturb this feeling, and if we take them as we should, chiefly as architectonic members in the effect of space, they seldom or never disturb us. Their stereotyped attitudes and expressions we should judge, not as if they were persons in a drama, but as so many columns of arches, of which we surely would not demand dramatic variety.

Perugino

Not that Perugino was contemptible as a mere Illustrator. Far from it! He had a feeling for beauty in women, charm in young men, and dignity in the old, seldom surpassed before or since. In his youth he painted a series of panels, now in the Perugia Gallery, recounting certain miracles of St. Bernardino. They keep us spellbound by a beauty, a charm, a grace peculiarly Umbrian, manifested in forms expressive of a feeling for line and movement almost Florentine. How fascinating are these scenes, with their refined Renaissance buildings, their garlanded triumphal arches opening on the high-skied Umbrian valley, their romantic landscapes, their lovely women and their still lovelier youth—tall, slender, golden-haired, dainty—Shakespeare's heroines in disguise. Then there is a well-ordered seemliness, a sanctuary aloofness in all his people which makes them things apart, untouched and pure. Great reserve also does much for him. Violent

Perugino as illustrator
Pls. 304–9

action he doubtless avoided because he felt himself unequal to the task—indeed, so little did he ever master movement that his figures when walking, dance on tiptoe, and on their feet they never stand; but he as carefully kept away from unseemly expression of emotion. How refreshingly quiet are his Crucifixions and Entombments! The still air is soundless, and the people wail no more; a sigh inaudible, a look of yearning, and that is all. How soothing must such paintings have been after the din and turmoil and slaughter of Perugia, the bloodiest town in Italy! Can it be wondered at that men, women, and children ran to see them? Nor yet is life so free from sordid cares and meaningless broils that we can forgo such balm for the soul as Perugino brings.

The space effect, however, plays so important a part in his compositions that it becomes difficult to say just how much of their quality is due to other factors. We shall be surer of our judgement if we look at one or two of Perugino's portraits. In young Messer Alessandro Braccesi we have the type so recurrent in the pictures, and we see that it loses little of its Peruginesque charm, although here there is no transfiguring background. And even in a portrait where there is a most soothing special accompaniment, the one, in the Uffizi, of Francesco delle Opere, Perugino shows his great mastery over Illustration by presenting to us one of the most ably interpreted, most firmly characterized, most convincing faces in the whole range of Renaissance art—so powerful a face that all the poppy drowsiness of the landscape cannot soften down its rigour. And how little of swooning sentimentality there really was in his nature we may infer from that sternly matter-of-fact self-appreciation, his own portrait in the Cambio at Perugia.

Pl. 309

Remarkable, however, as are Perugino's qualities as an Illustrator, I doubt whether we should rank him among the great artists for these alone. They are not sufficient—if, indeed, even the very highest reaches of mere Illustration ever are—to make up for a deficiency in feeling either for form or movement, a deficiency not so deplorable, thanks to his repeated contact with Florence, as Pintoricchio's, yet sad enough. But so potent was his charm as a space-composer that we never take his figures seriously as figures—or, if we do, we are wrong; for to quarrel with them is no wiser than to make ado about silly words set to a solemn music. These figures got worse and worse as he grew older, and, finally, when art already was awhirl with the revelation of Michelangelo, Perugino, altogether retiring from the struggle to count among artists, ceased visiting Florence, and lost

Perugino's charm as space-composer

what sense he ever had possessed for the figure and the nude. But his feeling for space he could not lose; nay, it gained in strength when, no longer wasting vitality on the effort of painting the figure as for itself it should be painted—an effort repugnant to his nature—he gave loose rein to his native impulse. He spent the last years of his life wreathing the Umbrian hills with his golden art, leaving on the walls of many a wayside shrine skies and horizons ineffable.

And now let us look more closely at a few of Perugino's compositions. One of his earliest works is the fresco, in the Sistine chapel, of 'Christ Giving the Keys to Peter', a work in which he has given more attention to structure than you shall find him doing again. As if by Pl. 306 miracle, several persons are standing on their feet. Note, however, that these are neither Christ nor the Apostles, whom doubtless Pietro was already painting by rote, but portraits of his own friends. And as if to explain the miracle, he has, on the extreme left, introduced himself standing by Luca Signorelli, with whom he then was closely associated. Yet you will not find even these persons life-enhancing by means of their tactile values or their movement. And throughout this fresco, Perugino's figures are no more attractive than Pintoricchio's, no better constructed than in the frescoes of those Florentine mediocrities, Cosimo Rosselli and Ghirlandaio, in movement contemptible beside Botticelli. And still among the paintings of the Sistine chapel Perugino's is certainly not the least agreeable. Nay, is there one more delightful? It is the golden, joyous colour, the fine rhythm of the groups, and above all the buoyant spaciousness of this fresco that win and hold us. Our attention first falls on the figures in the foreground, which, measured against the pavement cunningly tessellated for the purpose, at once suggest a scale more commensurate with the vastness of nature than with the puniness of man. Nor do these grand figures crowd the square. Far from it. Spacious, roomy, pleasantly empty, it stretches beyond them, inward and upward, over groups of men, surely of the same breed, but made small by the distance, until, just this side of the horizon's edge, your eye rests on a temple with soaring cupola and airy porticoes, the whole so proportioned to the figures in the foreground, so harmonized with the perspective of the pavement, that you get the feeling of being under a celestial dome, not shut in but open and free in the vastness of the space. The effect of the whole is perfectly determined both by the temple, through which runs the axis of this ideal hemisphere, and by the foreground, which suggests its circumference. And taking it as a sphere, you are compelled to feel as much space above and beyond the dome as there is between it and yourself.

We have no time to dwell at this length on Perugino's other paintings. But a few must not pass unmentioned. How cool in its warmth is the effect of the Albani Polyptych, with its space continuous through the various panels, felt through beautiful arches, stretching to enchanted distances, evoking freshness and fragrance, bringing back to you those rare moments when, new to life, in the early hour of a summer morning, for an instant you tasted of Paradise. Of Perugino's pictures in the Louvre alone, four have this golden, dreamy summeriness: the idyll, more than Theocritean, of 'Apollo and Marsyas'; the dainty small 'St. Sebastian', of Pietro's later years; and two earlier works: the round containing the Madonna with guardian Saints and Angels, all dipped in the colour of heaven, dreaming away in bliss the glowing summer afternoon; and, finally, the large 'St. Sebastian', enframed under an arch which opens out on Eden, and measuring, not as in *plein-air* painting, a mite against infinity, but as man should in Eden, dominant and towering high over the horizon. It is this exaltation of the human being over the landscape that not only justifies but renders great, paintings otherwise so feeble as the frescoes in the Cambio of Perugia—even the feeblest of them, the one where you see two lovely women unrecognizable, save for their symbols, as 'Strength of Will' and 'Temperance', and on the ground below them dreamy, lackadaisical, pretty knights and captains, still less recognizable as renowned exemplifiers of these virtues, yet grand and columnar in their relation to the vastness of the landscape. Far better, despite its somewhat gaunt blues, is the Triptych of the National Gallery, in London, mellow in its gold, with the adoring Virgin super-eminent over nature, and the singing Angels turning the sky they float in to the apse of some aerial cathedral. Without the transmuting power of the spacious pavilion opening out on the Umbrian vale, what would be the value of the Munich panel representing the 'Virgin Appearing to St. Bernard'? What but the uplifting skies and soothing distances draws your steps at Florence to Perugino's 'Crucifixion' in S. Maria Maddalena de' Pazzi?

Pl. 304

Pl. 305

Pl. 307

Pl. 308

XIV

Raphael

Pls. 310–20

And now we are face to face with the most famous and most beloved name in modern art—Raphael Sanzio. There have been in the last five centuries artists of far greater genius. Michelangelo was grander and more powerful, Leonardo at once more profound and more refined. In Raphael you never get the sweet world's taste as in Giorgione, nor

its full pride and splendour as in Titian and Veronese. And I am calling
up only Italian names—how many others, if we chose to cross the
Alps!—and it is only as Illustrator that he rivals these: for in the more
essential matters of figure-painting Raphael is not for a moment to be
ranked on a level with the great Florentines; nor does he, like the
Venetians, indelibly dye the world with resplendent colour. If you
measure him with the standards that you would apply to artists like
Pollaiuolo or Degas, you will soon condemn him to the radiant limbo
of heavily gilt mediocrities; for movement and form were to his tem-
perament, if not to his mind, as repugnant as ever they were to his
patriarchal precursor, Duccio. Sift the legions of drawings ascribed to
him until you have reduced their number to the few unmistakably his.
Would you then venture to place even these few among the works of
the greatest draughtsmen? Or look at his 'Entombment', the only The
'Entomb-
ment'
composition which he attempted to treat entirely as every serious
figure-painting should be treated, for the tactile values and the move-
ment that it may be made to impart. You see that the poor creature,
most docile and patient, had toiled and sweated to achieve what his
head understood but his heart felt not—direct communications of
force. The result is one of the most uncouth 'academies' that may be
seen, at least outside of that charnel-house of prize pictures, the
diploma gallery of the École des Beaux-Arts at Paris.

Ever ready to learn, Raphael passed from influence to influence. Raphael's
teachers
At whose feet did he not sit? Timoteo Viti's, Perugino's and Pin-
toricchio's, Michelangelo's, Leonardo's, and Fra Bartolommeo's, and
finally, Sebastiano del Piombo's. From the last-named, Sanzio, then
already at the very height of his career and triumph, humbly en-
deavoured to acquire those potent secrets of magical colour which
even a second-rate Venetian could teach him. And although he
learned his lesson well—for in this the Umbrians ever had been distant
cousins, as it were, of the Venetians—yet twice only did he attain to
signal achievement in colour: the fresco, so splendid as mere painting,
which represents the 'Miracle of Bolsena', and that exquisite study in
grey, the 'Portrait of Baldassare Castiglione'. But what are these beside
the mural paintings of Veronese, or the portraits of Titian? At
his rarest best Raphael, as a master of colour, never went beyond
Sebastino.

Whether, then, we are on the look-out for eminent mastery over
form and movement, or for great qualities of colour and mere painting,
Raphael will certainly disappoint us. But he has other claims on our
attention—he was endowed with a visual imagination which has

Raphael's
visual
imagination
never even been rivalled for range, sweep, and sanity. When surpassed, it has been at single points and by artists of more concentrated genius. Thus gifted, and coming at a time when form had, for its own sake, been recovered by the Naturalists and the essential artists, when the visual imagery, of at least the Italian world, had already suffered along certain lines, the transformation from the Medieval into whatever since has been for all of us the modern, when the ideals of the Renaissance were for an ineffable instant standing complete, Raphael, filtering and rendering lucid and pure all that had passed through him to make him what he was, set himself the task of dowering the modern world with the images that to this day, despite the turbulent rebellion and morose secession of recent years, embody for the great number of cultivated men their spiritual ideals and their spiritual aspirations. '*Belle comme une madonne de Raphael*' is, among the most artistic people in Europe, still the highest praise that can be given to female beauty. And, in sooth, where shall one find greater purity, more utter loveli-

Pl. 316
ness than in his 'Granduca Madonna', or a sublimer apparition of woman than appeared to St. Sixtus? Who, as a boy reading his Homer,

Pl. 313
his Virgil, or his Ovid, and dreaming dreams and seeing visions, but has found them realized a thousandfold in the 'Parnassus'! Who has ever had an ideal of intellectual converse in nobler surroundings but

Pls. 311–2
has looked with yearning at the 'Disputa' and the 'School of Athens'! Has Galatea ever haunted you? Tell me, has she not imparted a thousand times more life and freedom and freshness since you have seen her painted by Raphael in the midst of her Tritons and Sea-Nymphs? Antiquity itself has, in the figure-arts, left no embodiment so exultingly complete of its own finest imaginings.

We go to Raphael for the beautiful vesture he has given to the
Raphael as
humanist
Antiquity of our yearnings; and as long as the world of the Greeks and Romans remains for us what I fervently pray it may continue to be, not only a mere fact, but a longing and a desire, for such a time shall we, as we read the Greek and Latin poets, accompany them with an imagery either Raphael's own, or based on his; so long shall we see their world as Raphael saw it—a world where the bird of morning never ceased to sing.

What wonder then that Raphael became on the instant, and has ever remained, the most beloved of artists! A world which owed all that was noblest and best in it to classical culture, found at last its artist, the Illustrator who, embodying Antiquity in a form surpassing its own highest conceptions, satisfied at last its noblest longings. Raphael, we may say, was the master artist of the Humanists, and the artist of people nurtured on the Classics he remains.

But there is in our civilization another element which, though it is certainly much less important in our conscious intellectual life, and of much less interest to the pictorial imagination, is said, nevertheless, to be morally superior and poetically grander—all the Hebraic element, I mean, that has come to us from the Old and New Testaments. Sanzio here, also, performed a task by which we have benefited ever since, for, imperturbably Hellenic in spirit, he has given an Hellenic garb to the Hebraic universe. In pictures which he either executed or super-intended, or at least inspired, Raphael has completely illustrated both the Old and New Testaments; and such has been the spell of these Illustrations that they have trickled down to the lowest strata of society, and it will take not one but ten thousand M. Tissots to win even the populace away from them. And this imagery, in which Raphael has clothed the Hebrew world for us, is no more Hebraic than that of Virgil, singing the new order of things when the lion shall lie down with the lamb. Raphael has brought about the extraordinary result that, when we read even the Hebrew classics, we read them with an accompaniment of Hellenic imagery. What a power he has been in modern culture, Hellenizing the only force that could have thwarted it! If you would have examples in proof of what I have been saying, look at the *Loggia*, look at the cartoons for the tapestries, look at Marcantonio's engravings, but look, above all, in the Pitti at the 'Vision of Ezekiel'. Is it thus that Jehovah revealed himself to his prophets? Is it not rather Zeus appearing to a Sophocles?

Raphael's Bible

Raphael has enshrined all the noble tenderness and human sublimity of Christianity, all the glamour and edifying beauty of the antique world, in forms so radiant that we ever return to them to renew our inspiration. But has he not also given us our ideals of beauty? The Florentines were too great as figure-artists, the Venetians as masters of colour and paint, to care much for that which in Art, as distin-guished from Illustration, is so unimportant as what in life we call beauty. The 'beautiful woman' is apt to be what the real artist considers a bad subject—one in the painting of which it is exceedingly difficult, if at all possible, to present form or line. Such a woman, delightful though she may be in life, and ethically and socially perhaps the most desirable type, is apt to become in art a vulgar chromo. Many efforts have been made in our times, by artists who were mere Illustrators—or at least have had influence as such only—to change the ideal; but the fatalistic and ailing woman they tried to make popular, though more attractive to tastes bored with health and lovableness, is not in itself any more artistic than the other. So the type of beauty to which our

Ideals of beauty

eyes and desire still return is Raphael's—the type which for four hundred years has fascinated Europe. Not artist enough to be able to do without beauty, and the heir of the Sienese feelings for loveliness, too powerfully controlled by Florentine ideals not to be guided somewhat by their restraining and purifying art, Sanzio produced a type, the composite of Ferrarese, Central Italian, and Florentine conceptions of female beauty, which, as no other, has struck the happy mean between the instinctive demands of life and the more conscious requirements of art. And he was almost as successful in his types of youth or age—indeed, none but Leonardo ever conceived any lovelier or more dignified. Only for manhood was Raphael perhaps too feeble —and yet, I am not sure.

A surprise awaits us. This painter whose temperament we fancy to have been somewhat languid, who presented ideals Hesperidean, idyllic, Virgilian, could, when he chose, be not only grand in his conceptions—that we know already—but severe, impassive, and free from any aim save that of interpreting the object before him. And Raphael's portraits, in truth, have no superiors as faithful renderings

Pl. 315 of soul and body. They are truthful even to literal veracity, perceived in piercing light, yet reconstructed with an energy of intellectual and artistic fusion that places them among the constellations. Need we cite instances? Bear in mind the various portraits in the *Stanze* of Julius II;

Pl. 310 the cruel refinement of the Madrid bust of a young Cardinal; the genial faces of Navagero and Beazzano; the brutish greasiness of Leo X, nevertheless not wholly repellent; and, best of all, the majestic portrait of a young Roman matron—such as Cornelia must have looked— known in the Pitti as 'La Donna Velata'.

XV

Raphael as illustrator

But was this, then, all Raphael's merit—that he was a lovable Illustrator, the most lovable that we have ever had? With the vanishing of that world, offspring of Antiquity and the Renaissance, we now live in; with the breaking of that infinite chain of associations each link of which has the power to make us throb with joy;—if the ochlocracy prevail in our midst, not restrained as during the French Revolution by sublime catchwords, but at last persuaded that man lives by bread alone; or, worse fate, if, in the more than thrice millennial but still undecided duel between Europe and Asia, little Europe finally succumb to the barbarians; then, should another culture ever upspring, and in it people capable of appreciating art, what (if by miracle his work

survived) would they find in Raphael? As an Illustrator he would mean at the utmost no more to them than, as mere Illustrators, the great artists of China and Japan mean to us. He would not embody their ideals nor express their aspirations, nor be conjuring up to their minds subtly appreciative sensations, feelings, and dreams, imprisoned, since the glowing years of childhood, in the limbo of their unconscious selves, and needing the artist to fetch them out to the light. They could enjoy him, only as we who know nothing or next to nothing of the myths, poetry, or history of China and Japan, yet take pleasure in the art of those countries—as pure Art, independent of all accidents and all circumstances, confined to the divine task of heightening our vital and mental processes. And as pure Art, what supreme distinction would they discover in Raphael? Those who were wise enough to continue their quest, although they found him lacking in the qualities essential to the figure-arts, lacking also in the gifts which make the great craftsman, would end by seeing that he, Raphael Sanzio, was the greatest master of Composition—whether considered as arrange- Raphael as ment or as space—that Europe down to the end of the nineteenth space-
composer century had ever produced.

What space-composition is we already know, and here we need not discuss it again. It will suffice to examine a few of Raphael's master-pieces, as before we looked at certain of Perugino's. The earliest and perhaps loveliest revelation of Raphael's gift we shall find in his 'Sposalizio'. In essentials it is, as a space-composition, but a variant Pl. 317 on the fresco of Perugino that we studied in the Sistine chapel; the same grouping in the foreground, the same middle distance, the same closing of the horizon with a domed temple. The elements and the principle remain the same, but the indwelling spirit is not the same. Subtler feeling for space, greater refinement, even a certain daintiness, give this 'Sposalizio' a fragrance, a freshness that are not in Perugino's fresco. In presence of young Sanzio's picture you feel a poignant thrill of transfiguring sensation, as if, on a morning early, the air cool and dustless, you suddenly found yourself in presence of a fairer world, where lovely people were taking part in a gracious ceremony, while beyond them stretched harmonious distances line on line to the horizon's edge.

The space effect of Perugino's great fresco we compared to a celestial dome; but there perhaps it will escape you if you do not look carefully. Raphael, perchance more aware of just what he was seeking, produces a similar effect, but unmistakable, and grander. Look in the *Stanze* at that majestic theophany known as the 'Disputa'. On the top of Pl. 311

Olympus the gods and heroes are assembled in council. They are so arranged that the most obvious architecture could not better indicate the depth and roundness of a dome; but no architectural dome could so well convey a sense of the vastness yet commensurability, nay, shall we not say of the companionship of space. How much greater, how much purer than one's ordinary self—how transfigured one feels here!

The forms in the 'Disputa' are noble in intention, as they always are in Raphael's best work. But think away the spaciousness of their surroundings. What has become of the solemn dignity, the glory that radiated from them? It has gone like divinity from a god. And the other fresco, the 'School of Athens', would suffer still more from such treatment. We have a cartoon of this subject with the figures only, and we have Raphael's painting. How ordinary and second-rate are the mere figures; how transformed when seen against those sublime arches, almost the grandest ever conceived! And not only are the figures ennobled, but yourself. How like a demigod you feel here in this lighter, purer air!

Pl. 312

And what decorations for a small room! Into a room of dimensions almost mean and far from tempting to the decorator, the 'Disputa' and the 'School of Athens', the 'Parnassus' and the pure space occupied by 'Justice', bring all the out-of-doors of some Eden, where man has no sordid cares, no struggles, where thought and art are his only occupations.

For Raphael was not only the greatest Space-Composer that we have ever had, but the greatest master of Composition in the more usual sense of grouping and arrangement. Before we leave the *Stanza della Segnatura*, look again at the 'Disputa'. Note the balance of the masses about the Host, note the flow towards it of all the lines. Upon it your eye must rest. Or in the 'School of Athens' see how everything converges towards Plato and Aristotle, the effect further enhanced by the enframing distant arch against which they stand. It is the effect that we found in Duccio's 'Incredulity of Thomas', but here on a scale almost cosmic. In the ceiling of the same *Stanza* is a 'Judgement of Solomon'. Have you ever seen a flat space better filled, a clearer arrangement and better balance of masses? A kindred effect you may see in the Farnesina, where concave spherical triangles are so admirably filled with paintings of the various adventures of Psyche, that you think of them as openings revealing scenes that are passing, never as awkward spaces almost hopelessly difficult to deal with.

Pl. 314

But hard as it may be to fill spaces like these, it is yet no task beside the difficulty of treating one group, perhaps one figure only, so that,

perfectly dominating the space at command, it shall not become too abstract and schematic and fixed, but shall suggest freedom, evoke an environment of air and sunshine. When looking at the 'Granduca Madonna', has it ever occurred to you to note that the whole of her figure was not there? So perfect is the arrangement that the attention is entirely absorbed by the grouping of the heads, the balance of the Virgin's draped arm and the Child's body. You are not allowed to ask yourself how the figure ends. And observe how it holds its own, easily poised, in the panel which is just large enough to contain it without crowding, without suggesting room for aught beside.

Pl. 316

But great as is the pleasure in a single group perfectly filling a mere panel, it is far greater when a group dominates a landscape. Raphael tried several times to obtain this effect—as in the 'Madonna del Cardellino', or the 'Madonna del Prato', but he attained to supreme success once only—in the '*Belle Jardinière*'. Here you have the full negation of the *plein-air* treatment of the figure. The Madonna is under a domed sky, and she fills it completely, as subtly as in the Granduca panel, but here it is the whole out-of-doors, the universe, and a human being super-eminent over it. What a scale is suggested! Surely the spiritual relation between man and his environment is here given in the only way that man—unless he become barbarized by decay, or non-humanized by science—will ever feel it. And not what man knows but what man feels, concerns art. All else is science.

Pl. 318

XVI

To resume, Raphael was not an artist in the sense that Michelangelo, Leonardo, Velazquez, or even Rembrandt was. He was a great Illustrator and a great Space-Composer. But the success he attained was his ruin; for, obliged in the later years of his brief life to work hastily, superintending a horde of assistants, seldom with leisure for thought, he felt too pressed to work out his effects either as Illustration or as Space-Composition; so that most of his later work lacks the qualities of either of these arts, over which he was the natural master.

Raphael's following

And if this were so with him, how much worse with his pupils, his executants, brought up on hurry and turmoil, none of whom had talents either as Illustrators or as Space-Composers! And in truth what more unpalatable than their work? They have none of that feeling for space which pleases even in the worst immediate followers of Perugino; none of that pleasant colour which attracts us to even the meanest Venetian. No wonder that we have given over Giulio

Pl. 321 Romano, Pierino del Vaga, Giovan Franceschi Penni, Polidoro da Caravaggio, and their ignoble fellows to oblivion. It is all they deserve.

Let not these names come to our minds when we think of the artists of Central Italy, but the names of the splendid cohort of great Illustrators, great Figure-Artists, great Space-Composers, led by the bright genius of Duccio and Simone Martini, of Piero della Francesca and Signorelli, of Perugino and Raphael.

BOOK IV
THE NORTH ITALIAN PAINTERS

BOOK IV

I

PAINTING in Northern Italy had its share in the successes and failures of medieval Italian art. It was lit up by the Byzantine glow radiating from Duccio, and quickened, as in the rest of the peninsula, by the genius of Giotto. Many an unknown shrine in the Milanese, the Veronese, and the Paduan territories retains to this day frescoes of no less interest than the average of contemporary mural decoration in Florence or Siena. But no imposing artistic personality appeared in the vast region between the Alps, the Apennines, and the sea, until, in the second half of the fourteenth century, Altichiero Altichieri of Verona began to practise his art.[1]

Altichieri

The only considerable fragment of his which remains in his native town, the fresco in S. Anastasia, where three gentlemen of the Cavalli family are presented by their patron saints to the Madonna, is certainly one of the few great works of art of the later years of the Trecento. The large simplicity of the design, the heraldic pageantry of the costumes, the grandeur of the Saints, the impressiveness of the Virgin, the comely faces of the angels, give their painter a place among Giotto's followers second to none in Florence itself, not even to Orcagna, whom Altichiero so unexpectedly resembles. Giotto's seed, we are tempted to think, has found here a richer soil. But enthusiasm grows somewhat cooler before the frescoes at Padua. It is true that as regards colour they have every advantage of Florentine painting during the same years: they are more gorgeous, better fused, and altogether more harmonious. In design, too, excepting always Orcagna's, no work of a contemporary Tuscan has their excellence. Yet with all their merits they are disappointing in the comparison, for nothing Tuscan great enough to have their qualities would have had their faults.

The frescoes at Padua Pl. 322

Their qualities, in so far as they have not already been pointed out in the description of the Verona fresco, consist in clearness of narration, effective massing, and fine distances. The compositions and facial

[1] Unfortunately the bulk of his authenticated work at home has perished and his share in the two cycles of frescoes at Padua is uncertain. His countryman d'Avanzi worked with him, and many futile attempts have been made to assign this bit to one and that to the other. There are slight differences of quality, no doubt, but the inspiring and guiding mind is one, and surely Altichiero's. For our present purpose, the paintings in the Santo and in the contiguous chapel of St. George may count as his.

types are so fresh and memorable that they left their mark upon Veronese painting as long as it remained worthy of being called an art, and supplied Padua and even Venice with some of the most admirable motives of their respective schools. Architecture is handled with the loving precision of a Canaletto, and perspective, although naïve and unmathematical, is seldom wanting. The portrait heads, besides being vigorous, straightforward, and dignified, are individualized to the utmost limits permitted by form in that day, while to this gift of direct observation is added a power of rendering the thing seen, surpassed by Giotto alone.

Altichiero's
faults
But with these qualities Altichiero combines many faults of those later Trecento painters who never came near him in other ways. He has their exaggerated love of costume and finery, their delight in trivial detail, their preoccupation with local colour. He lacks distinction, he fails to be impressive, he misses spiritual significance. The accessories absorb him, so that the humorous trivialities which life foists upon the sublimest events, at his hands sometimes receive more tender care than the principal figures. Thus, while he masses well, he is too eager for detail not to overcrowd his compositions. Not a single one has that happy emptiness which makes you breathe more lightly and freely before the best compositions of a Giotto, a Simone Martini, or an Orcagna. Altichiero reduces the Crucifixion to something not far removed from a market scene, and the spectator is in danger of forgetting the Figure on the Cross by having his attention drawn to a dog lapping water from a ditch, a handsome matron leading a wilful child, or an old woman wiping her nose. The artist is so little heedful of the highest artistic economy that he constantly abandons it for the passing fashions of the day. One of these fashions was a delight in contemporary costume, and Altichiero clothes his figures accordingly, bartering impressiveness for frippery; although, as if to prove that he really knew better, he scarcely ever fails to drape his protagonists, whether they be St. George, St. Lucy, or St. Catherine, with the amplitude, simplicity, and sweep of Giotto's grandest manner. Another of the fashions of the day was what might be called 'local colour', an attention to some of the obvious characteristics of time and place. As nearly all sacred and much of legendary story has the Orient for a background, Altichiero misses no chance of introducing the Calmuck faces and pigtails of the most prominent Orientals of his time, the Tartar conquerors. Had the Inquisition been as meddlesome then as it became two hundred years later, the first great Veronese painter might have had to answer before its tribunal to charges as

many and as well founded as were brought against the last great
master of that school. Paolo Caliari, it will be remembered, was put on
trial for filling his 'Feast in the House of Levi'—a much less solemn
theme than that treated by Altichiero—with dwarfs, parrots, and
Germans.

Altichiero's faults, I repeat, might easily be matched in Tuscany,
but not in combination with his qualities. It is worth while to insist on
this point, because we shall discover it to be highly characteristic of
most North Italian painters. They are apt to be out of tone spiritually;
they find it difficult to keep to one moral and emotional atmosphere;
they are more active with their hands than with their heads. One
would almost think that with the mass of them, as indeed with all
Northern peoples, painting was rather a matter of reflex action than
of the eliminating, transubstantiating intellect. And it goes some way
to confirm the truth of this generalization that there would be no
difficulty in supposing that, had Altichiero and Paolo changed places,
we should never have known the difference: in other words, that
Altichiero in the sixteenth century would have been a Paolo, and
Paolo in the fourteenth an Altichiero.

II

Altichiero had scarcely ceased covering wall spaces with the pomp and
circumstance of medieval life, when his task was taken up by his better-
known Renaissance follower, Vittorio Pisanello. The larger part of Pisanello
this artist's work, in fact all his decoration of great houses and public
palaces, has perished. Even now, after earnest efforts to gather
together the strewn limbs of his art, only six or seven paintings of his
can be discovered: two frescoes, two sacred subjects, and two or three Pls. 323-5
portraits. His renown as a painter has therefore been eclipsed by his
fame as a medallist. And, in truth, never since the days when Greek
craftsmen modelled coins for proud city states, has there been such a
moulder of subtle reliefs in miniature. Yet Pisanello himself never
signed his name without the addition of the word PICTOR, and it
was as a painter that he received the stipends of princes and the
adulation of poets.

Although he was much more modern than his ancestor, there was
nothing in his paintings to startle princes and poets, or even less dis-
tinguished persons, whose education in art consisted then, no doubt,
as it does now, in confirming a fondness for the kind of picture to
which their eyes had grown accustomed during childhood and youth.

Pisanello, although counting as one of the great geniuses of the Renaissance, by no means broke with the past. He went, it is true, as far beyond Altichiero as Altichiero had gone beyond his immediate precursors, but he betrays no essential difference of intention or spirit. Some advance was inevitable, for the hard-won position of one genius is only the starting-point of the next. Altichiero had observed the appearance of objects, Pisanello observed more closely; Altichiero could characterize and individualize, Pisanello did the same, but more subtly; Altichiero could render distances fairly well, Pisanello rendered them with even better effect. But far from betraying the clumsy struggles of innovators, he has the refinement, the daintiness of the last scion of a noble lineage. In him, art-evolution produced a painter most happily fitted to hold up an idealizing mirror to a parallel product of social evolution, the sunset of Chivalry. No wonder that he was employed along with the kindred Gentile da Fabriano by the rich and noble, and that he was chosen to continue the courtly Umbrian's tasks.

Pisanello's
surviving
paintings Of Pisanello's seven paintings, six are distinctly court pictures, and their subjects bear witness to his interest in the courtier's mode of life. The fresco at S. Anastasia in Verona is first and foremost a knightly pageant; the little St. Hubert is the knight as huntsman: and in the other picture in the National Gallery the prominent figure is the cavalier St. George standing in gala costume beside his proud steed. His Leonello d'Este is of course a great gentleman, and the female portraits, if less commanding, are still great ladies. The only work which is not distinctly courtly in tone is an Annunciation, and the time was still far off when Michelangelo's followers so broke loose from tradition as to transform the meek Judean maiden into a haughty princess. But even this composition is crowned by the knightly figures of St. George and St. Michael, the favourite saints of chivalry.

A further examination of his works will reveal how far he was from feeling the inspiration of the real Italian Renaissance. In the S. Fermo fresco that we have just glanced at, the Virgin, with her folded hands resting on her lap, is neither in type nor pose nor silhouette obviously Italian, although nothing could be more in accordance with medieval Italian tradition than the obeisance of the announcing Angel, with the grand sweep of his gathered wings, his streaming hair, and his long trailing robes. The Virgin's chamber, with its elaborate Gothic pendentives, its tapestries and stuffs, recalls the contemporary paintings of far-away Bruges. St. George and St. Michael hark back to Altichiero.

Pl. 323 At S. Anastasia the fresco is on both sides of a Gothic arch, at such a height that only figures much above the ordinary size would convey

their effect to a spectator on the floor. Not only are the figures them- 'St. George and the Princess' selves much too small for this purpose, but no attempt has been made to divide them into lucid groups, or to detach them clearly from their background. No thought of composition entered the artist's head, no idea of extracting the significance of the noble deed. What arrange- ment there is, is due to a desire to introduce stock material, regardless of the requirements of the subject. Nothing in the part on the right (which never had any integral relation to the other part, now almost invisible) betrays that the subject is the story of St. George and the Princess of Trebizond. We see a knight getting ready to mount his horse. Between this beast, seen from the back, in order to display the master's command of foreshortening, and his squire's horse, seen for similar reasons nearly full face, stands a lady in profile, expressionless, immobile, in a dress with a long train. She is there as a stock figure of the great lady, the head being a portrait. The dogs in the foreground are not inappropriate, but the presence of a ram in an equally con- spicuous position can only be explained on the ground that Pisanello yielded to an irresistible desire to show how well he could paint him. A low knoll in the middle distance half hides the stone lacework of a group of wedding-cake Gothic palaces, such as even the Venetians of that time might have hesitated to erect along their canals. From the gate issues a procession of knights on horseback, one of whom, in profile, is manifestly a portrait, while the others are, like the archi- tecture and the head of St. George, but Altichiero's inventions brought up to date. Over these horsemen, on a high gallows-tree, swing two rogues, and beyond rises a tall cliff, beneath the shelter of which a ship under full sail is running to shore. A piece of water bounded by a hilly coast stretches across the pointed arch over which the fresco is painted. In the foreground on the other side of the arch lies a dead dragon in the midst of a multitude of creeping things. Now almost wholly effaced, and never visible to the normal eye from the floor below, these creatures are yet painted with the exactness of a naturalist, and with the detailed care of the miniaturist. Indeed, this wonderful fresco is a miniaturist's work, executed with no thought of the spectator on the floor of the church, but as an illuminator might cover the page of a missal.

We shall find the same advanced medieval traits in Pisanello's two 'The Vision of St. Hubert' works in the National Gallery, both, as it happens, little more than miniatures in size. In the one, St. Hubert, nobly clad and mounted Pl. 325 on a richly caparisoned hunter, in the midst of his dogs and hounds, encounters a stag, who stands still displaying between his antlers the

image of our Lord on His Cross. The merry huntsman lifts his hand, but betrays no other sign of emotion: there is more appropriate expression in the eye of the stag. Around and about them spreads a marvellous scene, rocks and trees, every flower and every beast of the field, every bird of the air and stream, each and all painted with the naturalist's accuracy of observation and the miniaturist's daintiness of touch. The beauty of detail is infinite, the form and structure of each individual bird or beast being rendered only less admirably than its characteristic movements. The eye could dwell on them for ever, captivated by the artist's feeling that his one 'vocation was endless imitation'. If that were indeed the whole of art, this were supreme art.

The Madonna with two Saints

Pl. 324

The other picture in the National Gallery represents the Madonna appearing against the sun in the midst of a radiance of glory, over a darkling wood, before which stand St. George and St. Anthony Abbot. The effect, which is noble and inspiring, is produced by the extreme simplicity of the composition and by the light; but here, once more, our attention is chiefly directed to the silver armour of the knight, to the amazing detail and texture of his straw hat, and to the fierce energy of the boar and the heraldic coils of the dragon.

Pisanello's portraits tell no different tale. No doubt the 'Leonello' of the Morelli Collection at Bergamo and the 'Este Princess' of the Louvre are ably and adequately characterized, one as born and bred to command, and the other as an amiable maiden of high lineage; but in both panels the patterns on the dresses and the texture and tissue of the flowers that decorate the backgrounds were evidently of prime import to the artist.

Of intellectuality, of spiritual significance, of the greatest qualities of the illustrator, Pisanello had even less than Altichiero, but in the rendering of single objects, whether in the animal kingdom or in nature, he was perhaps not inferior to any of his own contemporaries the world over. Indeed, he painted birds as only the Japanese have painted them, and his dogs and hounds and stags have not been surpassed by the Van Eycks themselves. Yet his place is somewhere between the late medieval Franco-Flemish miniaturists, such as the Limburgs, on the one hand and the Van Eycks on the other—much nearer to the first than to the second—rather than with Masaccio, Uccello, or even Fra Angelico. He draws more accurately, he paints more delightfully than his Florentine contemporaries. Why then are they yet actually greater as artists, and the forerunners of a new movement, the begetters of artists as great as themselves, or even greater, while he remains essentially medieval, a little master, and his art dies with him?

The proper answer to this question would require for its adequate development many times more space than is allotted for the whole of this small book, and would involve important problems of aesthetics as well as of history. The detailed answer is not to be thought of here; but I may venture to hint at it, warning the reader that my suggestions will be of little avail if he has not read the previous books in this volume.

III

It is conceivable that but for the influence of Florence, and to a minor degree of the Antique, the art of Pisanello would not have disappeared as it did without effect. As drawing, it was on a level with the Van Eycks, and as painting, but little inferior. What it lacked in intellectuality might have been, in such an age of progress as the Renaissance peculiarly was, more than made up by the next great painter. The successor of Pisanello in North Italian painting would naturally have been a Van Eyck; or, if not a Van Eyck, then, considering the Veronese master's love of birds and beasts, his feeling for line, and the supreme daintiness of his touch, his next successor, taking up these elements, might conceivably have initiated an evolution destined to end in a Hokusai. That Mantegna bears no resemblance to Pisanello, and has no likeness to the Van Eycks and their followers,[1] or to Hokusai and his precursors, is due to Florence and the Antique.

Comparison with Flemish art

The art of Pisanello, like that of the early Flemings, was too naïve. In their delight in nature they were like children who, on making the first spring excursion into the neighbouring meadow and wood, pluck

[1] The Van Eycks make me think of their greatest Italian follower, Antonello da Messina. What is left to us of his works confirms the tradition that he was formed under the influence of the Van Eycks or of their immediate follower Petrus Christus. He learnt from them not only the secrets of their superior technique, but inherited their preference for linear perspective and for pyramidal and conical shapes and masses. At the end of his relatively brief career Antonello spent some time in Venice and got more from Giovanni Bellini than he gave him and the other Venetians. His latest works are Venetian in spirit and between his and Giovanni Bellini's portraits the differences are slight.

As an illustrator this solitary impersonal artist seems to approach Piero della Francesca. His sense of space is scenic, and in one of his two larger pictures, the Saint Sebastian of the Dresden Gallery (the other being the Siracusa Annunciation) the architectural proportions are sumptuous and impressive. But his tactile values are not to be compared with those of a Piero della Francesca or of a Cézanne, nor are they superior to those of Giovanni Bellini.

Pl. 328

He is appreciated above all for his portraits, although they seem on the whole less fascinating as works of art than his Munich and Palermo Virgins or his noble Benson Madonna, now in the National Gallery of Washington. This last is a creation not less striking than Vermeer's head of a girl at the Hague, which recalls Piero della Francesca while anticipating Cézanne.

Pls. 327, 329

all the wild flowers, trap all the birds, hug all the trees, and make friends with all the gay-coloured creeping things in the grass. Everything is on the same plane of interest, and everything that can be carried off they bring home in triumph. To this pleasure in the mere appearance of things, the greatest of the early Flemings, the Van Eycks, joined, it is true, high gifts of the spirit and rare powers of characterization. They had, as all the world knows, a technique far beyond any dreamt of in Tuscany. And yet the bulk, if not the whole, of Flemish painting, to the extent that it is not touched by Florentine influences, is important only as Imitation and Illustration. That is perhaps why, as art, it steadily declined until, only a century after Pisanello's death, it perished in its turn, leaving nothing behind it but its marvellous technique. This is all of his heritage that Rubens, the next great Fleming after the Van Eycks, took up. In every other respect he was an Italian: and, after Michelangelo, to say Italian was practically to say Florentine.

It would be an interesting digression to speculate on what might have happened to the Low Countries if they had been situated nearer to Tuscany, and to conceive a Rubens coming, not after the Caracci, when the fight had been fought out, but, like Mantegna, almost at its beginning. But our present task is to try to discover what were the elements destined to conquer Europe, which Northern art in the fifteenth century lacked and Florentine art possessed.

The trouble with Northern painting was that, with all its qualities, it was not founded upon any specifically artistic ideas. If it was more than just adequate to the illustrative purpose, then, owing no doubt to joy in its own technique, it overflowed into such rudimentarily decorative devices as gorgeous stuffs and spreading, splendidly painted draperies. It may be questioned whether there exists north of the Apennines a single picture uninspired by Florentine influence, in which the design is determined by specifically artistic motices: that is to say, motives dictated by the demands of Form and Movement.

In the previous books in this volume I have stated or implied that the human figure must furnish the principal material out of which the graphic and plastic arts are constructed. Every other visible thing should be subordinated to man and submitted to his standards. The standards concerned are, however, not primarily moral and utilitarian, although ultimately in close connexion with ordinary human values. Primarily they are standards of happiness, not the happiness of the figure portrayed, but of us who look on and perceive. This feeling of happiness is produced by the way the human figure is presented to

us, and it must be presented in such a way that, instead of merely recognizing it as meant for a human being of a given type, we shall be forced by its construction and modelling to dwell upon it, until it arouses in ourselves ideated sensations that shall make us experience the diffused sense of happiness which results upon our becoming aware of an unexpectedly intensified, facilitated activity. The figures must be presented in such a way that all their movements are readily ideated, with none of the fatigue yet something of the glow of physical exertion. And, finally, each figure must be presented in such a relation to every other figure in the composition that it shall not diminish but increase the effect of the whole, and in such relation to the space allotted that we feel neither lost in a void nor jammed in a crowd: we must, on the contrary, have the kind of space in which our ideated sensations of breathing and moving, while increasing rather than diminishing our confidence in the earth's stability, shall almost seem to emancipate us from the tyranny of burdensome matter.

To these three ways of presenting the human figure—which are at bottom but one—I have in Books II and III of this volume given the names of 'Tactile Values', 'Movement', and 'Space-Composition'. If what was said there, and what is said now, be true, it follows that it is not enough to paint naïvely what we see, or even what fancy evokes. As a matter of fact, we see much more with our mind than with our eye, and the naïve person is the unsuspecting dupe of a mind which is only saved from being a bundle of inflexible conventialities by sporadic irruptions of anarchy. The larger part of human progress consists in exchanging naïve conventionality for conscious law; and it is not otherwise with art. Instead of painting indiscriminately everything that appeals to him, the great artist, as if with deliberate intention, selects from among the mass of visual impressions only those elements that combine to produce a picture in which each part of the design conveys tactile values, communicates movement, and uplifts with space-composition. The essential in the Figure arts

Not every figure is suited for conveying tactile values, not every attitude is fitted for communicating movement, and not every space is uplifting. It may even be doubted whether the requisites out of which the work of art is to be constructed exist originally in nature. The 'noble' savage, who may seem to offer a fit subject for the painter, is not by any means a primeval being, but moulded through immemorial ages by the ennobling arts of the chase, of the dance and the mime, of war and oratory. And even he, just as he stood, would seldom have lent himself to great artistic treatment.

Originally not to be found ready-made in nature, rarely met with in our own proud times, these figures had to be constructed by the artist, these attitudes discovered, these spaces invented. How he went to work with these ends in view are matters I have touched upon already in preceding books, too briefly, yet more fully than I shall in this place.

The credit of the achievement in modern Europe was due to Florence. There alone the task was understood in all its bearings, and there alone was found a succession of men able to take it over, one from the other, until it was completed. It is true that many, weary with cutting roads through forbidding forests, turned for repose into the first glade that offered immediate sunshine, caressing breezes, and wild fruits. But the sufficing few kept on conquering chaos all the way to their goal.

IV

Without Florence, then, painting in Northern Italy might have differed but slightly from contemporary painting in the Low Countries or in Germany. But Pisanello was still living when his native town was invaded by Florentine sculptors. Although of no high order, they travelled as missionaries of the art of Donatello. The mighty innovator himself came to Padua years before Pisanello's death, and worked there for a decade. He was preceded and followed by such of his fellows as Paolo Uccello and Fra Filippo, and always accompanied by a host of his townsmen as assistants. A tide of influence like this was not to be resisted. Yet it might have produced only quaint or ingenuously unintelligent imitations, if at Padua there had not then existed talents greater than were allotted to most of Squarcione's pupils. Happily these years were the apprentice years of a prince in the domain of art—Andrea Mantegna.

Mantegna At little more than ten years of age, Mantegna was adopted by a contractor named Squarcione. How much of a painter Squarcione was we do not know; but we do know that he undertook designing and painting to be executed by people in his employ. He was also a dealer in antiquities, and his shop was frequented by the distinguished people who passed through Padua, and by the Humanists teaching in the famous University. It happened to be a moment when in Italy Antiquity was a religion, nay, more, a mystical passion, causing wise men to brood over fragments of Roman statuary as if they were sacred relics, and to yearn for ecstatic union with the glorified past.

To complete the spell, this glorified past happened to be the past of their own country.

Reared among fragments of ancient art, in a shop haunted by Professors—great persons in any town overshadowed by a University, and at that time regarded as hierophants of the cult of the national past—a lad of genius could not help growing up an inspired devotee of Antiquity. A path of light spread before him, at the end of which, far away but not inaccessible, stood the city of his dreams, his longings, his desires. Throughout his whole life Imperial Rome was to Mantegna what the New Jerusalem was to the Puritan or the old Jerusalem to the Jew. To revive it in the fullness of its splendour must have seemed a task that could be achieved only by the unflagging labours of many generations, but meanwhile it could be reconstructed in the mind's eye, and the vision recorded in a form that would be at once a prophecy, an incentive, and a goal.

Mantegna and antiquity

Antiquity was thus to Mantegna a different affair both from what it was to his artist contemporaries in Florence, and from what it is to us now. If ever there be a just occasion for applying the word 'Romantic' —and it means, I take it, a longing for a state of things based not upon facts but upon the evocations of art and literature—then that word should be applied to Mantegna's attitude towards Antiquity. He entirely lacked our intimate and matter-of-fact acquaintance with it. He knew it visually from a small number of coins and medals, from a few statues and bas-reliefs, and from several arches and temples, mostly Roman. He knew it orally from the Paduan Humanists, who fired him with their love of the Latin poets and historians. That the first of Roman poets was a Mantuan and the first of Roman historians a Paduan, sons of his own soil, must have given no slight stimulus to his retrospective patriotism. No wonder Rome filled his horizon and stood to him for the whole of Antiquity.

Not only was he romantic in his feeling for Italy's glorious past, but naïvely romantic. His visual acquaintance with it being confined to a few plastic representations, he naïvely forgot that Romans were creatures of flesh and blood, and he painted them as if they had never been anything but marble, never other than statuesque in pose, processional in gait, and godlike in look and gesture. Very likely, if he had been quite free to choose, he would never have touched a subject not taken from Roman history or poetry; and in the last twenty years of his life he came near to having his way, for, thanks in no small degree to his own influence, the Romanization of his employers had advanced to a point where they also preferred Roman themes, such

Mantegna's Romanticism

themes as the 'Triumph of Caesar', the 'Triumph of Scipio', or 'Mucius
Scaevola'. But no subject at any time, unless indeed it was a portrait,
escaped his Romanizing process. Consequently, although he was
Court Painter for nearly half a century, he never reveals the fact except

Pl. 332

in the portraits of the *Camera degli Sposi;* and although a painter of
Christian mysteries, he betrays little Christian feeling.

Romanized
Christianity

It scarcely matters what 'religious pictures' we select as examples.
In all, the old men are proud, even haughty Senators, the young are
handsome and soldierlike, the women stately or gracious. They walk
in streets lined with temples, palaces, and triumphal arches, or in the
mineral landscapes of bas-reliefs. I shall not cite such works as the
frescoes in the Eremitani, which readily lent themselves to Antique
treatment, but call attention to subjects which Christians find most
awe-inspiring.

We are somewhat surprised at the start to discover how few subjects
of this kind Mantegna seems to have treated. At a time when his
brother-in-law, the young Bellini, and his fellow-pupil, Carlo Crivelli,
were inspired by the echoes of S. Bernardino's revival to paint scenes
and symbols of the Passion full of the deepest contrition, most tender
pity, and mystical devotion, Mantegna apparently remained aloof and
untouched. The only 'Pietà' from his earlier years holds a subordinate
place in the Brera polyptych, and is not to be compared as interpretation
to any of Bellini's handlings of the same theme. Each of these artists

Pl. 330

happens to have in the National Gallery an 'Agony in the Garden'.
The hush, the solemnity, the sense of infinite import conveyed by the
one finds no echo in the other, with its rock-born giant kneeling in
sight of Rome, in the midst of a world of flint, praying to several
momentarily saddened cupids. We may love this panel too, but not
for its Christian spirit.

Subjects like the Crucifixion, the Circumcision, the Ascension,
which again offer rare opportunities for the expression of specifically
Christian feeling, Mantegna treated as fitting occasions for the repro-
duction of the Antique world. The priceless Crucifixion of the Louvre
is, in the first place, a study of the Roman soldier. The Ascension in
the Uffizi is the apotheosis of a Roman athlete. The Circumcision on

Pl. 333

the companion panel represents the interior of a Roman temple, with
its sumptuous marbles, incrustations, and gildings. Placed beside
Ambrogio Lorenzetti's panel in the Uffizi at Florence, where the same
theme is handled, it would quickly reveal the difference between a
Christian and a pagan artist.

And Mantegna did not grow more Christian with years. On the

contrary, he lived to deserve even better than Goethe the surname of 'Old Pagan'. In mid-career he painted a picture, now at Copenhagen, with a wailing, half-nude Christ supported on a sarcophagus by two mourning angels with wings widespread. If you can forget the inane expression on the Saviour's face, and the perfunctory grimaces of the angels, you will be free to enjoy a design that sweeps you from earth to heaven, but not on the pinions of Faith! Or take the mystic subject belonging to Lord Melchett[1] which Mantegna painted when he was no longer young. Few things even in ancient art have more of the Roman and imperial air than this infant Caesar whom Mantegna has seen fit to pose there as the infant Christ. From his later years we have such negations of Christianity as the distinctly Roman figures meant to represent Christ between Longinus and Andrew, or those in the other engraving of a sublimely pagan Entombment.

Mantegna deserves no blame for Romanizing Christianity, any more than Raphael for Hellenizing Hebraism. Indeed, they both did their work so well that the majority of Europeans at this day still visualize their Bible story in forms derived from these two Renaissance masters. And Mantegna should incur the less reproach because it is probable that the Christian spirit cannot easily find embodiment in the visual arts. The purpose of the last few paragraphs was not to find fault but to show that, as an Illustrator, he intended to be wholly Roman.

Had he succeeded, we might perhaps afford to forget him, in spite of the three centuries of admiration bestowed upon him by an over-Latinized Europe. We do not any longer need his reconstructions. We know almost scientifically the aspect and character of the Rome which cast her glamour over his fancy. Besides, we no longer stop at Rome, but have gone back to her fountain-head, Athens. If Mantegna is still inspiring as an Illustrator, it is because he failed of his object, and conveyed, instead of an archaeologically correct transcript of ancient Rome, a creation of his own romantic mood, the Rome of his dreams, his vision of a noble humanity living nobly in noble surroundings.

Thus Mantegna's attitude towards Antiquity, unlike our own, was romantic; and it was equally remote from the attitude of his artist contemporaries in Tuscany. His aim was to resuscitate the ancient world; his method was the imitation of the Antique. Little as they shared his purpose, they shared his methods less.

There are different uses to which one may put the art of the past. One may use it as a child uses blocks. They enable him to build up his toy town, but, though he may forget the fact or be either too giddy or

[1] Now in the National Gallery, London.

too stupid to be aware of it, the scheme is predetermined. He can do only what may be done with the given blocks, and it is doubtful whether they can teach him to produce another toy town without blocks but with the pencil or brush or even clay. This use of ancient art may be called archaistic, and it was the way in which Roman fragments were employed again and again in the Middle Ages, notably in the thirteenth century at Rheims, at Capua, and by the greatest Italian sculptor before the Renaissance, Niccolò Pisano. On the other hand, the art of the past may be used as vintners nowadays use the ferment of a choice vintage, to improve the flavour of a liquid pressed from an ordinary grape. This is the most constant use to which it has been put, and, to a limited degree, it is a profitable use. The most profitable of all, however, is neither to imitate the past nor to seek merely to be refined and ennobled by it, but to detect the secret of its commerce with nature, so that we may become equally fruitful.

Florentine painting and the Antique

While Mantegna chiefly put the art of Rome to the first of these uses, his Florentine contemporaries cared to profit by the last only. So carefully did they abstain in the serious figure arts from any direct imitation of the Antique, that we can seldom trace its influence upon Quattrocento sculpture and even less upon Quattrocento painting in Tuscany. The utmost that would appear is that these arts benefited by the cult of physical beauty exemplified in ancient marbles and by the study of Greco-Roman proportions. Many of the Tuscan painters illustrated themes taken as directly from Latin poetry as any of Mantegna's, but they used their own visual imagery, their own forms, and their own accent. If we place Pollaiuolo's paintings of the Hercules myth, Botticelli's 'Spring' and 'Birth of Venus', and Signorelli's 'Pan' alongside of Mantegna's 'Parnassus', we shall have to acknowledge that his alone is painted, so to speak, in Latin, while the others are in pure Tuscan. Nor was there any diminution in the aloofness of Florentine sculpture and painting from any direct imitation of the Antique. Michelangelo seems more antique only because he so nearly reconquered the position of Antiquity. For the pursuit of tactile values and of movement, followed strenuously, and unhampered by the requirements of Illustration, tends to create not only the type of figure but the cast of features known as Classic.

In spite of these differences in purpose and method between Mantegna and the Florentines, the former labouring to reconstruct the world as seen by an imperial Roman, and to reconstruct it in that Roman's visual language, the latter toiling to master form and action, and design based upon form and action, Mantegna nevertheless owed

to Donatello and to Donatello's countrymen more than he owed to the Antique. He owed to them the knowledge and skill that it took to differ from them and to try to be antique.

We have already had occasion to note that in the thirteenth century at Rheims, at Capua, at Ravello, and at Pisa, Greco-Roman sculpture had found deliberate imitators. But they were sterile, and Giovanni Pisano, the son of the ablest and most conscious of them, turned his face towards France to become all but the greatest of Gothic statuaries. In the fourteenth century the tide of Humanism began to run. Petrarch, its mightiest adept, who, it may be remembered, spent his last years worshipped like a present deity within the sound of Padua's bells, composed in Latin an epic intended at the same time to revive the memories of old Rome and to create a passionate longing for its glorious restoration. He was not indifferent to the fine arts, and he must have used his gifts of persuasion to induce his artist friends to follow his example and to share his task. It is clear that he failed, as he was bound to fail. The painter who before Donatello ventured to imitate the ancients was in the position of Petrarch attempting to learn Greek. A Calabrian monk read Homer to him and gave him a general sense of the narrative, but could not teach him to read for himself, because the monk lacked the analytical, articulated, grammatical knowledge of the language. A modern scholar of equal genius, in Petrarch's place, would be able to master a language to which he had far less of a clue, because he is the heir to a philological training of many generations.

Before he could profit by the Antique, the artist had to have some appreciation of its artistic superiority. It was not enough that he should revere it as the achievement of a glorious past. Nor was it enough that he should admire it for its handsomer faces and more impressive poses (if indeed, as is questionable, the Gothic sculptor or painter did in fact find the faces in Greco-Roman art more handsome and the poses more impressive than in his own). When the living traditions of a great art have been destroyed, the archaistic imitation of its products will lead no farther towards creation than the naïve imitation of nature. A reviving art must begin at the beginning, and endeavour to penetrate step by step into the secrets of art construction. At every step it takes it will discover in the Antique an indication of how the next step is to be taken. The progress of an art which revives under these conditions will be almost as rapid as that of the individual who in a few decades learns what humanity needed a thousand centuries to acquire. But the Antique, in order to produce this effect, must be

The rise of Humanism

Stimulus of the Antique

accessible in sufficient examples of its best work, and it must encounter men of so vigorous an independence that its masterpieces will not lure them into imitation.

Donatello and Brunellesco, Uccello and Masaccio may have had the independence of mind to resist the allurements of Antiquity, but they were not severely tested, for, in their earlier days, at all events, ancient works of art were scanty and of a low order of merit. They were obliged to recover most of the secrets of art-creation for themselves. Had it been otherwise, it is possible that they would have been saved much waste, much affectation, and much bad taste. One must not dwell on the thought of all that might have happened had Donatello known Pheidian or—still more fascinating speculation!—Greek Archaic art! But as he and his countrymen had never seen the Elgin marbles, the Aeginetan and Olympian pediments, or the Delphian bas-reliefs, it is to their lasting glory that they at least knew better than to imitate the specimens of debased Greco-Roman sculpture which alone were accessible to them, and that they dared to be archaic for themselves.

Archaic and
archaistic art

For no art can hope to become classic that has not been archaic first. The distinction between archaistic imitation and archaic reconstruction, simple as it is, must be clearly borne in mind. An art that is merely adopting the ready-made models handed down from an earlier time is archaistic, while an art that is going through the process of learning to construct the figures and discover the attitudes required for the presentation of tactile values and movement, is archaic. On the other hand, an art which has completed the process is classic. Thus, while Niccolò Pisano may be ranked as archaistic, Giotto and his

'Classic' art

school are classic and not archaic, as also the Van Eycks and their followers, the French sculptors of the thirteenth century, and the Chinese and Japanese artists since many centuries. Merely primitive or even savage art is not necessarily archaic. There is, for instance, little of the archaic in most Egyptian art, and as little in Aztec carvings or Alaskan totem-poles. On the contrary, a painter of the nineteenth century, Degas, may boast of being archaic. And of course most

Definition of
archaic art

Florentine artists of the fifteenth century were archaic, for they were making for a goal which none of them could hope to touch. That goal was an art compounded of nothing but specifically artistic motives.

This definition gives even more than it promised, for it clearly suggests the reason why we care so much for genuinely archaic art. It is because such art is necessarily the product of the striving for form and movement. It may fail to realize them completely; it will by definition fail to realize them in proper combination, for then it would

already be classic; it may exaggerate any one tendency to the extreme of caricature, as indeed it frequently does: but through its presentation of form, or of movement, or of both, it never fails of being life-enhancing.

The same definition further suggests the chief reasons why Quattrocento Italian art was inferior to the Greek art of more than twenty centuries earlier, and why it led to no such great results. Renaissance art, although it had no acquaintance with the best products of Antiquity, was yet not frankly enough archaic. It may in a sense be called somewhat archaistic, seeing that it never completely emancipated itself from the art of the past, its own immediate past, if not the remoter past of Rome. Thus, in the allegorical figures on his 'Tomb of Sixtus IV', even so advanced and original a genius as Pollaiuolo never wholly abandoned the vapid elegance of the Romance of the Rose period. There was, moreover, the further difficulty of the subject-matter imposed upon the artists from the outside, for extra-artistic reasons, a subject-matter whose resistance no one could sufficiently overcome. The Greek archaic artist was more fortunate, enjoying the inestimable advantage of a free hand in the making of his own gods. Thanks to a hundred causes, the Greek artist of the pre-Pheidian time was the dictator of theologians and not their slave. The aspects and actions of his gods, being the creation of a specifically visual imagination, were necessarily perfect material for the sculptor and painter. Not so the gods of Christendom, who were fashioned by ascetics, mystics, philosophers, logicians, and priests, and not by sculptors or painters. The Greeks had the further advantage, that they could believe their gods to be present in the most strictly plastic work, while the Christians, before they could believe that their gods were so much as represented by an image, had to prove it by values current, not in the world of visual beauty but in the realms of mysticism or in those of dogmatic theology and canon law. Small wonder that, with such convictions, Michelangelo did not equal Pheidias, or that the precursors of the one did not dedicate themselves so entirely to pure art as the forerunners of the other.

Hampered then, as were the great Florentines, by too much reverence for the past and by the necessity they were under of representing personages and scenes which owed their origin to theology instead of to art, they were nevertheless working mainly in the right spirit, and were genuinely and hopefully archaic; and, for all his humanistic ardour, Mantegna, without the severe studies in the rendering of form and movement to which he was subjected by the tradition if not by

Reverence for the past

the personal stimulus of Donatello, would never have been able to record in any adequate semblance his vision of Antiquity. He must, at an age surprisingly precocious for even that century of early maturing genius, have become as well aware of his means as of his end, for as a mere lad he absorbed all that his Florentine teachers had to give him. But although he was gifted for whatever is essential in the figure arts as perhaps were none of their pupils at home, and endowed besides with a pictorial faculty that was unknown in Tuscany, Mantegna, in his earliest extant works, already betrays the subordination of the one and the suppression of the other. The suppression of his native impulse towards the pictorial was so complete that, but for two or three drawings, dashed off without effort, we should scarcely have suspected its existence. As for form and movement, he seems to have acquired before he was five and twenty nearly all he was destined to master. What progress he made later was brought about by mere force of momentum, for he never again gave them the first place in his thought. That place was taken by his Illustrator's purpose of reconstructing the Ancient World.

<div style="float:left; width:120px;">Mantegna's passion for antiquity</div>

There is no need to quarrel with Mantegna for preferring pagan to Christian subject-matter. Indeed, it was but his duty as an artist. We can readily sympathize with his passion for Antiquity, and love his vision of a perfected humanity, for among the many dreams of Perfection that have been dreamt, his is surely one of the healthiest and noblest. But we may well quarrel with him for the uncritical attitude he adopted towards the Antique, and deplore its result. Even had the Antique he was acquainted with been of the best, he should have endeavoured to fathom the secret of its craft rather than to copy its shapes and attitudes. Thus, and thus only, could he have drawn clear profit from it. But the Antique that he knew was, with the rarest exceptions, of a debased kind, a product of the successive copying of many generations. In types and poses these works did, it is true, retain something of their primitive beauty, but in every other respect they were listless, lifeless, and mechanical. Englamoured and undiscriminating as only an Italian Humanist could be, Mantegna was blinded to the fact that his models were, in everything but conception, inferior to the work of his own peers and contemporaries. If he had to put the art of the past to the use of a ferment, it was certainly unfortunate that he drew from a cask broached so long ago that all its flavour had evaporated. He was saved from insipidity only by the vigour and incorruptibility of genius. Quality of touch is a gift that nothing but physical decrepitude can take away, and, although he

doubtless wasted much of his talent upon the monstrous effort to assimilate an execution inferior to his own, he received no fatal injury.

The effort, however, did not advance him. Perhaps but for this waste of energy, his zealous quest of line would have been crowned with far greater success. Not only did he fail of the triumphs of Botticelli, but he never quite reached the full use of contour, of functional line, stopping short in his development at the outline, at the line that circumscribes but does not model.

Another factor of kindred origin contributed to his shortcomings with regard to line in contour. In his effort to assimilate the precise touch of his antique models, it is not surprising that, instead of waiting to evolve a canon of the human figure out of his own experience of form and movement, he attempted to adopt the one created by the Ancients. He succeeded only too well; but it could not end there. Active people cannot stand still. If not deliberately, then all the more certainly, do they speed forward on the path they have taken. Well for them if it is a genuine highway and not a blind alley. In each art there are a few things, and only a few, capable of intensification; and fruitful activity consists in taking hold of at least one of these things and working upon it. There are many other things, alluring and specious, which seem to promise profitable returns for outlay. Nor are their promises brusquely falsified. It is part of their wickedness that they do seem to pay: only, like other gifts of evil spirits—so our ancestors used to believe—like the luscious fruit that moulders to dust, or the ruby wine that changes into wind at the touch of the lip, these profits turn quickly to dross. To take another metaphor, they not only bring no interest upon investment, but show a capital so diminished that a few successive operations dwindle it away to nothing. In the figure arts it is an almost irresistible temptation to take over shapes and attitudes already evolved. By their means one seems so quickly to acquire charm, beauty, and dignity. Unfortunately shapes and attitudes are among the things that do not admit of intensification, but only of schematization; and Mantegna, in the measure that he took them over from the Antique as a canon ready made, tended to reduce them, despite obvious appearances to the contrary, to mere calligraphy. For contour, being line in function, line that renders the form and gives the pulse of life, cannot be found by travelling in the opposite direction!

The facility and accomplishment which mark the first steps of decay are apt to be mistaken for symptoms of the contrary process, especially when these steps are taken by an artist in such apparent rude health as

Dangers of the Antique

Mantegna. But other faults resulting from the imitation of the Antique may be brought home to him more easily. We have noted already how he tended to paint people as if they were made of coloured marble rather than of flesh and blood, and remarked that this may have been due to his naïvely thinking of the Ancients—those Ancients whose resurrection was his chief aim—as having had in real life the only aspect in which he knew them, the aspect of marbles in the round or in relief. We may well admire and like these beings when they are endowed, as they not infrequently are in Mantegna's earlier works, with all the splendour and grace and even tenderness of human beings, but built of a more insensible, more incorruptible material. Human qualities in such creatures have something more poignantly touching, just as the expression of tenderness is so much more appealing in a poetry like the Latin, because nothing has led one to expect it of the Roman and his hard lapidary language. We should find no fault with Mantegna on this score if, at other times, and more often, he did not betray the coarse and even vulgar inspiration of post-Augustan sculpture. But it is carrying things too far to confine one's attention so closely to men and women in marble as never to look at life—life, the only inexhaustible field for study, for experiment, for suggestion. One would be tempted to doubt whether Mantegna had ever seen with his own eyes—for I venture to believe that a man may be an artist of high, almost exalted rank, and yet never see with his own

Pl. 332 eyes—if, in his portraits in the Camera degli Sposi and elsewhere, we did not find proof that he possessed an almost unrivalled power of direct observation. It is unfortunate that he put it aside, prodigally blinding himself to all light that was not reflected from Roman bas-reliefs.

The Roman The Roman bas-relief took greater and greater hold upon him.
bas-relief There he found the forms, there the substances, there the arrangement of his ideal world, and he seems to have ended by seeing not in three dimensions but in the exquisitely artificial space-relations of low relief. In his last years, casting variety of tint like a vain thing from him, he painted more and more in monochrome, ending with such stone-coloured canvases as his London 'Triumph of Scipio', the Louvre

Pl. 334 'Judgement of Solomon', or the Dublin 'Judith'. It should be added that these final performances come dangerously near to being repro-ductions of Antonine bas-reliefs. But from this ignominy he was saved to some extent by his genius, and even more by the nervous silhouetting he had learned from Donatello.

Too great devotion to the Antique thus hampered Mantegna in all

his movements, checking in every direction his free development, and curbing the natural course of his genius. This, however, was so prodigious that despite the mummy-cloths that he wrapped about him, he burst through them and walked more freely than most others not so self-handicapped. There is but one more addition to make to the inventory of his errors, and this relates to the subjects of which he made choice. His Florentine rivals, seldom forgetting that the real triumphs of art are reserved for those who exploit the elemental, eternal, inexhaustible resources of Form and Movement, rarely failed to seize an opportunity to compose accordingly, or to create an opportunity if one did not present itself. Botticelli, even where the subject was given him, as it doubtless was in the 'Spring' and the 'Birth of Venus', produced creations of so purely decorative an order that the merely illustrative material is completely consumed away. Even more is this the case with Pollaiuolo. He also loved the Antique. But note what subjects he chose to illustrate: 'Combats of Gladiators' and the 'Deeds of Hercules'. He selected themes which dissolve themselves without residue into values of form and movement, creating of themselves their necessary shapes, attitudes, and relations. But Mantegna, here again, was tied hand and foot. Determined to revive Antiquity, he did not sufficiently consider whether a given subject, given shapes, and given attitudes were those calculated to produce the really great work of art. The humanist in him was always killing the artist. Consequently, although he is magnificent and inspiring, he never produced a composition approaching the 'Combat of Gladiators', nor a painting to rival the 'Spring'. His 'Combat of Virtue and Vice' is choked with unconsumed illustrative material, and even his 'Parnassus' fritters away one's attention on various archaeological side-shows, for thus they may irreverently be called, seeing that they are artistically unrelated to the main composition of the picture.

Choice of antique subjects

This, in brief, is what I have to say of Mantegna, whom so much of me loves and worships. Perhaps it will help my readers to understand my view of him if they are told that in essentials, although on a much grander scale, he seems to have been not unlike a great artist of our own day. Like Burne-Jones, he was archaistic rather than archaic in his intention and romantic in his attitude towards the past, and, like Burne-Jones, he substituted a schematic vision for a remarkable native gift of observation.

It is a pity that so highly gifted a genius went astray. Had Mantegna devoted all his talents to the real problems of painting as a figure art, he might, besides creating masterpieces intrinsically finer, have

transmitted such a feeling for serious construction as would have uplifted all the schools of Northern Italy, and prevented Correggio from being so boneless, and Veronese so ill-articulated. As it was, he accomplished little more than to help bring about a change in visualizing, and to bequeath a passion for the Antique. It was in no slight degree due to him that the region where he lived, fostered or employed the most archaizing sculptors, bronze-workers, and architects of the Renaissance. But he left no direct heirs, and it was only as an Illustrator that his influence on the art of painting perpetuated itself. His cult of Paganism prepared the way for Giorgione's 'Fête Champêtre' and Titian's Bacchanals.

V

Past and present views on art

At this point, the eighteenth-century critic, who was apt to be both shrewd and rational, would have turned his attention first to Leonardo and then to Correggio. I confess I envy the giant strides which enabled the writers of old to pass from peak to peak, unconscious of all that lay between! Any picture that interested them, they set down to some well-known master; and if the picture chanced to be of Lombard origin, it had to be a Mantegna, a Leonardo, or a Correggio. Their attributions were more frequently wrong than not, but their attitude was, in the main, right. To the objections of us latter-day connoisseurs they could have replied that Art formed no exception to the rest of their interests, which were always intellectual, and that, intellectually, there was little or nothing calling for attention in painters whose works might be easily assimilated to those of their more famous peers. Perhaps theirs was too rationalistic and lofty an attitude, but it stands in refreshing contrast to the microscopic outlook and groping methods from which we suffer. If we could return to it, we might devote the resulting leisure to the study of Art.

The study of art, as distinct from art-fancying, and from the biography of artists, should be, in the first place, a study of the specific ideas embodied in works of art. From this point of view, there is nothing to be said about the North Italian contemporaries of Mantegna that has not already been said about him; he subsumes them all. Their purpose, when they had one, was not different from his. Most of them followed him. A few walked and some stumbled or staggered independently, but all took his road. It would be difficult to find among them a single idea—by which I mean, in the figure arts, a motive exploiting the possibilities of form and movement—which

Mantegna had not used better. The student of art might well ignore these minor men, but of the small number for whom art, as art, has any meaning, few are students. The rest are fanciers or pedants, and it is to them, and as one of them, that I shall speak of the Quattrocentists of the valley of the Po.

VI

Among the North Italians who were young in the third quarter of the fifteenth century, there is no painter of mark who did not study at Padua or under someone fresh from her studios. At first, it seems mysterious that one town, and that by no means the largest or most convenient, should have exerted such an influence; but on closer inspection it appears that the whole country had been carefully prepared to join the new movement, for the Humanists, during three generations, had been preaching the emancipation from the canons and symbols of the Middle Ages, in favour of a return to the Antique. Northern Italy was therefore, like Tuscany, intellectually ready to take the new step, and there lacked nothing but initiative and a practical acquaintance with the means. These were furnished by Donatello at Padua, and when you add to this the emulation aroused by the successes of the adolescent Mantegna, and the seductive advertisement supplied by the applauding Humanists, it is easy to understand why all the young and gifted flocked to Squarcione's workshop. There each acquired what his energy enabled him to graft upon his own gifts, as these had been already modified by his previous training at home under a local teacher. Thence they brought away even more than they had bargained for, since, along with an enthusiasm for Antiquity, they caught the contagion of an ardent, if sometimes short-lived, realism. When they returned home, they radiated the new knowledge, and before the greater number of them had died, the revolution was complete. Excepting in remote upland valleys, no painters remained who visualized and rendered in the old way.

The Paduan school

Of the young men who flocked to Padua, none brought greater gifts, none drank deeper of Donatello's art, and none had a more remarkable destiny than Cosimo Tura. He founded a line of painters which flourished not only in his native town of Ferrara, but throughout the dominions of its Este lords and the adjacent country from Cremona to Bologna. It was destined that from him should descend both Raphael and Correggio.

Tura

Yet nothing could be more opposed to the noble grace of the one,

Pls. 336-7

or the ecstatic sensuousness of the other, than the style of their Patriarch. His figures are of flint, as haughty and immobile as Pharaohs, or as convulsed with suppressed energy as the gnarled knots in the olive tree. Their faces are seldom lit up with tenderness, and their smiles are apt to turn into archaic grimaces. Their claw-like hands express the manner of their contact. Tura's architecture is piled up and baroque, not as architecture frequently is in painters of the earlier Renaissance, but almost as in the proud palaces built for the Medes and Persians. His landscapes are of a world which has these many ages seen no flower or green leaf, for there is no earth, no mould, no sod, only the inhospitable rock everywhere. He seldom finds place even for the dry cornel tree which other artists, trained at Padua, loved to paint.

There is a perfect harmony in all this. His rock-born men could not fitly inhabit a world less crystal-hard, and would be out of place among architectural forms less burdensomely massive. Being of adamant, they must take such shapes as that substance will permit, of things either petrified, or contorted with the effort at articulation. And where the effort at movement produces such results, expression must freeze into grimace before it has reached its conclusion.

Where there is harmony there is necessarily purpose, and Tura's purpose is clear. It is to realize substance with almost maniac ferocity. He will have nothing in his world which will not firmly resist his conquering embrace. Nothing soft, nothing yielding, nothing vague. His world is an anvil, his perception is a hammer, and nothing must muffle the sound of the stroke. Naught more tender than flint and adamant could furnish the material for such an artist.

Tura had drunk too deeply, perhaps, of Donatello's art, and had his vision too much englamoured by Mantegna's earliest achievements. And who knows what flower-like, ghost-like medieval painting he was violently revolting from, to lead him to exaggerate so passionately the only principle he seems to have grasped at Padua? Hokusai, in his extreme old age, used to sign himself 'The Man-mad-about-Drawing', and with equal fitness, Tura, all his life, might have signed, 'The Man-mad-about-Tactile-Values'.

To this one principle he sacrificed the whole of a genius kindred and perhaps not inferior to Pollaiuolo's. With no conspicuous mental training and lacking, like all provincials, the intelligent criticism of serious rivals, he was never driven out of his narrow formula into a more intellectual pursuit of his art. He ranks, consequently, not with his Florentine peers, but with another product of the Paduan school, Carlo Crivelli. The one exaggerates definition as the other exaggerates

precision, and like all born artists who lack adequate intellectual purpose, both ended in the grotesque.

Not so evil a fate this, when all is said and done! Next to Giotto and Masaccio, to Leonardo and Michelangelo, and their glorious company the world over, we must place the artists who, with an infinite gift for quality of touch, never passed beyond the point of creating designs that demand the utmost vitality in every detail. Now a design inspired by delight in nothing but life-enhancing detail is bound to turn into the grotesque, and the makers of these designs are always masters of this art, as the Japanese, for example. To them we must not give our highest esteem, but it is difficult not to love them as much as the best, for to love is to have life enhanced by the object loved.

And so Tura is much loved, for he was a great master of the grotesque, and of the heraldic grotesque, which is its finest form. His works abound not only in the unconscious, but in the deliberate grotesque. He revels in strange sea things and stranger land things. He loves symbolic beasts, and when he paints a horse, as in his 'St. George and the Dragon', he gives him, as an armourer would, a proudly heraldic head. Pl. 336

Another reading of Tura is possible. It may be that his purpose was merely illustrative, and that he loved this arid, stony world of his, inhabited by rock-born berserkers, as others love the desert, or glaciers, or the Arctic regions. These are inspiringly tonic to some temperaments, and, in aesthetic form, to all of us. The illustrator who communicates ideated sensations which compel us to identify ourselves with such virility, with such proud insensibility, with such energy and endurance, is an artist indeed. Which is the right interpretation of Tura is of no consequence, for in him, as in every complete artist—and Tura was complete though narrow—Illustration and Decoration are perfectly fused.

VII

It would take no considerable changes to make these paragraphs on Tura apply to his slightly younger townsman, Cossa. They form a double star, each so resembling the other, and of such equal magnitude, that it is not easy to keep them apart, nor to decide which revolved round the other. Prolonged acquaintance, however, reveals differences of purpose and quality, due partly to a difference in orbit. Tura veers towards Padua, while Cossa is attracted by the more specifically pictorial influence of Piero della Francesca, the mighty Tuscan, who worked for a time at Ferrara. Cossa

Pls. 338-9 Cossa took over Tura's world bodily, and, when possible, exaggerated it. His landscapes are as sublimely sterile as Tura's, and, to deepen the desolation, his architecture is shattered to ruins. His figures are no less convulsed with energy, and if they are less haughty, it is only because they condescend to be insolent. He took over, as well, Tura's violent realization, but he was saved from the consequence of intensifying it to the utmost by the example of Piero's large planes and quiet surfaces. Thanks to these, he learned to broaden to a boss what in Tura would have remained a knob. To Piero again, Cossa owed his interest and consequent eminence in the treatment of diffused light; but to his own genius alone did he owe his command of movement.

His distinguishing characteristics are due to this. Where he departs in type from Tura, it is largely owing to greater mobility and more detailed articulation. Like all artists with unusual feeling for movement, he understood functional line, and the contours of his figures gain thereby a correspondence to tactual impression as convincing as it is in Pollaiuolo or the young Botticelli. Even the insolence of most of his figures may be due to his putting them in motion, for insolence is only haughtiness in action.

To the same source may be traced his unexpected rendering of the holiday life of his time that we find in the 'Schifanoia'. He paints a race between slim horses and men and women runners, each with an individual movement, yet all together making a continuous pattern. They are watched with evident delight by onlookers, among them elegant court ladies, stretching their lovely necks from balconies. Line cannot be too ductile to convey action so quick and contours so delicate. No Greek bas-relief or vase can show a design more swift.

It required faculties of all but the most exalted rank to create a Pl. 338 figure like his 'Autumn' at Berlin. She is as powerfully built, as sturdy and firm on her feet, as if she had been painted by Piero himself; but in atmospheric effect and in expression she reminds us of Millet and Cézanne.

The artist who had this range and this touch might have left who knows what, had he but added intellectual purpose, and had he while still young migrated to Florence instead of to Bologna.

VIII

Ercole Roberti Tura's and Cossa's austere vision of vehement primeval beings in a severely mineral world suffered a certain change as it passed into the eyes of their ablest follower, Ercole Roberti. While remaining, at all

events in his earlier years, an artist of a high order, he was much more given to Illustration than to Decoration. He was thus keenly alive to the 'literary' qualities in the works of his predecessors, and used them with full consciousness of their emotional effect. But this exact effect could, if he had but known it, only be produced by its own causes, and not by using itself as building material; for then it became a new cause, bound to have another result. The fresh product would very likely appeal even more vividly to a poetical mood, and yet it must end in a mirage, standing for nothing. Pls. 340-3

It seldom came to this with Ercole, thanks to certain compensating qualities he possessed. Either because he lacked his masters' feeling for substance, or because they themselves were not intellectual enough to teach it, his works never produce anything like the conviction that theirs inspire. His pattern tends to be calligraphic, as it must be when composed of figures that have more volume than bulk, with limbs at times little more than silhouettes, with feet that seldom press the ground, and hands that never grasp. Before his Dresden 'Betrayal' and 'Procession to Calvary', if you stop to think of the substance in the figures represented, you must conclude that they consist of nothing solid, but of some subtle material out of which they were beaten, like repoussé work, having no backs at all, or with hollow insides. But, on the other hand, he had enough feeling for functional line to enable him, if not to communicate movement, to present action so that he succeeded in conveying a sense of things really happening. Then, he understood almost as well as his Umbrian contemporaries, or as Millet among moderns, the solemnity of the sky-line, and the sense of profound significance it can impart to figures towering above it, as we see in his Berlin 'Baptist'. Moreover, in his best pictures, such as the Dresden *predelle*, the figures are so sharply silhouetted, and so frankly treated like repoussé work, that, far from taking them amiss, one is bewitched by their singularity. Finally, his colour has the soothing harmonies of late autumn tints. Pl. 342

Yet none of these qualities and faults, nor all of them together, explain the fascination of the man, which is to be looked for rather in his gifts as an Illustrator. These gifts were of the intensest type, although narrow in range. There is in the works already mentioned, in the Liverpool 'Pietà', in the Cook 'Medea', and in the mono- chrome decorations in the Brera altar-piece, a vehemence so passionate, an unrestraint so superhuman, that we surrender to them as we do to every noble violence, happy to identify ourselves with their more vividly realized life. If ever man had 'wrinkled lip and sneer of cold Pl. 341

command', it is Herod in the ferocious scene in the Brera painting representing the 'Massacre of the Innocents'. But the treatment as a bas-relief adorning a throne takes away all possible literalness, and leaves nothing but that delight in the absence of human sensibility which we get in the Icelandic Sagas, or, better still, in the flint-hearted last days of the Nibelungen Not.

Even as an Illustrator, Ercole recalls his masters, Tura and Cossa, as this description will have revealed. But in him the effect is deliberately aimed at, while with them it may have been but the unsolicited result of their style. Therefore, as Illustration, his work has the advantage of set purpose; yet nothing shows more clearly how small a part even the most fascinating illustration plays in art. At his best, Ercole Roberti is but a variation played by the gods on the much grander theme they had invented in Tura; and at his worst, as in his Modena 'Lucretia', he is fit subject for a sermon on the text that no Illustrator, who is not also a master of form and movement, retains any excellence whatever after he has worn out the motives he took over from some other artist who had had these essentials at his command.

IX

If miserable decline was the lot of Ercole, who had come in contact with reality at second hand and with intellect at third hand, we may
Costa know what to expect from his pupil, Lorenzo Costa, whose contact with life and thought was only at third and fourth hand. He began with paintings, like the Bentivoglio portraits and the 'Triumphs' in San Giacomo at Bologna, which differ from Ercole's later works only in increased feebleness of touch and tameness of conception. He ended with such pictures as the one in S. Andrea at Mantua, where there remains only the remote semblance of a formula that once had had a meaning. Between his earliest and his latest years, however, he had happy moments. Despite his predilection for types vividly suggesting the American Red Indian, an altar-piece like the one in San Petronio at Bologna has not only the refulgent colour of a well-tempered mosaic, but a certain solemnity and even dignity in the figures. But in the greater number of his works, the figures have no real existence. Usually they are heads screwed on—not always at the proper angle— to cross-poles hung about with clothes. Yet, even thus, his narration is so gay, his arrangement so pleasant, his colour so clean and sweet, that one is often captivated, as, notably, by the Louvre picture repre-
Pl. 344 senting 'Isabella d'Este in the Garden of the Muses'. Here, however,

as in most instances where Costa pleases, it is chiefly by his landscapes, which, without being in any sense serious studies, are among the loveliest painted in his day. Their shimmering hazes, their basking rivers running silver under diffused sunshine, their clumps of fine-stemmed trees with feathery foliage, their suggestion of delicious life out of doors, make one not only forget how poor an artist Costa was, but even place him among those of whom one thinks with affection.

Naturally the masters I have mentioned are the tallest trees in the little wood of Ferrarese art. There are many others growing under their branches, some of them clinging, like the mistletoe, to the boughs of the sturdiest oaks. In places the trunks and branches are so tangled and intertwined that as yet many a one has not been traced down to its roots. Bianchi, for instance, if he painted the impressive 'St. John' Bianchi at Bergamo and M. Dreyfus's Portraits of the Bentivoglios,[1] would deserve a high rank in the school. But a still higher place belongs to the author of the Louvre altar-piece ascribed to him. Its severely Pl. 345 virginal Madonna, its earnest yet sweet young warrior saint, its angels, so intent upon their music, the large simplicity of its arrangement, the quiet landscape seen through slender columns, the motionless sky, all affect one like a calm sunset, when one is subdued, as by ritual, into harmony with one's surroundings.

Before leaving, for the present, the school of Ferrara, a word will be in place about Francesco Francia and Timoteo Viti. Francia, whom meticulous finish, gracious angel faces, and quietistic feeling render Francia popular, was, from the point of view of universal art, a painter of small importance. Trained as a goldsmith, he became a painter only in his maturity, and thus he missed the necessary education in the essentials of the figure arts. But his feeling, before it grew exaggerated (when it anticipated his townsmen of a century later), was, in its quietism, at least as fine as Perugino's. No work by the Umbrian master is more solemnly gracious, tender, yet hushed with awe, than Francia's Munich picture of the Virgin stooping, with hands rever- Pl. 346 ently crossed on her breast, to worship the Holy Child lying within the mystic rose-hedge. Perugino, without his magical command of space effects, could never have moved us thus; and even Francia owes much of his modest triumph to his landscapes. Many of us have felt their dainty loveliness, and been soothed by such silent pools—*sine labe lacus sine murmure rivos*—such deep green banks, such horizontal sky-lines as give charm to his altar-piece in S. Vitale at Bologna.

[1] Now in the National Gallery of Art, Washington.

Timoteo Viti has left two pictures—the 'Magdalen', at Bologna, and the 'Annunciation', at Milan, which, as figure art, are perhaps as good as any of Francia's. It is not these, however, that earn him mention here. His importance is due to the fact that it was he who first taught Raphael, and that it was through him that the boy genius inherited many of the traditions which, in however enfeebled a form, had been handed down from the grand patriarch, Tura. It need scarcely be said that, in the condition in which it reached Raphael, it was a heritage he might have done well not to take up. At all events, it would have stood him in no stead if he had not added to it the wealth of Florence.

X

We return to Verona, this time not as to a capital of the arts, mistress of Italy between the Alps and the Apennines, but as to a provincial town, whose proud memories served only to prevent her taking the new departure at the most profitable moment and in the most fruitful way. Few of her young men seem to have frequented Padua while Donatello was there and while the revolution started by his presence was in full strength. Most of them stayed at home, sullenly waiting for its flood to sweep up to their gates.

The visit of Mantegna, in the flush of his early maturity, was a visit of conquest, and the altar-piece which he left behind at San Zeno remained, like a triumphal arch, a constant witness to his genius. From the neighbouring Mantua, where he established his reign, he kept Verona, for two generations and more, a fascinated captive at his feet.

In some ways this was unfortunate. As the Veronese painters had not known Donatello, nor been brought into contact with reality through a direct acquaintance with his sculptures, they could not understand the ultimate source of Mantegna's inspiration, and could only imitate its final results. These were by no means the inevitable outcome of Florentine ideals—which, as we recollect, were to base design on form and movement and space—but were more frequently the offspring of a desire to present his vision of the Ancient World in the accent of that world itself; and if this touch of a dead hand did not entirely paralyse his own, happily too vital and resistant, it did never-theless succeed in relaxing his contours to a slackness more readily found in Roman bas-reliefs than in the works of his fellow-pupils, Bellini and Tura. This over-schematized but very seductive product gave no monition to strive for understanding, but held out every

incentive to imitation. Although it will be granted that the first imitations retained something of the excellence of the originals, successive copying could not fail soon to have the usual consequences, decay and death. If Veronese painting was saved from these disasters, and lived to boast of a Paolo Caliari, it had to thank the solid heritage of naïve observation, colour feeling, and sound technique handed down from Altichiero and Pisanello, which, as was hinted earlier in this book, formed part of that fund of merit held by Verona in common with the rest of Northern Europe.

XI

The Quattrocento painters of Verona betray two fairly distinct tendencies. One of these, manifested most clearly and potently in Domenico Morone, was to admit nothing of the old spirit in adopting the new imagery and the new attitudes introduced by Mantegna. The other, headed by Liberale, was inclined to retain the old types and such of the old ways as would make a compromise with the new vision. So tenacious was this party of ancient traditions that it succeeded in transmitting them to the Cinquecento school which resulted from the fusion of the two movements.

Domenico Morone is known to us in his last phase only. In his one important work now extant, the amusing Crespi canvas, now in the Palace at Mantua, representing the expulsion of the Buonaccolsi by the Gonzagas, we have one of those Renaissance battles that partook more of a spirited dress-parade than of a field of carnage. Refined cavaliers on deftly-groomed horses are making elegant thrusts at one another, and at times even bending over each other as if with ungentle intention. But it is clear that they will do no harm; they are only taking poses that will show to best advantage their own graceful carriage and lithe limbs, and the mettle of their steeds. And charmingly indeed do they group in the midst of the broad city square, surrounded by its quaint façades, and backed by the distant mountains.

Domenico Morone

Pl. 349

The man who ended thus must have begun as a strenuous workman, for in art, as in love, 'none but the brave deserve the fair'. Indeed, at San Bernardino there exist ruined frescoes which betray no preoccupation with elegance and grace, but show every sign of having been done under the stress of an ambition to master form and movement. They also make one question whether their author had not studied in Padua. Faint echoes of his earlier struggles reach one from the works of his pupils, and further proof of a certain intellectual endeavour may be

Pl. 348

Pl. 351

discovered in the fact that these pupils comprised the best, with the one exception of Caroto, of their generation. But Mantegna's influence upon Morone ran contrary to intimacy with reality, and swept him away towards schematization and towards that kind of elegance which, in happy circumstances, is the first as well as the finest product of this kind of intensification.

Morone's followers Little remained to be accomplished by his son, Francesco, and his other followers, Girolamo dai Libri and Cavazzola. Being his imitators, they were by so much farther removed from the source, and, lacking his relatively serious training, they could not attain his gracefully vivid action. It is to their credit that they seem to have made no futile attempts, and that they confined themselves to spreading abroad unambitious, honest, and frequently delightful imitations and recombinations of the style and motives of their master. As serious figure art, their work ranks no higher than that of the Umbrians; and if they have not the compensating space harmonies of those artists, they please and tarnquillize one almost as much with their poetical landscape backgrounds and soft diffused lights. Their arrangement is as restfully simple, while their grouping is perhaps larger. Their types are frequently as quiescent and even as ecstatic, although they exhale at the same time the well-being that turns each picture of their descendant, Paolo Veronese, into a temple of health. Then they have a radiance which they shared with the Venetians only, due to the treatment of colour as substance, as the material out of which the visible world is made, not as if it were only an application on the surface of matter, as colour was regarded elsewhere in Italy. For these reasons one may rank the school of Domenico Morone on a level with Perugino's, provided one first excluded Raphael. It is excluding much, but the Umbrian remainder is almost as inferior to the Veronese average as he is above it.

One can speak of Domenico's followers thus together, because their resemblances are so much more striking than their differences. Nevertheless, each introduced the newness his temperament could not avoid.

Francesco Morone Francesco Morone was the severest of them, as if educated while his father was still in his more archaic and more earnest humour. Indeed, his 'Crucifixion' at San Bernardino in Verona, with its cross towering gigantic over the low horizon, and its firm figures, must count among the most inspired renderings of the sublime theme. He declined from this strenuous mood, but without losing his poetical feeling, which expressed itself chiefly in skies filled with cloudlets, purpled and bronzed with transfiguring sunrise or sunset lights. He had an almost

Giorgionesque gift for fusing landscape and figures into romantic significance. His 'Samson and Delilah' at Milan transports one to a world of sweet yearnings, of desires one would not have fulfilled, into a lyric atmosphere which tempers existence as music does.

Pl. 350

Girolamo dai Libri was perhaps the most talented of Domenico's pupils, and certainly the most admirable in achievement. He not only had greater solidity and better action, but he attained to fuller realization in landscape. And of landscape he was, if not a master, at least a magician. What views of grand and beautiful yet humanized nature, full of comforting and even poetical evocations, all bathed in warm tranquil light! What distances, too, as in the 'Madonna with Peter and Paul' of the Verona Gallery, where the three figures frame in, like an arch, harmonious expanses of flood and field, of mountain and meadow! Girolamo just failed of being a great space-composer, another Perugino.

Girolamo dai Libri

Pl. 352

Cavazzola, the youngest of the group, the least at ease in its traditions, but lacking the genius to react against them fruitfully, is, except in portraits and in landscapes, somewhat distasteful. But at times, as in the portrait at Dresden, he attains to an almost Dürer-like intensity, while keeping to the large handling of his school. And in a landscape like the background of his Verona 'Deposition', he anticipates the quiet effects of Canaletto.

Cavazzola

Pl. 356

XII

At the head of the rival group of Veronese painters stood Liberale. He was trained as a miniaturist, and it is perhaps owing to this—for traditions last on longest in the minor arts—that in his types and colour-schemes he retained through life such a close connexion with the old school. But he did not escape the influence of the new art. Whether through coming in contact in Siena with Girolamo da Cremona, the most intellectual, imaginative, and accomplished of Italian miniaturists; or whether, on his return, through falling under the attraction of the grand sculptor Rizzo; or whether through having glimpses of Mantegna's and even Bellini's earlier masterpieces; or whether, as is indeed more probable, through all these in combination, he found ample opportunity of becoming acquainted with the products of the new movement. Unfortunately he never seems to have fully comprehended its springs of action, and hence his inferiority. Endowed by nature with an unusual if not deep sense for form and structure, and with a certain poetical feeling as well, Liberale, had he

Liberale

Girolamo da Cremona

enjoyed the education of a Florentine or even a Paduan, would not have been satisfied with the few remarkable works that were the accidental fruit of his talent, but would have learnt to exploit his gifts systematically, as the scientific miner delves for precious metals, and would not have been contented, like a thoughtless barbarian, with what he had the luck to find on or near the surface. Nor would he have painted, when inspiration failed, the feeble and contemptible pictures of his prolonged old age.

Liberale's
miniatures
Pl. 354
His beginnings were brilliant, for he was scarcely out of his teens when he commenced those illuminations which, although inferior to Girolamo da Cremona's, are still among the finest of Italian miniatures. They have alertness of action and extraordinary vigour of colour, while at times they all but attain the rare heights of Imaginative Design. Few who have seen them in the Library of the Cathedral at Siena will forget the blue-bodied Boreas blowing, or the white-turbanned, Klingsor-like priest at an altar, or the vision of the Castle St. Angelo. Not long after completing them he must have painted, under the influence perhaps of Bellini and certainly of Rizzo, his most intellectual and most admirable work, the Munich 'Pietà'. Despite its over-sinuous contours, betraying the miniaturist, and despite its draperies taken heedlessly from sculpture, in which art they are intelligible if not beautiful, this 'Pietà' is impressive in feeling and convincing in effect. It does not occur to one to question the existence of the figures, the reality of their action, or the genuine pathos of their expression. Still under Rizzo's impulse, he painted two Sebastians, one now in Berlin and one in Milan, which are among the most comely if not the most fully realized nudes of their day, figures which, for their shortcomings as well as for their virtues, may be compared with Perugino's Sebastian in the Louvre. The Milan example has for background one of the best presentments in existence of a Venetian canal with its sumptuous palaces and out-of-door life. Even greater delight in architecture, the beauty of its material, its relation to sky and landscape, and its decorating subservience to man—all those qualities which afterwards played so superb a part in Paolo Caliari's art—are displayed in Liberale's most charming work, his National Gallery 'Dido'. On the other hand, such a picture as the 'Epiphany' of the Verona Cathedral, while based on Mantegna's great creation in the Uffizi, has something rustic and Tyrolese about it, as if a shepherd accustomed to yodelling were trying to sing Bach's *Christmas Oratorio*. And Liberale's late works prove how little he had submitted himself to the serious discipline of the figure arts, for most of them are mere rags.

XIII

We need not linger here over such followers of Liberale as Giolfino, with his taste for ugliness occasionally relieved by a certain whimsical winsomeness, nor Torbido, who, before he was swept away by the deluge brought down by Giulio Romano, tasted of the pure springs of Giorgione's art, and, refreshed by them, painted two or three haunting portraits, such as the wistful young man in the Doria Gallery, or the ivy-crowned youth at Padua.

The best of Liberale's pupils was Francesco Caroto, on the whole the ablest Veronese painter of his generation. A sojourn at Mantua brought him under Mantegna's personal influence, which therefore not only affected him more vitally than it had his other townsmen, but prepared him to assimilate his own style to that of the more Mantegnesque among them. In him, therefore, the two tendencies of which we spoke before ran together and fused perfectly, while neither lost its qualities. But those qualities had never been intellectual, nor was Mantegna in his last phase the man to give Caroto the discipline he required. He lived without it, and with no ideas of his own; yet, vaguely aware of their need, he was humbly eager to take over Raphael's or Titian's, and was even ready to copy other people's designs.

Caroto was thus, in spirit, little more than an eclectic; but, happily for him, the traditional conventions of his predecessors still kept firm hold on him, and even when he strayed, he never strayed from their colour sense and their honest technique. On the contrary, by remaining faithful to these, he was able to improve and even extend them, and hand them on to become that almost unrivalled instrument which Paolo Caliari perfected.

There is something winningly simple in the comeliness of Caroto's women, as in the 'St. Ursula' at San Giorgio, and in the sturdiness of his men, as in the San Fermo altar-piece. In his landscape there is a haze and a distance, and, at times, a mystery suggestive of Leonardo. At his rare best, his colour partakes of the harmonies subtilized almost into monochrome of the late Titian.

XIV

Thus far we have dealt with artists whose mode of visualization never broke through the forms created at Padua under Donatello's influence and developed under the inspiration of the Antique by Mantegna. I

have spoken in Book III, *Central Italian Painters*, of visualization, how important a part it plays in art, how it is affected by success or failure in comprehending the specific problems of art, and how the works it produces modify and even dictate the way each one of us looks at the visible world. I need not repeat what was said there. But here, where the treatment is necessarily more historical, for the better understanding of what is to follow, I must add, in the abbreviated and almost cryptic form required by the exiguity of this small book, one or two observations that would need as many volumes for their full development with commentary and instances.

During the three centuries from about 1275 to 1575, when Italy created masterpieces deserving universal attention, two changes in visualization took place. At the beginning, we discover a method founded on line—first on dead line, to which debasement had reduced form, and then on ductile, and at times even functional line, which revived the attenuated forms, gave them contours, and lifted them up to the exalted beauty of the early Sienese. Under Niccolò Pisano, Arnolfo, and Giotto this linear mode of visualizing began to give place **Plastic** to the plastic, based upon the feeling for planes and the striving for **visualization** fully realized substance and solidity. Arrested by the lack of genius among the followers of these three pioneers, plastic visualizing had to await the fifteenth century for its complete triumph. The victory was scarcely achieved when that great but unconscious revolutionary, Giovanni Bellini, hitherto an adept of the plastic vision, began all at once to visualize in still another mode, which, to differentiate it from the linear and the plastic, I may call the commencement of the pictorial mode. This happened because he had a revelation of the possibilities **Bellini and** of colour. Before his day, except in a rudimentary way at Verona, **the pictorial** colour, no matter how enchanting in its beauty, was a mere ornament **model** added to the real materials, which were line in the fourteenth century, and line filled with light and shade in the fifteenth. With Bellini, colour began to be the material of the painter, the chief if not the sole instrument with which his effects were to be produced. Yet Bellini never dreamt of abandoning the shapes which the plastic vision had evolved; he simply rendered them henceforth with colour instead of with line and chiaroscuro; he merely gave up the plastic-linear for the plastic-pictorial.

Now, Bellini's great followers, Giorgione and Titian, were far too intellectual as artists, as well as too firmly rooted in a mighty and still recent past, to surrender, any more than their master did, the fine feeling for form, for movement, and for space engendered by the

Quattrocento. They and their companions and pupils remained still within the plastic-pictorial mode of visualizing, and never reached the purely pictorial—not Tintoretto, not even Bassano. But the Veronese, who started with a certain rudimentary sense of their own for colour as material, and quickly appreciated Bellini's revelation, had no continuous tradition of form, no steadying intellectual purpose, and they found it only too easy to drop the plastic element and to be purely pictorial.

XV

The first purely pictorial artist in Italy was Caroto's pupil, Domenico Brusasorci—a statement, it must be understood, made historically and not at all with intent to praise. By no means all Brusasorci's works, however, show him in this light. Most of them, while pleasant and occasionally delightful, tell a tale of groping and stumbling, with Caroto's baggage on his back, after Michelangelo and Parmigianino, Titian and Bonifazio. But in the altar-piece at Sant' Eufemia, in his frescoes at the Bishop's Palace, or those of even less intrinsic merit in the Ridolfi Palace at Verona, in certain decorations elsewhere in that town and at Trent, and in such portraits as the one in the Uffizi, which still passes for the likeness of Giorgione by himself, or, better still, in that of a lady, in the collection of the late E. P. Warren, of Lewes,[1] we find a way of handling contour, mass, and surface, of grouping and co-ordinating, even a dependence upon effects produced by actual brushwork, which only seem to us less modern than Tiepolo or certain famous painters of today because of their inevitable cargo of Cinquecento shapes and attitudes. Brusasorci's historical importance is therefore of the highest order, for, with this new vision resulting from the almost complete emancipation of colour from the control of plastic form and line, he designed afresh what came to hand, much as Giotto and Mantegna had done before him, leaving a mode of arrangement and lighting, as well as actual compositions, that his successors could take over with little or no change.[2]

One may ask why, if he brought in as much newness, he is not to be considered as great as Giotto or Mantegna. The answer is simple. Newness is a very minor consideration in the world of art. In that

Brusasorci

Pl. 358

Newness in art

[1] Now in the Rhode Island School of Design, Providence, R.I.

[2] It seems less certain now than it did three decades ago that the innovator was Brusasorci. Probably it was Paul Veronese. This artist's variety, fecundity, and pictorial mastery still await the recognition from our generation that previous centuries never failed to give him.

world it is the intrinsic quality only that counts, and that quality, no matter by what materials and with what vision it is obtained, must always be Form, Movement, and Space harmonized together: and of this harmony Brusasorci was only an inferior master.

His followers, Farinati, Zelotti, and Paolo Caliari, not to speak of others like Felice, his son, and Bernardino India, illustrate the value of the new material and formulae in a way that has been repeated perhaps millions of times since; for it is their mode of visualizing, if any, that still reigns in the world of painting. That mode, in the hands of genius, serves some of the highest purposes, but it affords no assistance whatever to the mediocre. These it does not, as did the Giottesque and Quattrocento traditions, draw forth, foster, and lead, enabling them to produce their best; it arms them with instruments beyond their feeble strength to wield; it furnishes them no guidance, and encourages them to seek for originality when they are only capable of anarchy.

Pl. 357

Farinati, despite much excellent work done after the pattern of Brusasorci, ended miserably, while Paolo, using the same patterns, lifted them by the force of genius into that Palace of Art where there are but few mansions, not all equal, but all great. I have spoken in Bk. I, *Venetian Painters*, of Paolo's career, and here I can but refer to

him briefly and in connexion with his precursors. In a sense, although he holds the relation to Brusasorci that Giotto held to Cimabue or Mantegna to Squarcione, he is not one of the very greatest artists. The lack of intellectual tradition in the school that produced him prevented his raising himself to the rarest peak of all. But taken as a whole, he was as much the greatest master of the pictorial vision as Michelangelo was of the plastic, and it may be doubted whether, as a mere painter, Paul Veronese has ever been surpassed.

XVI

We must turn back a century and more to the beginnings of the Renaissance in Milan and its dependencies. The art of painting must have had every material encouragement in a country so flourishing, abounding in opulent towns, not wanting in luxurious country gentry, and ruled by splendour-loving princes. There seem to have been painters enough and to spare, as we may infer from Giovanni da Milano's activity in Florence and Leonardo da Bisuccio's in San Giovanni a Carbonara at Naples. But the life of art must depend upon causes other than those merely economic and political, or it would not have to be said that Milan and all her lands never produced a painter

even approaching the first rank. She lacked genius, and was therefore always a dependency in matters aesthetic. In the fourteenth century her painters were provincial Giottesques; in the earlier decades of the next century they were humble, somewhat quaint followers of Pisanello; and the chronicle of Milanese painting for the remainder of that century and the first half of the Cinquecento would be brief indeed if we withdrew the names of Foppa, Bramante, and Leonardo. Foppa was a Brescian, trained in Padua; Leonardo was a Florentine, and so, in education, was Bramante. That there was a school of painting in Milan during all these years is as undeniable as that there was one during the same period in Rome; but it was scarcely more indigenous in the one place than in the other.

The most important work of the early Milanese Quattrocento still extant is the compendious cycle of frescoes in the Monza Cathedral, recounting the life of Queen Theodolinda. It is clear that they owe their inspiration to Pisanello, and it is interesting to observe how their authors have left out the modelling, relaxed the line, and added to the prettiness, particularly of the faces. One is almost tempted to accuse them of deliberate purpose in making away with all that might interfere with prettiness. | Pl. 355

What is true of these Monza frescoes holds true for the entire school of Milan. Prettiness, with its overtones of gentleness and sweetness, formed, as it were, the primordial substance of Milanese painting. Like an infinite ocean of soap-bubbles, it covered even the most salient figures with a formless iridescence, while less resisting shapes were dissolved into it as if they were dewdrops upon the shining sea.

If we stop to consider the nature and origin of prettiness, we shall soon understand why it is a source at once of inferiority and of popularity in art. Prettiness is all that remains of beauty when the permanent causes of the sensation are removed. Beauty is the quality we ascribe to things visible, when we realize that they are life-enhancing. In the figure arts that quality is the offspring of a perfect harmony between tactile values (or form) and movement. It finds embodiment in such shapes, attitudes, and compositions as enable the artist, with the vision he commands, to convey his effect. By themselves, these shapes, attitudes, and compositions are mere skins and, like skins, when removed from the bodies which grew them, they quickly wither, shrivel, and fall to dust. | Prettiness in art

The painter who lacks the capacity for tactile values and movement, in other words, the painter who has no creative talent, is reduced to imitating those who have; for in art all shapes, all attitudes, all

arrangements are in origin the outcome of the life-communicating power. Such an artist's imitation will necessarily be without form and void, for could he produce the effect of inner substance and vitality, he need not have imitated; it will have the skin of beauty without the life. Yet just as the human face at the moment when death robs it of the inspiring force and sustaining will, may, for an instant, wear its love-liest expression, so art, when smoothed out and simplified by the subtraction of vital modelling, and relaxed by the withdrawal of movement, becomes at that moment most seductive and alluring. The warmth of vitality, the life of life, that created it has not completely left it, while all that overwhelmed one, all that was as a Burning Bush, has given way to something quite within one's grasp, almost at one's mercy.

This is the moment in the decline of art when it necessarily produces prettiness (hence, by the way, the attractiveness of the first-fruits of a decline); and prettiness, being what it is, is, for the reasons already given, necessarily inferior. It is at the same time popular, because it is intelligible, even to the point of flattery.

It follows from what has been said, that prettiness can only appear when a given art movement has reached its climax, when full-blown beauty has been attained, and so consciously enjoyed as to tempt imitation of the apparent cause, the mere design or pattern. Prettiness is not easily generated by archaic art because, while art is in that condition, it is so obviously striving for the realization of form and movement that no imitation can fail to show signs of the same zeal, and therefore to partake, in no matter how feeble a degree, of its excellence. Archaic art, when aped, will result in crudity, in quaintness, in childish absurdities, but not in prettiness. When this does appear in the midst of archaic art, it may safely be considered as a survival from the last phase of finished art, as the Gothic prettiness which occasionally shows its bewitching face in the midst of all the stern endeavour of the Quattrocento.

It has been necessary to say these few words about prettiness, because the struggles it engaged in with real art take up so much of the history of painting at Milan, although more, of course, in its later than in its earlier phase.

XVII

Foppa Quattrocento painting in Milan, as we know it at least, owed its existence to Vincenzo Foppa. Although in composition and landscape

he occasionally shows traces of Pisanellesque training, he got his serious education at Padua along with the Bellini, Mantegna, and Tura. His achievement, as represented by works that have come down to us, is less in quantity and probably also in quality than that of his fellows. Yet it may be questioned whether, putting Mantegna on one side, Foppa's native talents were inferior to Tura's or even to the Bellinis'. Had these artists suffered his exile from all sources of inspiration, had they during their more plastic period been completely deprived of stimulating rivalry, they might have stopped where he did, or even sooner—as befell Tura, in spite of his later start and his close vicinity to Padua and Venice. That Foppa's arrested development was not due to natural torpor but to the lack of incentive, may be justly inferred from the perspective and the light and space in his National Gallery 'Epiphany', which tell us that, although he was then over fifty, he was quick to learn of Bramante.

Pls. 360-1

Pl. 360

It is even possible to imagine in what direction he might have developed under favouring circumstances. He reveals, in his treatment of figures and landscape, a powerful grasp of inner substance, but, excepting in architecture when painted under Bramante's influence, a singular indifference to the precise and sharp definition of surface. As perhaps no other master of his time, he tends to soften the impact between surface and atmosphere, and his feeling for colour is in accord, for he prefers silvery, almost shimmering effects, bordering on monochrome, to the variegated tints esteemed by the adepts of utmost definition. These few words will suffice to show that Foppa's instincts were not with Mantegna or Tura, but with Giovanni Bellini. Under as favourable a start the Brescian might have attained to pictorial vision as early as the Venetian, or even earlier, for he never, like Bellini, passed through an initial phase of intense precision of outline.

What he did attain, if much less, is still considerable. With his profound sense of interior substance he could not help having a grandeur of form at times recalling Piero della Francesca; and though he lacks the poetry of space and shuns rather than courts action, his compositions are among the most impressive of his century. He is never without merit. Even his action, as we must grant while looking at his two 'St. Sebastians' at Milan, is that of a master, and in a work like his Berlin 'Deposition' of a great master. In what other treatment of this subject do we find such anticipations of Michelangelo's noblest style? Then his conceptions, like Bellini's, have a smile of tenderness in their severity. Nothing is so near in spirit to the Venetian's Madonnas

Pl. 361 as some of Foppa's—for example, the one formerly belonging to Prince Trivulzio.[1] His colour schemes, with their pervasive silvery greys and subdued greens, are the perfect vehicle for all that he attempts to convey. In Northern Italy he ranks, indeed, after Mantegna and the Bellini alone, and his influence was scarcely less, for no nook or cranny between Brescia, the Gulf of Genoa, and the crest of the Mt. Cenis escaped it.

XVIII

Butinone and Zenale We cannot linger over Butinone and Zenale, the first and elder of whom seldom rises above the quaintness and whimsicality of that attractive little imitator of Donatello and Mantegna, Gregorio Schiavone; while the younger was sufficiently skilful to be able to graft certain minor Leonardesque fruits upon the rugged Foppesque Pls. 364–5 trunk. Together they painted a polyptych which still lights up with splendour the sordid market town of Treviglio, where both were born. It is, in the main, an offspring of Foppa's art, but less serious, more pleasing, and, above all, more gorgeous.

Borgognone The most remarkable of Foppa's followers was Ambrogio Borgognone—one is tempted to say the most remarkable native painter of the whole Milanese land. It is true that his range is limited, seldom carrying him beyond the horizon of his master, and it is also true that he is not conspicuous for peculiar excellence in form or movement or space-composition. Nor is he altogether free from the feebleness of the imitator, and from the prettiness which, in his later years, was deluging his country. But he has left us one of the most restrained, most profound, and most refined expressions in art of genuine piety. Were Christian piety the real source of the pleasure that Pl. 362 religious people take in painting, they would greatly prefer Borgognone to their actual favourites, Fra Angelico, or Francia, or Perugino. But they are attracted consciously by the sweetness of type in all these masters, and unconsciously by the charm of line and colour in Angelico, the cool, green meadows of Francia, and the space harmonies of Perugino. The Milanese is not so appealing on any of these grounds; nevertheless, besides being a rare and noble Illustrator, he was all but a great painter.

As a painter, he came perhaps as near as was possible for a man firmly fixed in habits of plastic visualizing to being a Renaissance Whistler. He had Whistler's passion for harmonies of tone, and

[1] Now in the Castello Museum, Milan.

synthetized, abbreviated, symbolized drawing. Such drawing could scarcely assert itself against the plastic sturdiness of his figures in altar-pieces, nor yet (although somewhat more) when he was putting in a set landscape; but in the glimpses he gives of city streets, of stretches of canal, of rural bits, and at times in quite small figures, his taste was more free to follow its bent. He then reminds one, as no other Italian, of the exquisite American. At Nantes there is an ideal harmony in grey, blue, and black that the modern artist could not easily have surpassed.

<div style="text-align:right">Pl. 363</div>

XIX

With Borgognone the Foppesque tradition in the Milanese disappeared. But, long before his death, it had put forth in Brescia, its founder's native town, a branch destined to extend it to its utmost limits, and to carry it over into the new horizons of pictorial vision, for which, from the first, it seemed so well adapted. Here, for the the present, we must leave it, until we complete our tale of Milanese painting.

We turn back to the beginning of the last quarter of the fifteenth century, when Foppa's style had not yet completely conquered the field. At that moment it received reinforcement from Bramante, who came to stay for many years in Milan. It may be questioned whether his influence upon Lombard architecture was wholly beneficent, seeing that his own forms were already so far advanced as to invite imitation and prettiness rather than solid comprehension, and thus acted there like a dissolvent, as Leonardo's art did to a much greater degree in his own domain of painting. Yet it is certain that in that domain too Bramante, though playing much less of a part, had an influence very significant and almost wholly for good. It could not be otherwise, for Foppa's problems were still his problems, while he brought to bear upon them one of the most soaring intellects of the age, developed under its most advanced and severest teaching.

<div style="text-align:right">Bramante</div>

As a figure artist we must rather infer him from certain Central Italian elements in the pictures of his followers than actually know him in his own works. Although he practised sculpture, painting, and even engraving, it seems clear that it was generally in subordination to architecture, if not actually dictated by it. Yet the few paintings that remain reveal a decorator in the most serious sense of the word, with heroic types, statuesque in pose, grand in form, and magnificent in movement, closely allied in spirit and pattern to those of Piero della

Francesca and his pupils, Melozzo, Signorelli, and 'Bartolommeo della Gatta'. Bramante must, however, have painted relatively little, or his influence on this art would be much more perceptible than it is. Although it doubtless extended to Zenale and others, its main channel was Bramantino. Through him it spread in due measure over the later stretches of Milanese painting, fecundating perhaps the best elements in the art of Luini and Gaudenzio.

Bramantino But as we might expect from one following close upon the footsteps of a master whose chief interest was another craft, Bramantino, in spite of such excellent attempts at serious treatment of form as are seen in General del Mayno's 'Christ'[1], soon sank to a formlessness meticulously devoid of substance, and a flimsiness the contemptible effects of which it takes all his fascination to dispel. Fascinating, however, he remains. In the first place, he inherited from his artistic forebears something of the poetic madness of the Umbro-Tuscans which all his native Milanese instincts for prettiness could not squander and bring to naught. At times he is positively captivating, as in the Brera fresco of the 'Madonna and Angels', or the Locarno 'Flight into Egypt'. His types retain something of Melozzo's grandeur, while anticipating much of Parmigianino's or Rosso's sensitiveness. Then, as Bramante's pupil, he had an exquisite feeling for architectural profiles, so that in truth many of his pictures would lose nothing except the massing of the general arrangement if the figures were absent. His practice of lighting as much as possible from below, and his fondness for poetical contrasts of light and shade, complete the impression of a style that is seductive for all its frequent intrinsic inferiority. If we seek for a groundwork of

Pl. 366 serious figure art in such works as the Layard 'Adoration of the Magi' (now in the London National Gallery), or the already mentioned 'Flight', we meet with disappointment; but they have something irresistibly winning—like the airs in Berlioz's *Enfance du Christ*.

XX

The rest of Renaissance painting in the Milanese is grouped around

The School of Leonardo the artist who so determined its character and shaped its course that it has ever since been known as his school—the school of Leonardo da Vinci—while its finest products have commonly passed for his own.

When towards 1485 that most gifted of Florentines settled in Milan, he was little over thirty; and, although he had behind him his

Pl. 192 'Epiphany', the least quaint and most intellectual design produced in

[1] Now in the Rohoncz Castle Collection, Thyssen Bequest, Lugano.

the Christian world up to that date, although he had already passed out of the region Mantegna held as his demesne and beyond the tasks its dwellers had set themselves, he had not yet reached his full growth. He still clung to many of the mere *impedimenta* handed on to him by Verrocchio; he still had to find his way to perfect freedom. It will scarcely be maintained that the road thither lay through the streets of Milan, and it may be questioned whether Leonardo would have found it at all if he had not returned to Florence. One even wonders whether, if he had never left his own city, he would not have attained to a much greater emancipation of his real self, and attained it much sooner; and one may well deplore that he was so long exiled from the focus of the arts, to its loss, to his own loss, and to the loss of beauty for ever. Imagine what might have been if he had had for pupils, or at least for followers, Michelangelo and Andrea del Sarto, instead of Ambrogio da Predis and Boltraffio! But he passed his best years in Lombardy, perhaps not unaffected by the pervasive passion for prettiness. Even a Leonardo was scarcely the better for having to paint the court beauties of that subtle sensualist, Ludovico il Moro. As the reward for everything is more of the same thing, these clients probably increased their demands with every revelation the mighty genius condescended to make of a loveliness hitherto perceived passionately but vaguely. Leonardo was thus, despite himself, an accomplice in chief in the conspiracy for prettiness; for if his sovereign art could illumine with beauty even the prettiest woman, this was quite beyond the reach of ordinary men, his scholars. Considerations of this kind may perhaps account for Leonardo's almost too great attention to the head, and for his carrying facial expression perilously close to the brink of the endurable: they may also account for the fact that never, during his long residence in Milan, did he find a full opportunity for exercising his highest gift, his mastery over movement.

If Leonardo was not the better for Milan, it may be maintained that neither was Milan the better for Leonardo. In the face of the productions of Predis, Boltraffio, Cesare da Sesto, Gianpietrino, Solario, Oggiono, Luini, Sodoma, and others, it may sound paradoxical to doubt that Leonardo's long abode was clear gain for the school. But most of these productions are of small intrinsic value. The only serious interest attached to them is that they record ideas of the master's; their chief attraction is that they record these ideas in terms so easy to grasp and remember that, like mnemonic jingles, they flatter the most commonplace minds. Take away Leonardo's share in these compositions, and you have taken away nearly all that gave them worth. We

The influence of Leonardo

Pls. 367-77

are grateful to these Lombards for preserving designs of the Florentine only as we are to disciples who have preserved sayings of Sages too absorbed or too indifferent to record them with their own hands. It is possible, however, that these Milanese painters, if left to their natural development, would have been capable of an utterance of their own not altogether without import. Perhaps if the great Etrurian lord had not reduced them to slave amanuenses, these secondary artists, stimulated by germane Venetian influences, would have developed out of Foppa's tradition a school of painting like the Brescian, but of wider range and longer breath; and it is not inconceivable that it would have culminated in an artist more like Veronese than like Luini.

Notoriously enslaving are minds more developed and ideas more advanced than one's own. The only conditions upon which they may do us good, forming better habits and teaching better methods, are patient submission and well-nigh endless imitation. But while we remain in this probationary stage, to the extent that we succeed in becoming copies of someone else, we are more interesting morally than aesthetically. Nor is it otherwise in the arts. The temporary effect of contact between the man who has solved most of the problems of his profession and the one who has solved only a few, is to make the latter throw up his problems altogether and abandon himself to imitating what he can—the obvious. In the domain of the figure arts, the obvious appears as shape, as silhouette, as smile. These are copied to the best of the imitator's ability, until the day when he understands just what, in terms of art, they mean: and that day frequently fails to dawn.

XXI

Leonardo's first effect on Milan was slight. Except in the most super-ficial way, it was felt solely by his few assistants and pupils. It may have been that he painted only for the Court and its connexions, and remained almost unknown to others; or that the local craftsmen were not ready to value his merits. For his first stay of fifteen years or more, if he had never come back, would have left relatively faint traces. It was only upon his return after a long absence that he exerted his prodigious, perchance disastrous influence. There had been time for the enthusiasm of his rare adherents, backed up by reports of his instantaneous triumph in Florence, to draw the attention of their companions to his greatness, and to bring all the young to his feet.

Leonardo's earlier followers at Milan were not only fewer in

number than his later ones, but less enslaved. They had known other masters, and had already formed habits that were hard to get over. Furthermore, he himself was still seeking, and although he was so close to perfection, he had not yet attained it. There was thus no finished product to entice them. If they imitated him at all, they had also to imitate something of his endeavour, and their work was necessarily the more vital for it. He was, for instance, constantly striving for that subtler and subtler intensification of modelling by means of light and shade which he finally attained in his 'Mona Lisa'; and some serious reflection of this striving is found occasionally in Predis and Boltraffio, but almost never in the younger generation, despite their showy high finish. It was no doubt due to this more intimate acquaintance with Leonardo's methods that Predis was able to execute a copy like his National Gallery 'Virgin of the Rocks', so much closer to the original than any copies of the 'Last Supper' made by the more glib imitators of the younger generation.

But even these early followers, who have left us so many straight-forward, dignified portraits of men, also fell into mere prettiness when they attempted to follow the master in the portrayal of charming women and peach-faced boys. Predis, the painter of the Poldi profile Predis of Francesco Brivio, all mind and character, could sink to the gipsy Pl. 367 prettiness of the 'Girl with Cherries' in New York; and Boltraffio, Boltraffio from the sturdiness of the male bust in the late Dr. Frizzoni's collection at Milan,[1] to the sugariness of the women's heads in the choir of S. Maurizio, or of effeminate lads like his youthful Saviours and St. Sebastians. Even Madonnas, probably executed on the designs of the master, and replete with his fascination, like those of the Poldi and National Gallery, Boltraffio contrives to spoil with sugar and perfume. Pl. 368 It was unavoidable: for Leonardo's heads of women and children had a tendency to sweetness which was kept down by the exercise of his sovereign power over form, but which was bound to assert itself directly that power was lacking.

It was much worse with those pupils who came under Leonardo when, returning to Milan, too busy to teach them in earnest, employing them as executants rather than scholars, he had completely perfected his art, and created types as incapable of further intensification as are his 'Mona Lisa' and the heads in his 'Madonna with St. Pl. 194 Anne'. Every attempt to reproduce them was bound, except in the hands of another Leonardo, to end in mere prettiness. And this perhaps wholly accidental result was unhappily only too welcome:

[1] Now in the collection of Conte Contini-Bonacossi, Florence.

once revealed it was bound to increase. By its own momentum, as it were, it would tend to greater and greater sweetness. It would absorb all interest, and end in sickliness, affectation, or sheer vulgarity, as so frequently it did in Gianpietrino, Cesare da Sesto, and Sodoma.

We Europeans, even when not aware of it, hold to our own individuality, and can never be content with merely copying our masters, however great they may be. Accordingly, when once the form has dropped out of a beautiful and significant face, how will the secondary artist assert his own individuality if not by making the face prettier and more expressive than the one he is imitating? Not only is there no other course, but this one is popular and remunerative. Yet that way lies Avernus, from which, proverbially, the return is not easy.

Prettiness in art

But why, one may ask, are prettiness and expression not sources of artistic enjoyment? The answer is that mere prettiness appeals, not to those ideated sensations which are art's real province, but directly to the head, to the heart, and to less noble parts of us; and appeals as actuality, not as art. The admirers of a pretty woman in a picture regard her with Stendhal's eyes as the promise of the same face in real life—it cannot be otherwise, since living prettiness is so overwhelmingly attractive. Prettiness is thus little more than a pictograph, and is scarcely an art quality at all, seeing that the figure arts have for their materials the only elements that in vision can cause direct life enhancement—form, movement, space, and colour—and of these prettiness is practically independent.

Expression is the twin sister of prettiness. Of course I do not refer to the unconscious mirroring in the face of the entire body's action. That is permissible, and may have independent quality as Illustration, although the greater the art the more careful is it not to let this quality get out of hand. But I mean the expression which in actual life we connect with the emotions, and which is reproduced for the value it has there. In art it can have little or no intrinsic merit, for all such merit accrues from tactile values and from action and their harmonies, while the muscles concerned with the subtle facial transformations required for emotional expression have little if any systemic effect upon us, and the ideation of their play can have but the faintest direct life-communicating power.

Besides these specifically artistic reasons, there is at least one other, of a more general but important order, against emotional expression in art. It is this. Directly expression surpasses its visible cause—the action manifested by the figures—we are inevitably led to seek for the cause of it in sources beyond and outside the work of art. The aesthetic

moment—that too brief but most exquisite ecstasy when we and the work of art are one—is prevented from arriving; for the object of vision, instead of absorbing our entire attention as if it were a complete universe, and permitting us to enjoy the feeling of oneness with it, drives us back on curiosity and afield for information, setting up within us a host of mental activities hostile to the pure enjoyment of art.

And if all this be true of figures and whole compositions, it is much more true of single heads. In the best art the head alone is but a limited vehicle for expression, and great art has always been perfectly aware of these limitations, making a point, it would seem, of giving the face, when presented alone, its most permanent aspect. But such treatment requires genius on the part of the producer, and natural as well as cultivated appreciation on the part of his public. The ordinary crafts-man must exercise such functions as he has, and, standing at the level of the masses, he produces what they crave for, pictures that communicate information and promises, instead of life and beatitude.

XXII

Enough perhaps has been said to justify my want of enthusiasm for such bewitching Leonardesque heads as the 'Belle Colombine' of Leningrad, and to prepare the reader for my estimate of Luini, Sodoma, Gaudenzio Ferrari, and Andrea Solario. Pl. 375

Luini is always gentle, sweet, and attractive. It would be easy to form out of his works a gallery of fair women, charming women, healthy yet not buxom, and all lovely, all flattering our deepest male instincts by their seeming appeal for support. In his earlier years, under the inspiration of the fancy-laden Bramantino, he tells a biblical or mythological tale with freshness and pleasing reticence. As a mere painter, too, he has, particularly in his earlier frescoes, warm harmonies of colour and a careful finish that is sometimes not too high. Luini

But he is the least intellectual of famous painters, and, for that reason, no doubt, the most boring. How tired one gets of the same ivory cheek, the same sweet smile, the same graceful shape, the same uneventfulness. Nothing ever happens! There is no movement; no hand grasps, no foot stands, no figure offers resistance. No more energy passes from one atom to another than from grain to grain in a rope of sand. Pl. 371

Luini could never have been even dimly aware that design, if it is to rise above mere orderly representation, must be based on the

possibilities of form, movement, and space. Such serious problems seem, as I have said, to have had slight interest for any of Leonardo's pupils, either because the pictures the master executed at Milan offered insufficient examples, or because the scholars lacked the intelligence to

Pl. 370 comprehend them. Certainly Marco d'Oggiono's attempts encourage the conclusion that the others did well to abstain. But the subtlety of Leonardo's modelling, at least, Luini could not resist; and as he had little substance to refine upon, he ended with such chromolithographic finish as, to name one instance out of many, in the National Gallery 'Christ among the Doctors'. His indeed was the skill to paint the lily and adorn the rose, but in serious art he was helpless. Consider the vast anarchy of his world-renowned Lugano 'Crucifixion'; every attempt at real expression ends in caricature. His frescoes at Saronno are like Perugino's late works, without their all-compensating space effects.

Sodoma Sodoma, the most gifted of Leonardo's followers, is not a great artist, but at his best he half persuades us that, with severe intellectual training, he might have been one. It is possible that he lacked only education and character to become another Raphael. He obviously had as keen a sense of beauty, and he was as ready to appreciate and to attempt to appropriate the highest achievement of others—provided it was not too intellectual. But he had neither the initial training nor the steady application to master the fundamental problems, and it is significant that while he was for years in Rome and imitated Raphael, there is no trace in his numerous paintings of any acquaintance with Michelangelo.

Pls. 372–3 The bulk of his work is lamentable. No form, no serious movement, and, finally, not even lovely faces or pleasant colour; and of his connexion with Leonardo no sign, unless the slapdash, unfunctional light and shade be a distorted consequence of the great master's purposeful chiaroscuro.

Gaudenzio Ferrari Gaudenzio seems to have been less than his fellows under the direct influence of Leonardo or his works. He was by temperament an energetic mountaineer, with a certain coarse strength and forcefulness.

Pl. 374 His earliest paintings, the Scenes from the Passion at Varallo, are provincial but pretty miniatures on a large scale. Prettiness gained on him at Milan, but never quite conquered a certain crude sense for reality, which, when it reasserted itself, permitted him to produce works with a curious breath of Rubens about them, like his frescoes at Vercelli.

Solario Solario was by training almost as much a Venetian as a Leo-
Pl. 376 nardesque Milanese. His magnificent National Gallery 'Portrait of a

Senator' recalls Antonello, Alvise Vivarini, and Gentile Bellini; and even his Louvre 'Cardinal d'Amboise' is more Venetian than Milanese. But the bulk of his work is only too obviously Lombard. Yet, for all his high porcelain finish, for all his prettiness, for all his too long sustained smile, he is neither so lifeless nor so stereotyped as Luini. It is harder to forget a youthful delight in his Louvre 'Vierge au Coussin Vert' than to renounce almost any other early enthusiasm for paintings of this school. How they enhanced one's dream of fair women, all these painters so distasteful now; how they guided desire and flattered hope! Youth still looks at them with the same eyes, and from their Elysian seats they smile down upon me with the words: 'It is for the Young that we worked—what do you here?'[1]

Pl. 377

XXIII

Before turning east to Brescia, where, as I have already said, Foppa's tradition found its final development, we must glance for an instant westwards. It has been remarked before that this master's influence made itself felt to the shores of the Mediterranean, and to the crests of the Mt. Cenis. But as it passed over Piedmont, it encountered the last waves of Franco-Flemish tradition, and drove them back, not, however, without losing part of its own Italian character and itself acquiring something of the Northern. To the historian, this encounter and mingling of art forms, and all that it implies in the state of mind of the artist, should constitute an important and even delightful field of study. But we must content ourselves with a word regarding the completest product of this movement, Defendente Ferrari.

The School of Piedmont

Were we to treat him as a serious artist, the fourth rank might be too high for him, for he has none of the qualities essential to the figure arts. But he disarms criticism by naïvely abandoning all claims to them, and he even inveigles us, for the twinkling of an eye, into disregarding their existence. He gives us pleasant flat patterns with pleasant flat colour, put on like enamel or lacquer, sometimes with jewel-like brilliance. Into these bright arabesques he weaves the outlines of pious, quasi-Flemish Madonnas, and occasionally the clean-cut profile of a donor—one of those profiles that even the humblest Lombards struck off so well. I recollect a grand triptych, gorgeous in gilt, with a Gothic canopy daintily carved, and in the midst the Blessed Virgin, the

Defendente Ferrari

Pl. 380

[1] What has just been said of Luini, Gianpietrino, and Sodoma applies equally to the two Castilian Ferrandos, one surnamed Yanez and the other de Llanos, who painted the copious reredos of Valencia Cathedral. They are at least as Milanese as Cesare da Sesto.

silhouette of a tender Flemish Madonna, with the Child caressingly held in her arms, as she floats in space with the crescent moon at her feet; and I confess that the memory of this picture fills me with a greater desire to revisit it than do many far more ambitious and even more admirable works. Defendente, living, like Crivelli, out of the current of ideas, developed, like that enchanting Venetian, although on the most modest lines, the purely decorative side of his art. In truth, painting is a term that covers many independent arts; and this little Piedmontese master practised one of them. Its relation to the great art is not unlike that of monumental brass to sculpture: and we prefer a good brass to a poor piece of sculpture.

XXIV

The School
of Brescia

Pl. 378

Foppa's real successors, those who carried to their logical conclusion his tendency to greyish silvery harmonies of colour and a plastic-pictorial vision, were his own countrymen, the Brescians. We shall not delay over Civerchio and Ferramola, for the one is too shadowy and the other too insignificant a figure, but hasten on to their pupils, Romanino and Moretto. In spite of their faults—and they are many—it is a pleasure to turn from the later Milanese, with their mere surface colour and their merely plastic light and shade, to these Brescians, less talented, perhaps, but left free to unfold their own character under the genial influences of Venice. While speaking of Foppa, we noted how much he had in common with Bellini; we observed the same feeling for inner substance, and the same inclination to let this substance melt gradually, as it were, into the circumambient atmosphere, losing nothing of its own consistency, yet not ending abruptly as if imprisoned within a razor-edged outline. His followers were naturally ready to understand all the advances made on that road by Giambellino, and perfected by his pupils, Giorgione and Titian. Consequently, in a sense, Moretto, Romanino, and their companions, whom political and social conditions submitted to the domination of Venice, were all but Venetians in their art. What distinguished them from the islanders was, in the first place, the Foppesque heritage of grey, silvery, rather sombre tone, and then that inferiority in draughtsmanship and that want of intellectual purpose always to be expected from dependants and provincials, which resulted in great inequality of output. On the other hand, they were not behind the best Venetians in a command over the imaginative moods, particularly of the solemn yet reconciling and even inspiring kind, produced by the play of light

and colour. It is this, in fact, which almost gives some few of their works a place in the world's great art.

Romanino was the older, the more facile, the cleverer, but also, for all his brilliancy, the more unrestrained and provincial, in spite of having been so much exposed to Giorgione's influence that more than one picture of his, moulded by that influence, is still attributed to Giorgione himself, or to Titian. His altar-pieces, as a rule, are too rich and fiery in tone, and his best qualities appear only in fresco. There, however, he carries one away on the wings of his wafting ease, his fresh, clean colour, his unpretentious yet frequently happy design. Delightful indeed are the sunny colonnades of the castle at Trent, where Romanino's frescoes, with much of the flimsiness, have still more of the delicious colour of· gorgeous butterflies floating in the limpid spring atmosphere! Delightful, again, is it in passing along fragrant Bergamask lanes to stop and enjoy the easy grandeur and charming dignity of his paintings in the open-air shrine at Villongo!

Moretto, the fellow-pupil of Romanino, is the nearest approach to a great artist among his exact contemporaries in Northern Italy outside Venice, and even if we include Venice he is more than able to hold his own with men like Paris Bordone and Bonifazio. He has left, it is true, no such record of the all but realized Renaissance dream of life's splendour and joy as they have done with their 'Fisherman and Doge' and 'Rich Man's Feast'. His colour is not so gay, and at his worst he sinks perhaps even lower than they, but he is much more of a draughtsman and of a poet, and consequently more of a designer. Thanks to these gifts, when Moretto is at his best, his figures stand and grasp, their limbs have weight, their torsos substance; and, even when these merits are less conspicuous, we can forgive him many a shortcoming for the sake of the shimmer, the poetic gravity of his colour, shot through as it is with light and shade. He had, besides, unusual gifts of expression, and a real sense of the spiritually significant. It is therefore not surprising to find that, although he has left no such irresistible works as Bordone's and Bonifazio's two masterpieces, he has produced more truly admirable designs, more genuine portraits, and finer single heads. His 'St. Justina', now at Vienna, is one of the heroic creations of Italy, with something almost of Antique grandeur and directness. Only less remarkable in its simplicity of expression and largeness of design is the picture in the pilgrimage church of Paitone, representing the apparition of the Madonna to a peasant boy; and worthy of a place beside it is the fresco at Brescia, wherein we see an ancient hermit

Girolamo Romanino

Pl. 381

Moretto

Pl. 90

Pl. 383

beholding the Queen of Heaven rising out of a burning bush. Won-
Pl. 382 derful as illustration is his so-called 'Elijah Waked by an Angel' (in
San Giovanni Evangelista), which is really a highly poetical landscape,
in the foreground of which we see two grand figures that we might
easily mistake for the sleeping Centaur Chiron mounted by Victory.
In quite another phase he takes a more purely mundane complexion,
and in a work like the 'Christ at the Pharisee's', in S. Maria della Pietà
at Venice, he anticipates, as no other, the handling of similar themes
by Paolo Veronese. As for Moretto's portraits, I will mention but one,
Pl. 385 the 'Ecclesiastic' at Munich, but that one not easily outmatched: as
character penetratingly perceived and frankly presented, as design
simplicity itself, and as colour a perfect harmony in dark, soft, twilight
greys.

Moroni Moretto had for pupil Moroni, the only mere portrait painter that
Italy has ever produced. Even in later times, and in periods of miser-
able decline, that country, Mother of the arts, never had a son so
uninventive, nay, so palsied, directly the model failed him. His altar-
pieces are pitiful shades or scorched copies of his master's, and the one
exception proves the rule, for the 'Last Supper' at Romano is only
redeemed from the stupidest mediocrity by the portrait-like treatment
of some of the heads. But even with the model before him, Moroni
seldom attained to his master's finest qualities as a painter; and while
it is true that some of his work is distinguished with difficulty from
Moretto's, it is only from the master's less happy achievements.
Moroni is at once hotter and colder in colour than Moretto, totally
wanting that artist's poetry of light, and seldom if ever approaching
his cool, grave tones. As a draughtsman, on the other hand, he is
scarcely inferior; and in his pre-eminent masterpiece, the National
Pl. 388 Gallery 'Tailor', there are form and action better than Moretto's best.

We must judge Moroni, then, as a portrait painter pure and simple;
although even here his place is not with the highest. His teacher's
masterpiece, the 'Ecclesiastic' we have just described, inevitably sug-
gests Velazquez. It has design and style, and is lifted up into universal
relations, bearing the honour with simplicity. Moroni gives us the
sitters no doubt as they looked, with poses that either were character-
Pls. 386–7 istic or the ones they wished to assume. But, with the possible excep-
tion of the 'Tailor', the result is rather an anecdote than an exemplar of
humanity. These people of his are too uninterestingly themselves.
They find parallels not in Titian and Velazquez and Rembrandt, but
in the Dutchmen of the second class. Moroni, if he were as brilliant,
would remind us of Frans Hals.

XXV

Scarcely less Venetian than the Brescians were the later Ferrarese; and the ablest of them before Correggio, the only one who need occupy us here, Dosso Dossi, owed everything that gives him consideration to Giorgione and Titian. As a figure artist in any serious sense he merits no attention. His drawing is painfully slipshod, his modelling puffy and hollow; but he must have been richly endowed by nature with a feeling for poetic effects of light and colour, and he caught something of Giorgione's haunting magic. As a romantic Illustrator he has few rivals. He painted with the same ease, the same richness of tone, the same glamour, and the same drollery as his friend Ariosto wrote. There is as little inner substance in the paintings of the one as there is its literary equivalent, character, in the poems of the other, but in both the texture is too gorgeous and too fascinating to permit a sober thought. So we look spellbound at Dosso's Circes absorbed in their incantations, and are lost in the maze of his alluring lights. His landscapes evoke the morning hours of youth, and moods almost mystically rapt. The figures convey passion and mystery. His pictures may not be looked at too long or too often, but when you do come into their presence, for an enchanted moment, you will breathe the air of fairyland.

The School of Ferrara

Dossi

Pl. 389

XXVI

It is easy to trace Correggio's art back to some of its sources. To begin with, there were his earliest masters, Costa and Francia, and after-wards, at Mantua, the wealth of Mantegna's works, besides personal contact with Dosso and perhaps Caroto. Venice also cast her spell upon him, not improbably through Lotto and Palma; and finally came acquaintance, no matter how indirect, with the designs of Raphael and Michelangelo. But it is obvious that these various rivulets tapped from rolling rivers did not, by merely combining, constitute the delicious stream which we know as Correggio. The same influences doubtless spread in the same region over others without such results. He alone had genius; and he offers a rare instance of its relative inde-pendence. A Michelangelo was perhaps inevitable in Florence, a Raphael in Umbria, a Titian in Venice, but not a Correggio in the petty principalities of the Emilia. His appearance in those uninspiring surroundings was a miracle.

His time had no greater right to him than his birthplace; for by

Correggio

temperament he was a child of the French eighteenth century. As is attested by the universal enthusiasm he then inspired, it is in that seductive period that his genius would have found its friendliest environment, both as an Illustrator and as a Decorator—and few have lived in whom these two elements of art coincided more exactly.

The more one reflects upon the art of the epoch known as the Eighteenth Century, the more must one concede its distinguishing trait to have been its sensitiveness to the charm of mere Femininity. The Greeks of course felt this charm, and expressed it in many a terra-cotta figurine which still survives to delight us. Then many centuries intervened during which the charm of femininity remained unrecorded, and until the eighteenth century there was no change, except for one beam that yet sufficed to light up the whole sky. That beam was Correggio. None of his contemporaries, older or younger, expressed it, not even his closest follower, Parmigianino, in whom charm was quickly lost in elegance. Giorgione felt the beauty of womanhood, Titian its grandeur, Raphael its noble sweetness, Michelangelo its sibylline and Pythian possibilities, Paul Veronese its health and magnificence; but none of them, and no artist elsewhere in Europe for generations to come, devoted his career to communicating its charm.

<div style="margin-left:2em">Correggio's character
Pls. 390–3</div>

Assuming that a sensitiveness to the charm of femininity was Correggio's distinguishing trait, let us see whether it offers the key to his successes and failures as an artist. Before approaching this inquiry, we must get acquainted with his qualities and faults, in order to be able to distinguish what he could do best, what he could do less well, and what not at all. If we compare his merits and shortcomings with those of his great contemporaries, and particularly with those of Raphael, his cousin in art descent, we shall find that Correggio displays less feeling for the firmness of inner substance than any of them, even Raphael. Both these painters made a bad start in a school where form had not been a severe and intellectual pursuit; but the latter, at the right moment, underwent the training that Florence then could give, while the former had nothing sterner in the way of education than the example of Mantegna's maturer works. On the other hand, Correggio was a much finer and subtler master of movement: his contours are soft and flowing as only in the most exquisite achievements of eighteenth-century painting; his action, at the best, is unsurpassable, as in the 'Danaë', with her arm resting on the pillow and Cupid's legs clinging to the couch; in the 'Leda', with the swan's neck gliding over her bosom; in the Budapest Madonna, with the Child's arm lying over

<div style="margin-left:2em">Pl. 390</div>

her breast; or in the 'Antiope', with her arm resting on the ground.

Yet for all his superiority, his movement seldom counts as in Raphael, and his form, inferior as it is, is even less effective than, on its merits, it should be. In both cases the fault is not specific but intellectual. Correggio lacked self-restraint and economy. Possessing a supreme command over movement, he squandered it like a prodigal, rioted with it, and sometimes almost reduced it to tricks of prestidigitation, as in his famous 'Assumption of the Virgin'. He thereby practically defeated the purpose of the figure arts, which is to enhance the vital functions by communicating ideated sensations of substance and action. To produce that effect the figure must be presented with such clearness that we shall apprehend it more easily and swiftly than in real life, with the resulting sense of heightened capacity. Now no work of art meriting attention could be less well fitted to realize this purpose than the fresco in the Parma Cathedral. Instead of quickened perception, this confused mass of limbs, draperies, and clouds, wherein we peer painfully to descry the form and movement, gives us quite as much trouble and is consequently quite as life-diminishing as a similar spectacle in reality. And as actuality it is scarcely superior to those modern round dances, where the changing groups of interlaced whirling figures leave nothing for the tired eyes of the onlooker to rest upon. How much it is a failure in economy and not in specific gift, is illustrated by the 'Ganymede' at Vienna. The Pl. 392 eye contemplates this figure with caressing delight, as it floats over the hill-tops; and yet it is nothing but the exact transfer of one of the figures from a pendentive under the 'Assumption'. Although one of the least confused parts of that whole work, and relatively well placed, this figure of a boy needed isolation—and isolation only—to become a masterpiece of imaginative design. If it be realized that many of the figures thus isolated would become equally triumphant, Correggio's reckless and fabulous extravagance may be appreciated.

This fatal facility in the presentation of movement accounts for his obvious faults, his attitudinizing and nervous restlessness, as well as for the showman's gestures that disgrace his later altar-pieces. Everybody must be doing something, even when least to the point, whether as Illustration or Decoration, although of course such a genius would finally twist pattern around to serve his master passion. A good example is the impish boy in the Parma 'Madonna with St. Jerome', Pl. 393 who is making a face as he smells the Magdalen's vase of ointment! We may go farther, and ascribe to the same cause Correggio's distaste for everything static, which almost amounts to saying for everything monumental. Obliged by the traditions of art in his day to attempt

the monumental in the architectural settings of his altar-pieces, he created, or at least foreshadowed the Baroque. Left quite to himself, he might very well have plunged at once into Rococo, and perhaps ended by emancipating himself, like the Japanese, from everything architectonic.

Such an artist obviously could not be a space-composer in any signal sense; and indeed Correggio's name in this connexion is not to be mentioned in the same breath with Raphael's. Correggio adds to all the extravagance and restlessness so incompatible with space-composition one of the worst tendencies of his time, that of packing the largest possible figures into a given space—witness his 'St. John the Evangelist' at Parma, an inspired creation, with no room for the noble head!

On the other hand, he surpassed Raphael in landscape, as he was bound to do, with his command over most of the imaginative possibilities of light; for in the domain of light and shade he was perhaps the greatest Italian master. Some, with Leonardo as their chief, had used it to define form; others, like Giorgione, had caught its glamour and reproduced its magic; but Correggio loved it for its own sake. And it rewarded his love, for it never failed to do his bidding; and, besides what it enabled him to do for the figure, it put him above all his contemporaries in the treatment of the out-of-doors. The Crespi 'Nativity' and the Benson 'Parting'[1] show that he was not inferior to any in conveying the mystery, the hush, the crepuscular coolness of earliest dawning and latest twilight; nor was he excelled by any other in the understanding of conflicting lights—as we can see only too well in his Dresden 'Night'; and he surpasses them all in effects of broad daylight, such as we find in most of his mythological pieces, and in the Parma 'Madonna with St. Jerome', rigdy surnamed the 'Day'. This is the only picture known to me which renders to perfection the sweeping distances, the simple sea of light evenly distributed yet alive with subtle glimmerings through the hazes, that constitute one of the most majestic of nature's revelations, broad noontide in Italy.

Correggio's mastery of light In the figure, also, Correggio's command of light and shade, the exquisite coolness yet sunny transparency of his shadows, discovered new sources of beauty. He was not only among the very first—a mere question of precedence with which art has no concern—but he remains among the very best who have attempted to paint the surface of the human skin. Masaccio's terra-cotta-faced people are greater than

[1] The first now in the Brera, Milan, and the second in the National Gallery, London.

Correggio's, for it is more vital to convey a tonic sense of inner substance than to give the most admirable rendering of the surface. But the skin too has its importance; and its pearliness, its sunny iridescence, as in the 'Antiope', are a source of vivid yet refined pleasure. Without attention to all its aspects, no one could have attained to such a supreme achievement as the 'Danaë', where we watch a shiver of sensation passing over the nude like a breeze over still waters. Correggio's mastery of light explains his colour. Light is the enemy of variegated and too positive colour, and, where it gets control, it endeavours to dissolve tints into monochrome effects of tone. Hence the real masters of light have never been pretty and attractive, although for the same reason they have been great Colourists. Yet, while one would not hesitate in this respect to rank Correggio above Raphael, one must put him below Titian. His surface is too glossy, too lustrous, and too oily to give the illusion of colour as a material.

Aware of what were Correggio's gifts and what his shortcomings, I kept studying his works to find the reason of his rare successes and his frequent failures. Supposing, at one time, that the latter were caused principally by his prodigality, I yet could not account for the small pleasure I took in his altar-pieces and other sacred subjects, where the relatively simple arrangements of monumental composition left little room for extravagance. It occurred to me then that these subjects imposed too great a restraint upon his passion for movement: which indeed is true, although it does not explain all their failings; and I thought that perchance in mythological and kindred themes, wherein the Renaissance painter could emancipate himself from the galling fetters of tradition hostile to his art and rejoice in the freedom of a Greek, Correggio would prove triumphant. This also turned out to be not quite, although almost, satisfactory as an explanation; and I was driven finally to conclude that among these pieces it was only those few wherein the female nude was predominant, and where the nude was treated so as to bring to the surface the whole appeal of its femininity, that his exaggeration, his nervousness, his restlessness, disappeared entirely and left only his finer qualities singing, in most melodious unison, harmonies seldom sweeter to human sense. I then understood why his sacred subjects could not please, for he had no serious interest in the male figures, and as to the female figures, the charm of femininity, mixing with the expression imposed by the religious motive, resulted in that insincerity which closely anticipates, if it be not already an embodiment of what in painting we call Jesuitism—and quite rightly, for the Jesuits always traded upon human

Correggio's failures

Pls. 390-1

weakness, and ended by marrying sensuality to Faith. I understood also why one constantly returned to the 'Danaë', the 'Leda', the 'Antiope', and the 'Io' as Correggio's only perfect works, and I realized that they were perfect because in them his genius created fully, without let or hindrance, while all his faculties were lifted to their highest function. And they are hymns to the charm of femininity the like of which have never been known before or since in Christian Europe. For the eighteenth century, with all its feeling for the same quality, either failed to bring forth the genius to express it in such resplendent beauty, or else cooped it up in types too pretty and too trivial. Correggio was fortunate, seeing that in his day form, which is the alphabet of art, still spelt out mighty things.

And yet, if we may not place Correggio alongside of Raphael and Michelangelo, Giorgione and Titian, it is not merely that on this or that count he is inferior to them for specific artistic reasons. The cause of his inferiority lies elsewhere, in the nature of all the highest values, whereby everything, whether in art or in life, must be tested. He is too sensuous, and therefore limited; and the highest human values are derived from the perfect harmony of sense and intellect, such a harmony as since the most noble days of Greece has never again appeared in perfection, not even in Giorgione or Raphael.

XXVII

My tale is told. It has been too brief to need recapitulation, and I shall

Parmigianino

add but a word about Parmigianino, the last of the real Renaissance artists in North Italy. He had too overmastering a bent for elegance

Pl. 395

to rest contented with Correggio's sensuous femininity. But this elegance he approached with such sincerity, with such ardour, that he attained to a genuine, if tiny, quality of his own, a refined grace, a fragile distinction, that please in fugitive moments.

There remain no other painters of this period in Northern Italy who deserve even passing mention here, unless indeed it be the Campi,

Pl. 394

dainty, elegant eclectics, who have left—to speak only of the best—one of the most elaborate schemes of decoration of the entire Renaissance, in a church near Soncino, and exquisite mythological frescoes in the now deserted summer palace at Sabbioneta.

THE DECLINE OF ART

THE DECLINE OF ART

IN this volume it has been my intention to sketch a theory of the arts, particularly of the figure arts, and especially of those arts as manifested in painting. I chose Italian examples, not alone because I happen to have an intimate acquaintance with the art of Italy, but also because Italy is the only country where the figure arts have passed through all the phases from the imbecile to the sublime, from the sub-barbarian to the utmost heights of intellectual beauty, and back to a condition the essential barbarism of which is but thinly disguised by the mere raiment, tarnished and tattered, of a greater age. I have already treated of what makes the visual, and, more definitely, the figure arts: to test the theory, we must see whether it explains what it is that unmakes them.

It will not be amiss to restate this theory once more; and in brief it Art defined is this. All the arts are compounded of ideated sensations, no matter through what medium conveyed, provided they are communicated in such wise as to produce a direct effect of life-enhancement. The question then is what, in a given art, produces life-enhancement; and the answer for each art will be as different as its medium, and the kind of ideated sensations that constitute its material. In figure painting, the type of all painting, I have endeavoured to set forth that the principal if not sole sources of life-enhancement are TACTILE VALUES, MOVEMENT, and SPACE-COMPOSITION, by which I mean ideated sensations of contact, of texture, of weight, of support, of energy, and of union with one's surroundings. Let any of these sources fail, and by that much the art is diminished. Let several fail, and the art may at the best survive as an arabesque. If all be dried up, art will perish. There is, however, one source which, though not so vital to the figure arts, yet deserves more attention than I have given it. I mean COLOUR. The book on the Venetian Painters, where colour is discussed, was written many years ago, before I had reached even my present groping conceptions of the meaning and value of things. Some day I may be able to repair this deficiency; but this is not the place for it, nor does the occasion impose it; for as colour is less essential in all that distinguishes a master painting from a Persian rug, it is also less important as a factor in the unmaking of art.

In order to avoid using stereotyped phrases, I have frequently substituted the vague objective term 'Form' for the subjective words 'Tactile Values'. Either refers to all the more static sources of life-

enhancement, such as volume, bulk, inner substance, and texture. The various communications of energy—as effective, of course, in presentations of repose as of action—are referred to under 'Movement'.

Desire for newness It is clear that if the highest good in the art of painting is the perfect rendering of form, movement, and space, painting could not decline while it held to this good and never yielded ground. But we Europeans, much more than other races, are so constituted that we cannot stand still. The mountain-top once reached, we halt but to take breath, and scarcely looking at the kingdoms of the earth spread at our feet, we rush on headlong, seldom knowing whither, until we find ourselves perchance in the marsh and quagmire at the bottom. We care more for the exercise of our functions than for the result, more therefore for action than for contemplation. And the exercise of our functions, among those of our race who are the most gifted, rarely if ever dallies with the already achieved, but is mad for newness. Then too we care vastly more for the assertion of our individuality than for perfection. In our secret hearts we instinctively prefer our own and the new to the good and the beautiful. We are thus perpetually changing: and our art cycles, compared to those of Egypt or China, are of short duration, not three centuries at the longest; and our genius is as frequently destructive as constructive.

Nature of genius Utilitarian prejudice misleads us concerning the true nature of genius, which word we almost invariably restrict to those human forces which are highly beneficial. Defining genius thus, we naturally fail to discover it in periods of decline, and we wonder vacuously how ages can pass without producing it. Now, while there may well be considerable differences in the human crop from generation to generation, and age to age, there seems to be no reason for assuming that these differences can be great enough to exclude genius—unless indeed there occurs some actual race decay such as manifested itself among the Mediterranean stocks in our fourth and fifth centuries. Even in those humiliating periods, when the shrivelled crone of an Ancient World, growing more and more benumbed, retained but the bare strength for keeping body and soul together, genius was not totally extinct, although narrowed down to the more menial tasks of soldiering, governing, persuading, and exhorting. But Italy, after Raphael and Michelangelo, Correggio, Titian, and Veronese, was by no means in such straits. The race remained not only vigorous but expansive, and was then only beginning to exert, through countless self-appointed emissaries, its fullest influence upon European culture. It was displaying abundant genius in other fields, even in the arts, if we consider

music, and it would be singular if it produced none with the highest aptitudes for figure painting.

If, however, we define genius as the capacity for productive reaction against one's training, we shall not be obliged to deny it to whole professions in ages that are otherwise healthy and brilliant; we shall learn to regard it as given almost as much to destruction as to construction; we shall explain its self-assertiveness, and understand the instinctive sympathy and imitation it inspires, even when it seems to be most baneful in its effects.

Imagine Michelangelo, Raphael, and Correggio followed by artists who could have as effectively reacted against them as they did against their masters, Ghirlandaio, Timoteo Viti, and Costa. When you bear in mind that each of them, before he died, introduced a peculiar mannerism—that Michelangelo lived long enough to be distinguished with difficulty from Marcello Venusti, and that perhaps a premature death alone saved Raphael from sinking to a less brutal Giulio Romano—it is not hard to conceive that a genius with the Florentine's fury, but succeeding him, might have whirled his hammer through the accepted moulds of form, and finished closer to Courbet and Manet than to their distant precursor Caravaggio; that another with the Umbrian's sweetness and space might have become a more admirable Domenichino and that a third with Correggio's gift for the rendering of femininity might have combined the best elements in Fragonard, Nattier, and Boucher. Each would remain a person of note, and historically interesting, but none, in spite of undeniable genius, would occupy a throne in the most sacred precincts of the Palace of Art. *Course of genius*

Thus the relatively diminished power of reaction displayed by the most vigorous of the Mannerists and Eclectics, Realists and Tenebrists, who succeeded the classic masters, was due most probably not merely to a lack of energy, but to their energy being misdirected, scattered, and otherwise ill-spent. It is not unlikely that the sheer talent manifested by the Caracci and Guido Reni, by Domenichino and Caravaggio, would, while the figure arts were on the ascending curve, have given them the places of Signorelli and Perugino, Pintoricchio and Uccello. *Pls. 397–400*

But decline in their day was inevitable. Art form is like a rolling platform, which immensely facilitates advance in its own direction, while practically prohibiting progress in any other course. During the archaic stage of art, as I have defined it earlier in this book, no artist of talent can stray far, for archaic art is manifestly inspired by the purpose of realizing form and movement. The artist may fail to realize them

completely; he will certainly fail to realize them in proper combination, for then he would be already classical. He may exaggerate any one tendency to the extreme of caricature, as indeed the less gifted of archaic artists are apt to do. But through his presentation of form, or of movement, or of both together, he cannot fail of being in some measure life-enhancing; for these essential elements of life-enhancement are the necessary preoccupations of the archaic artist.

As a consequence of the successful striving for form and movement, shapes are produced, types created, attitudes fixed, and all raised to their highest power, in designs which, in the exact degree of their excellence, draw attention away from the means that went to make them and concentrate it admiringly upon the end achieved. The effect is then readily mistaken for the cause, and the types, shapes, attitudes, and arrangements, which have resulted from the conquest of form and movement, come to be regarded as the only possible moulds of beauty, and are canonized.

Talent readily perceives the new goal, and its progress now is hastened not only by the instinctive craving for self-assertion no matter against what, and for change no matter from what, but also by the flattering breezes of popularity. For the populace is sensually emotional, and the archaic, with its dryness, has nothing to say to it; while in an art that has reached its culmination and become classic, as I have endeavoured to explain earlier in this book when defining prettiness, certain elements invariably come to the surface which, besides appealing to the heart of the crowd and glorifying its impulses, procure it one of its darling joys, the utmost emotion at the least outlay of rational feeling.

But classic art, producing these things adventitiously and never aiming for them, speaks too softly to the emotions, is too reticent in expression and too severe in beauty to satisfy the masses. They therefore greet with applause every attempt which self-assertiveness and the mere instinct for change will inspire the younger artists to make. And this because every variation upon classic art leads necessarily through schematization and attenuation to the obvious. Once the end is mistaken for the means, it will occur to the first clever youth that, by emancipating the oval of the face from the modelling which originally produced it, he would be skimming off all that made it attractive, and would present its attractiveness unalloyed. He thus gets prettiness of oval, and to make it more interesting, the artist of the new school will not long hesitate to emphasize and force the expression. Nor will he stop there, but will proceed in like fashion with the action,

and continue with the simple process of neglecting the source of its value, Movement, and accentuating the resulting silhouettes, till they too become accurate, fully representative pictographs. Having got so far, he will then be borne one stage farther along the rolling platform of art-reaction, and will attempt to combine these pictographs, not of course in designs based on the requirements of form and movement, but in arrangements that will be most obviously pretty and eloquent. But that time, without realizing whither his applauded progress— which is really no more than blind energy—was taking him, he will have got rid of form and movement; he will have thrown art out of the door, and, unlike nature, art will not come back through the window.

In art, as in all matters of the spirit, ten years are the utmost rarely reached limits of a generation. The new generation follows hard on the heels of the old. Its instincts for change and self-assertion, far from being the same, are naturally opposed, and the newcomers, looking coolly at the achievements of their immediate precursors, end with a feeling of vague but extreme dissatisfaction. Just what is wrong they cannot tell, for their teachers, unlike those in archaic schools, have not directed their attention to form and movement; and their own in-creased facility and pleasure in mere representation and execution, instead of helping them, lead them astray. They feel the groping need of a return to the classics; but on the one hand they seldom have the energy to wrench themselves wholly free from the domination of the authorities still in power, and on the other they have lost the key, forgotten the grammar, and do not know what it is in the classics to which they should return. One thinks it is the colour, or the chiaro-scuro; another the shapes; another the attitudes; and yet another the invention or symmetrical arrangement. Finally one, abler than the rest, must and does arise, who persuades himself and others that, by combining all these elements, great art will return.

The Mannerists, Tibaldi, Zuccaro, Fontana, thus quickly give place to the Eclectics, the Caracci, Guido, and Domenichino. Although counting many a painter of incontestable talent, and some few who, in more favouring circumstances, might have attained to greatness, yet taken as a school, the latter are as worthless as the former, under-standing as little as they that art will only return with form and move-ment and that, without them, it is mere pattern. No amount of rearrangement will infuse life. Vitality will reappear only when artists recognize that the types, shapes, attitudes, and arrangements produced in the course of evolution are no more to be used again than spent

cartridges, and that the only hope of resurrection lies in the disappearance of that facility which is in essence an enslaving habit of visualizing conventionally and of executing by rote. Then artists shall again attain tactile values and movement by observing the corporeal significance of objects and not their ready-made aspects, which were all that the Realists like Caravaggio cared about. This has not yet taken place in Italy, and consequently, although in the last three and a half centuries she has brought forth thousands of clever and even delightful painters, she has failed to produce a single great artist.

THE PLATES

VENETIAN PAINTERS

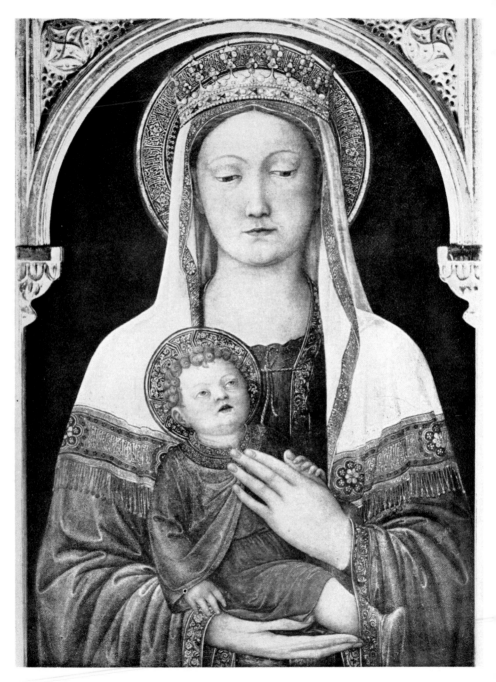

1. JACOPO BELLINI: *Madonna and Child*. Uffizi, Florence

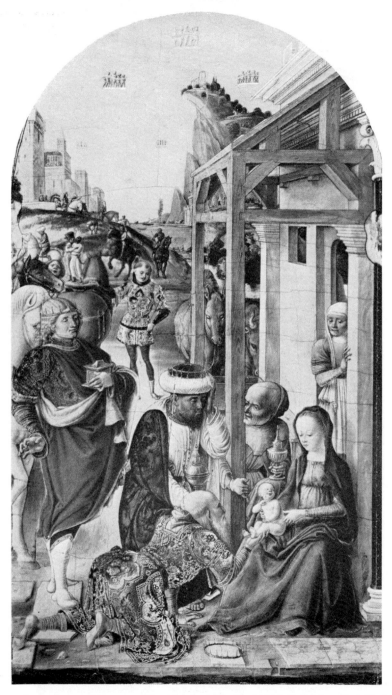

2. Bartolommeo Vivarini: *The Adoration of the Magi*. Frick Collection, New York

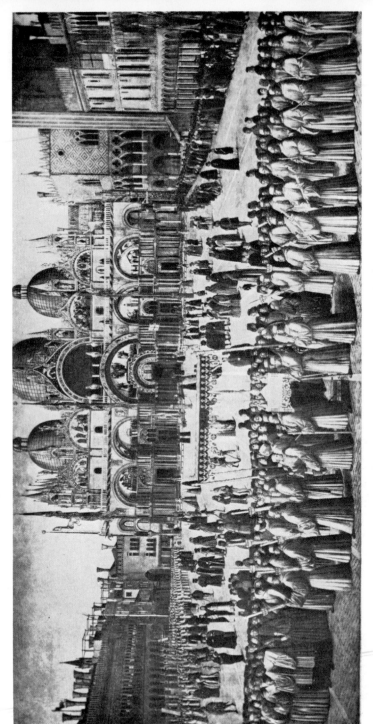

3. GENTILE BELLINI: *Procession in Piazza S. Marco.* Academy, Venice

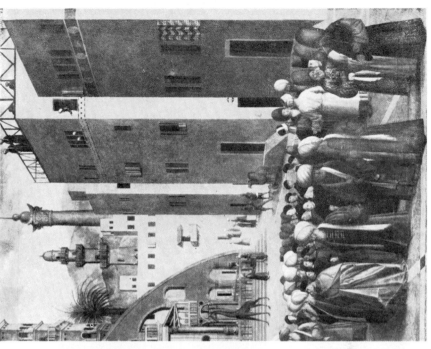

4. GENTILE BELLINI: *Detail from 'Saint Mark preaching'.* Brera, Milan

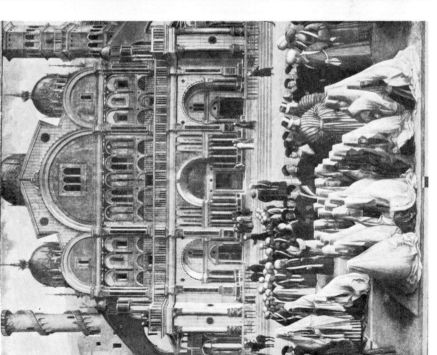

5. GENTILE BELLINI: *Detail from 'Saint Mark preaching'.* Brera, Milan

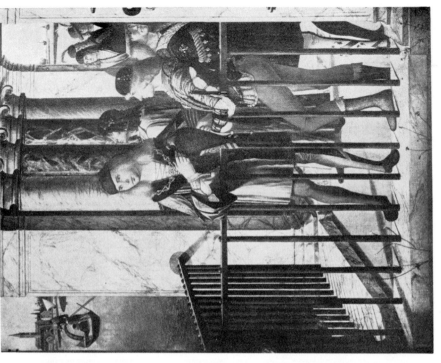

7. VITTORE CARPACCIO: *Detail from the 'Story of Saint Ursula'.*
Academy, Venice

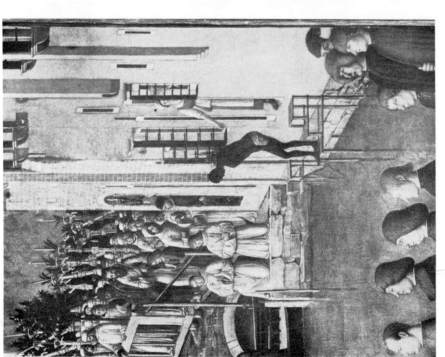

6. GENTILE BELLINI: *Detail from the 'Miracle of the Cross'.*
Academy, Venice

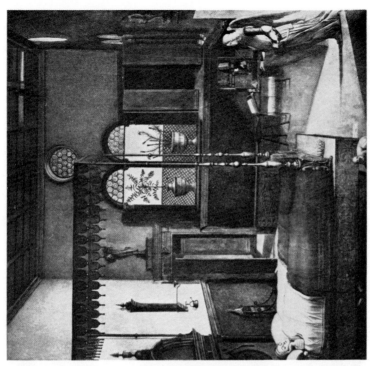

9. VITTORE CARPACCIO: *Saint Ursula's Dream.*
Academy, Venice

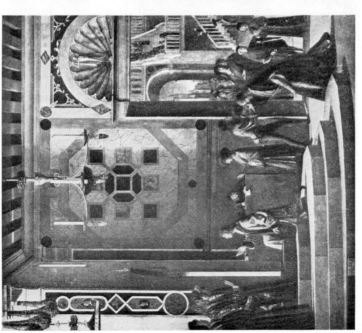

8. VITTORE CARPACCIO: *Detail from the 'Story of Saint Ursula'.*
Academy, Venice

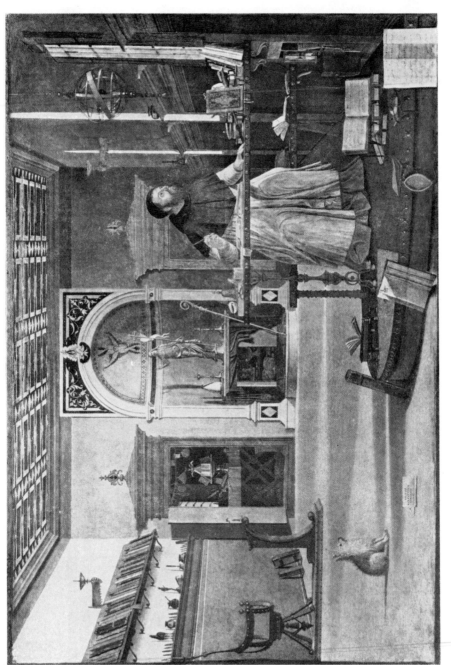

10. VITTORE CARPACCIO: *Saint Jerome in his Study*. S. Giorgio degli Schiavoni, Venice

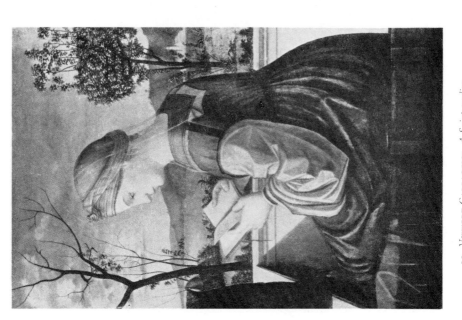

11. Vittore Carpaccio: *A Saint reading.*
National Gallery of Art, Washington (Kress Collection)

12. Carlo Crivelli: *Madonna and Child.*
National Gallery of Art, Washington (Kress Collection)

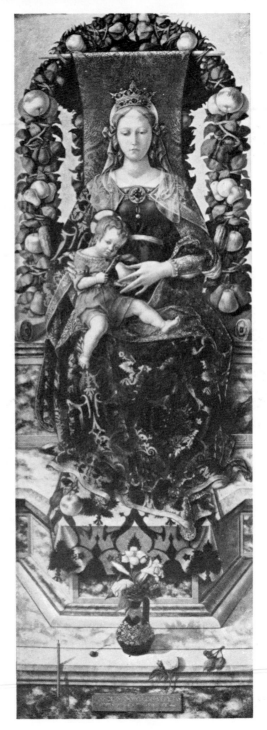

13. CARLO CRIVELLI: *Madonna and Child enthroned*.
Brera, Milan

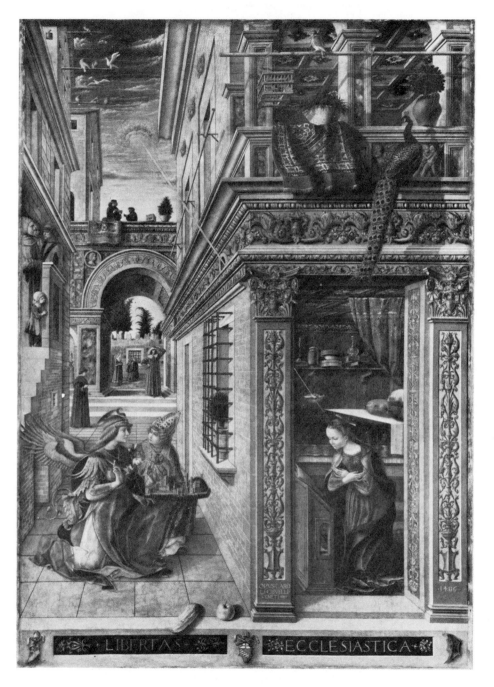

14. CARLO CRIVELLI: *The Annunciation*. National Gallery, London

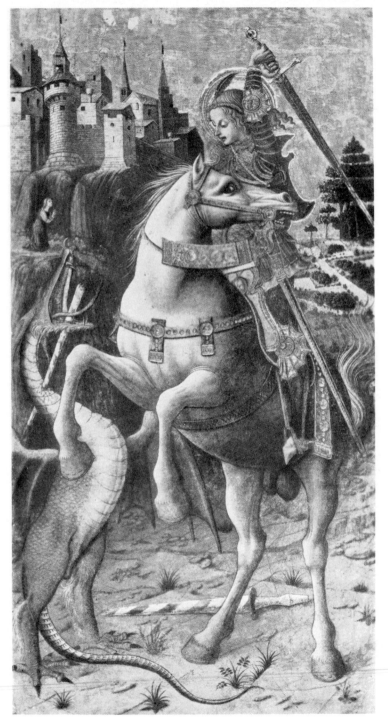

15. CARLO CRIVELLI: *Saint George and the Dragon*. Isabella Stewart Gardner Museum, Boston

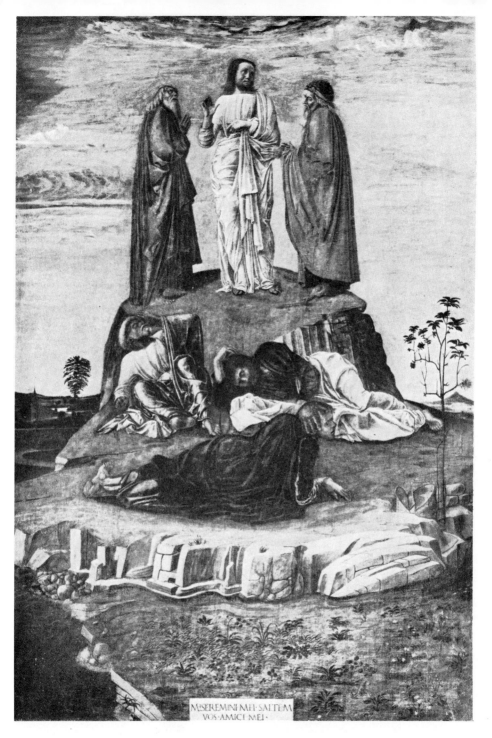

16. GIOVANNI BELLINI: *The Transfiguration*. Museo Correr, Venice

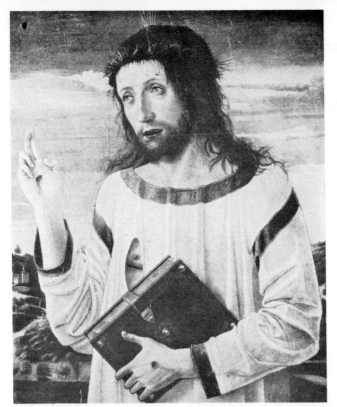

17

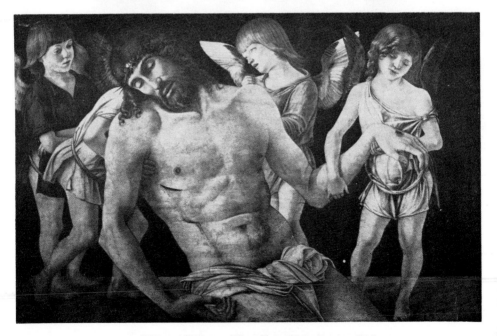

17. GIOVANNI BELLINI: *The suffering Christ*. Louvre, Paris
18. GIOVANNI BELLINI: *Pietà*. Palazzo Comunale, Rimini

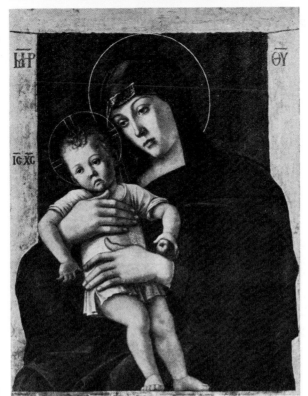

19

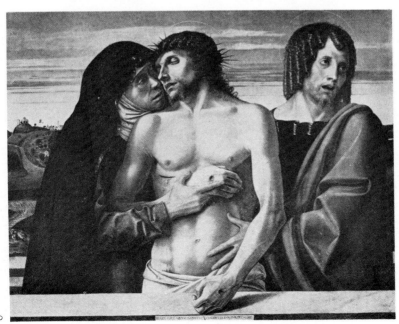

20

19. GIOVANNI BELLINI: *Madonna and Child*. Brera, Milan
20. GIOVANNI BELLINI: *Pietà*. Brera, Milan

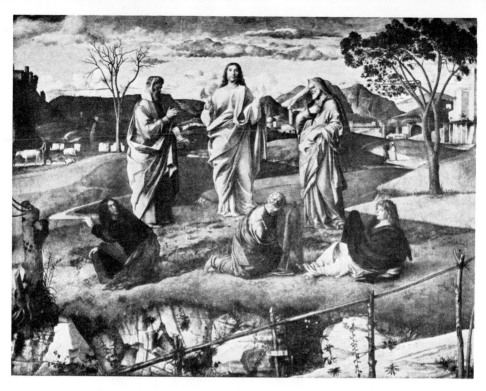

21. GIOVANNI BELLINI: *The Transfiguration*. Pinacoteca, Naples

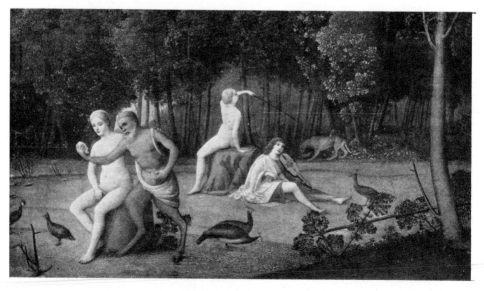

22. GIOVANNI BELLINI: *Orpheus*. National Gallery of Art, Washington (Widener Collection)

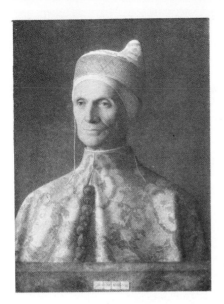

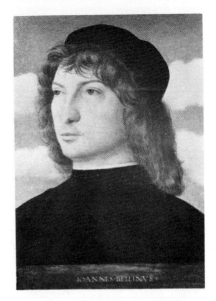

23. GIOVANNI BELLINI: *Portrait of Doge Loredan.* National Gallery, London

24. GIOVANNI BELLINI: *Portrait of a Venetian Gentleman.*
National Gallery of Art, Washington (Kress Collection)

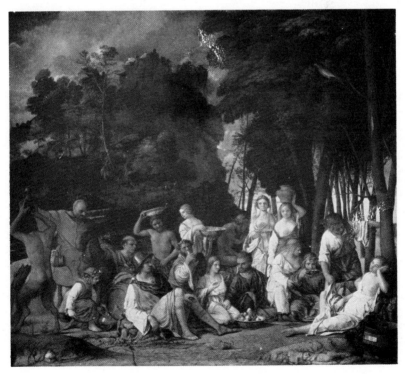

25. GIOVANNI BELLINI: *The Feast of the Gods.* National Gallery of Art, Washington
(Widener Collection)

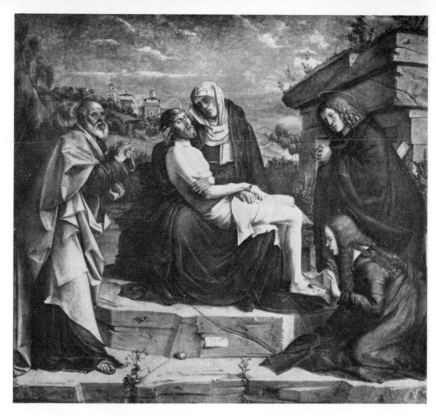

26. BARTOLOMMEO MONTAGNA: *Pietà*. Monte Berico, Vicenza

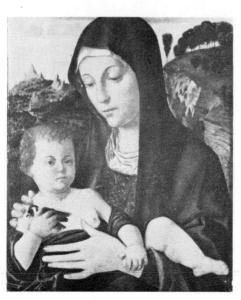

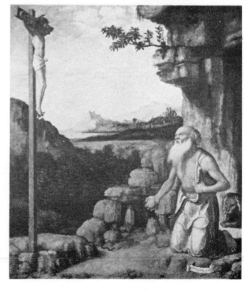

27. BARTOLOMMEO MONTAGNA: *Madonna and Child*. Ashmolean Museum, Oxford

28. CIMA DA CONEGLIANO: *Saint Jerome in the Wilderness*. National Gallery of Art,
Washington (Kress Collection)

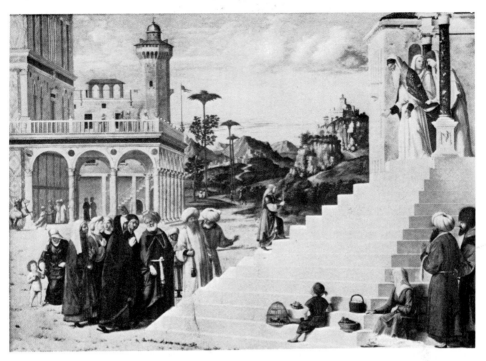

29. CIMA DA CONEGLIANO: *The Presentation of the Virgin*. Gallery, Dresden

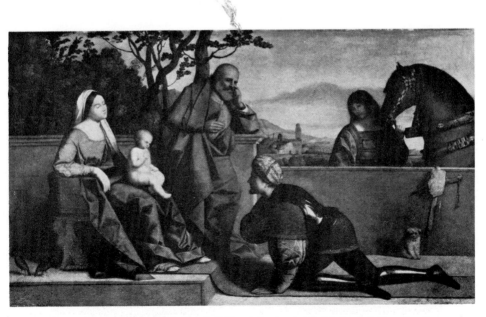

30. VINCENZO CATENA: *Madonna and Child with kneeling knight*. National Gallery, London

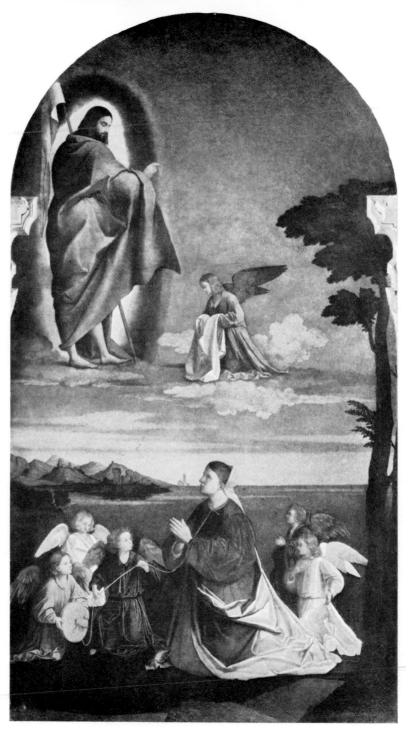

31. VINCENZO CATENA: *Christ appearing to Saint Christina.*
Santa Maria Mater Domini, Venice

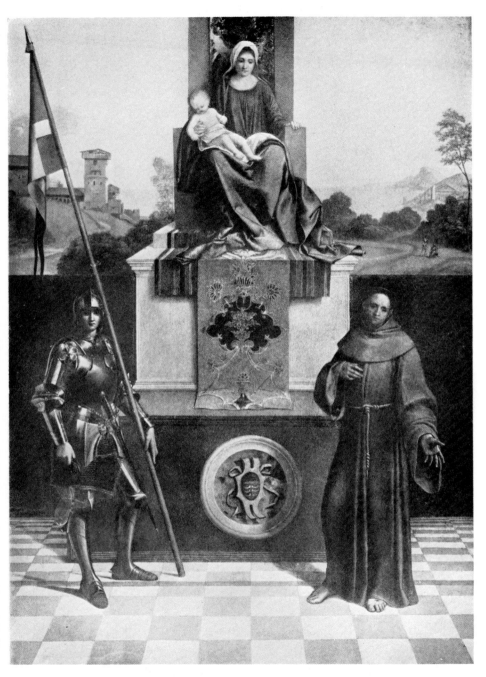

32. GIORGIONE: *Madonna and Child with Saints*. San Liberale, Castelfranco

34. GIORGIONE: *Detail from the Castelfranco Madonna*

33. GIORGIONE: *Detail from the Castelfranco Madonna*

36. GIORGIONE: *The Trial of Moses.* Uffizi, Florence

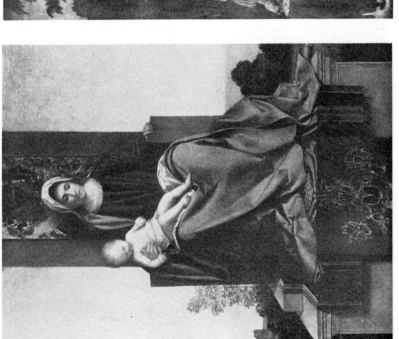

35. GIORGIONE: *Detail from the Castelfranco Madonna*

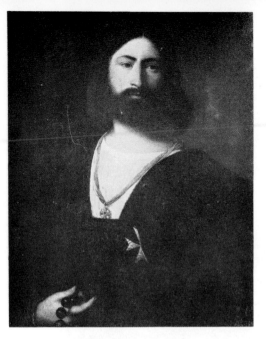

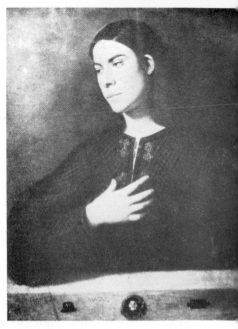

37. GIORGIONE: *Portrait of a Man*. Uffizi, Florence

38. GIORGIONE: *Portrait of a Man*. Gallery, Budape

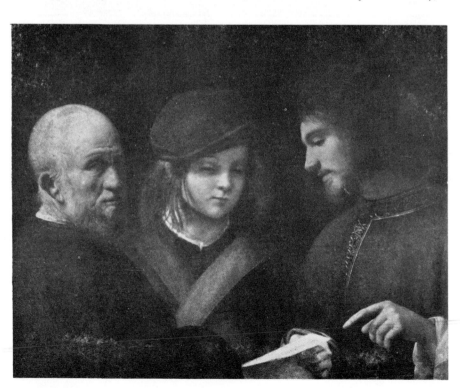

39. Master of the Three Ages (early Giorgione?): *The Three Ages*. Pitti Palace, Florence

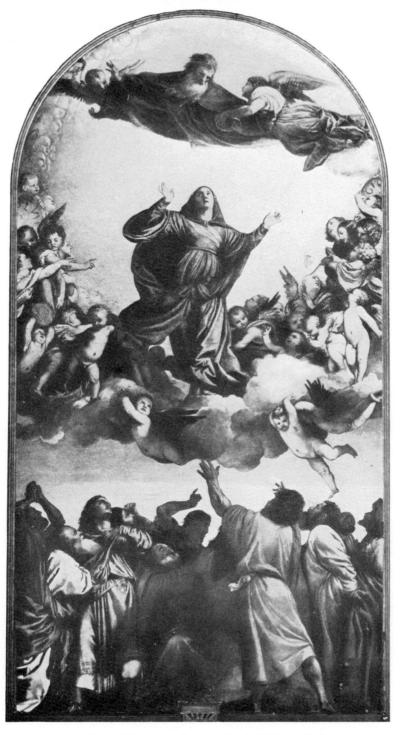

40. TITIAN: *The Assumption*. Santa Maria dei Frari, Venice

43. TITIAN: *Bacchus and Ariadne*. National Gallery, London

44. TITIAN: *Detail from 'Bacchus and Ariadne'*. National Gallery, London

45. TITIAN: *Detail from 'Bacchus and Ariadne'*. National Gallery, London

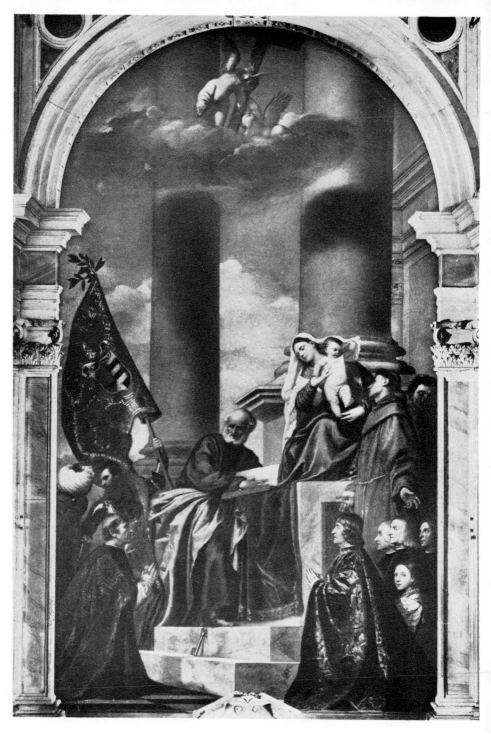

46. TITIAN: *Madonna di Ca' Pesaro*. Santa Maria dei Frari, Venice

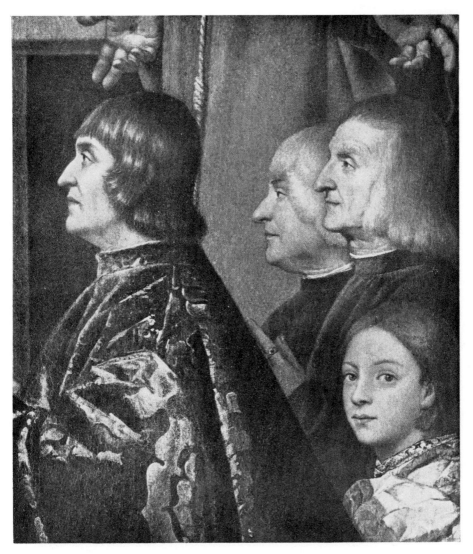

47. TITIAN: *Detail from the 'Pesaro Madonna'*. Santa Maria dei Frari, Venice

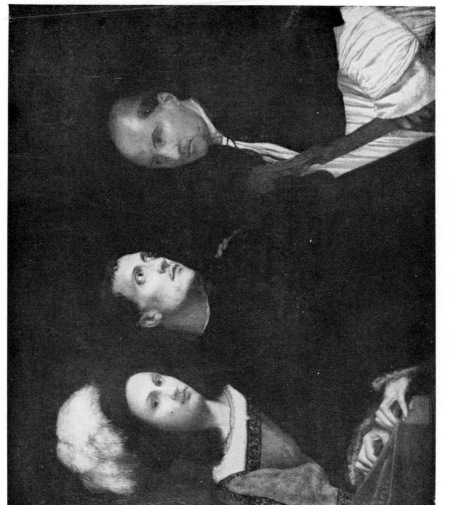

48. TITIAN: *The Concert*. Pitti Palace, Florence

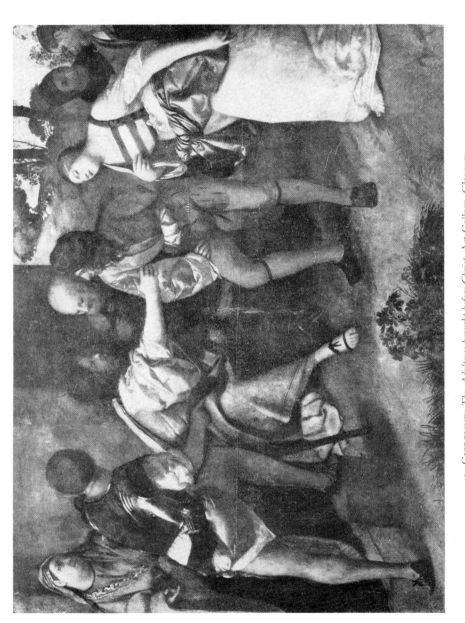

49. GIORGIONE: *The Adultress brought before Christ. Art Gallery, Glasgow*

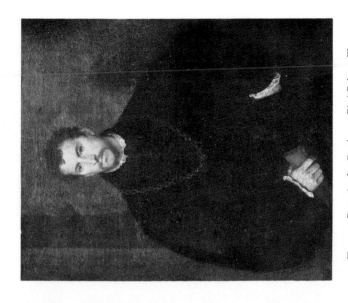

51. Titian: *Portrait of a Gentleman*. Pitti Palace, Florence

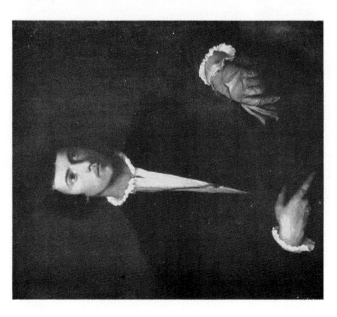

50. Titian: '*L'homme au gant*'. Louvre, Paris

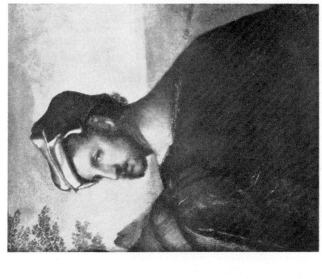

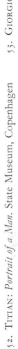

52. TITIAN: *Portrait of a Man*. State Museum, Copenhagen

53. GIORGIONE: *Bust of a Man*. Arthur Sachs Collection, Paris

54. LORENZO LOTTO: *Madonna and Child with Saints*. San Bernardino, Bergamo

55. LORENZO LOTTO: *The Marriage of Saint Catherine*. Accademia Carrara, Bergamo

56. LORENZO LOTTO: *Portrait of a bearded Man*. Doria Gallery, Rome

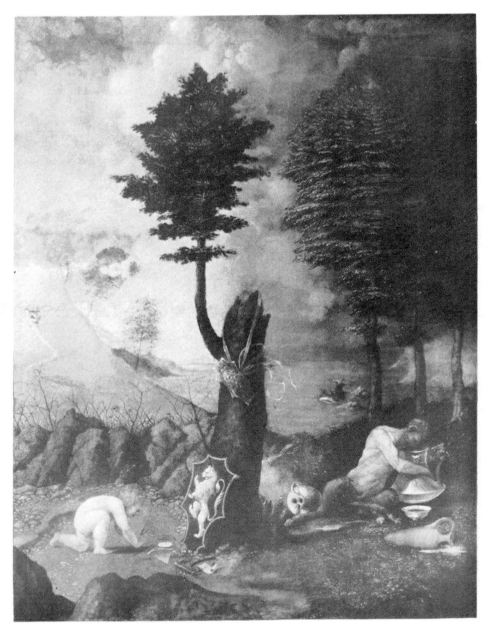

57. LORENZO LOTTO: *Allegory*. National Gallery of Art, Washington (Kress Collection)

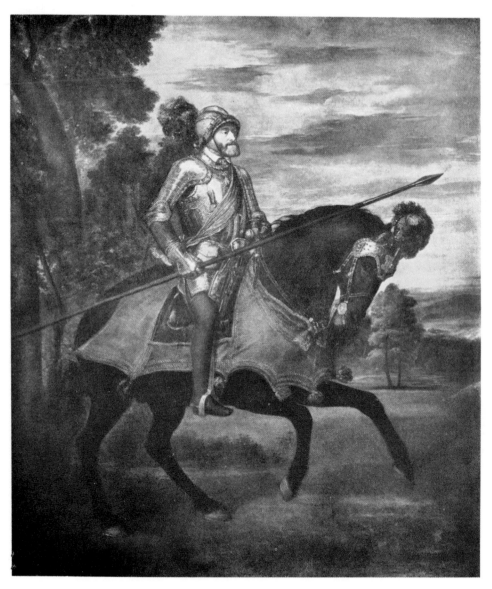

58. TITIAN: *Charles V on horseback*. Prado, Madrid

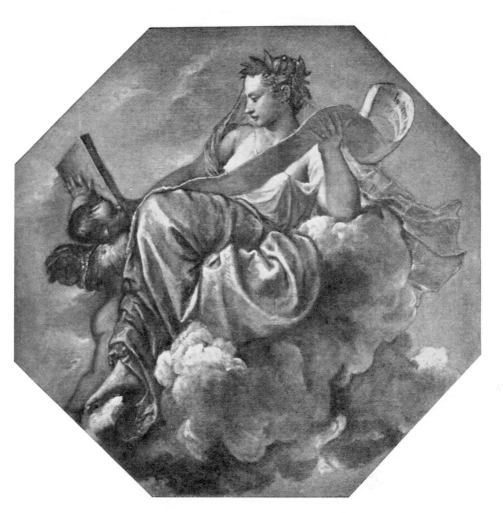

59. TITIAN: *Allegory of Wisdom*. Library of St. Mark's, Venice

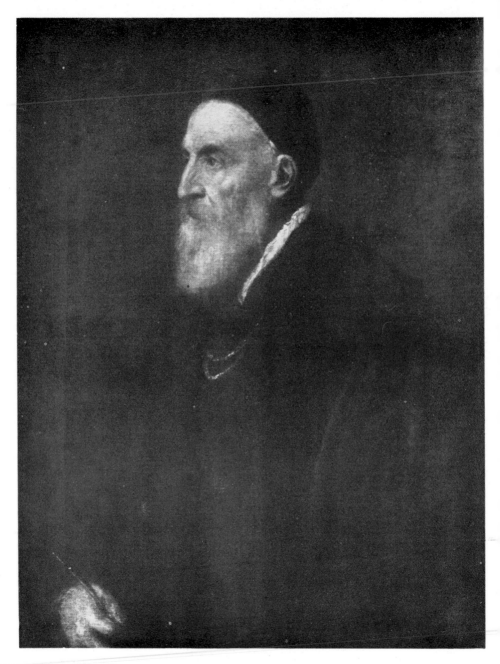

60. TITIAN: *Self-portrait*. Prado, Madrid

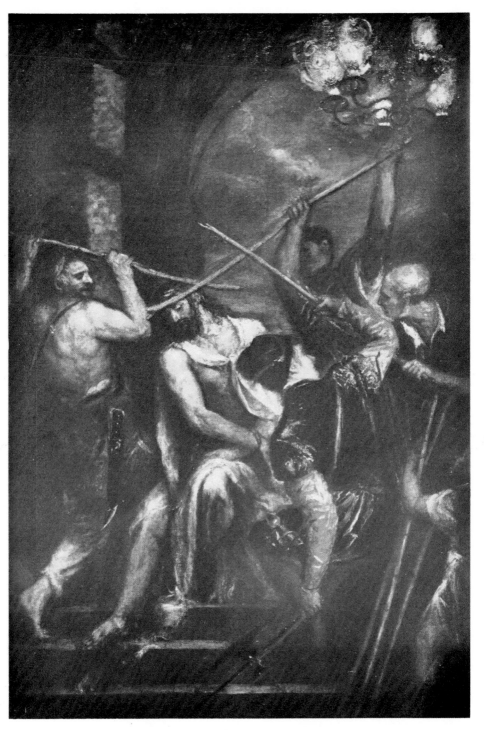

61. TITIAN: *Christ crowned with Thorns*. Alte Pinakothek, Munich

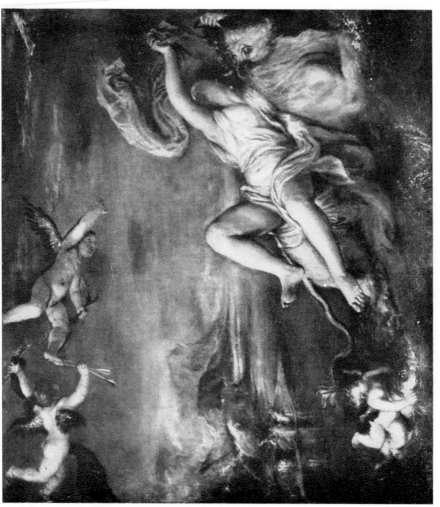

62. TITIAN: *The Rape of Europa*. Isabella Stewart Gardner Museum, Boston

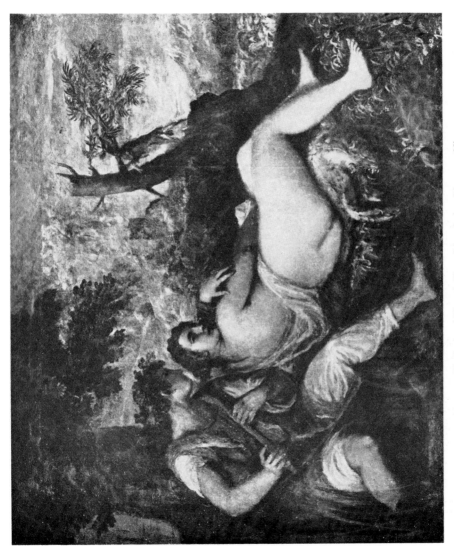

63, Titian: *Shepherd and Nymph*. Kunsthistorisches Museum, Vienna

64. SEBASTIANO DEL PIOMBO: *The Holy Family with a Donor*. National Gallery, London

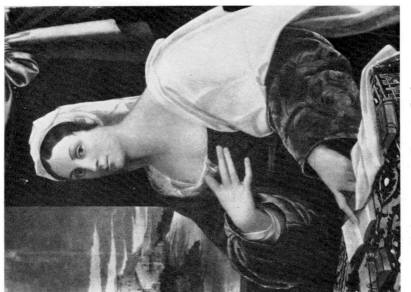

66. Sebastiano del Piombo: *Gentlewoman.*
Museum, Barcelona

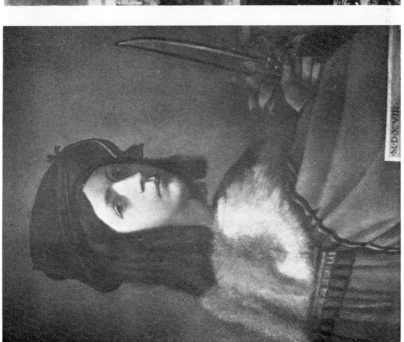

65. Sebastiano del Piombo: *A Violinist.*
Rothschild Collection, Paris

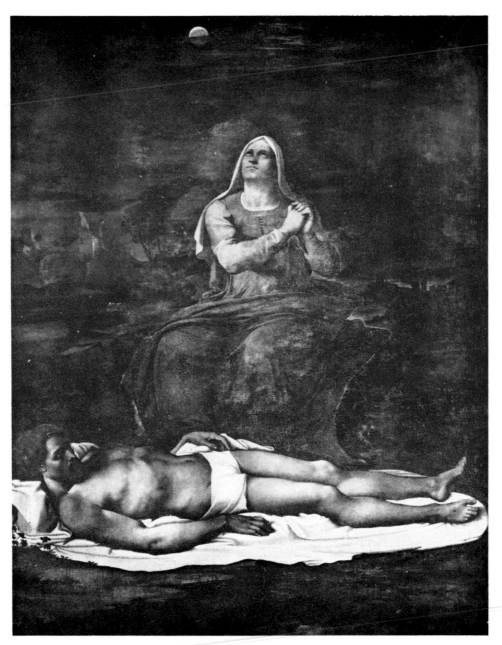

67. Sebastiano del Piombo: *Pietà*. Museo Civico, Viterbo

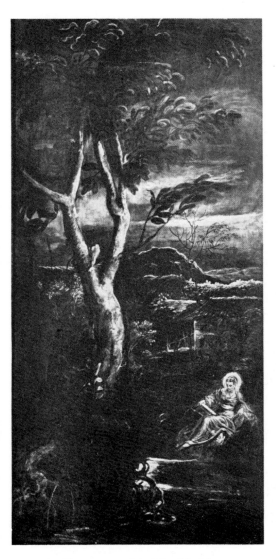

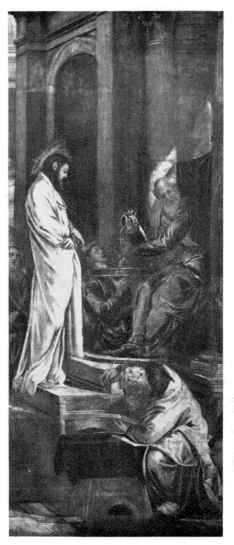

68. TINTORETTO: *Saint Mary Magdalene.*
Scuola di San Rocco, Venice

69. TINTORETTO: *Detail from 'Christ before Pilate'.*
Scuola di San Rocco, Venice

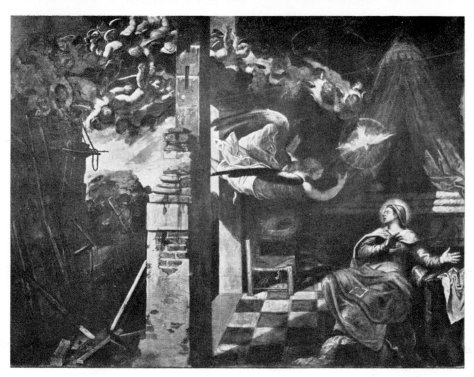

70. TINTORETTO: *The Annunciation*. Scuola di San Rocco, Venice

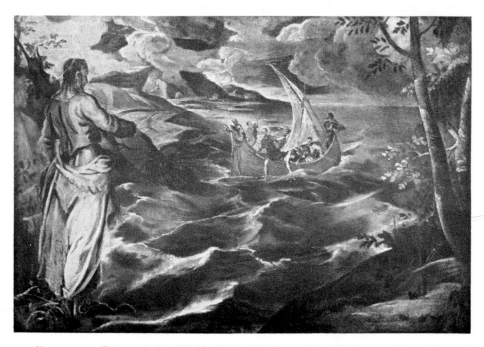

71. TINTORETTO: *Christ at the Sea of Galilee*. National Gallery of Art, Washington (Kress Collection)

72. Tintoretto: *The Liberation of Arsinoe*. Gallery, Dresden

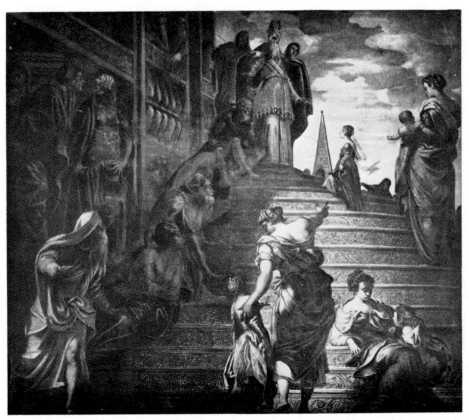

73. Tintoretto: *The Presentation of the Virgin*. Santa Maria dell'Orto, Venice

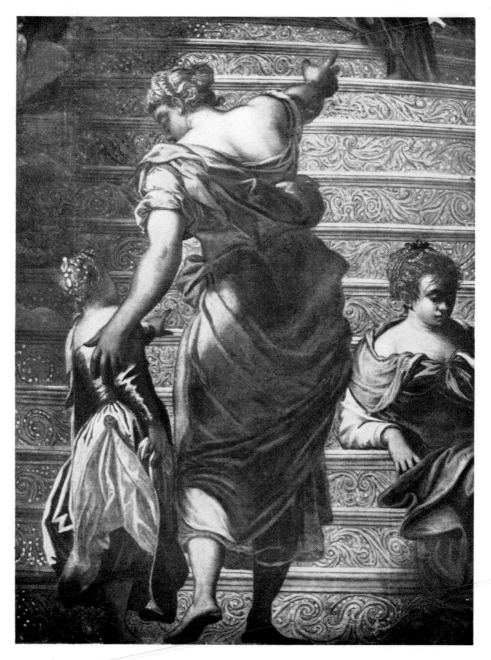

74. TINTORETTO: *Detail from the 'Presentation of the Virgin'*. Santa Maria dell'Orto, Venice

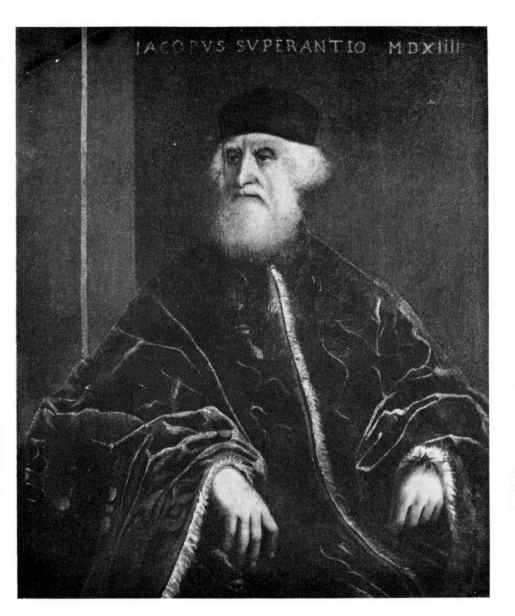

75. TINTORETTO: *Portrait of Jacopo Soranzo*. Academy, Venice

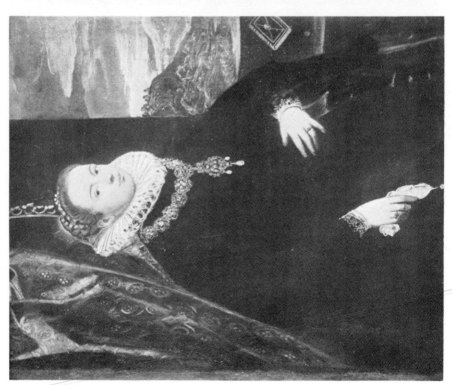

76. TINTORETTO: *Portrait of a Gentlewoman*, Isabella Stewart Gardner Museum, Boston

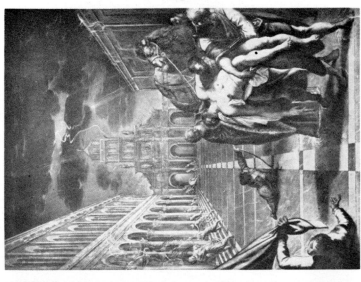

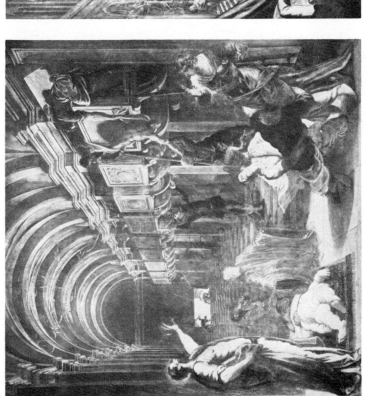

78. TINTORETTO: *The Discovery of the Body of Saint Mark.* Brera, Milan

79. TINTORETTO: *Storm rising while the Body of Saint Mark is being transported.* Academy, Venice

79

78

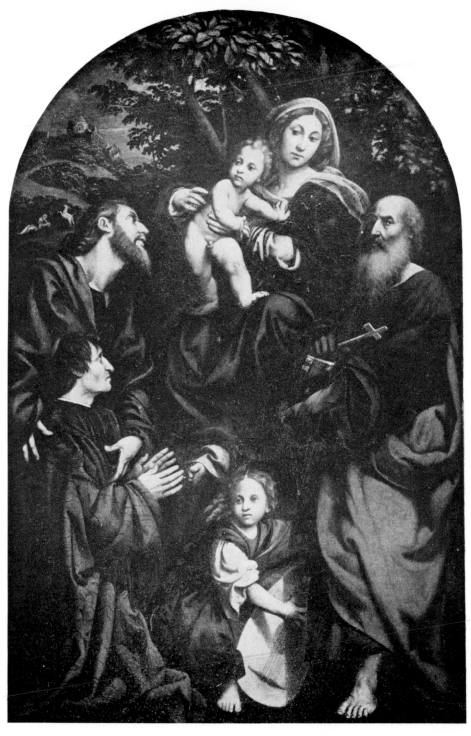

80. PORDENONE: *Madonna and Child with two Saints and Donor*. Duomo, Cremona

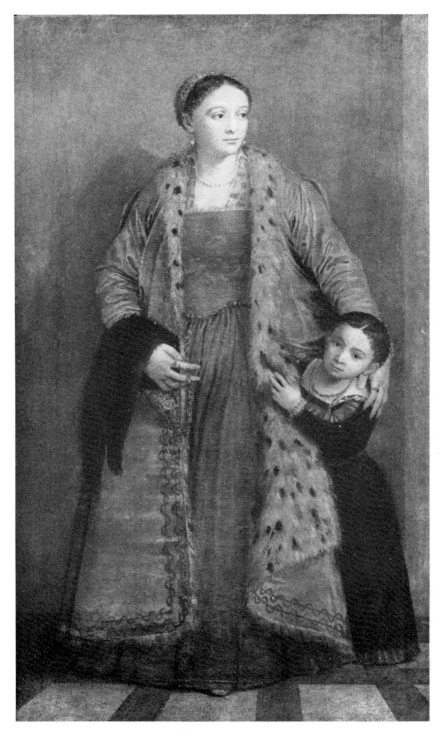

81. PAOLO VERONESE: *Portrait of a Lady with her small Daughter*. Walters Art Gallery, Baltimore

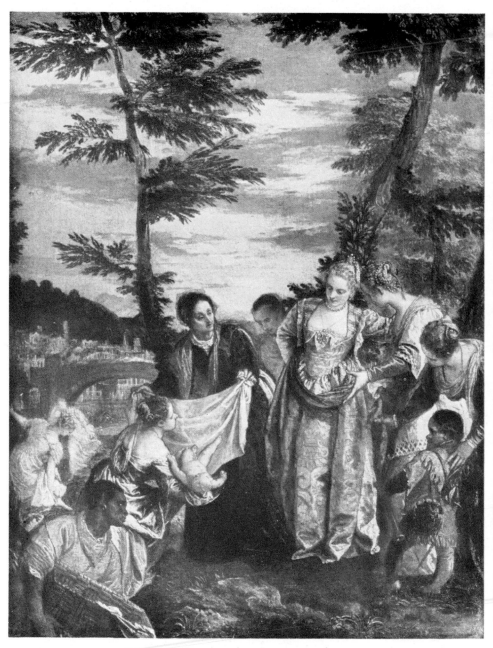

82. PAOLO VERONESE: *The Finding of Moses*. Prado, Madrid

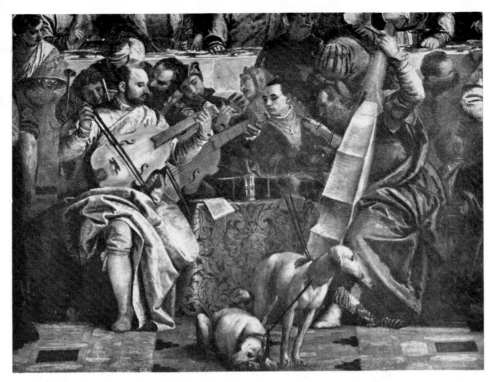

83. PAOLO VERONESE: *Detail from the 'Feast at Cana'*. Louvre, Paris

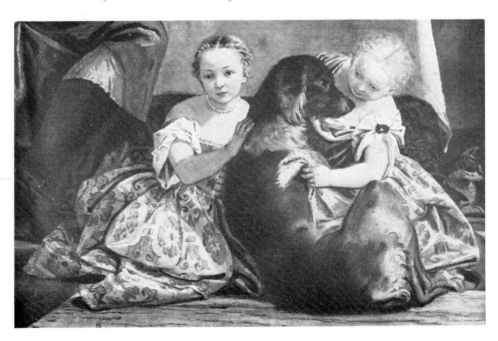

84. PAOLO VERONESE: *Detail from 'Christ at Emmaus'*. Louvre, Paris

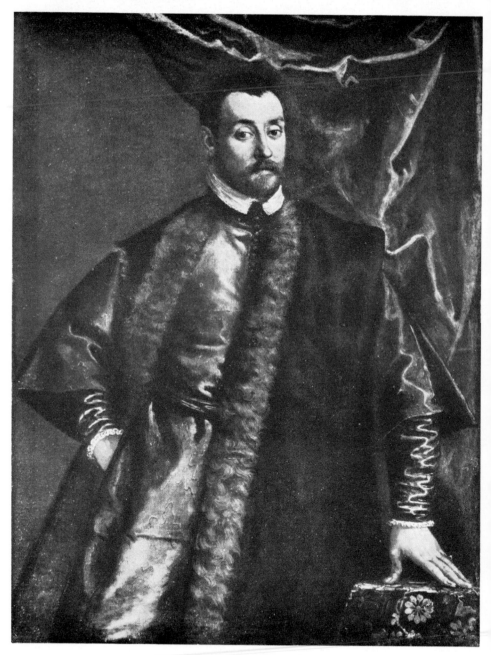

85. PAOLO VERONESE: *Portrait of a Man*. Colonna Gallery, Rome

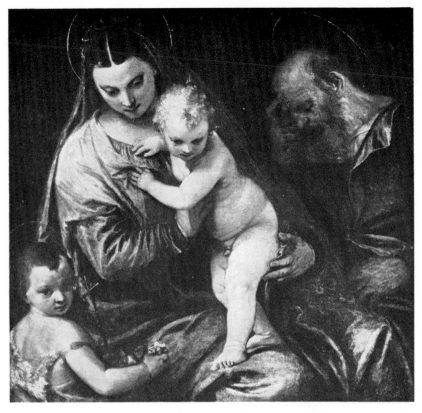

86. Paolo Veronese: *The Holy Family with the Infant Saint John.*
Rijksmuseum, Amsterdam

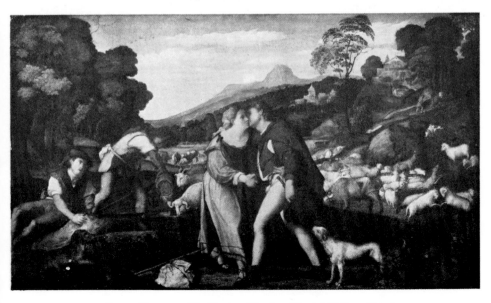

87. Palma Vecchio: *The Meeting of Jacob and Rachel.* Gallery, Dresden

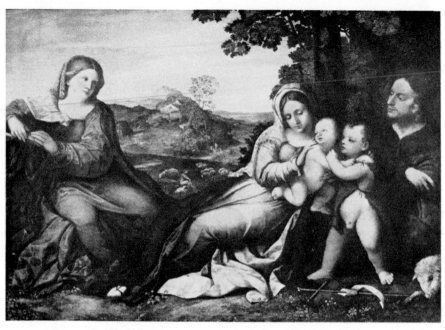

88. PALMA VECCHIO: *Sacra Conversazione*. Gallery, Dresden

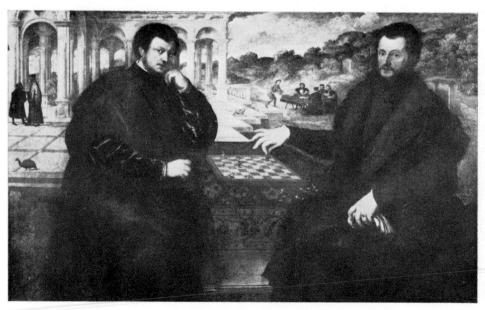

89. PARIS BORDONE: *The Chess Players*. Staatliche Museen, Berlin-Dahlem

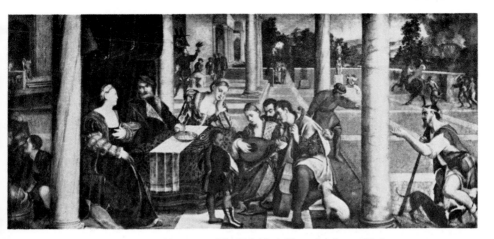

90. BONIFAZIO VERONESE: *The Rich Man's Feast*. Academy, Venice

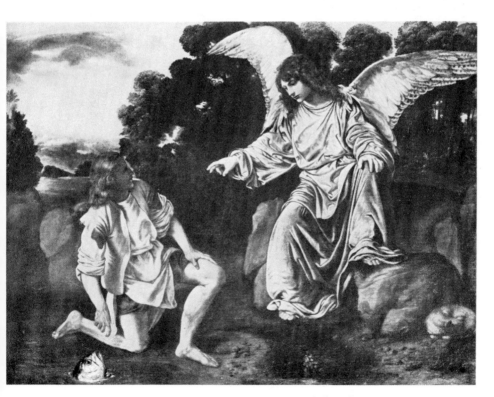

91. SAVOLDO: *Tobias and the Angel*. Borghese Gallery, Rome

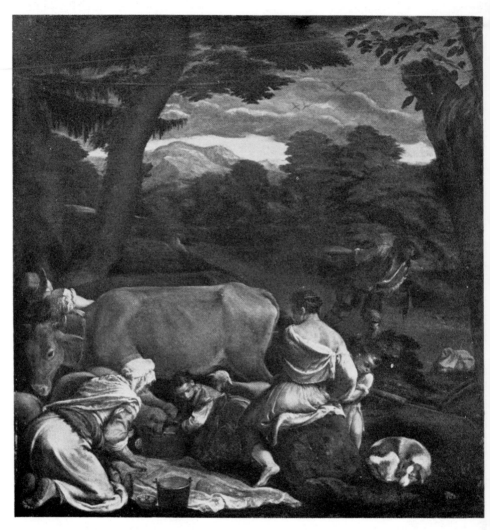

92. JACOPO BASSANO: *Rustic Scene*. Thyssen Collection, Lugano

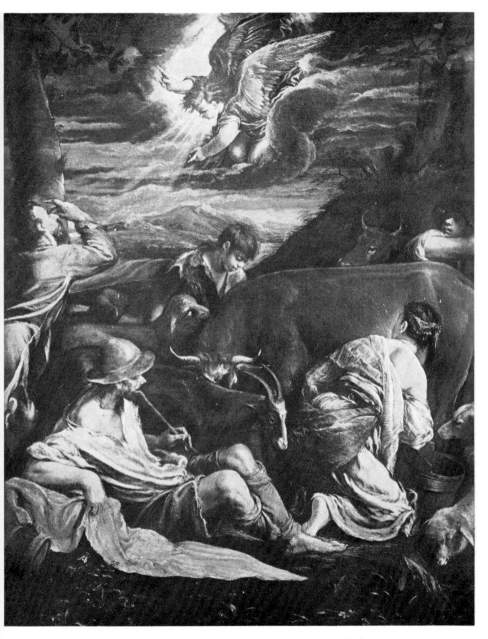

93. JACOPO BASSANO: *The Annunciation to the Shepherds.*
National Gallery of Art, Washington (Kress Collection)

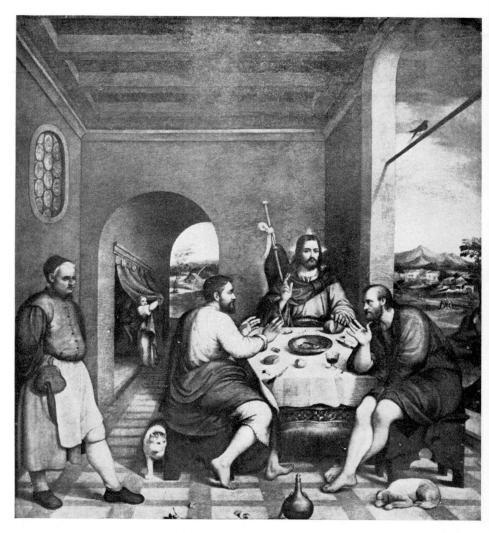

94. Jacopo Bassano: *Christ at Emmaus*. Parish Church, Cittadella

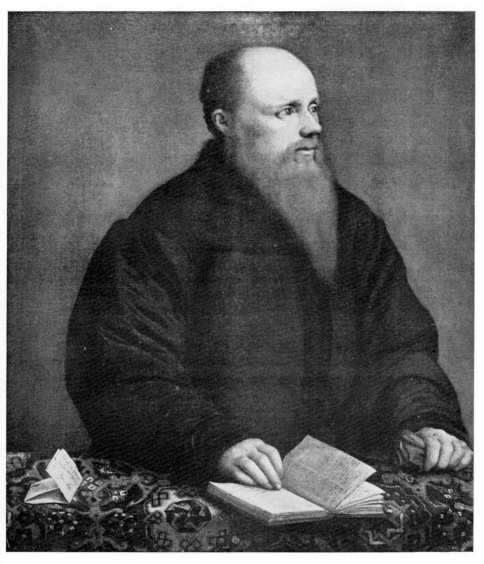

95. JACOPO BASSANO: *Portrait of a Man of Letters.*
Brooks Memorial Art Gallery, Memphis, Tennessee (Kress Collection)

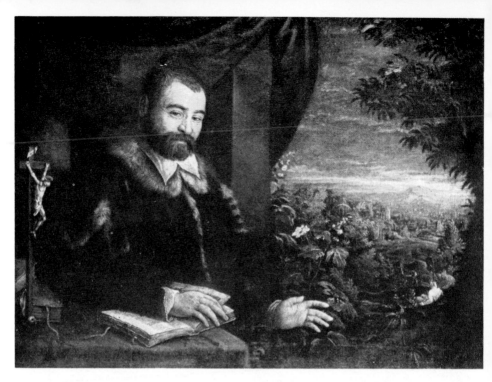

96. LEANDRO BASSANO: *Portrait of a Man*. John G. Johnson Collection, Philadelphia

97. LEANDRO BASSANO: *Christ appearing to a Gentleman in Prayer*. Fogg Art Museum, Cambridge, Mass.

98. PALMA GIOVANE: *The Prophet Elijah carried up to Heaven*. Ateneum, Helsinki

99. PIETRO LONGHI: *Blind Man's Buff*. National Gallery of Art, Washington (Kress Collection)

100. CANALETTO: *View in Venice*. National Gallery of Art, Washington (Widener Collection)

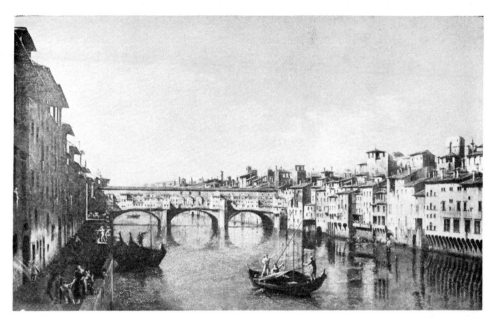

101. BERNARDO BELLOTTO: *View of the Ponte Vecchio, Florence*. Museum of Fine Arts, Boston

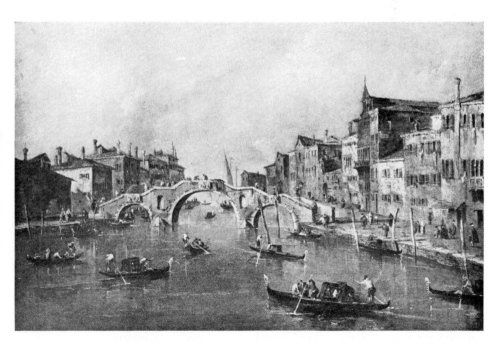

102. FRANCESCO GUARDI: *View on the Cannaregio, Venice*. National Gallery of Art, Washington
(Kress Collection)

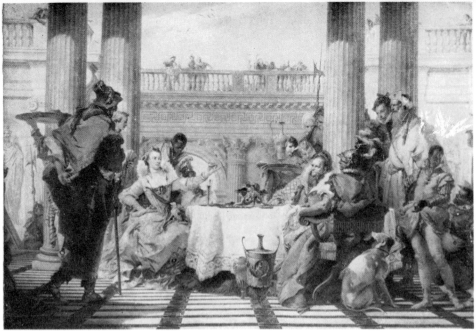

103. GIOVAN BATTISTA TIEPOLO: *The Banquet of Cleopatra*. National Gallery of Victoria, Melbourne (Felton Bequest)

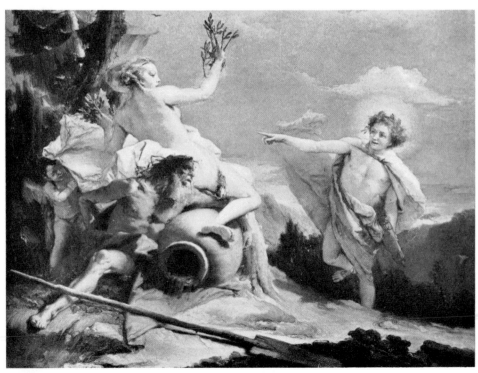

104. GIOVAN BATTISTA TIEPOLO: *Apollo pursuing Daphne*. National Gallery of Art, Washington (Kress Collection)

FLORENTINE PAINTERS

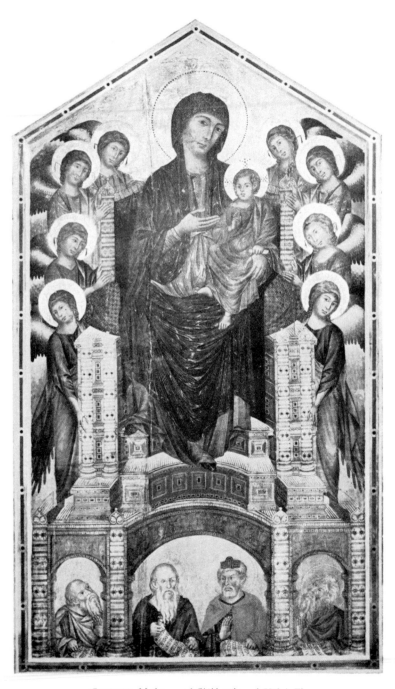

105. CIMABUE: *Madonna and Child enthroned*. Uffizi, Florence

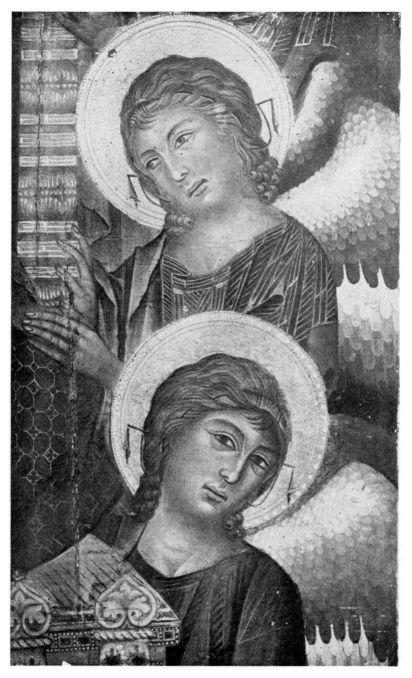

106. CIMABUE: *Detail from 'Madonna and Child enthroned'*. Uffizi, Florence

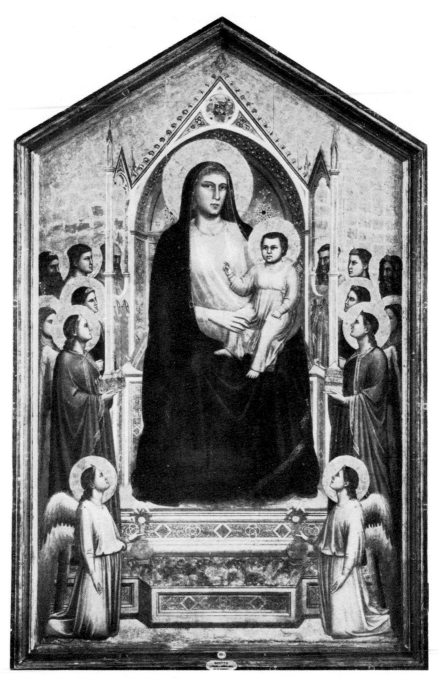

107. GIOTTO: *Madonna and Child enthroned*. Uffizi, Florence

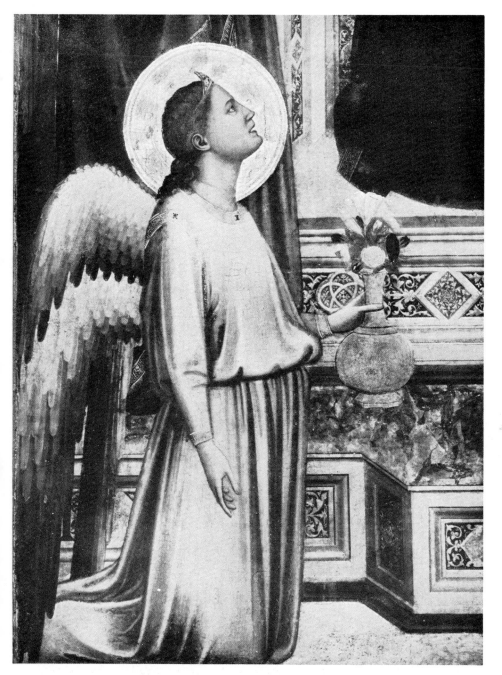

108. Giotto: *Detail from 'Madonna and Child enthroned'*. Uffizi, Florence

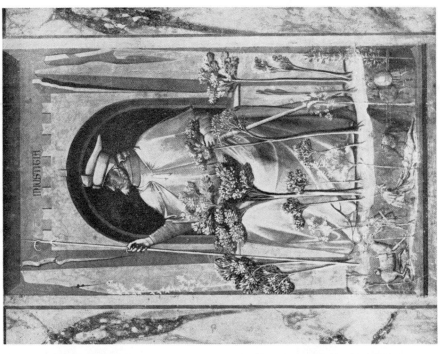

110. Giotto: *Injustice*. Arena Chapel, Padua

109. Giotto: *Saint Francis preaching to the Birds*. San Francesco, Assisi

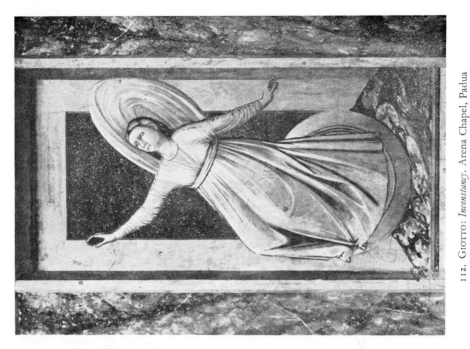

112. Giotto: *Inconstancy*. Arena Chapel, Padua

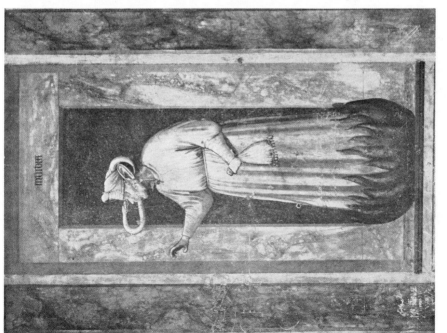

111. Giotto: *Avarice*. Arena Chapel, Padua

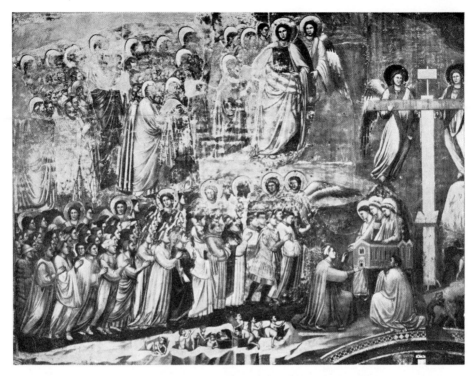

113. GIOTTO: *The Resurrection of the Blessed*. Arena Chapel, Padua

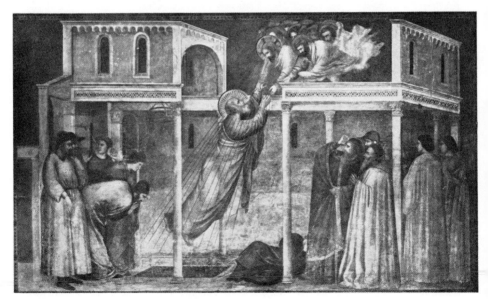

114. GIOTTO: *The Ascension of St. John the Evangelist*. Santa Croce, Florence

115. MICHELANGELO: *Drawing from Giotto's 'Ascension of the Evangelist'*. Louvre, Paris

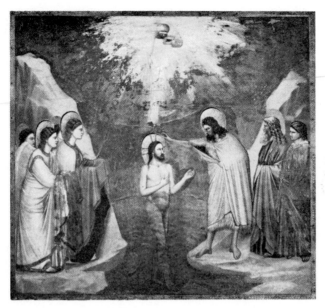

116. GIOTTO: *The Baptism of Christ*. Arena Chapel, Padua

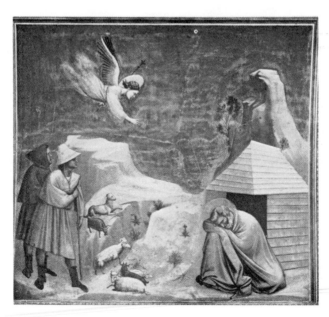

117. GIOTTO: *The Vision of St. Joachim*. Arena Chapel, Padua

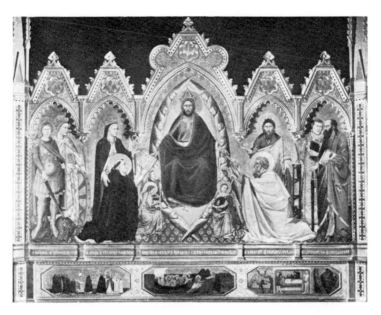

118. ANDREA ORCAGNA: *Christ enthroned, surrounded by Angels, with the Virgin and seven Saints*. Santa Maria Novella, Florence

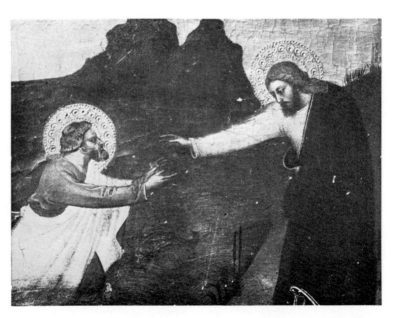

119. ANDREA ORCAGNA: *Detail from the Altarpiece*. Santa Maria Novella, Florence

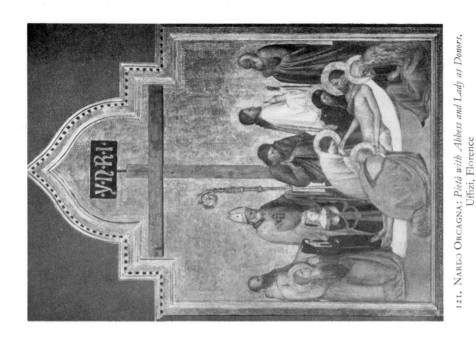

121. Nardo Orcagna: *Pietà with Abbess and Lady as Donors.*
Uffizi, Florence

120. Andrea Orcagna: *Detail from the Altarpiece.*
Santa Maria Novella, Florence

123. Nardo Orcagna: *Detail from 'Paradise'*. Santa Maria Novella, Florence

122. Nardo Orcagna: *Detail from 'Paradise'*. Santa Maria Novella, Florence

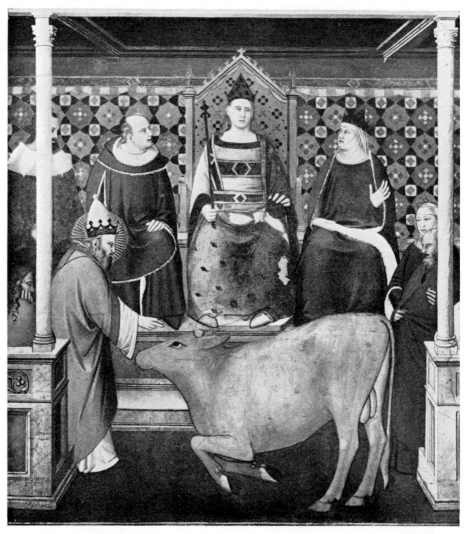

124. MASO DI BANCO: *Detail from the 'Miracles of Saint Sylvester'*. Bardi Chapel, Santa Croce, Florence

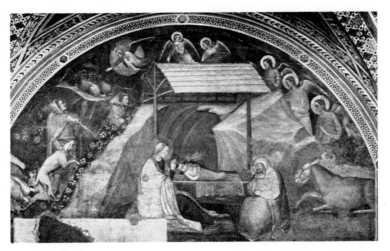

125. JACOPO DI CIONE: *The Nativity*. Cloisters of Santa Maria Novella, Florence

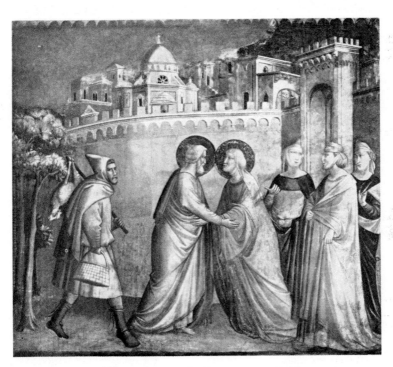

126. TADDEO GADDI: *The Meeting at the Golden Gate*.
Baroncelli Chapel, Santa Croce, Florence

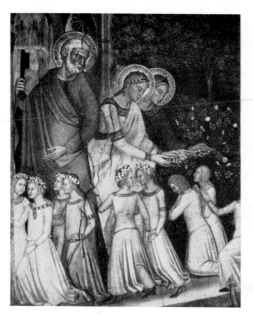

127-8. ANDREA DA FIRENZE: *Two details from the 'Triumphant and Militant Church'.*
Cappellone degli Spagnuoli, Santa Maria Novella, Florence

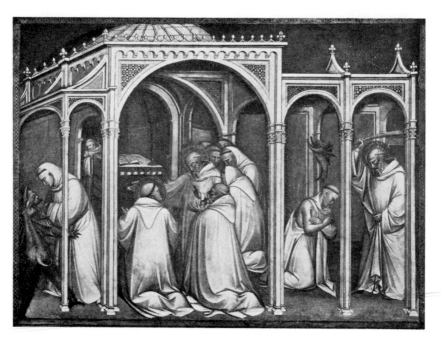

129. SPINELLO ARETINO: *The Miracle of Saint Benedict.* Sacristy of San Miniato, Florence

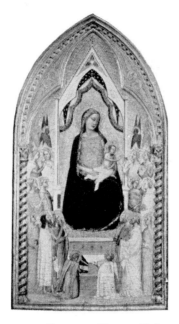
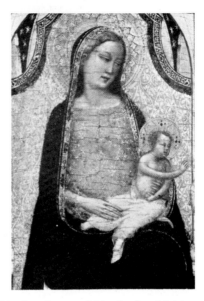

130. BERNARDO DADDI: *Madonna and Child enthroned, surrounded by Angels and Saints.*
National Gallery of Art, Washington (Kress Collection) and 130 a. *Detail*

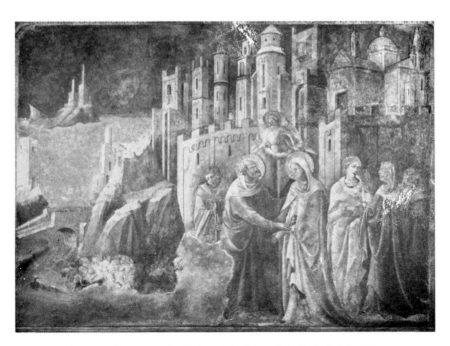

131. LORENZO MONACO: *The Meeting at the Golden Gate.* Santa Trinita, Florence

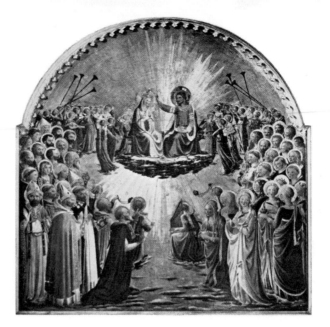

132. FRA ANGELICO: *The Coronation of the Virgin*. Uffizi, Florence

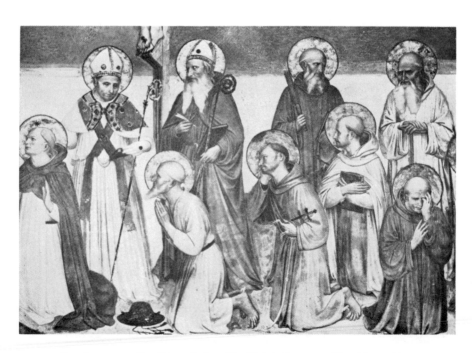

133. FRA ANGELICO: *Detail from the large 'Crucifixion'*. Convent of San Marco, Florence

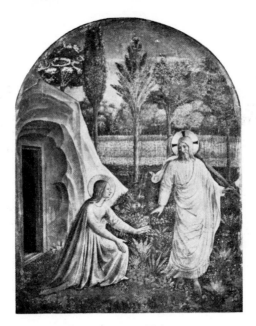

134. FRA ANGELICO: *Noli me tangere.*
Convent of San Marco, Florence

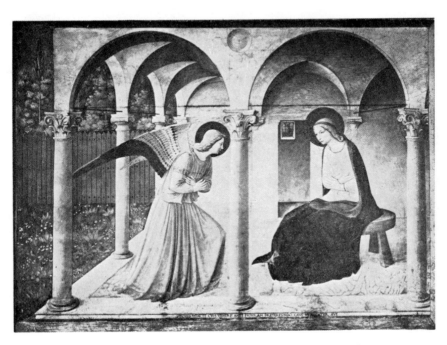

135. FRA ANGELICO: *The Annunciation.* Convent of San Marco, Florence

136. Fra Angelico: *Detail from the 'Deposition'.* San Marco Museum, Florence

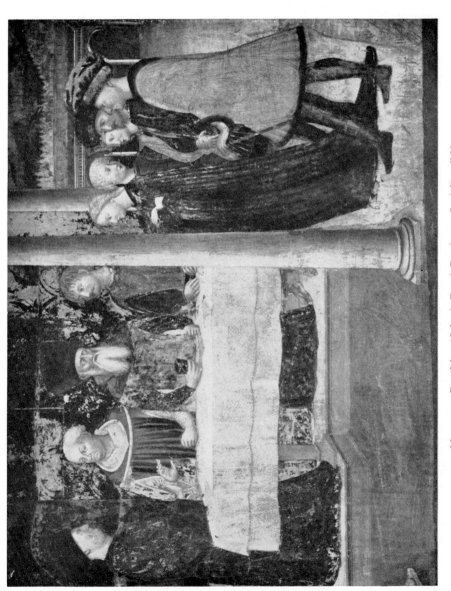

137. MASOLINO: *Detail from 'Salome's Dance'*. Baptistery, Castiglion d'Olona

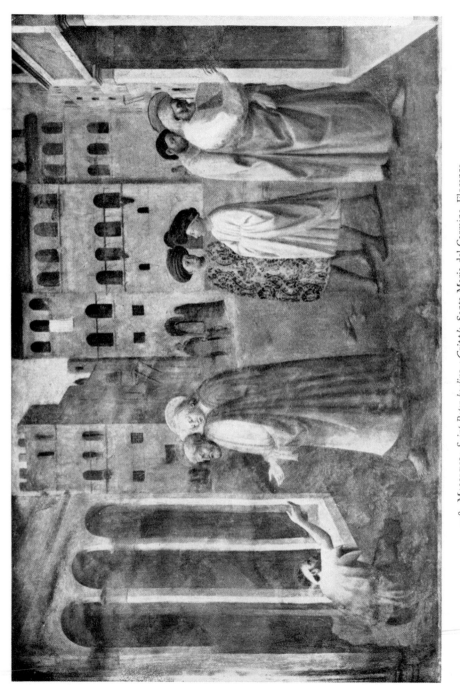

138. Masolino: *Saint Peter healing a Cripple*. Santa Maria del Carmine, Florence

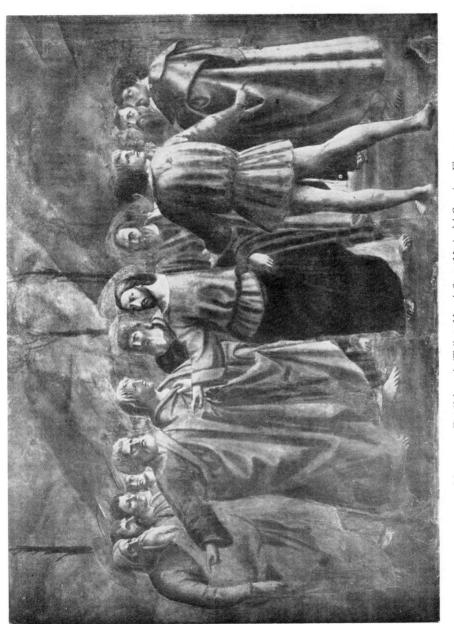

139. MASACCIO: *Detail from the 'Tribute Money'*. Santa Maria del Carmine, Florence

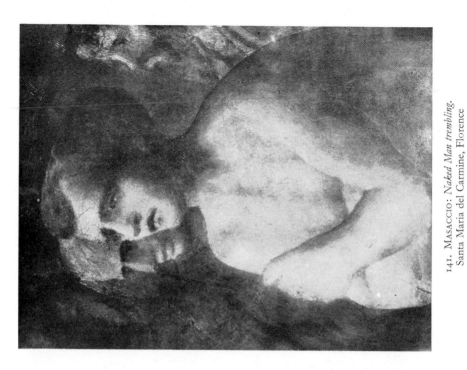

141. MASACCIO: *Naked Man trembling.*
Santa Maria del Carmine, Florence

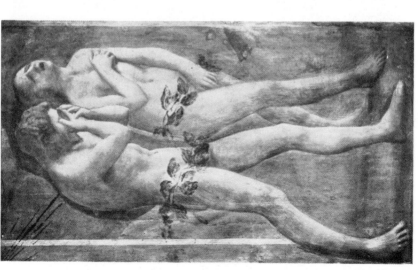

140. MASACCIO:
Detail from the 'Expulsion from Paradise'.
Santa Maria del Carmine, Florence

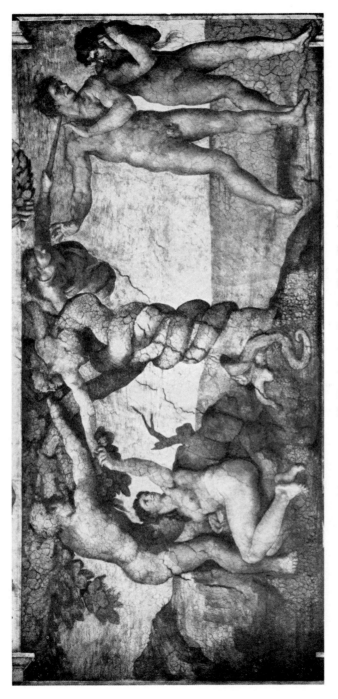

142. MICHELANGELO: *The Expulsion from Paradise.* Sistine Chapel, Vatican

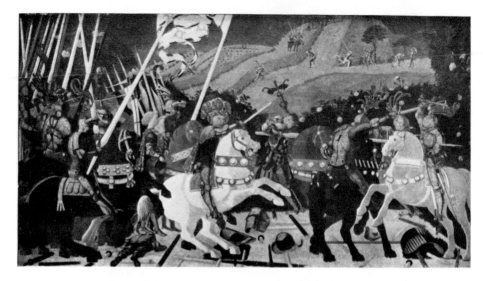

143. PAOLO UCCELLO: *The Rout of San Romano*. National Gallery, London

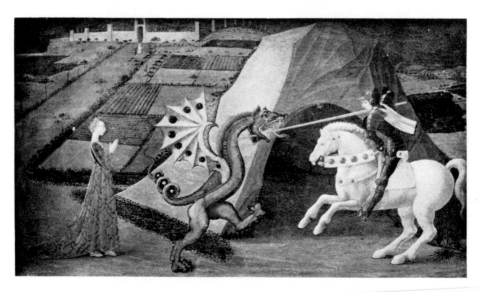

144. PAOLO UCCELLO: *Saint George and the Dragon*. Musée Jacquemart-André, Paris

145. PAOLO UCCELLO: *Hunting Scene*. Ashmolean Museum, Oxford

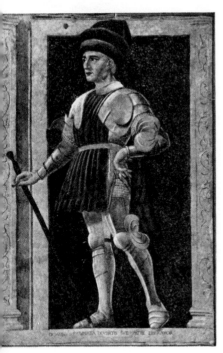

146. ANDREA DEL CASTAGNO:
Farinata degli Uberti. Castagno Museum, Florence

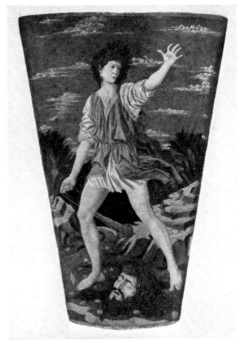

147. ANDREA DEL CASTAGNO:
The youthful David. National Gallery of Art,
Washington (Widener Collection)

148. ANDREA DEL CASTAGNO: *Saint Julian*. SS.Annunziata, Florence

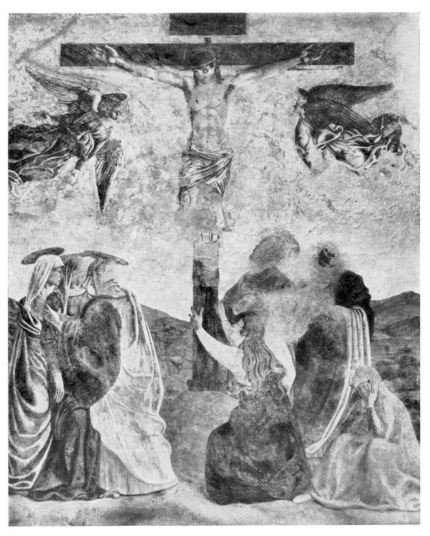

149. ANDREA DEL CASTAGNO: *The Crucifixion*. Castagno Museum, Florence

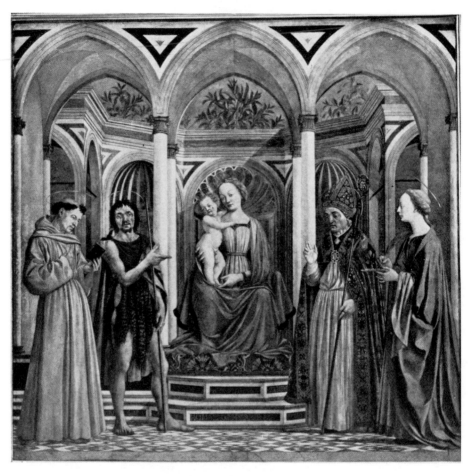

150. Domenico Veneziano: *Madonna and Child with Saints*. Uffizi, Florence

151. DOMENICO VENEZIANO: *Saint John in the Desert*. National Gallery of Art, Washington
(Kress Collection)

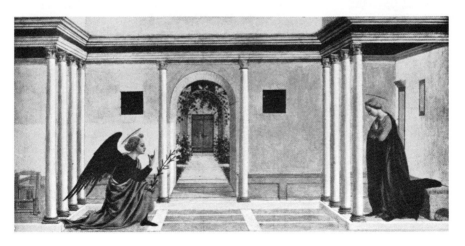

152. DOMENICO VENEZIANO: *The Annunciation*. Fitzwilliam Museum, Cambridge

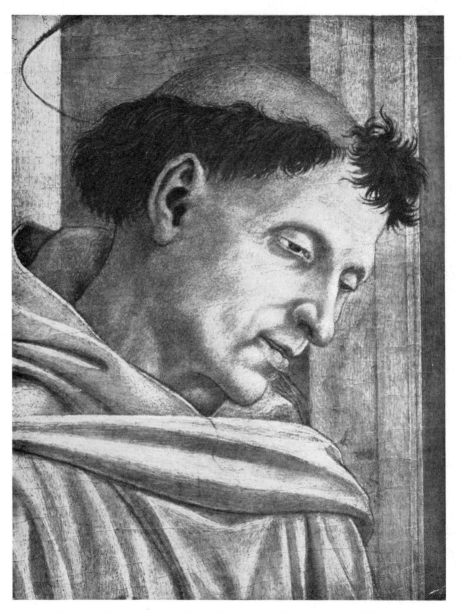

153. DOMENICO VENEZIANO: *Detail from 'Madonna and Child with Saints'*. Uffizi, Florence

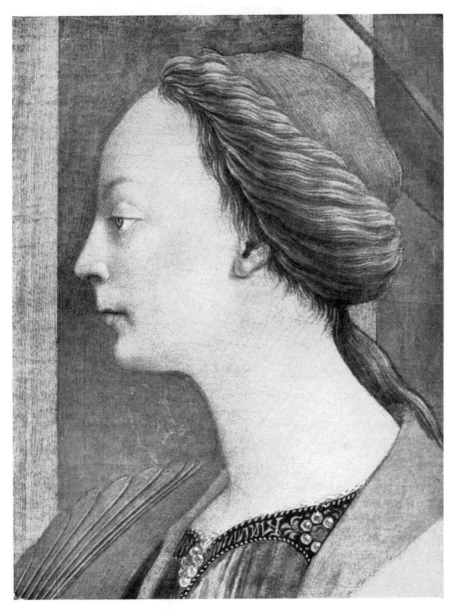

154. Domenico Veneziano: *Detail from 'Madonna and Child with Saints'*. Uffizi, Florence

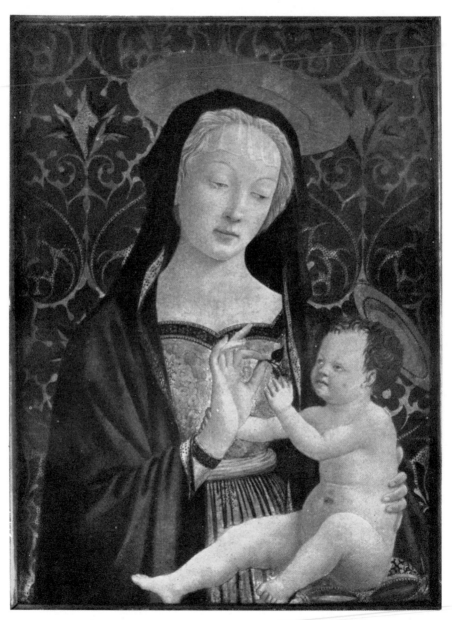

155. Domenico Veneziano: *Madonna and Child*. Berenson Collection, Settignano, Florence

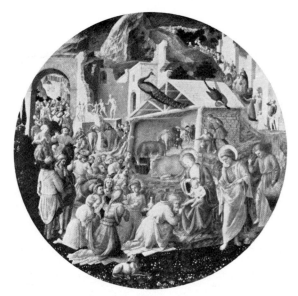

156. Begun by Fra Angelico and finished by Fra Filippo Lippi:
The Adoration of the Magi. National Gallery of Art, Washington (Kress Collection)

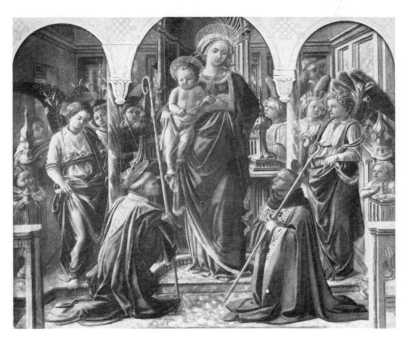

157. Fra Filippo Lippi: *Altarpiece.* Louvre, Paris

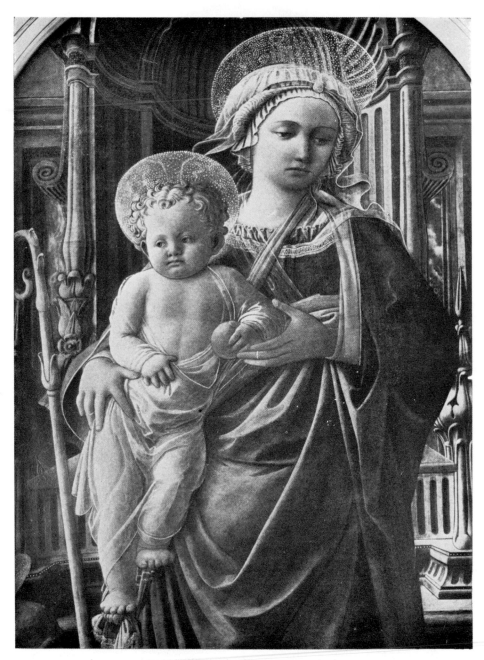

158. Fra Filippo Lippi: *Detail from the 'Altarpiece'*. Louvre, Paris

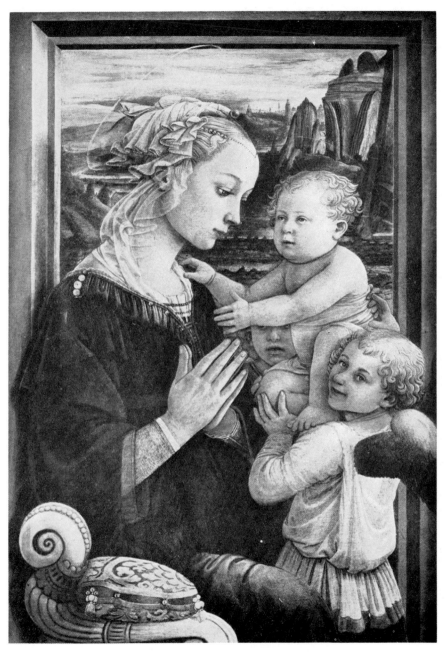

159. Fra Filippo Lippi: *Madonna and Child*. Uffizi, Florence

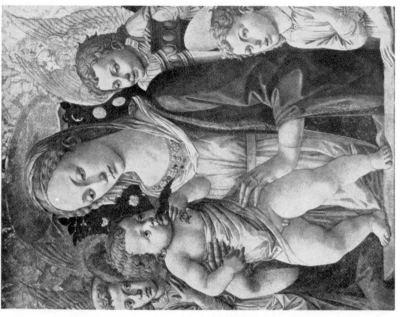

161. FRANCESCO PESELLINO: *Madonna and Child.*
Museum of Art, Toledo, Ohio
(*Gift of Edward Drummond Libbey*)

160. FRA FILIPPO LIPPI: *Madonna and Child.*
Palazzo Riccardi, Florence

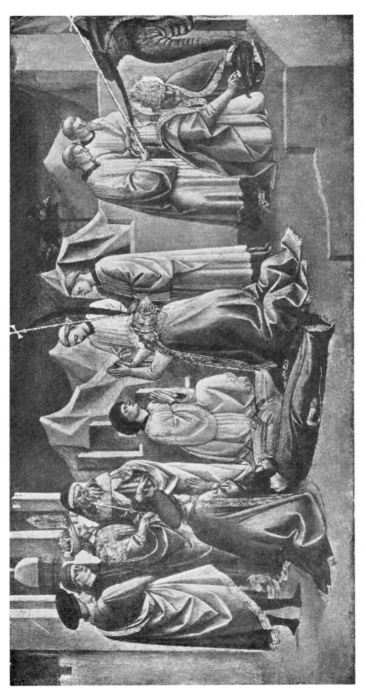

162. Francesco Pesellino: *Two Miracles of St. Leo.* Doria Palace, Rome

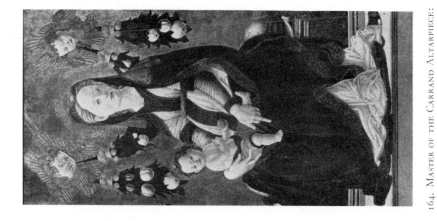

163. Master of the Castello Nativity:
Madonna adoring the Child.
Huntington Art Gallery, San Marino, California

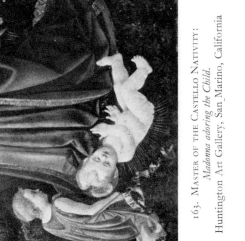

164. Master of the Carrand Altarpiece:
Madonna and Child.
Contini Bonacossi Collection, Florence

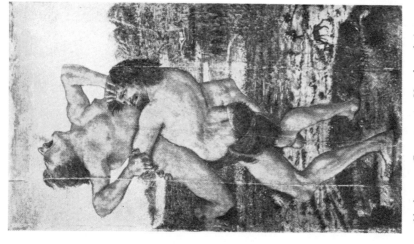

166. Antonio Pollaiuolo: *Hercules and Antaeus.*
Uffizi, Florence

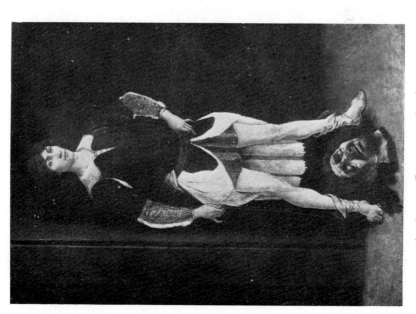

165. Antonio Pollaiuolo: *David.*
Staatliche Museen, Berlin-Dahlem

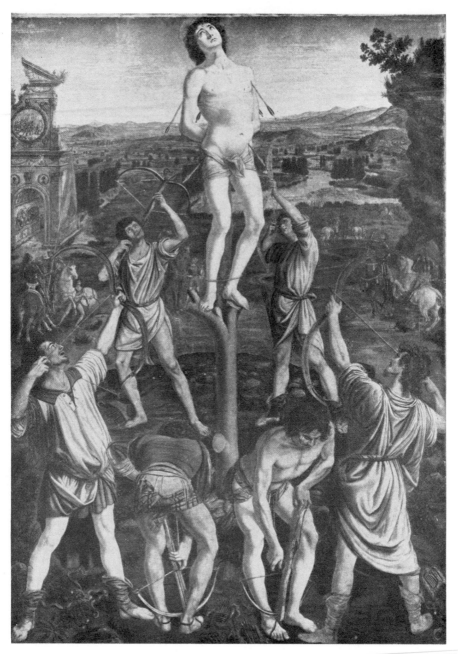

167. ANTONIO POLLAIUOLO: *The Martyrdom of Saint Sebastian*. National Gallery, London

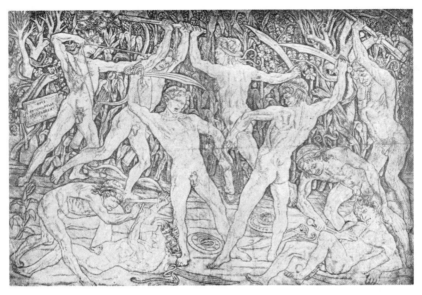

168. Antonio Pollaiuolo: *The Battle of the Nudes*. Uffizi, Florence

169. Andrea del Castagno (formerly ascribed
to Antonio Pollaiuolo): *Portrait of a Man*.
National Gallery of Art, Washington
(Mellon Collection)

170. Alesso Baldovinetti:
Madonna adoring the Child. Louvre, Paris

172. Andrea del Verrocchio: *Bartolommeo Colleoni on Horseback.*
Venice

171. Andrea del Verrocchio: *Putto with Dolphin.*
Palazzo Vecchio, Florence

174. ANDREA DEL VERROCCHIO: *Madonna adoring the Child.*
Edinburgh, National Gallery of Scotland

173. ANDREA DEL VERROCCHIO: *Madonna and Child.*
Staatliche Museen, Berlin-Dahlem

175. ALESSO BALDOVINETTI: *Detail from the 'Nativity'*.
Cloisters of the SS. Annunziata, Florence

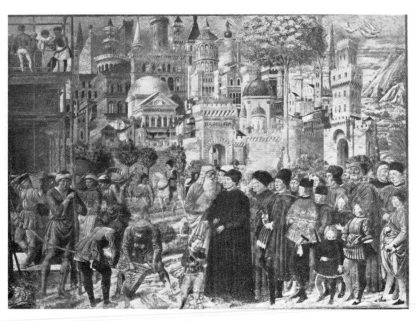

176. BENOZZO GOZZOLI: *The City of Babylon*. Camposanto, Pisa

177. BENOZZO GOZZOLI: *Detail from the 'Procession of the Magi'*. Palazzo Riccardi, Florence
178. BENOZZO GOZZOLI: *Detail from the Story of Noah*. Camposanto, Pisa

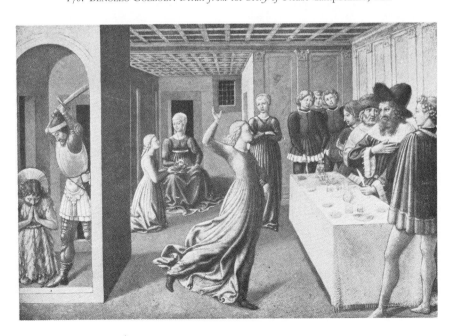

179. BENOZZO GOZZOLI: *Dance of Salome and Beheading of Saint John the Baptist*.
National Gallery of Art, Washington (Kress Collection)

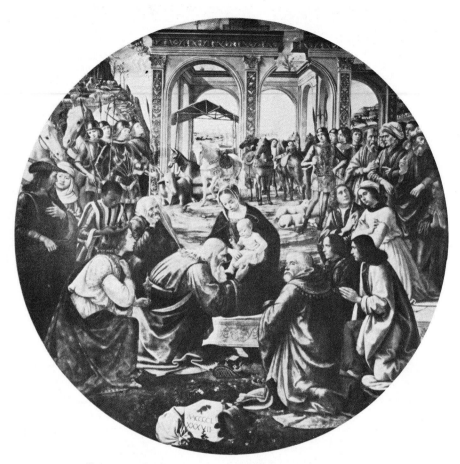

180. Domenico Ghirlandaio: *The Adoration of the Magi*. Uffizi, Florence

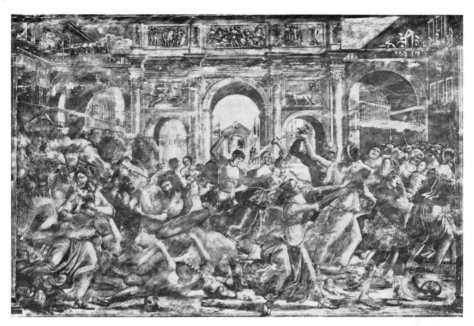

181. DOMENICO GHIRLANDAIO: *The Massacre of the Innocents*. Santa Maria Novella, Florence

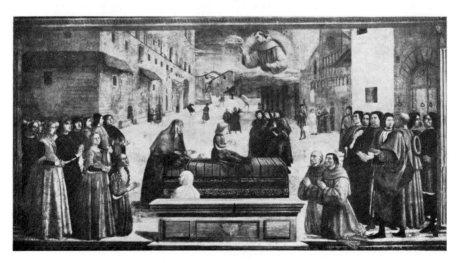

182. DOMENICO GHIRLANDAIO: *St. Francis resuscitating a child of the Sassetti family*.
Santa Trinita, Florence

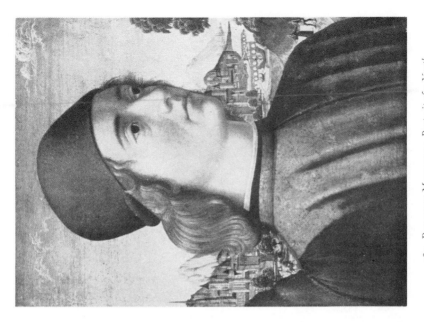

184. Bastiano Mainardi: *Portrait of a Youth.*
Staatliche Museen, Berlin-Dahlem

185. Domenico Ghirlandaio: *Portrait of a Man with his grandson.*
Louvre, Paris

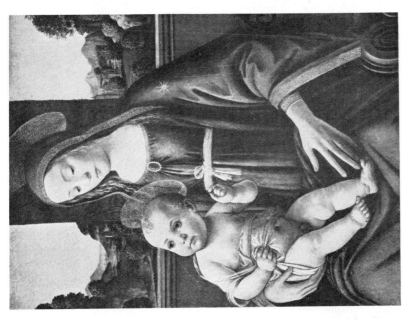

185. Cosimo Rosselli: *Portrait of a Man.*
Metropolitan Museum of Art, New York
(Harkness Collection)

186. Cosimo Rosselli: *Madonna and Child.*
Museum of Art, Birmingham, Alabama
(Kress Collection)

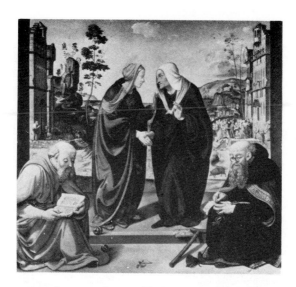

187. PIERO DI COSIMO: *The Visitation with two Saints.*
National Gallery of Art, Washington (Kress Collection)

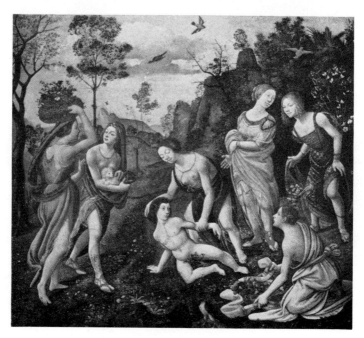

188. PIERO DI COSIMO: *Hylas and the Nymphs.*
Wadsworth Atheneum, Hartford, Connecticut

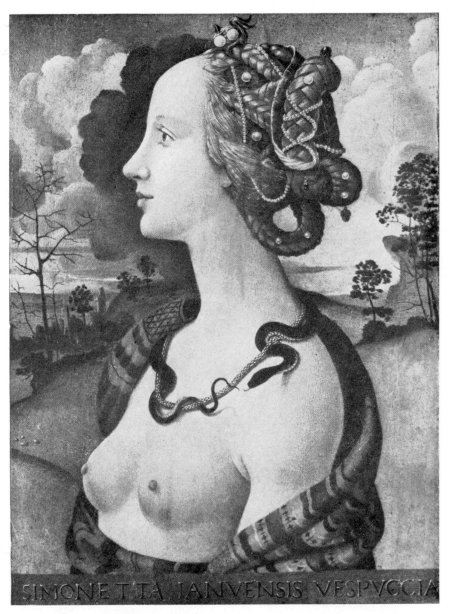

SIMONETTA JANVENSIS VESPVCCIA

189. PIERO DI COSIMO: *Profile of a Young Woman*. Musée Condé, Chantilly

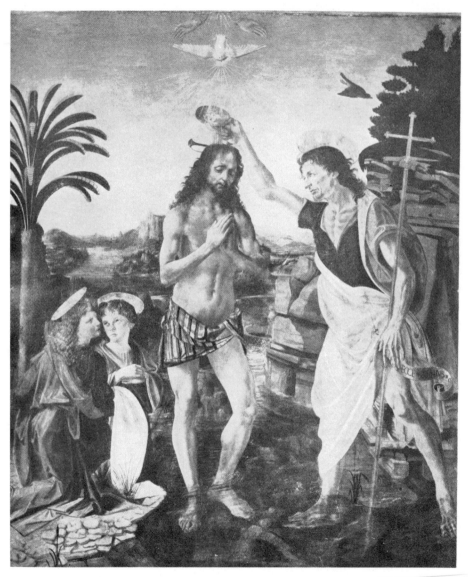

190. LEONARDO DA VINCI AND VERROCCHIO: *The Baptism of Christ.* Uffizi, Florence

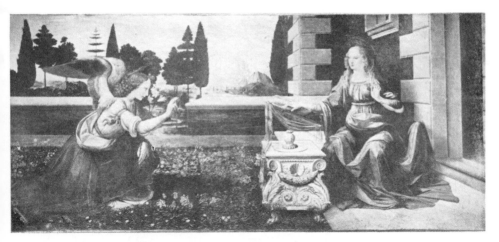

191. LEONARDO DA VINCI: *The Annunciation*. Uffizi, Florence

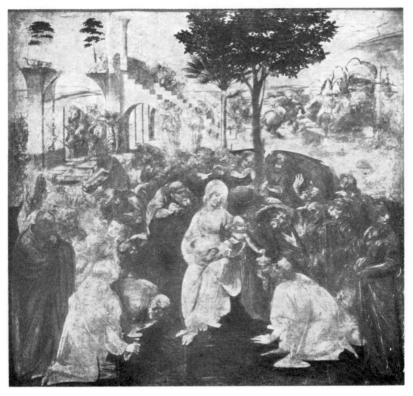

192. LEONARDO DA VINCI: *The Adoration of the Magi*. Uffizi, Florence

193. LEONARDO DA VINCI: *Detail from the 'Adoration of the Magi'*. Uffizi, Florence

194. LEONARDO DA VINCI: *Cartoon for 'Madonna and Child
with Saint Anne'*, National Gallery, London

195. LEONARDO DA VINCI: *Madonna and Child*.
Alte Pinakothek, Munich

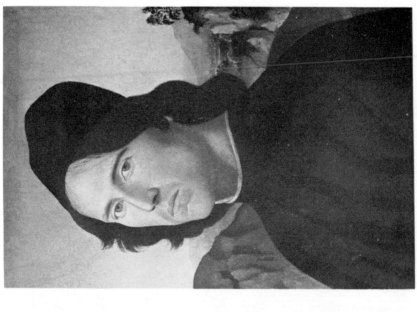

197. LORENZO DI CREDI: *Self-Portrait*. National Gallery of Art, Washington (Widener Collection)

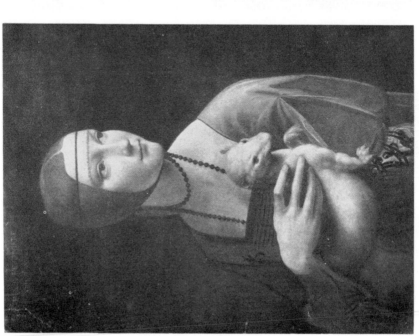

196. LEONARDO DA VINCI: *Lady with Weasel*. Czartoryski Museum, Cracow

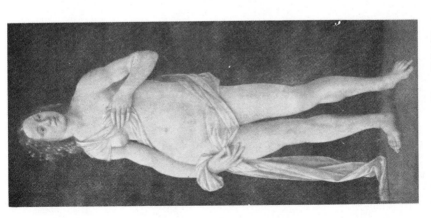

198. Lorenzo di Credi: *Venus*. Uffizi, Florence

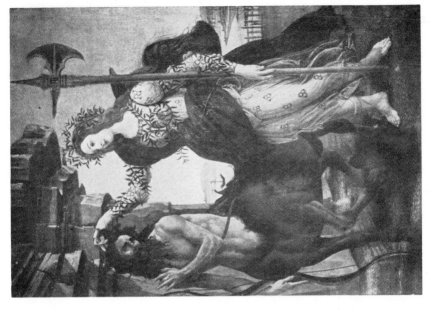

199. Botticelli: *Pallas and Centaur*. Uffizi, Florence

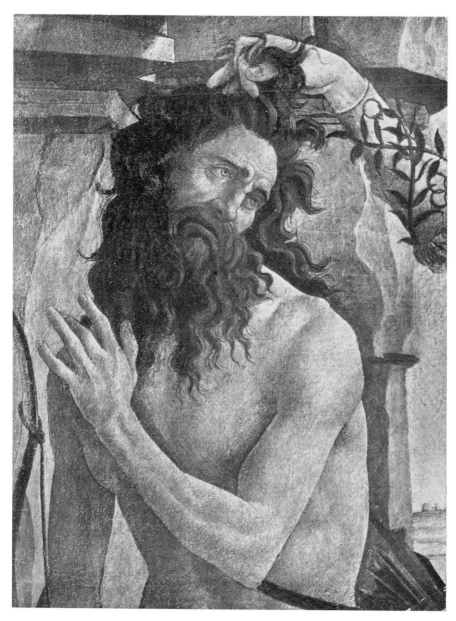

200. Botticelli: *Detail from 'Pallas and Centaur'*. Uffizi, Florence

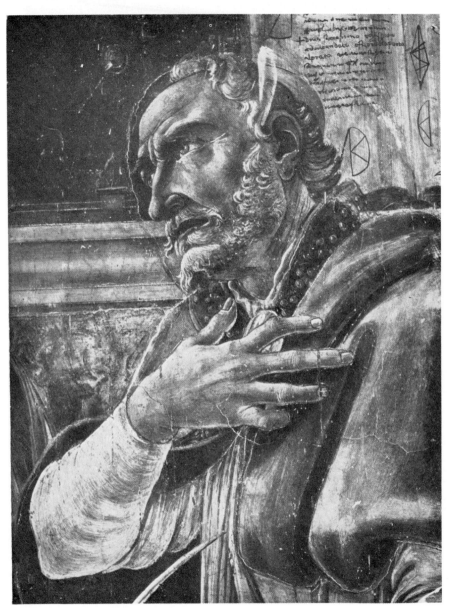

201. BOTTICELLI: *Detail from 'Saint Augustine'*. Ognissanti, Florence

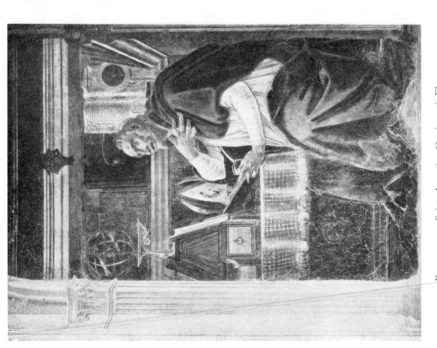

203. BOTTICELLI: *Detail from 'Spring'*. Uffizi, Florence

202. BOTTICELLI: *Saint Augustine*. Ognissanti, Florence

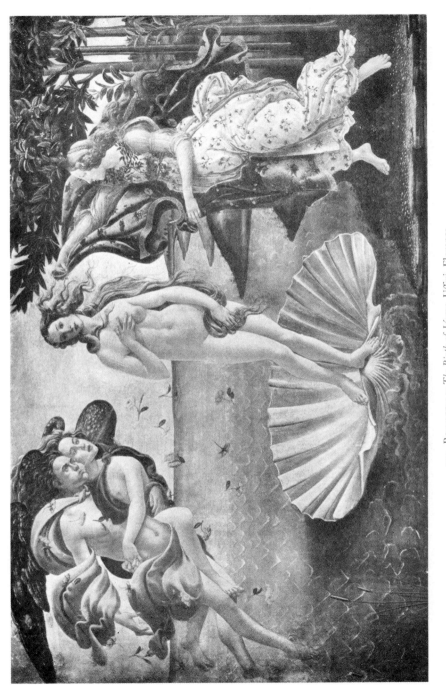

204. Botticelli: *The Birth of Venus*. Uffizi, Florence

205. BOTTICELLI: *Detail from the 'Birth of Venus'*. Uffizi, Florence

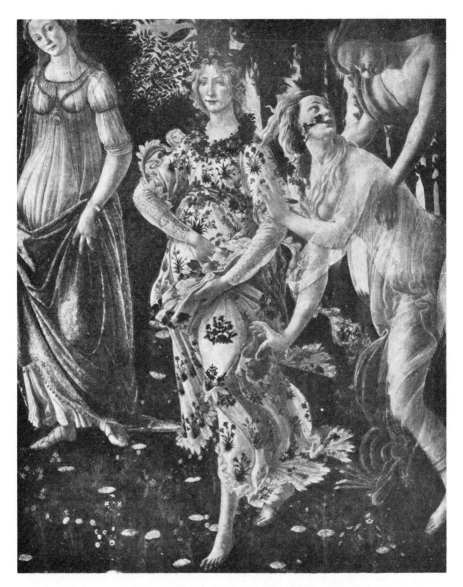

206. BOTTICELLI: *Detail from 'Spring'*. Uffizi, Florence

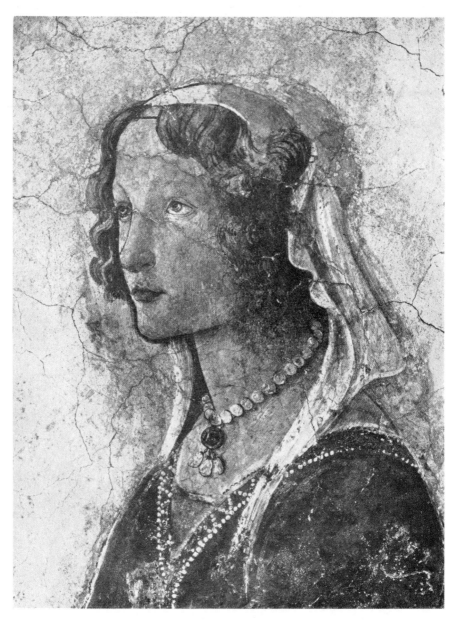

207. BOTTICELLI: *Detail from the Villa Lemmi Frescoes*. LOUVRE, Paris

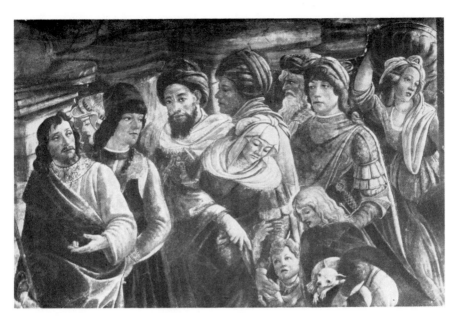

208. BOTTICELLI: *Detail from 'Moses leaving Egypt'*. Sistine Chapel, Rome

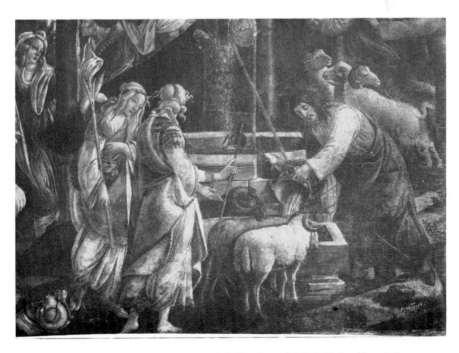

209. BOTTICELLI: *Detail from 'Moses and the Daughters of Jethro'*. Sistine Chapel, Rome

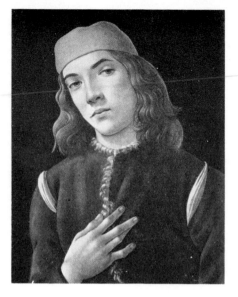

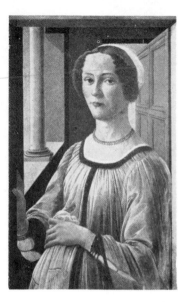

210

21

210. BOTTICELLI: *Portrait of a Youth.* National Gallery of Art, Washington (Mellon Collection)
211. BOTTICELLI: *Portrait of Esmeralda.* Victoria and Albert Museum, London

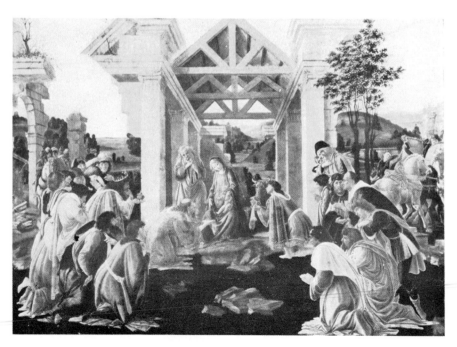

212. BOTTICELLI: *The Adoration of the Magi.* National Gallery of Art, Washington (Mellon Collection)

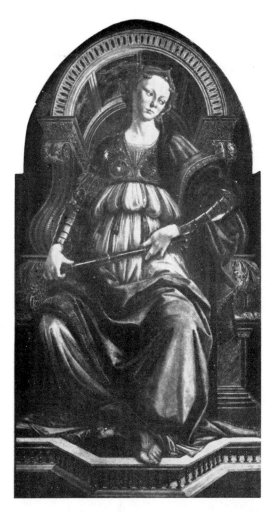

213. BOTTICELLI: *Fortitude*. Uffizi, Florence

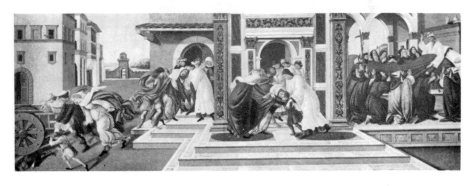

214. BOTTICELLI: *Detail from the 'Story of San Zanobi'*. Gallery, Dresden

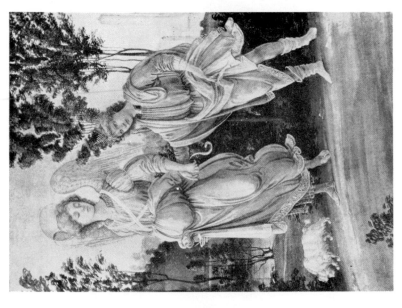

216. Filippino Lippi: *Tobias and the Angel.*
National Gallery of Art, Washington (Kress Collection)

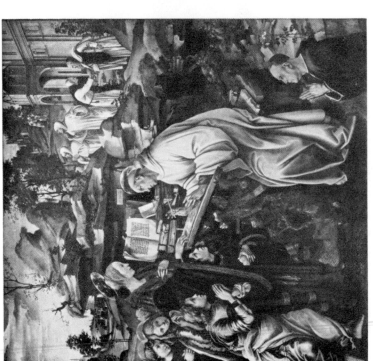

215. Filippino Lippi: *The Vision of Saint Bernard.*
Badia, Florence

218. RAFFAELLINO DEL GARBO: *Detail from the 'Deposition'.*
Alte Pinakothek, Munich

217. RAFFAELLINO DEL GARBO: *Madonna and Child with the little St. John.*
Museum, Naples

219

220

219. FRA BARTOLOMMEO: *Detail from 'Madonna and Child with Saints and Angels'*. Cathedral, Lucca
220. FRA BARTOLOMMEO: *The Nativity*. National Gallery, London

221. FRA BARTOLOMMEO: *The Holy Family with music-making Angel*. Sketch in pen and ink.
Musée Condé, Chantilly

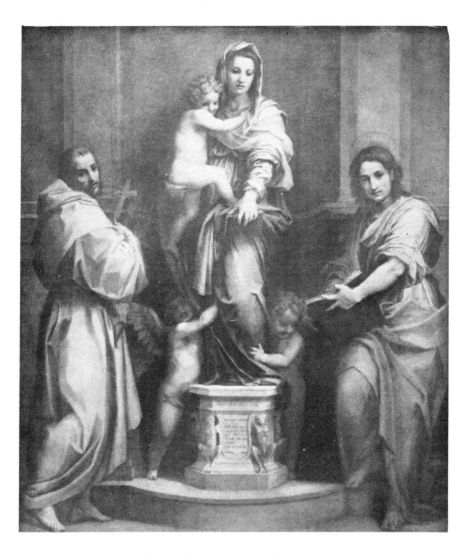

222. ANDREA DEL SARTO: *The Madonna of the Harpies*. Pitti Palace, Florence

223: Andrea del Sarto: *Madonna del Sacco*. Cloisters of the SS. Annunziata, Florence

225. Andrea del Sarto: *Portrait of an Architect.*
National Gallery, London

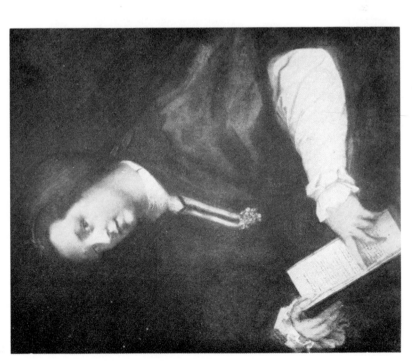

224. Andrea del Sarto: *Lady reading Petrarch.*
Uffizi, Florence

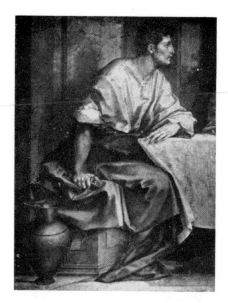

226. ANDREA DEL SARTO: *Detail from the
'Last Supper'*. San Salvi, Florence

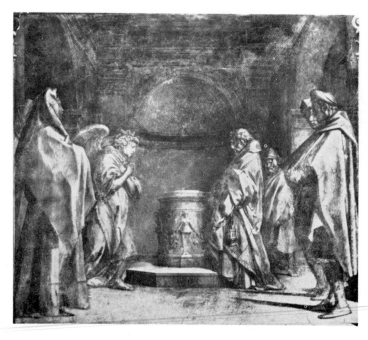

227. ANDREA DEL SARTO: *Zacharias in the Temple*. Chiostro dello Scalzo, Florence

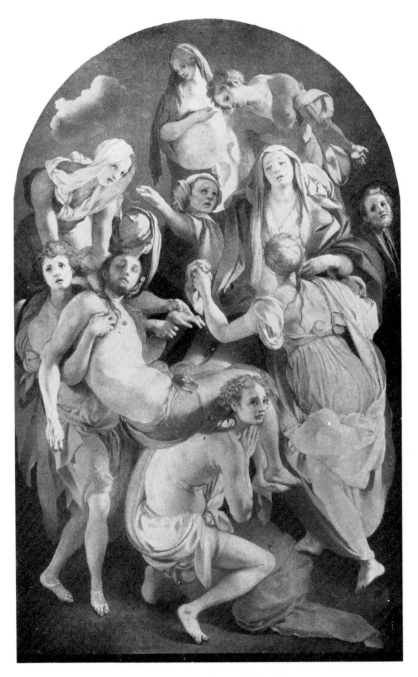

228. Pontormo: *Pietà*. Santa Felicita, Florence

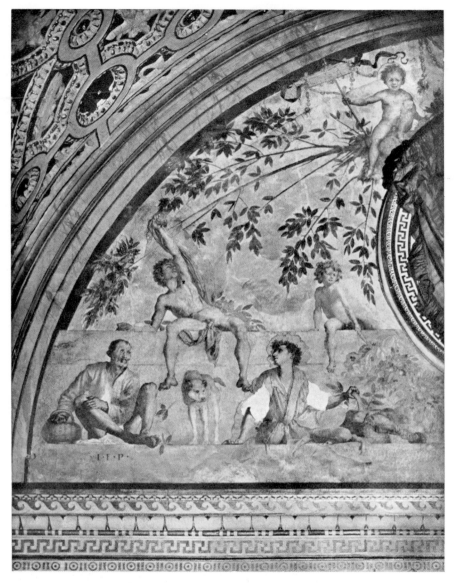

229. PONTORMO: *Detail from Decorative Fresco*. Poggio a Caiano

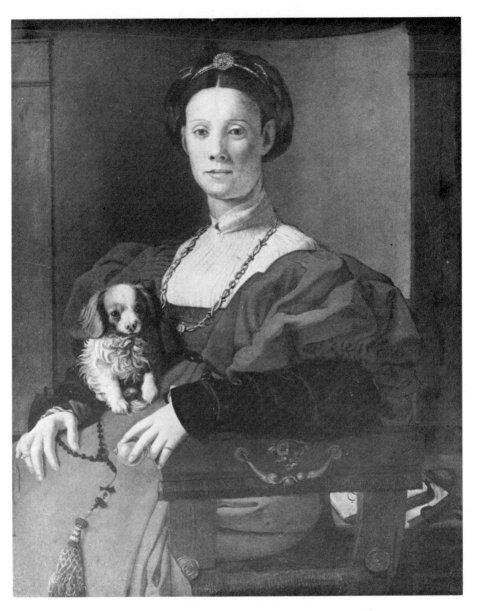

230. PONTORMO: *Lady with Lap-Dog*. Staedel Institute, Frankfurt

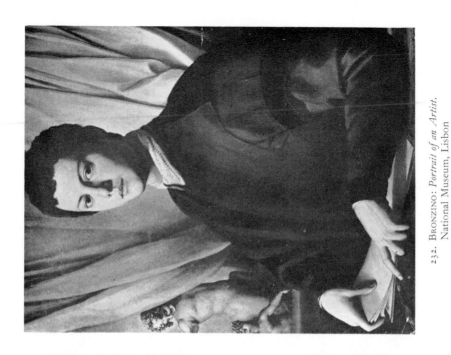

232. BRONZINO: *Portrait of an Artist.*
National Museum, Lisbon

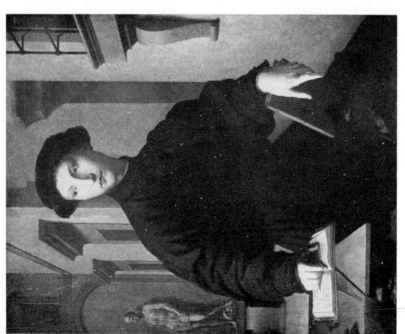

231. BRONZINO: *Portrait of Ugolino Martelli.*
Staatliche Museen, Berlin-Dahlem

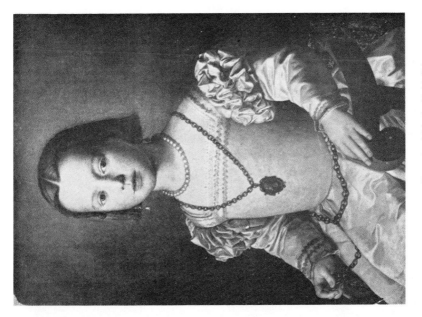

234. BRONZINO: *Portrait of Maria de' Medici.*
Uffizi, Florence

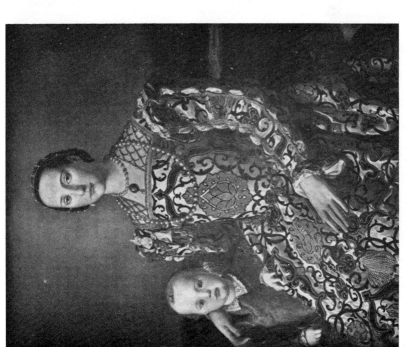

233. BRONZINO: *Portrait of Eleonora da Toledo and her son Ferdinand.*
Uffizi, Florence

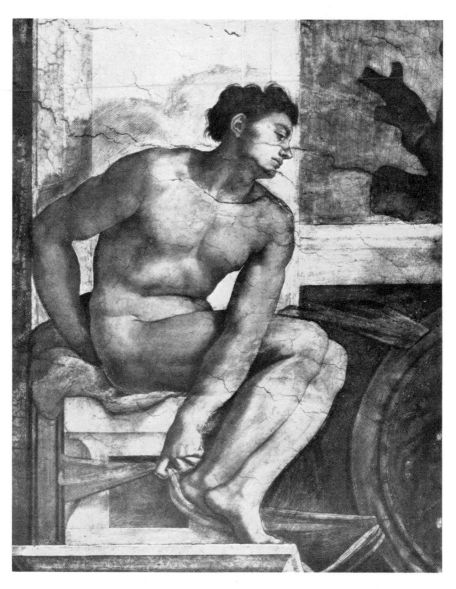

235. MICHELANGELO: *Decorative Nude*. Sistine Chapel, Rome

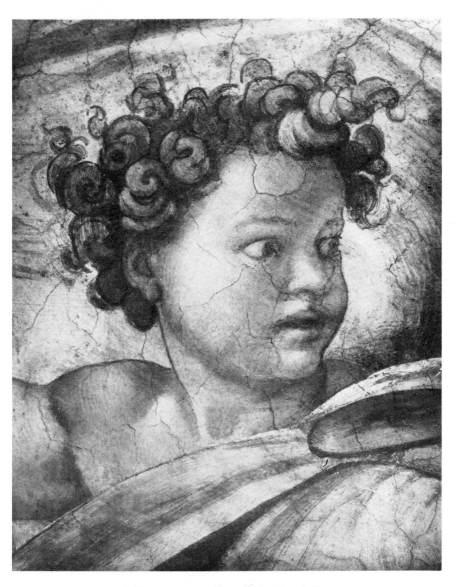

236. Michelangelo: *Putto*. Sistine Chapel, Rome

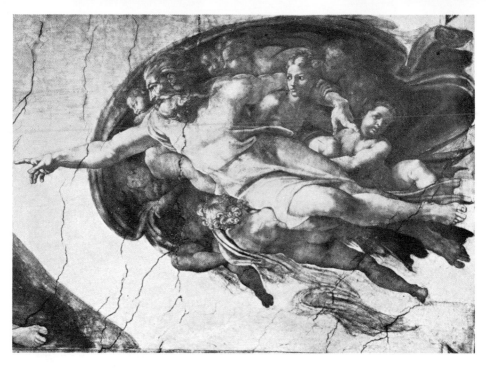

237. MICHELANGELO: *God the Father and Angels*. Sistine Chapel, Rome

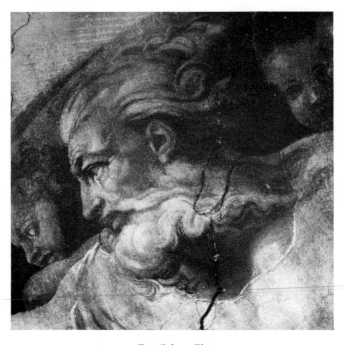

237 a. Detail from Plate 237

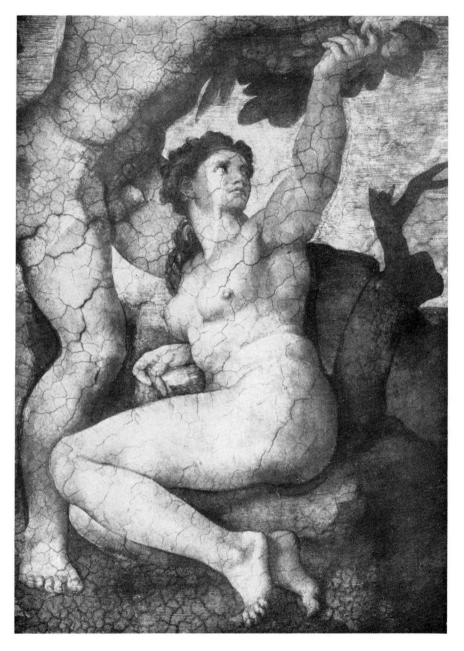

238. MICHELANGELO: *Detail from the 'Temptation of Eve'*. Sistine Chapel, Rome

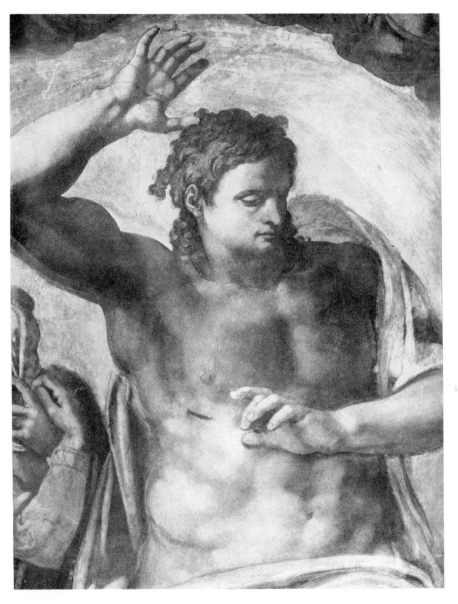

239. MICHELANGELO: *Detail from the 'Last Judgement'*. Sistine Chapel, Rome

240. MICHELANGELO: *Gods shooting at a Mark*. Drawing. Royal Library, Windsor Castle.
Reproduced by gracious permission of H.M. The Queen

241. MICHELANGELO: *Three Labours of Hercules*. Drawing. Royal Library, Windsor Castle.
Reproduced by gracious permission of H.M. The Queen

242. ROSSO FIORENTINO: *Moses and the Daughters of Jethro*. Uffizi, Florence

CENTRAL ITALIAN PAINTERS

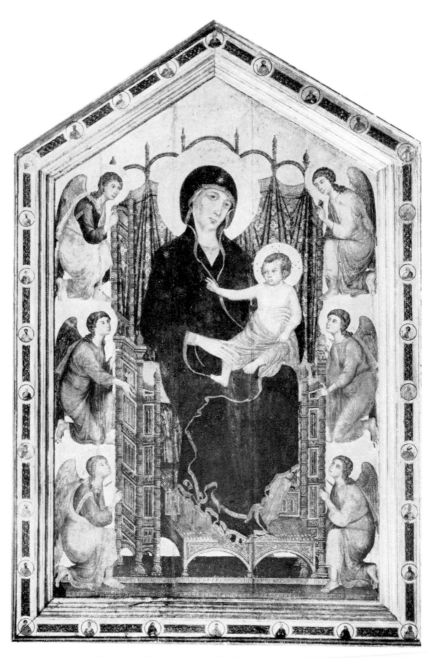

243. Duccio di Buoninsegna: *Madonna Rucellai*. Uffizi, Florence

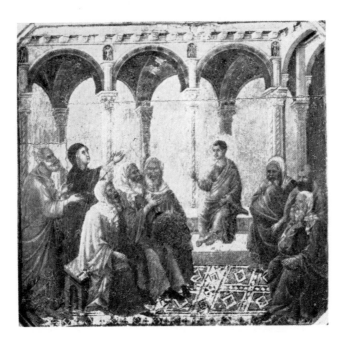

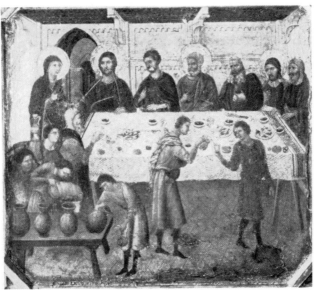

244. Duccio di Buoninsegna: *Christ among the Doctors* and *the Feast at Cana*. Museo dell'Opera, Siena

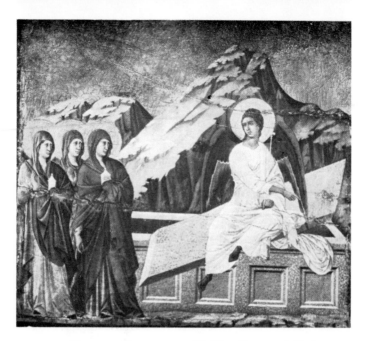

245. DUCCIO DI BUONINSEGNA: *The Three Marys at the Tomb.*
Museo dell'Opera, Siena

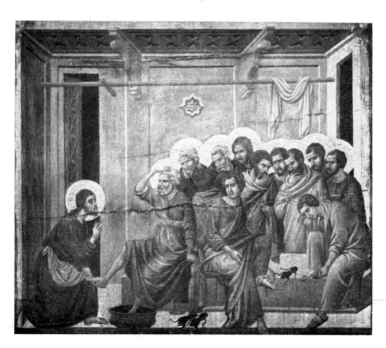

246. DUCCIO DI BUONINSEGNA: *The Washing of Feet.*
Museo dell'Opera, Siena

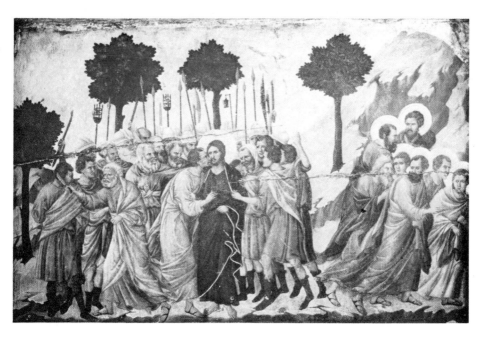

247. DUCCIO DI BUONINSEGNA: *The Betrayal of Judas.*
Museo dell'Opera, Siena

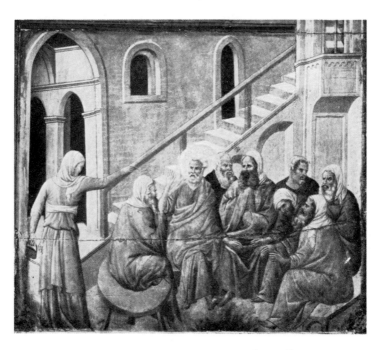

248. DUCCIO DI BUONINSEGNA: *Peter denying Christ*
Museo dell'Opera, Siena

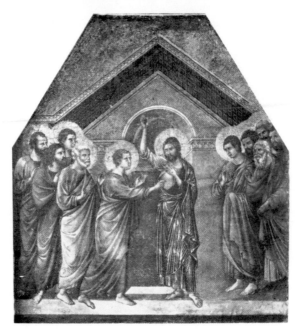

249. DUCCIO DI BUONINSEGNA: *Doubting Thomas*.
Museo dell'Opera, Siena

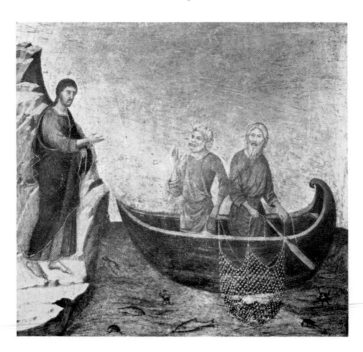

250. DUCCIO DI BUONINSEGNA: *The Calling of the Apostles Peter and Andrew*.
National Gallery of Art, Washington (Kress Collection)

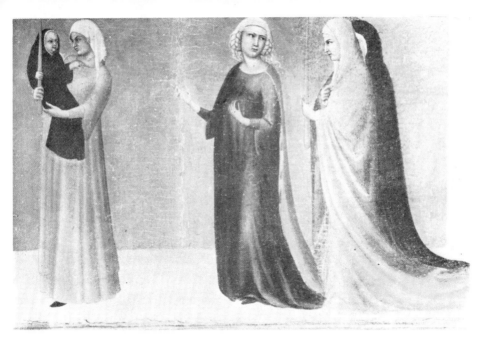

251. SIMONE MARTINI: *Detail from a Miracle of the Beato Agostino Novello.* Sant'Agostino, Siena

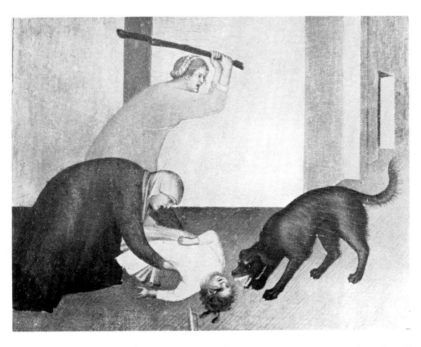

252. SIMONE MARTINI: *Detail from a Miracle of the Beato Agostino Novello.* Sant'Agostino, Siena

253. SIMONE MARTINI: *Maestà*. Palazzo Pubblico, Siena

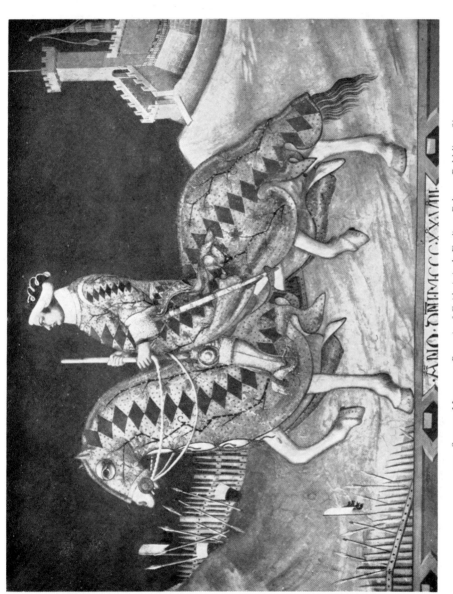

254. SIMONE MARTINI: *Portrait of Guidoriccio da Fogliano.* Palazzo Pubblico, Siena

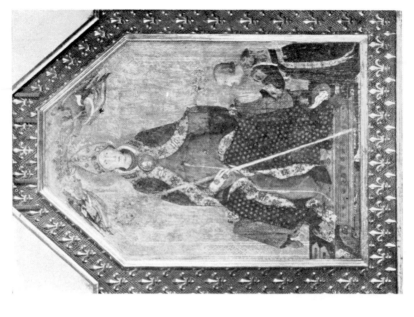

256. SIMONE MARTINI: *Robert of Anjou crowned by Saint Louis.*
National Museum, Naples

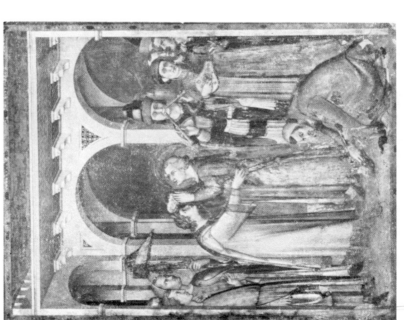

255. SIMONE MARTINI: *Saint Martin being knighted.*
San Francesco, Assisi

257. SIMONE MARTINI: *The Annunciation with two Saints*. Uffizi, Florence

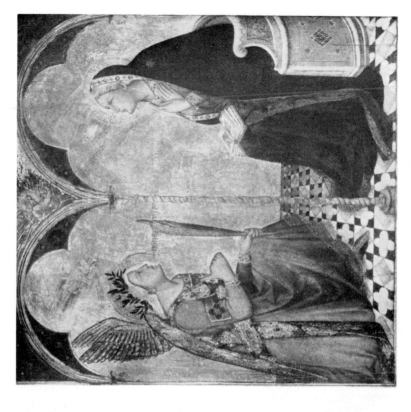

259. AMBROGIO LORENZETTI: *The Annunciation.*
Gallery, Siena

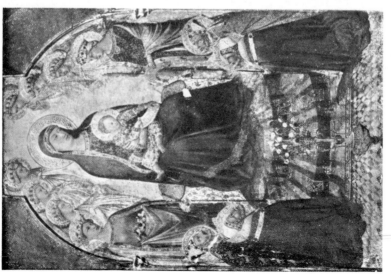

258. AMBROGIO LORENZETTI: *Madonna and Child with Saints.*
Gallery, Siena

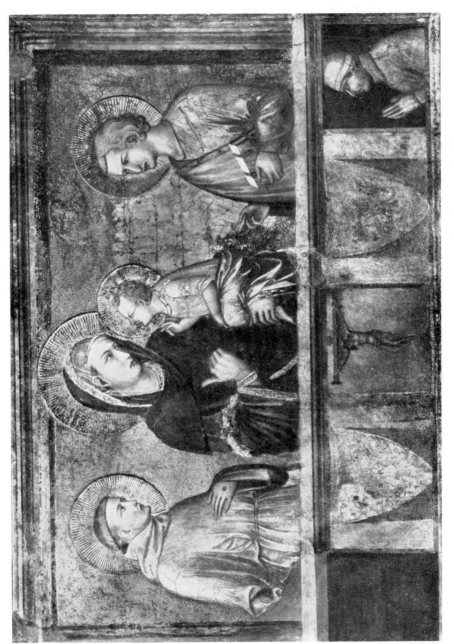

260. PIETRO LORENZETTI: *Madonna and Child with two Saints*. San Francesco, Assisi

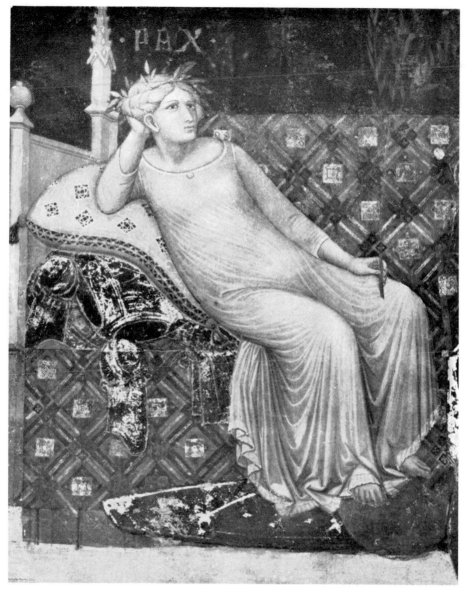

261. Ambrogio Lorenzetti: *Detail from 'Good and Bad Government'*. Palazzo Pubblico, Siena

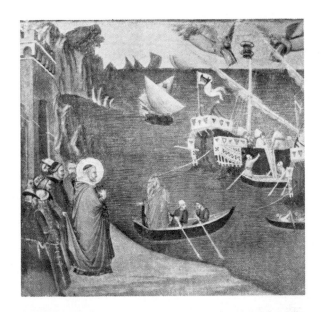

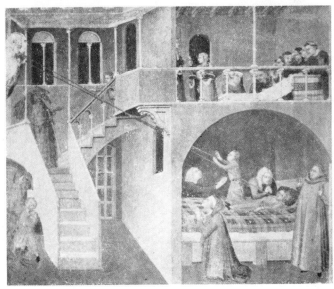

262. AMBROGIO LORENZETTI: *Two Scenes from the Legend of Saint Nicholas of Bari*. Uffizi, Florence

263. Pietro Lorenzetti: *The Deposition*. San Francesco, Assisi

265. BARNA DA SIENA: *Detail from the 'Crucifixion'.*
Cathedral, San Gimignano

264. AMBROGIO LORENZETTI: *Detail from 'Madonna and Child with Saints'.*
Sant'Agostino, Siena

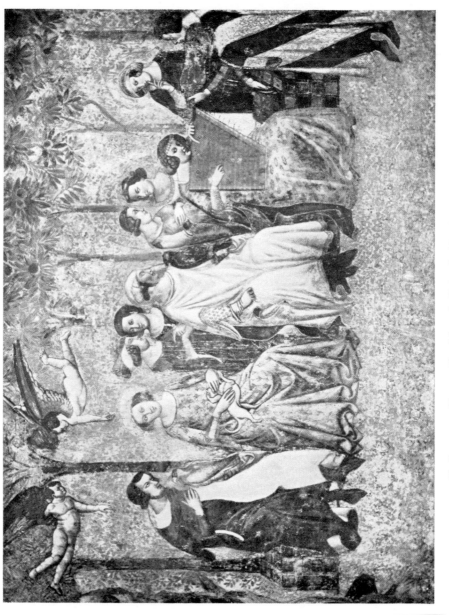

266. Francesco Traini: *Detail from the 'Triumph of Death'*. Camposanto, Pisa

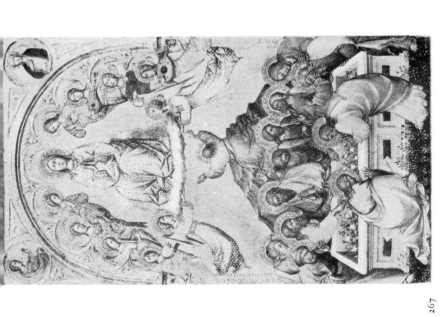

267. PAOLO DI GIOVANNI FEI: *The Assumption of the Virgin*. National Gallery of Art, Washington (Kress Collection)
268. ANDREA VANNI: *The Agony in the Garden*. Wing of a triptych. Corcoran Gallery of Art, Washington (W. A. Clark Collection)

269. TADDEO DI BARTOLO: *The Coronation of the Virgin*.
University of Arizona, Tucson, Arizona (Kress Collection)

270. DOMENICO DI BARTOLO: *The Distribution of Alms*. Ospedale della Scala, Siena

271. SASSETTA: *Saint Francis' Betrothal with my Lady Poverty.*
Musée Condé, Chantilly

272. VECCHIETTA: *San Bernardino preaching.* Walker Art Gallery, Liverpool

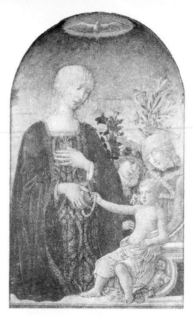

273. BENVENUTO DI GIOVANNI: *Madonna and Child with two Angels*. Yale University Art Gallery, New Haven, Connecticut

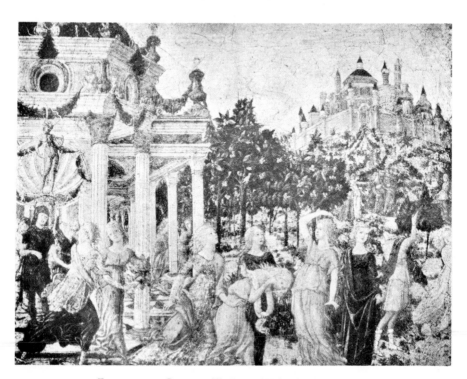

274. FRANCESCO DI GIORGIO: *The Rape of Helen*. Fragment of a Cassone. Berenson Collection, Settignano

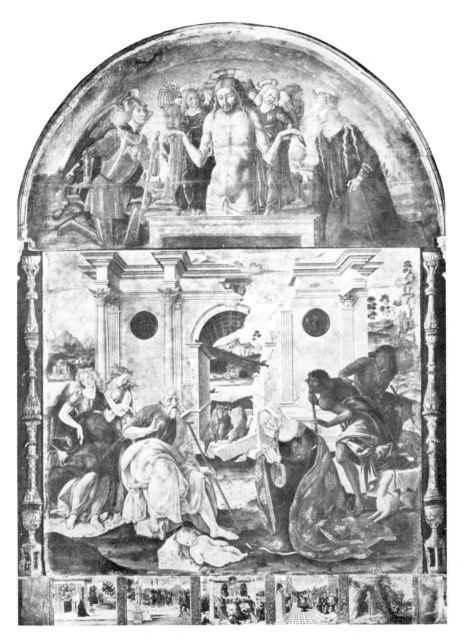

275. FRANCESCO DI GIORGIO: *The Nativity*. San Domenico, Siena

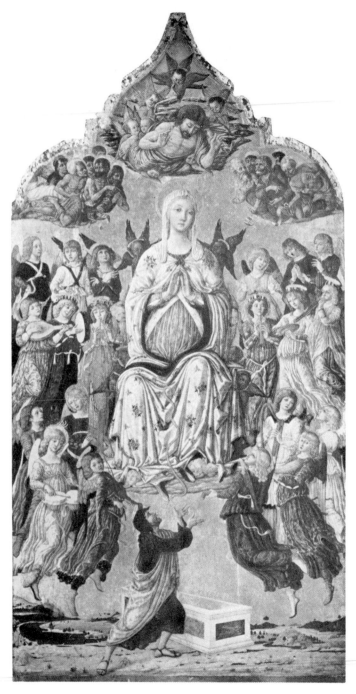

276. MATTEO DI GIOVANNI: *The Madonna of the Girdle*. National Gallery, London

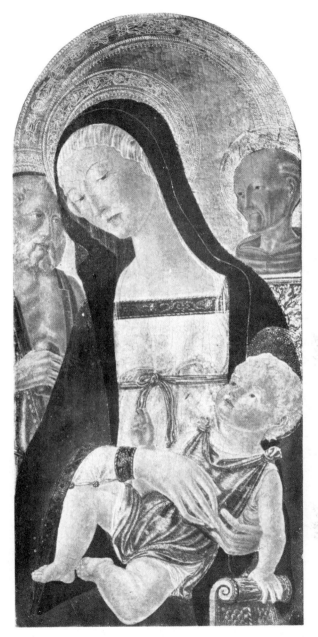

277. Neroccio de' Landi: *Madonna and Child*. Gallery, Siena

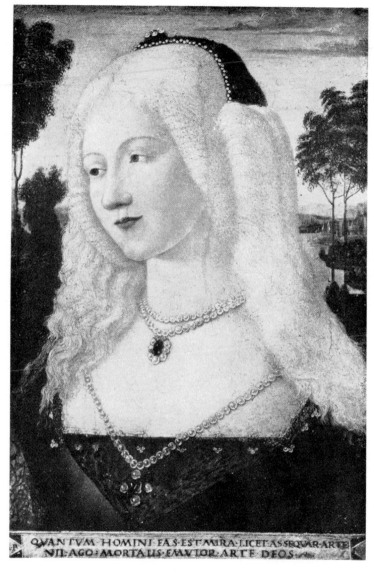

QVANTVM·HOMINI·FAS·EST·MIRA·LICET·ASSEQVAR·ARTE
NIL·AGO·MORTALIS·EMVLIOR·ARTE·DEOS

278. NEROCCIO DE' LANDI: *Portrait of a Lady*. National Gallery of Art,
Washington (Widener Collection)

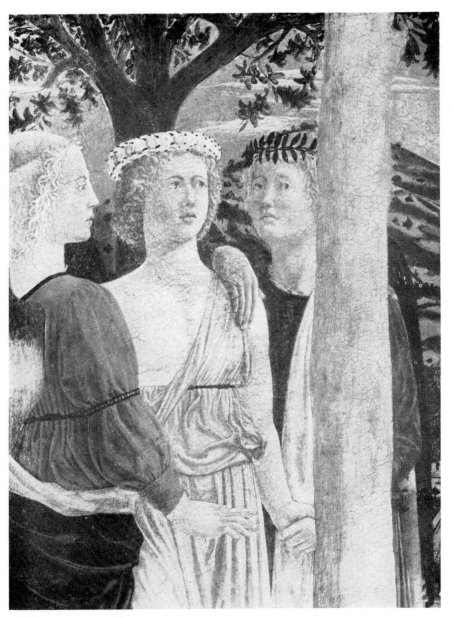

279. PIERO DELLA FRANCESCA: *Detail from the 'Baptism of Christ'*. National Gallery, London

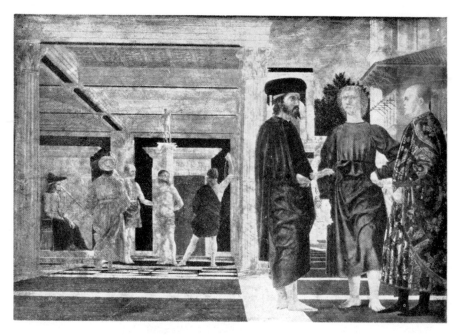

280. PIERO DELLA FRANCESCA: *The Flagellation*. Ducal Palace, Urbino

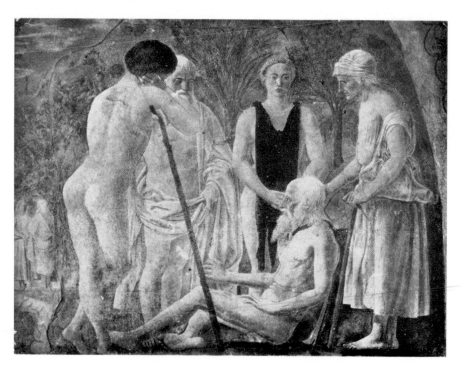

281. PIERO DELLA FRANCESCA: *Detail from the 'Death of Adam'*. San Francesco, Arezzo

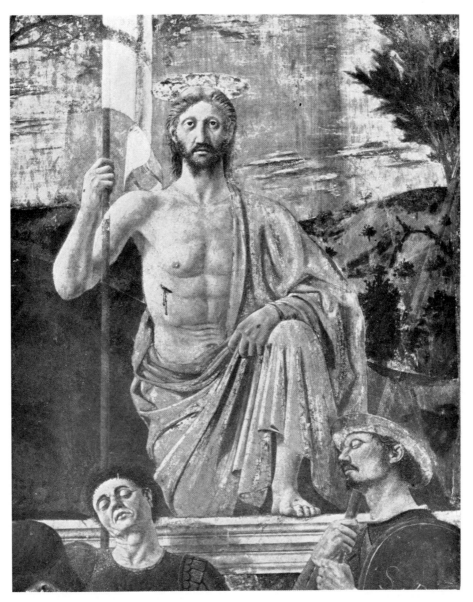

282. PIERO DELLA FRANCESCA: *Detail from the 'Resurrection'*. Palazzo Comunale, S. Sepolcro

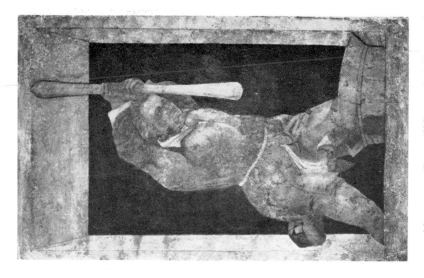

284. Melozzo da Forli: '*Il Pestapepe*'. Gallery, Forli

283. Melozzo da Forli: *Angel*. Pinacoteca Vaticana, Rome

285. LUCA SIGNORELLI: *Angel.* Santuario, Loreto

286. LUCA SIGNORELLI: *Scene from Dante's Purgatory.* Cathedral, Orvieto

287. LUCA SIGNORELLI: *Two Fragments from the 'Baptism'*. Museum of Art, Toledo, Ohio

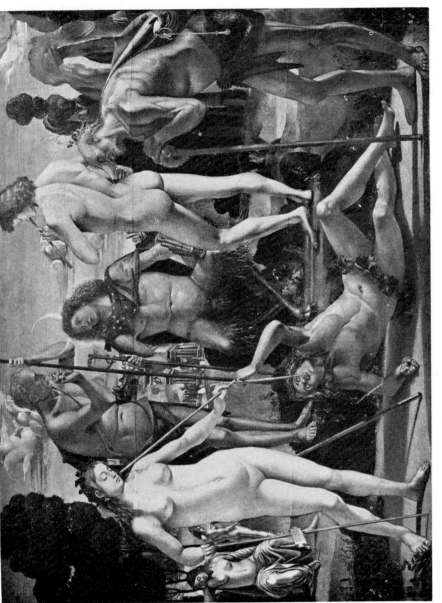

288. LUCA SIGNORELLI: *Pan and other Gods*. Destroyed, formerly Kaiser Friedrich Museum, Berlin

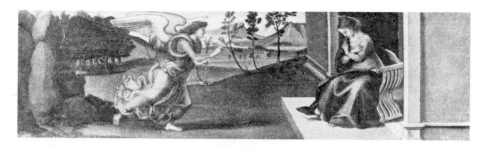

289. LUCA SIGNORELLI: *The Annunciation.* Uffizi, Florence

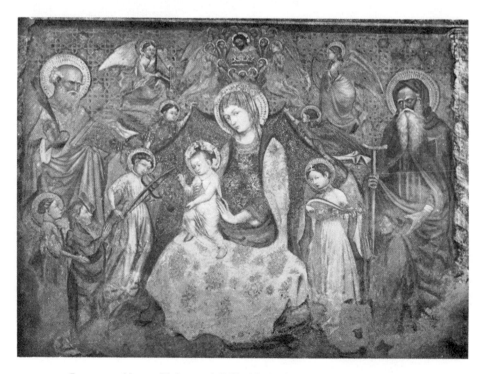

290. OTTAVIANO NELLI: *Madonna and Child with Angels, two Saints and two kneeling Donors.*
Santa Maria Nuova, Gubbio

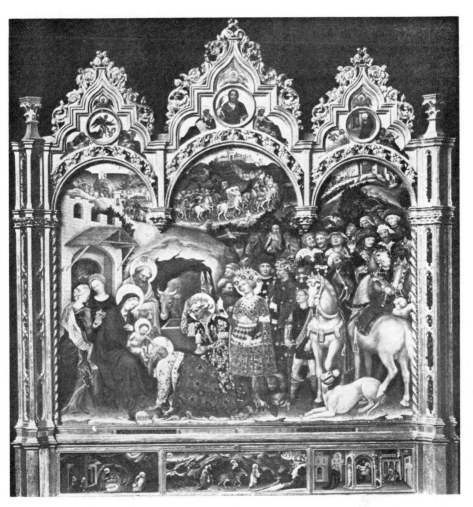

291. GENTILE DA FABRIANO: *The Adoration of the Magi*. Uffizi, Florence

293. GENTILE DA FABRIANO: *Madonna and Child*.
National Gallery of Art Washington (Kress Collection)

292. GENTILE DA FABRIANO: *Detail from the 'Adoration of the Magi'*.
Uffizi Florence

295. GIROLAMO DI GIOVANNI DA CAMERINO:
Madonna and Child with Angels. Brera, Milan

294. LORENZO DA SAN SEVERINO: *Madonna and Child with Four Saints.*
The Cleveland Museum of Art, Ohio (Holden Collection)

297. Lorenzo da Viterbo: *Detail from the 'Sposalizio'*. Formerly Santa
Maria della Verità, Viterbo

296. Boccatis da Camerino: *Madonna and Child with Angels*.
Berenson Collection, Settignano

299. BENEDETTO BONFIGLI: *The Nativity*. Berenson Collection,
Settignano

298. NICCOLO DA FOLIGNO: *The Coronation of the Virgin with two Saints*.
San Niccolò, Foligno

300. FIORENZO DI LORENZO: *The Nativity*. Gallery, Perugia

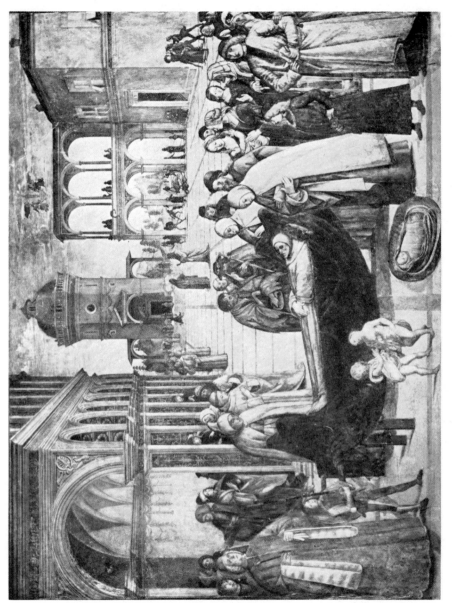

301. BERNARDINO PINTURICCHIO: *The Funeral of San Bernardino.* Santa Maria in Aracoeli, Rome

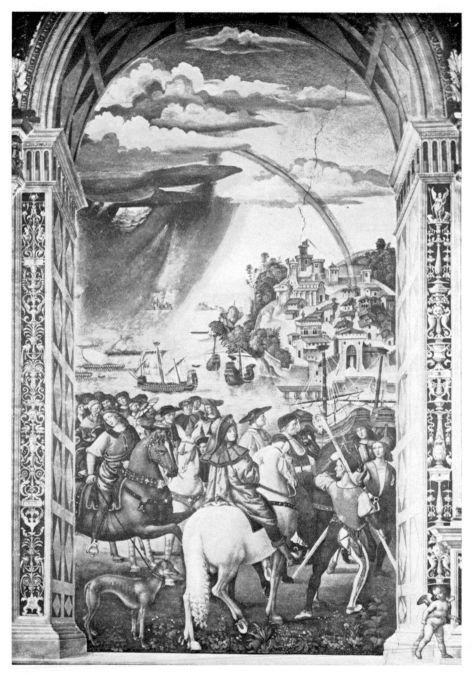

302. BERNARDINO PINTURICCHIO: *Piccolomini's Departure for Basle*. Duomo, Siena

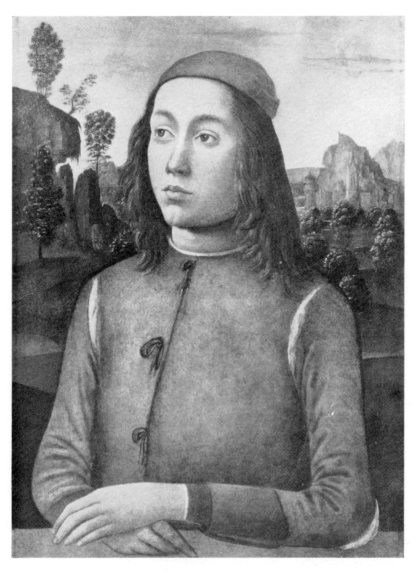

303. Bernardino Pinturicchio: *Portrait of a Youth*. National Gallery of Art, Washington (Kress Collection)

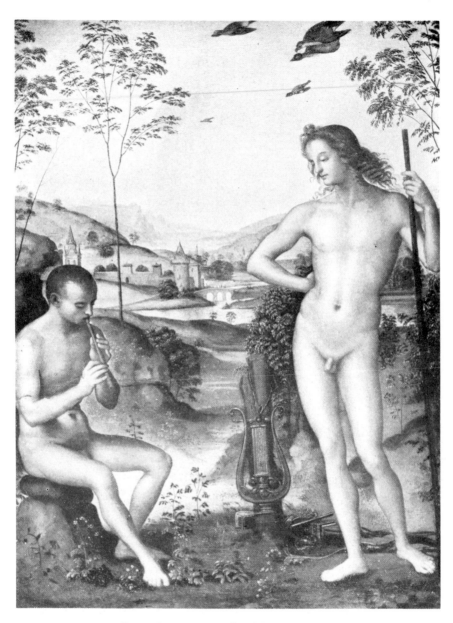

304. Pietro Perugino: *Apollo and Marsyas*. Louvre, Paris

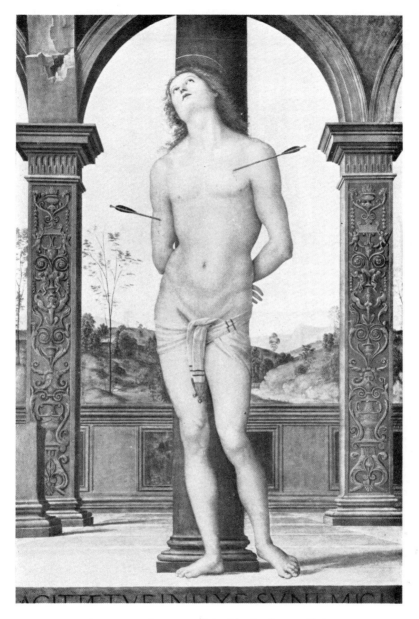

305. PIETRO PERUGINO: *Saint Sebastian*. Louvre, Paris

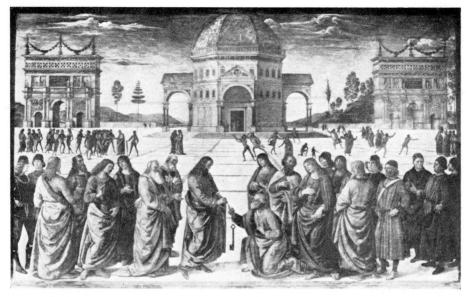

306. PIETRO PERUGINO: *Christ giving the Keys to St. Peter*. Sistine Chapel, Rome

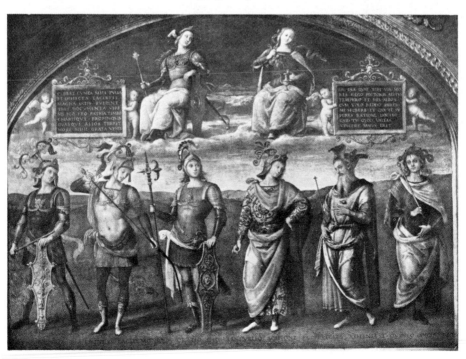

307. PIETRO PERUGINO: *Virtues and Heroes*. Collegio del Cambio, Perugia

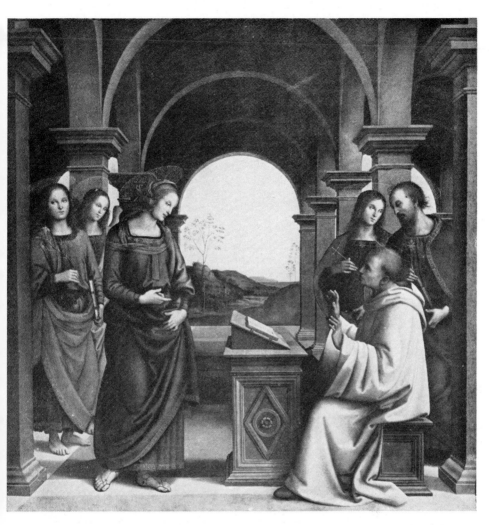

308. Pietro Perugino: *The Vision of Saint Bernard*. Alte Pinakothek, Munich

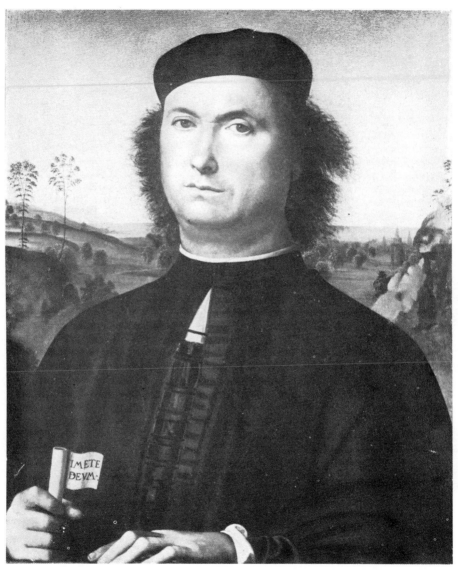

309. PIETRO PERUGINO: *Portrait of Francesco delle Opere*. Uffizi, Florence

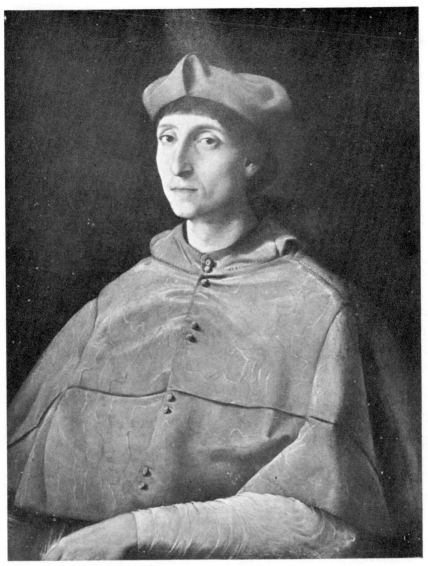

310. RAPHAEL: *Portrait of a Cardinal*. Prado, Madrid

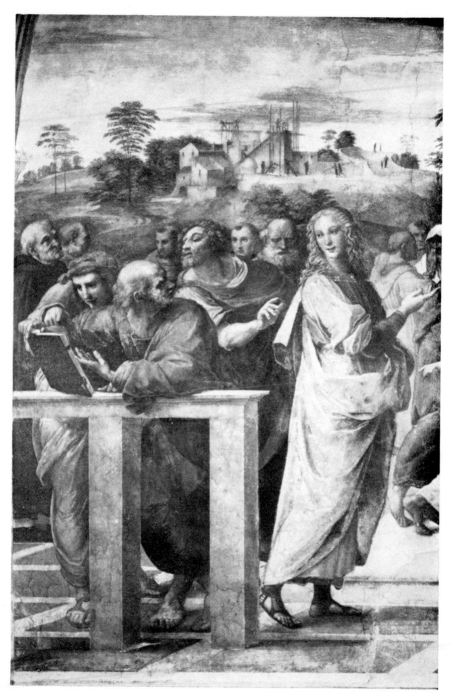

311. RAPHAEL: *Detail from the 'Disputa'*. Stanze del Vaticano, Rome

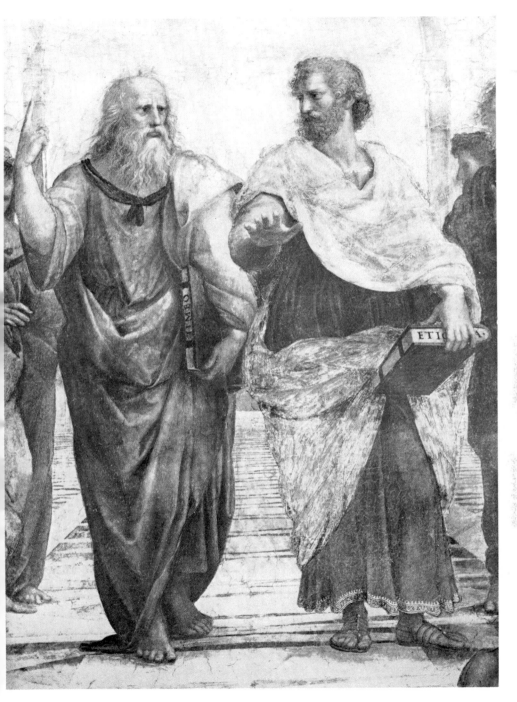

312. RAPHAEL: *Detail from the 'School of Athens'*. Stanze del Vaticano, Rome

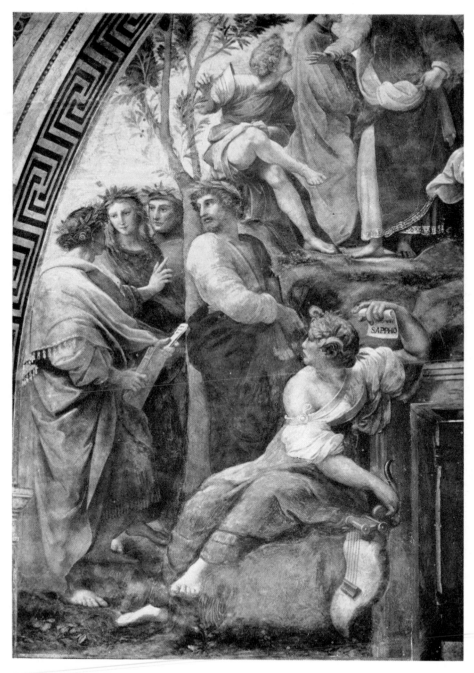

313. Raphael: *Detail from the 'Parnassus'*. Stanze del Vaticano, Rome

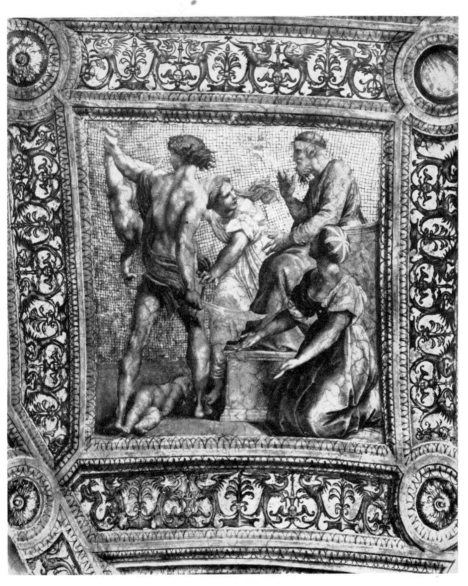

314. RAPHAEL: *The Judgement of Solomon*. Stanze del Vaticano, Rome

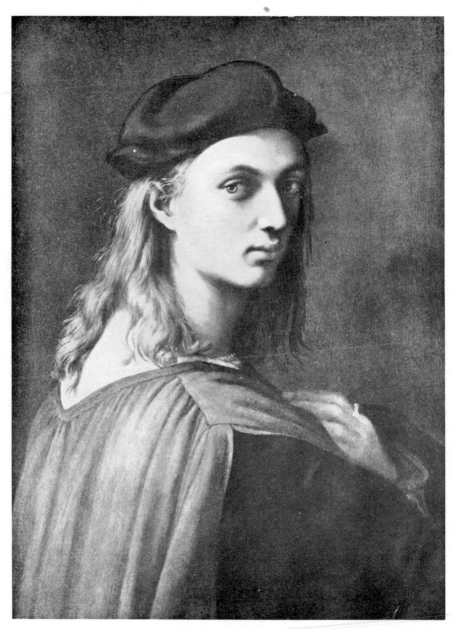

315. RAPHAEL: *Bindo Altoviti*. National Gallery of Art, Washington (Kress Collection)

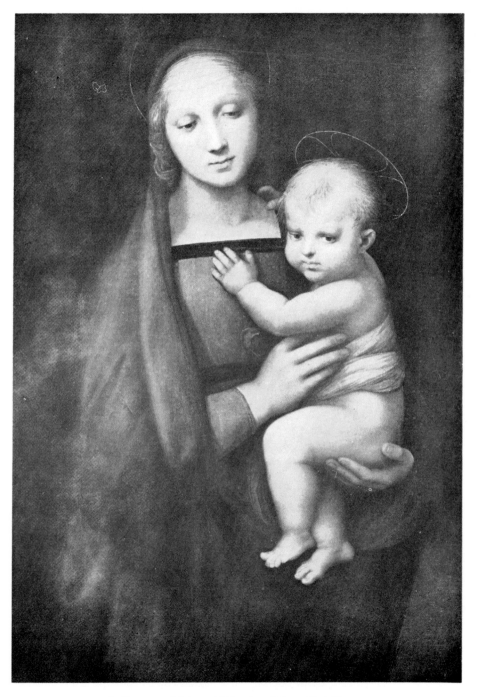

316. RAPHAEL: *Madonna del Granduca*. Palazzo Pitti, Florence

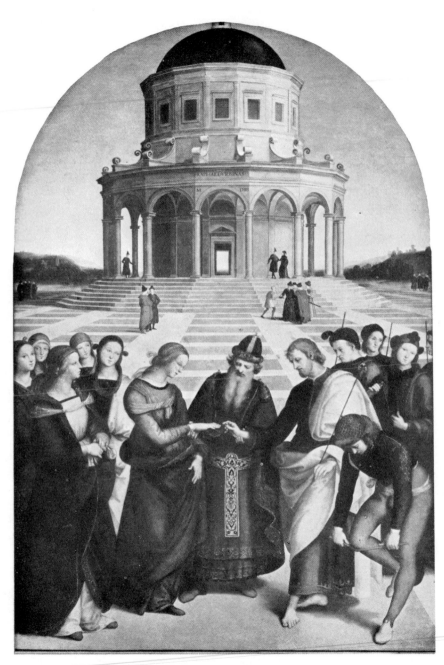

317. RAPHAEL: *The 'Sposalizio'*. Brera, Milan

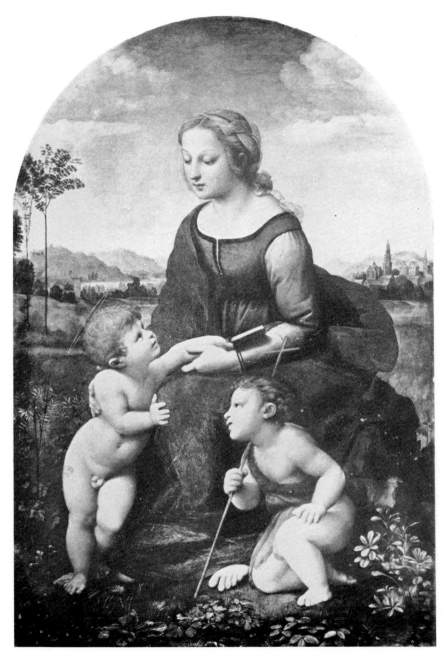

318. RAPHAEL: '*La Belle Jardinière*'. Louvre, Paris

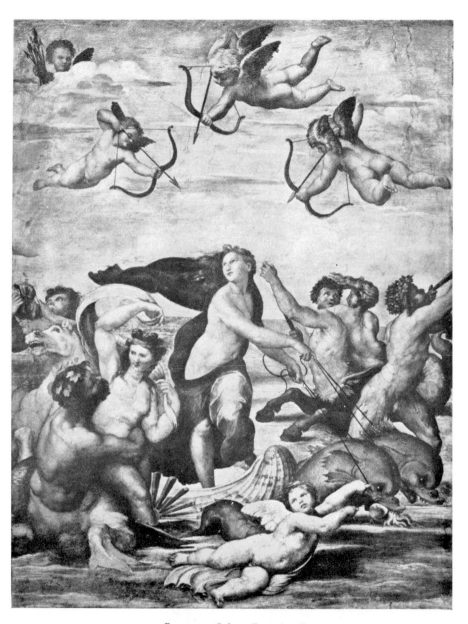

319. RAPHAEL: *Galatea*. Farnesina, Rome

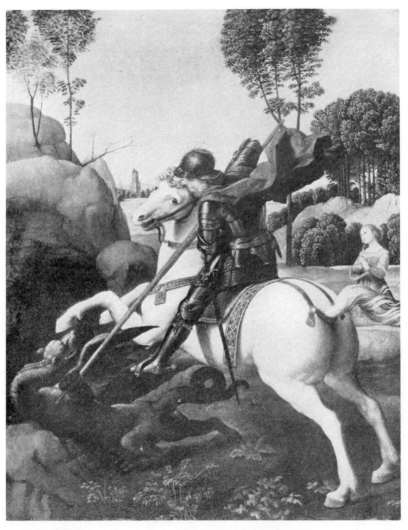

320. RAPHAEL: *Saint George and the Dragon.*
National Gallery of Art, Washington (Mellon Collection)

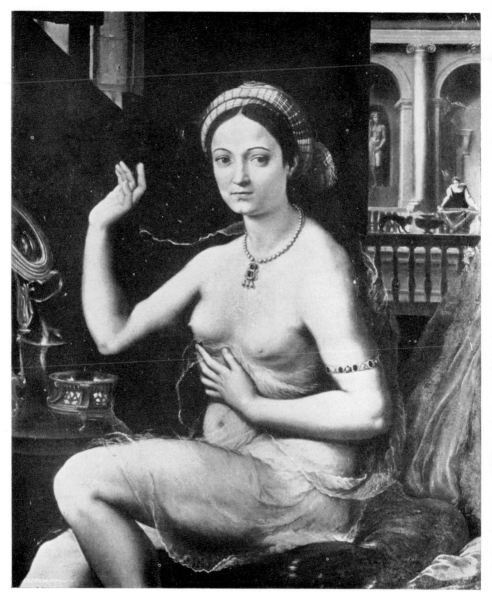

321. GIULIO ROMANO: *Lady at her Toilet*. Pushkin Museum, Moscow

NORTH ITALIAN PAINTERS

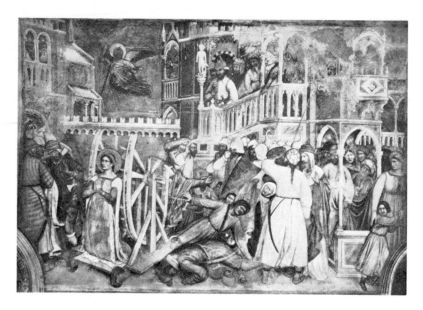

322. ALTICHIERO: *The Martyrdom of Saint Catherine*. Oratory of S. Giorgio, Padua

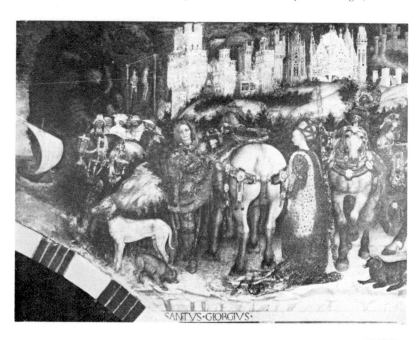

SANCTVS·GIORGIVS·

323. PISANELLO: *Saint George and the Princess of Trebizond*. Sant'Anastasia, Verona

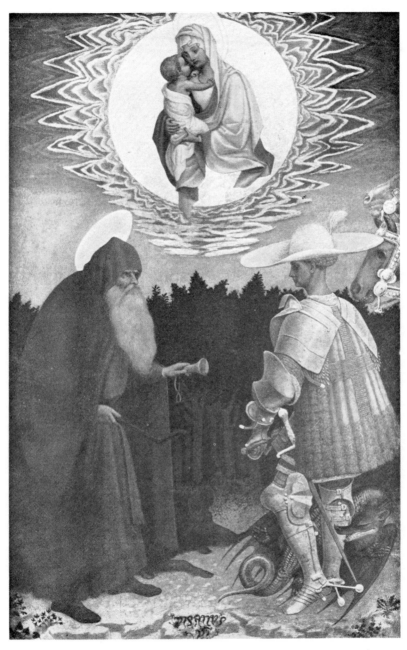

324. PISANELLO: *Madonna and Child with two Saints*. National Gallery, London

325. PISANELLO: *The Vision of Saint Eustace.* National Gallery, London

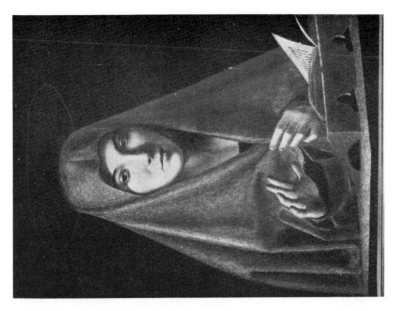

327. Antonello da Messina: *The Virgin Annunciate*.
National Museum, Palermo

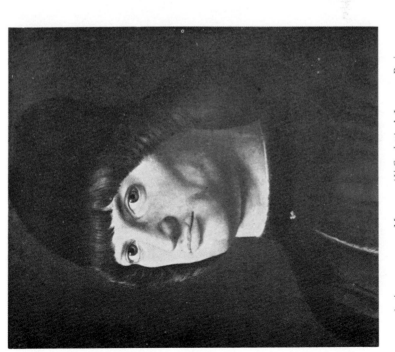

326. Antonello da Messina: '*Il Condottiere*', Louvre, Paris

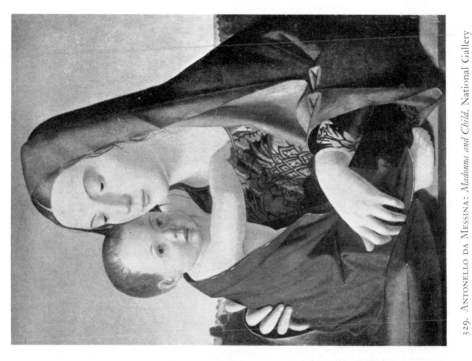

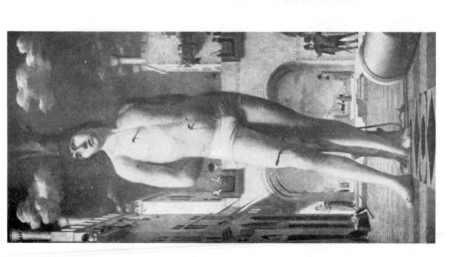

329. ANTONELLO DA MESSINA: *Madonna and Child*. National Gallery of Art, Washington (Mellon Collection)

328. ANTONELLO DA MESSINA: *Saint Sebastian*. Gallery, Dresden

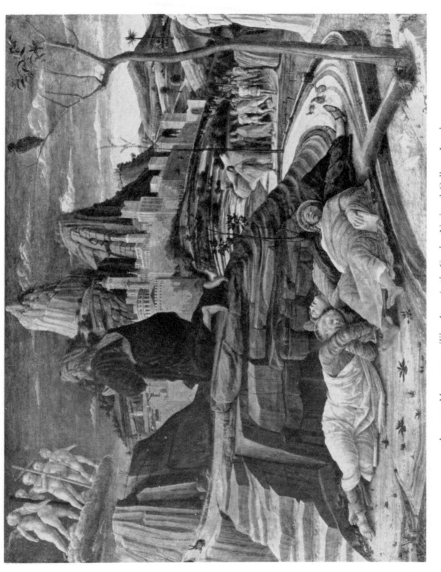

330. ANDREA MANTEGNA: *The Agony in the Garden.* National Gallery, London

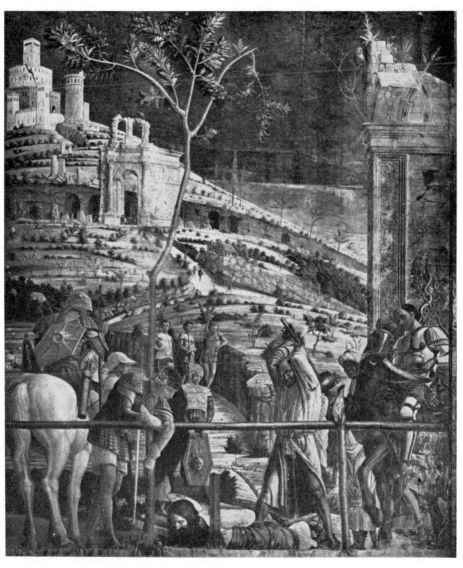

331. ANDREA MANTEGNA: *The Martyrdom of St. James*. Formerly Eremitani Church, Padua

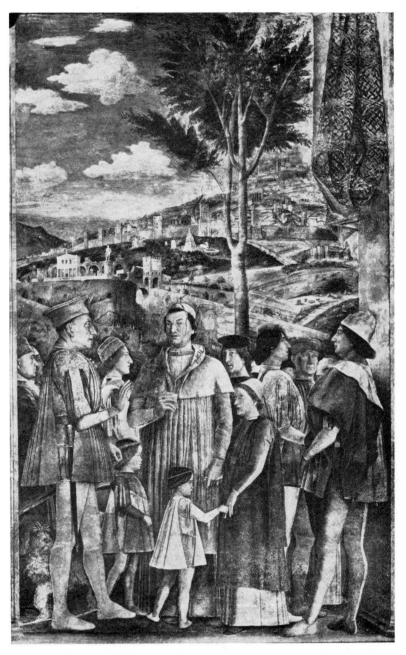

332. ANDREA MANTEGNA: *Lodovico Gonzaga and his family*. Camera degli Sposi, Mantua

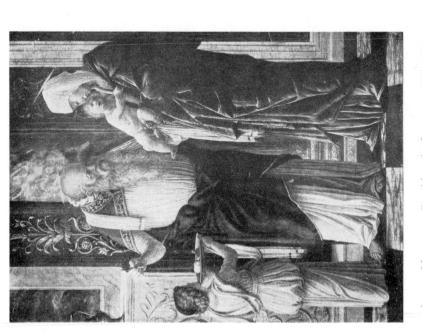

333. ANDREA MANTEGNA: *Detail from the 'Circumcision'*. Uffizi, Florence

334. ANDREA MANTEGNA: *Judith*. National Gallery of Ireland, Dublin

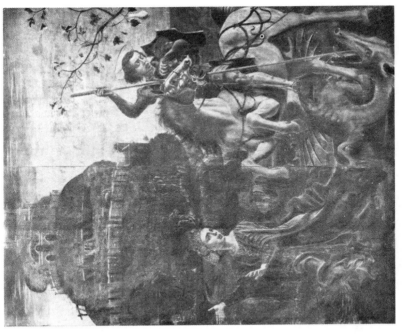

336. COSIMO TURA: *Saint George and the Dragon.*
Cathedral Museum, Ferrara

335. ANDREA MANTEGNA: *Saint Jerome in the Wilderness.*
Museu de Arte, São Paulo, Brazil

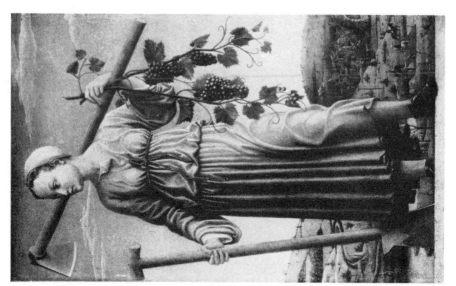

338. Francesco Cossa: *Autumn.*

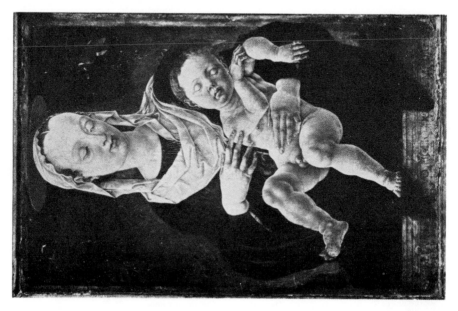

337. Cosimo Tura: *Madonna and Child.*

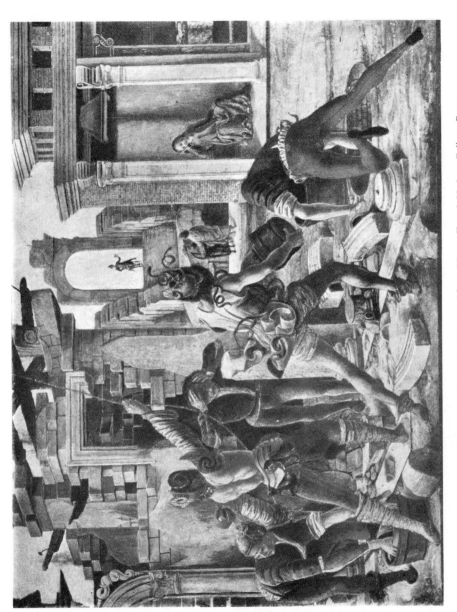

339. FRANCESCO COSSA: *Detail from the 'Miracles of Saint Vincent Ferrer'*. Vatican Gallery, Rome

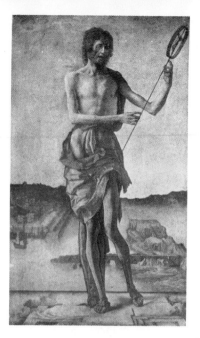

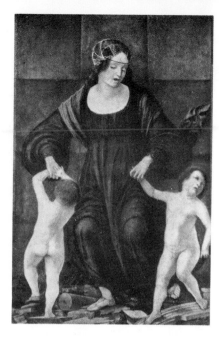

340. ERCOLE ROBERTI: *Saint John the Baptist in the Wilderness*. Staatliche Museen, Berlin-Dahlem

341. ERCOLE ROBERTI: *Hasdrubal's Wife* (formerly known as *Medea*). National Gallery of Art, Washington (A. Mellon Bruce Fund)

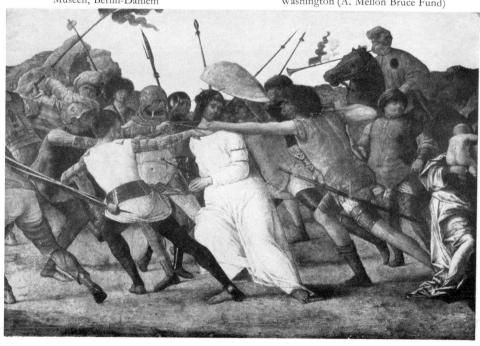

342. ERCOLE ROBERTI: *Detail from 'Christ carrying the Cross'*. Gallery, Dresden

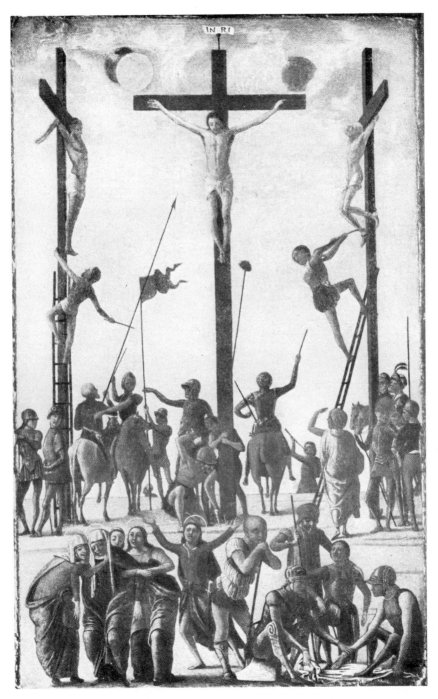

343. ERCOLE ROBERTI: *The Crucifixion*. Berenson Collection, Settignano

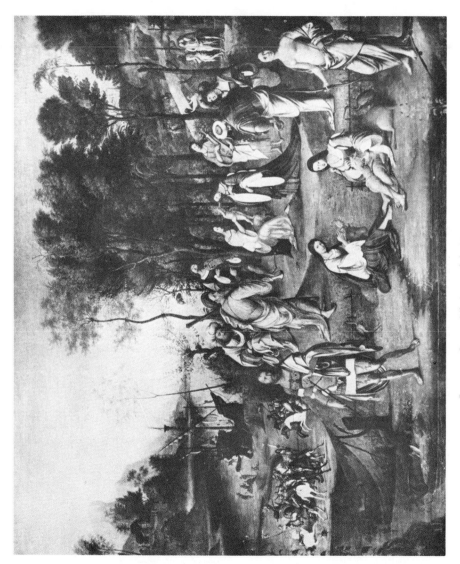

344. LORENZO COSTA: *The Reign of the Muses*. Louvre, Paris

346. Francesco Francia: *Madonna of the Roses.*
Alte Pinakothek, Munich

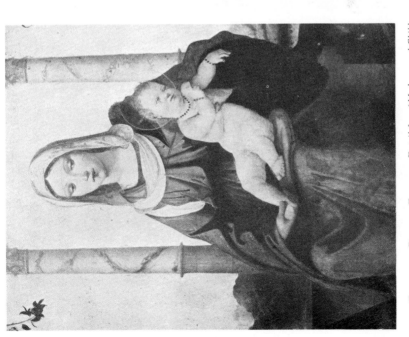

345. Francesco Bianchi Ferrari: *Detail from 'Madonna and Child
with Saints'.* Louvre, Paris

348. DOMENICO MORONE: *Detail from 'Madonna and Child'*.
San Bernardino, Verona

347. TIMOTEO VITI: *Saint Mary Magdalene*.
Gallery, Bologna

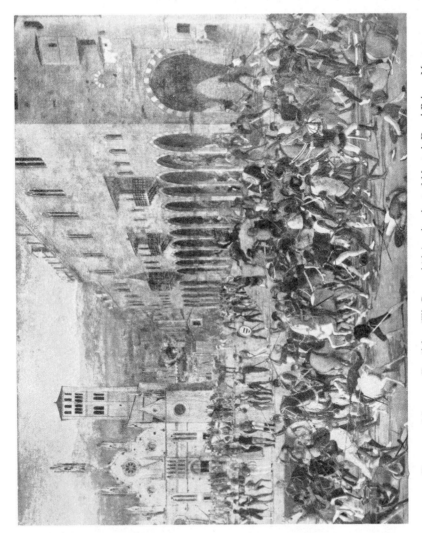

349. DOMENICO MORONE: *Detail from 'The Bonaccolsi being chased out of Mantua'. Ducal Palace, Mantua*

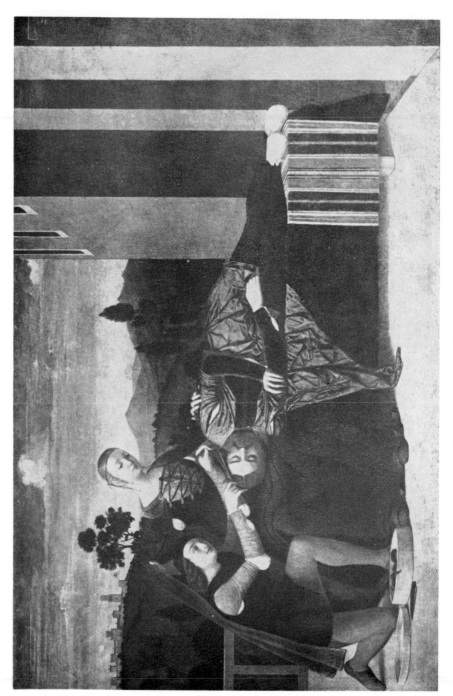

350. FRANCESCO MORONE: *Samson and Delilah.* Poldi-Pezzoli Museum, Milan

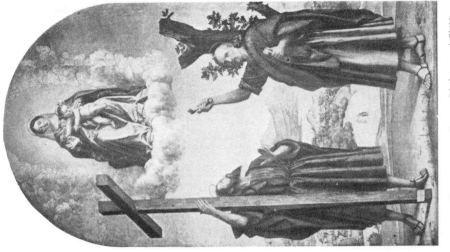

352. GIROLAMO DAI LIBRI: *Madonna and Child with two Saints*. Castelvecchio Museum, Verona

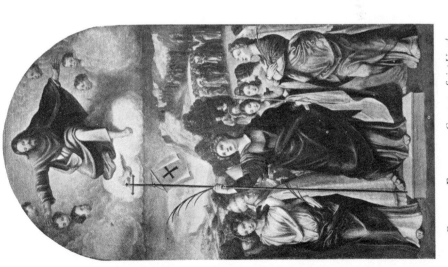

351. GIOVANNI FRANCESCO CAROTO: *Saint Ursula*. San Giorgio in Braida, Verona

353. GIROLAMO DA CREMONA: *Illuminated Initial.*
Cathedral Library, Siena

354. LIBERALE DA VERONA: *Illuminated Initial.*
Cathedral Library, Siena

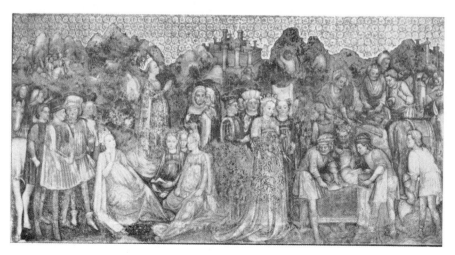

355. FRATELLI ZAVATTARI: *Scene from the Life of Queen Teodelinda.* Cathedral, Monza

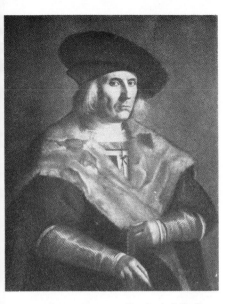

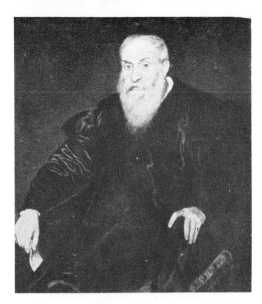

356. PAOLO CAVAZZOLA: *Emilio degli Emili*.
Gallery, Dresden

357. PAOLO FARINATI: *Portrait of an Old Man*.
Art Museum, Worcester, Massachusetts

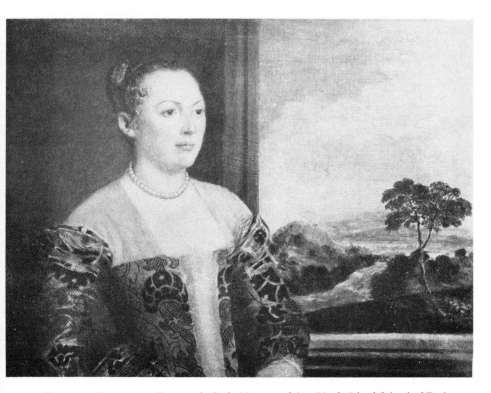

358. DOMENICO BRUSASORCI: *Portrait of a Lady*. Museum of Art, Rhode Island School of Design,
Providence, Rhode Island

359. Battista Zelotti: *A Concert.* Castelvecchio Museum, Verona

360. VINCENZO FOPPA: *Detail from the 'Adoration of the Magi'*. National Gallery, London

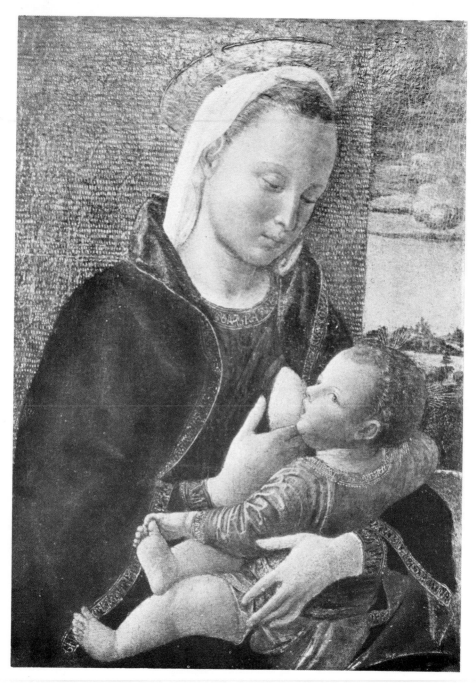

361. Vincenzo Foppa: *Madonna and Child*. Berenson Collection, Settignano

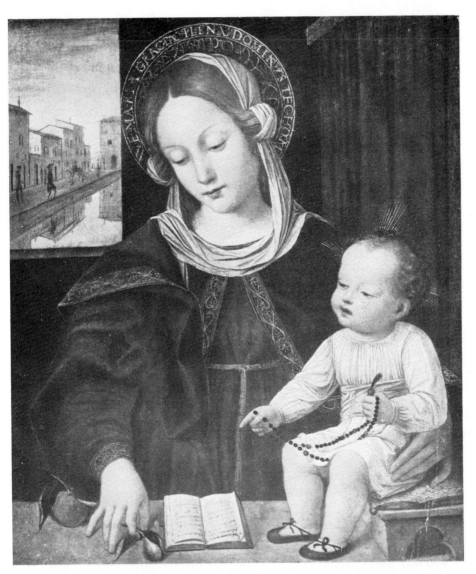

362. Borgognone: *Madonna and Child*. Rijksmuseum, Amsterdam

363. BORGOGNONE: *Scene from the Life of Saint Benedict.* Museum, Nantes

365. Bernardino Butinone: *Detail from Polyptych.*
San Martino, Treviglio

364. Bernardino Zenale: *Detail from Polyptych.*
San Martino, Treviglio

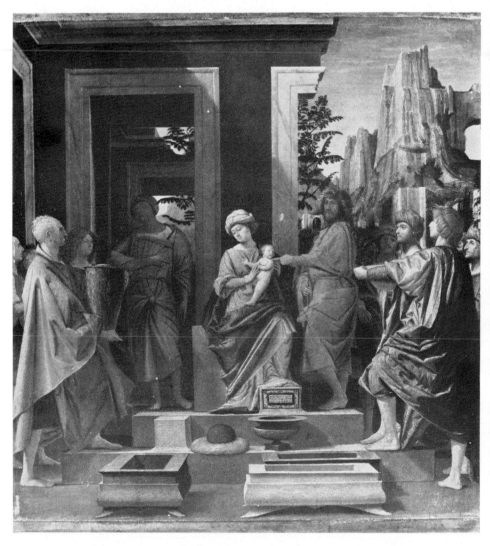

366. BRAMANTINO: *The Adoration of the Magi*. National Gallery, London

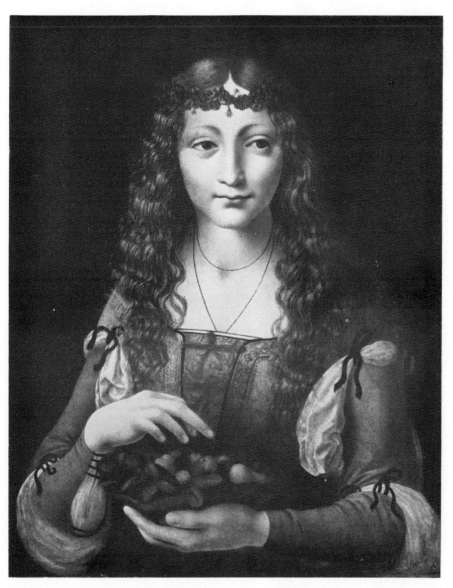

367. Ambrogio da Predis: *Girl with Cherries*. Metropolitan Museum of Art, New York

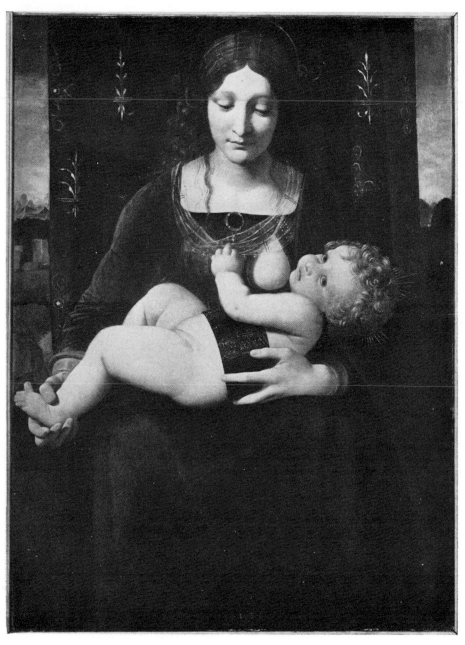

368. BOLTRAFFIO: *Madonna and Child*. National Gallery, London

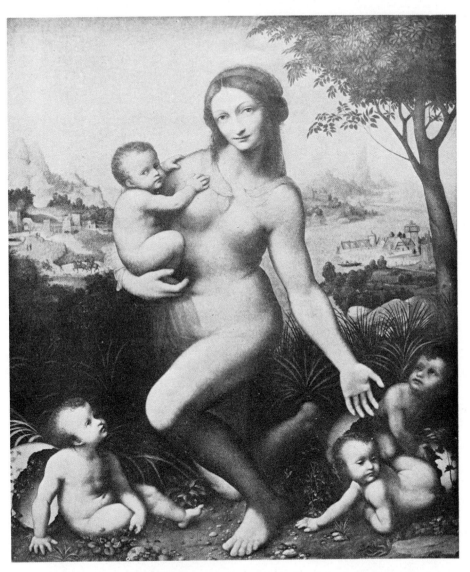

369. GIANPIETRINO: *Leda*. Fürst zu Wied, Neuwied

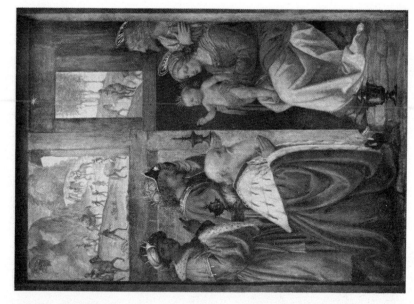

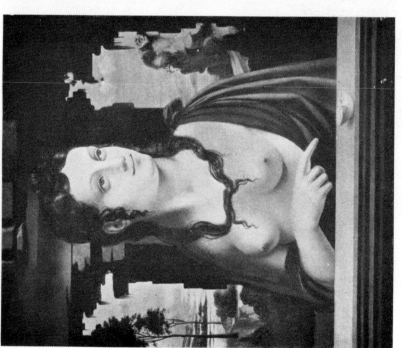

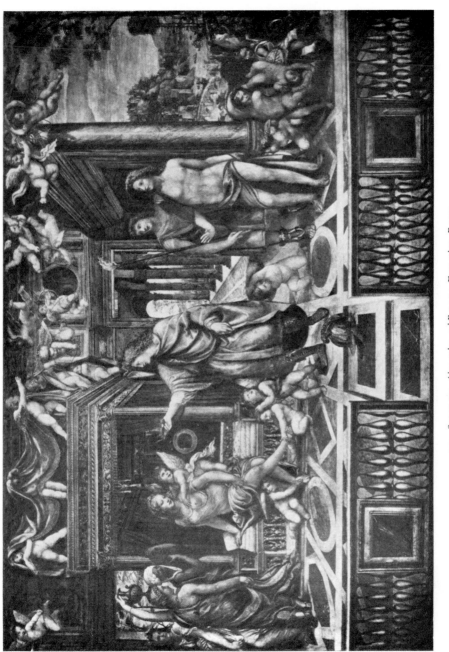

372. SODOMA: *Alexander and Roxana*. Farnesina, Rome

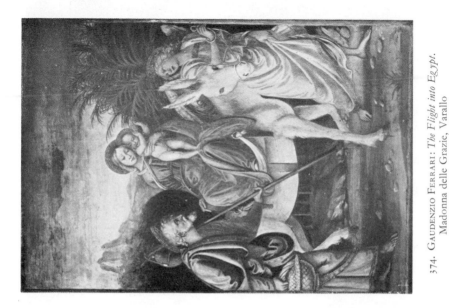

374. GAUDENZIO FERRARI: *The Flight into Egypt.*
Madonna delle Grazie, Varallo

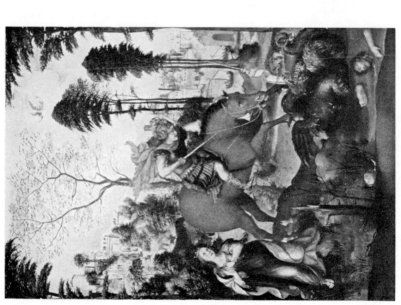

373. SODOMA: *Saint George and the Dragon.*
National Gallery of Art, Washington (Kress Collection)

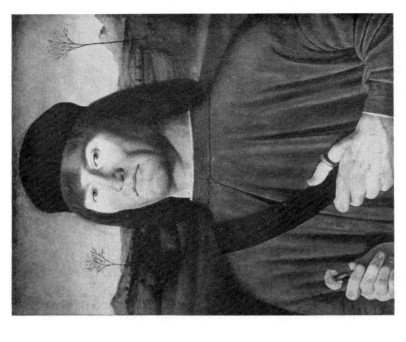

376. ANDREA SOLARIO: *Portrait of a Venetian Senator*.
National Gallery, London

375. MILANESE, follower of Leonardo: 'La belle Colombine'.
Hermitage, Leningrad

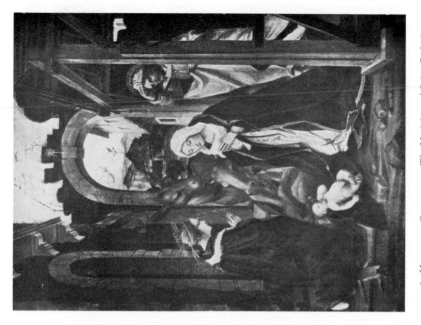

378. Vincenzo Civerchio: *The Nativity and Saint Catherine.*
Brera, Milan

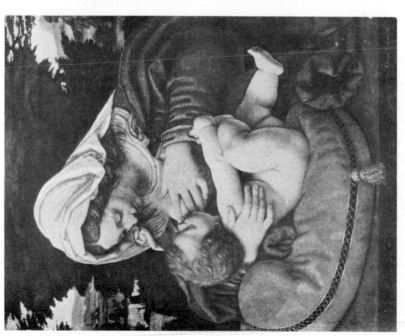

377. Andrea Solario: '*La Vierge au Coussin Vert*'.
Louvre, Paris

379. Girolamo Romanino: *Detail from Decorative Fresco*. Castello del Buon Consiglio, Trento

380. DEFENDENTE FERRARI: *The Nativity.* Staatliche Museen, East Berlin

381. GIROLAMO ROMANINO: *Enthroned Madonna with Saints and Angels.* Municipal Museum, Padua

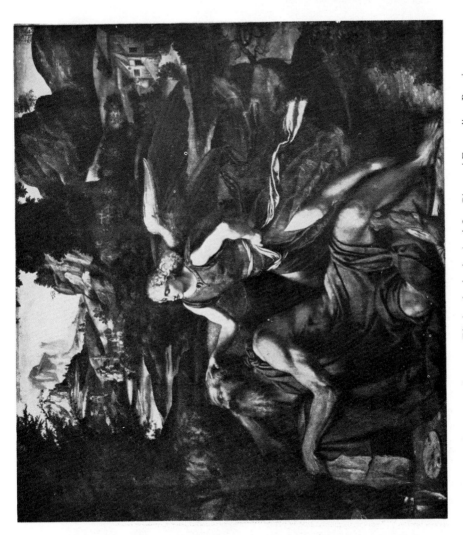

382. Moretto da Brescia: *Elijah woken by the Angel.* San Giovanni Evangelista, Brescia

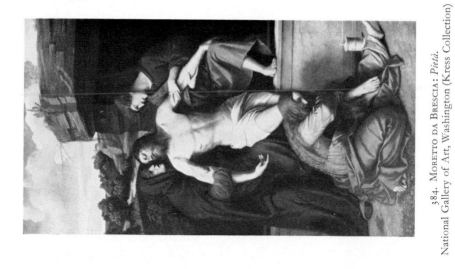

384. MORETTO DA BRESCIA: *Pietà.*
National Gallery of Art, Washington (Kress Collection)

383. MORETTO DA BRESCIA: *The Virgin appearing to a peasant boy.*
Pilgrimage Church, Paitone

386. Giovanni Battista Moroni: 'Titian's Schoolmaster'.
National Gallery of Art, Washington (Widener Collection).

385. Moretto da Brescia: Portrait of an Ecclesiastic.
Alte Pinakotek, Munich

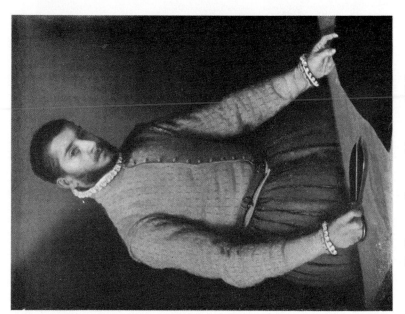

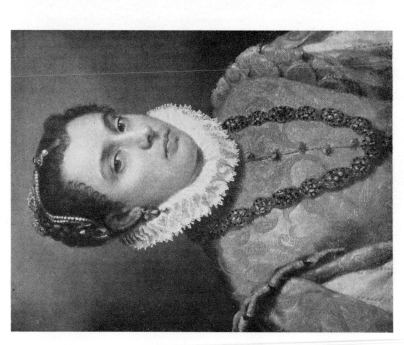

388. Giovanni Battista Moroni: *A Tailor.*
National Gallery, London

387. Giovanni Battista Moroni: *Portrait of a Lady.*
Formerly Cintas Collection, Havana

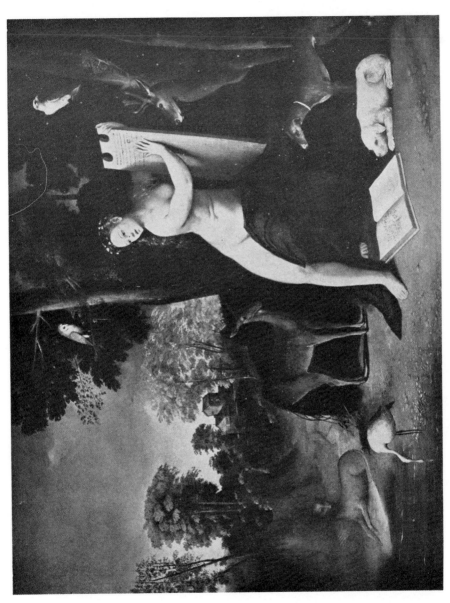

389. Dosso Dossi: *Circe and her Lovers in a Landscape*. National Gallery of Art, Washington (Kress Collection)

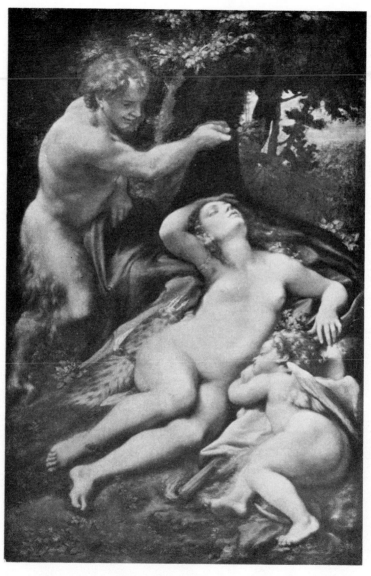

390. CORREGGIO: *Antiope*. Louvre, Paris

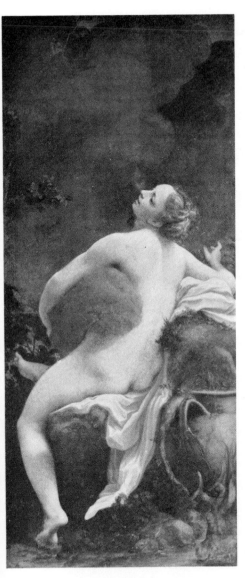

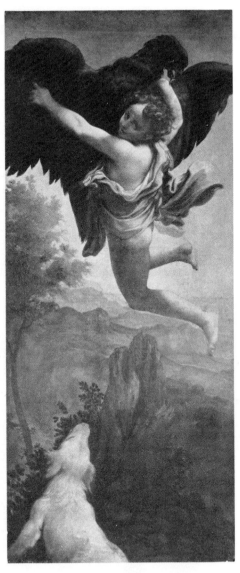

391. CORREGGIO: *Jupiter and Io.*
Kunsthistorisches Museum, Vienna

392. CORREGGIO: *Ganymede.*
Kunsthistorisches Museum, Vienna

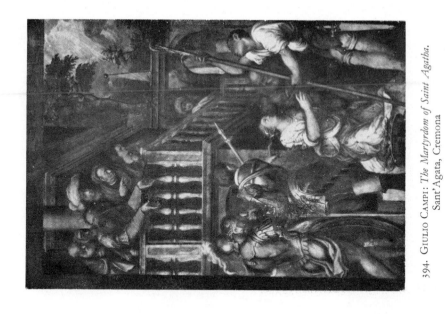

394. GIULIO CAMPI: *The Martyrdom of Saint Agatha.*
Sant'Agata, Cremona

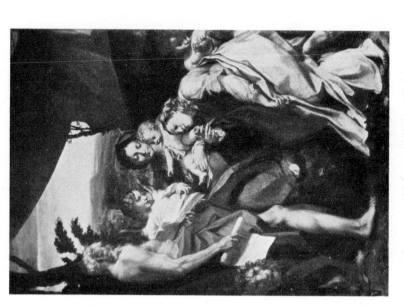

393. CORREGGIO: *Madonna and Child with Saint Jerome.*
Gallery, Parma

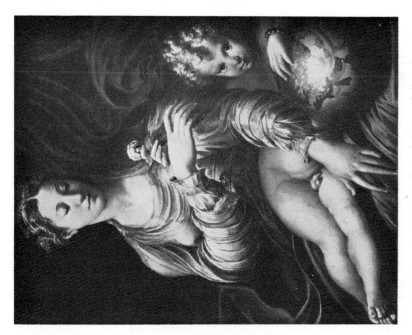

396. PARMIGIANINO: *The Madonna of the Rose*. Gallery, Dresden

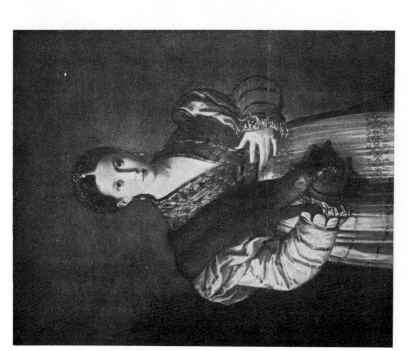

395. PARMIGIANINO: '*La Bella*'. *Detail*. National Museum, Naples

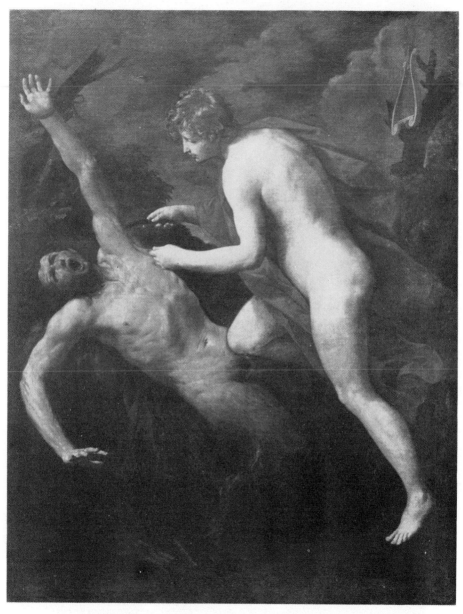

397. GUIDO RENI: *Apollo and Marsyas*. Alte Pinakothek, Munich

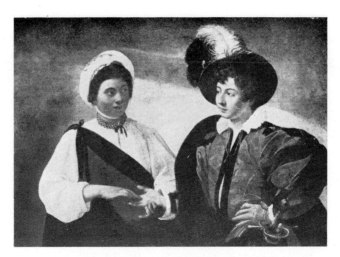

398. CARAVAGGIO: *Gipsy and Soldier*. Louvre, Paris

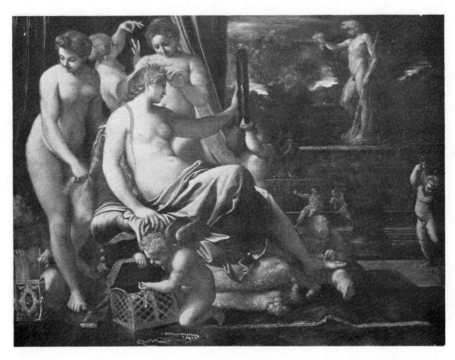

399. ANNIBALE CARRACCI: *Venus adorned by the Graces*. National Gallery of Art, Washington
(Kress Collection)

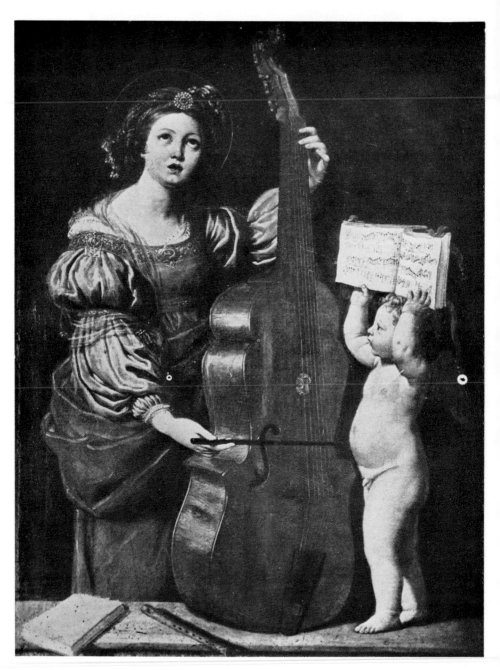

400. DOMENICHINO: *St. Cecilia*. Louvre, Paris

INDEX

ACKNOWLEDGEMENTS

Plates 240 and 241 are reproduced by gracious permission of Her Majesty The Queen.
We also wish to record our gratitude to the following public and private collections for their courtesy in giving us permission to reproduce paintings in their possession:
The Samuel H. Kress Foundation, New York (Pls. 104, 130, 186, 269); the National Gallery of Art, Washington (Pls. 11, 12, 22, 24, 25, 28, 57, 71, 93, 95, 99, 100, 102, 147, 151, 156, 169, 179, 187, 197, 210, 212, 216, 250, 267, 278, 293, 303, 315, 320, 329, 373, 384, 386, 389, 399); the Metropolitan Museum of Art, New York (Pls. 185, 367); the Frick Collection, New York (Pl. 2); the Walters Art Gallery, Baltimore (Pl. 81); the Museum of Fine Arts, (Boston (Pl. 101); the Isabella Stewart Gardner Museum, Boston (Pls. 15, 62, 76); the Fogg Art Museum, Cambridge, Mass. (Pl. 97); the Cleveland Museum of Art, Cleveland (Pl. 294); the Wadsworth Atheneum, Hartford, Conn. (Pl. 188); the Yale University Art Gallery, New Haven, Conn. (Pl. 273); the John G. Johnson Collection, Philadelphia (Pl. 96); the Museum of Art, Rhode Island School of Design, Providence, R.I. (Pl. 358); the Henry E. Huntington Library and Art Gallery, San Marino, Cal. (Pl. 163); the Toledo Museum of Art, Toledo, Ohio (Pl. 161); the Corcoran Gallery of Art, Washington (Pl. 268); the Worcester Art Museum, Worcester, Mass. (Pl. 357); the Royal Academy, Burlington House, London (Pl. 194); the National Gallery, London (Pls. 30, 43–5, 64, 77, 143, 167, 220, 225, 276, 279, 324, 325, 330, 360, 366, 368, 376, 388); the Victoria and Albert Museum, London (Pl.211); the Art Gallery, Glasgow (Pl. 49); the National Gallery of Ireland, Dublin (Pl. 334); the Ashmolean Museum, Oxford (Pls. 27, 145); the Fitzwilliam Museum, Cambridge (Pl. 152); the Walker Art Gallery, Liverpool (Pl. 272); the Ruskin Museum, Sheffield, and the Guild of St. George, Ledbury (Pl. 174); Sir Francis Cook, Bt., and the Trustees of the Cook Collection (Pls. 287, 341); the National Gallery of Victoria, Melbourne (Pl. 103); the Royal Museum of Fine Arts, Copenhagen (Pl. 52); the Rijksmuseum, Amsterdam (Pl. 362); the Kunsthistorisches Museum, Vienna (Pls. 63, 391, 392); the Alte Pinakothek, Munich (Pls. 218, 308, 346, 385, 397); the Rohoncz Castle Collection, Thyssen Bequest, Lugano (Pl. 92); the Atheneum, Helsinki (Pl. 98); the Staedel Institute, Frankfurt-on-Main (Pl. 230); the Museo de Sao Paulo, Brazil (Pl. 335); M. Arthur Sachs, Paris (Pl. 53); Conte Contini-Bonacossi, Florence (Pl. 164).

INDEX